rethinking aesthetics
the role of body in design

edited by Ritu Bhatt

Routledge
Taylor & Francis Group

NEW YORK AND LONDON

First published 2013
by Routledge
711 Third Avenue, New York, NY 10017

Simultaneously published in the UK
by Routledge
2 Park Square, Milton Park, Abingdon, Oxon OX14 4RN

Routledge is an imprint of the Taylor & Francis Group, an informa business

Library of Congress Cataloging in Publication Data
Rethinking aesthetics : the role of body in design / Ritu Bhatt [editor].
pages cm
Includes index.
1. Design--Human factors. 2. Human body. I. Bhatt, Ritu, editor of
compilation.
NK1110.R48 2013
701'.17--dc23
2012027479

ISBN: 978-0-415-53474-1 (hbk)
ISBN: 978-0-415-53475-8 (pbk)

Typeset in Sabon
by Saxon Graphics Ltd, Derby
Printed and bound in the United States of America on acid-free paper.

Acquisition Editor: Wendy Fuller
Editorial Assistant: Laura Williamson
Production Editor: Alanna Donaldson

SFI Certified Sourcing
www.sfiprogram.org
SFI-00453

Printed and bound in the United States of America
by Edwards Brothers, Inc.

This book is dedicated to the loving memory of my mother, Varsha Bhatt (1940–2011)

contents

contents

list of image credits

list of contributors

Chris Abel is an architectural theorist, teacher, and critic based in Northern Ireland close to Belfast. A graduate of the Architectural Association School of Architecture in London, he is the author of over 120 publications. His books include two collections of his essays, *Architecture and Identity* (1997/2000; 2nd edition), and *Architecture, Technology and Process* (2004). He has also contributed to numerous monographs on leading architects and is a recognized authority on the works of Norman Foster. In 2003 he was co-curator with Lord Foster for the Royal Academy of Arts Summer Exhibition, *Sky High: Vertical Architecture*, and is the author of the book with the same title. He has taught in many parts of the world, including the UK, North and South America, the Middle East, and Southeast Asia and held the Hyde Chair of Excellence in Architecture at the University of Lincoln, Nebraska in 2008. Most recently he taught at the University of Sydney and the University of New South Wales.

Sonit Bafna is an Associate Professor in the College of Architecture, Georgia Institute of Technology. He graduated with a professional degree in architecture from CEPT, Ahmedabad, and finished postgraduate studies at MIT and Georgia Tech. He conducts analytical studies of architecture, dealing mainly with spatial and visual organization of buildings, theory of architecture, and aesthetics. He has published papers in the *Journal of Architecture*, *Journal of the Society of Architectural Historians*, *Environment and Planning B*, and *Environment and Behavior*. Some of his applied research has been supported by the GSA, Kaiser Permanente, the Robert Wood Johnson Foundation, and Ascension Health.

Ritu Bhatt has taught as an Assistant Professor at the School of Architecture in the College of Design at the University of Minnesota (2004–2012). Her areas of interest include history and theory of modern architecture, environmental behavior research, cross-cultural criticism, and the relationship between philosophy and architecture. She has published articles in *Journal of Architectural Education*, *Journal of Architecture*, *Visible Language*, *Design Issues*, *Harvard Asia Pacific Review*, *Architecture + Design*, and *Traditional Dwellings and Settlement Review*. Her research has been supported by grants from the Woodrow Wilson Foundation, the Institute for Advanced Studies, the University of Minnesota, and the Doreen B. Townsend Center for the Humanities, UC Berkeley, where she was a postdoctoral fellow.

Remei Capdevila Werning is a postdoctoral researcher at Columbia University (2009–11). She received her Ph.D. in philosophy from the Universitat Autònoma de Barcelona (UAB) in 2009 for her dissertation Construing Architecture—Constructing Philosophy: Meaning and Symbolization of Architecture and Nelson Goodman's Aesthetics. She is the recipient of a Beatriu de Pinós Postdoctoral Fellowship, a Real Colegio Complutense at Harvard Fellowship, a La Caixa Fellowship for Graduate Studies in the U.S., a predoctoral fellowship from the Catalan government, and several travel grants. Her research focuses mainly on analytical aesthetics and epistemology, aesthetics and philosophy of architecture, aesthetic experience of art and architecture, and the cognitive role of the arts. She is currently working on the particularities and philosophical problems posed by restored, preserved, and reconstructed buildings.

Galen Cranz is Professor of Architecture at the University of California, Berkeley. She teaches courses in the social and cultural basis of architectural and urban design and research methods. Her current research activity includes body conscious design; display in the decorative arts: pragmatic, symbolic, and aesthetic tableaux; and post-occupancy evaluation. She is the author of *The Chair: Rethinking Culture, Body and Design* (1998) and *The Politics of Park Design: A History of Urban Parks in America* (1982).

Mark Johnson is Knight Professor of Liberal Arts and Sciences in the Department of Philosophy, University of Oregon. He is author of *The Body in the Mind* (1987), *Moral Imagination* (1993), and *The Meaning of the Body* (2007) and co-author of *Metaphors We Live By* (1980), and *Philosophy in the Flesh* (1999). His current work focuses on the role of the body in the shaping of human meaning and understanding.

Juhani Pallasmaa, Architect SAFA, Hon. FAIA, Int FRIBA, Professor Emeritus, Helsinki, has practised architecture since the early 1960s and established his own office, Juhani Pallasmaa Architects, in 1983. He has also been active in urban, exhibition, product, and graphic design. Pallasmaa has taught and lectured widely in Europe, North and South America, Africa, and Asia, and published books and essays on the philosophy and critique of architecture and the arts in over thirty languages. His numerous books include *The Thinking Hand: Embodied and Existential Wisdom in Architecture* (2009), *Encounters: Architectural Essays* (2005), *The Aalto House* (2004), *The Eyes of the Skin* (1996; 2005), and *Maailmassaolon Taide* [The Art of Being-in-the-World: Essays on Art and Architecture] (1993). Pallasmaa has received three honorary doctorates from the University of Industrial Arts, Helsinki (1993); Helsinki University of Technology (1998); and Estonian Academy of Arts (2004). He is also Honorary Professor of the International Academy of Architecture. Pallasmaa has received several awards as well, including the Arnold W. Brunner Prize for Architecture from the American Academy of Arts and Letters in 2009.

Yuriko Saito is Professor of Philosophy at the Rhode Island School of Design. Her research areas include environmental aesthetics and ethics, Japanese aesthetics, and everyday aesthetics. She has published many articles in these areas in a variety of academic journals, such as *The Journal of Aesthetics and Art Criticism, Environmental*

Ethics, and *Contemporary Aesthetics*, as well as in numerous anthologies. One of her most recent works is her book *Everyday Aesthetics* (2008).

David Seamon is a Professor of Architecture at Kansas State University in Manhattan, Kansas. Trained in geography and environment-behavior research, he is interested in a phenomenological approach to place, architecture, and environmental design as place-making. His books include *A Geography of the Lifeworld* (1979); *Dwelling, Place and Environment* (edited with Robert Mugerauer, 1985); *Dwelling, Seeing, and Designing* (1993); and *Goethe's Way of Science: A Phenomenology of Nature* (edited with Arthur Zajonc, 1998). He edits the *Environmental and Architectural Phenomenology Newsletter* (www.arch.ksu.edu/seamon).

Richard Shusterman is the Dorothy F. Schmidt Eminent Scholar in the Humanities at Florida Atlantic University and directs its Center for Body, Mind, and Culture. His books include *Surface and Depth* (2002), *Performing Live* (2000), *Practicing Philosophy* (1997), *Pragmatist Aesthetics* (1997, translated into twelve languages), and most recently *Body Consciousness* (2008). A graduate of Hebrew University of Jerusalem and Oxford University (D. Phil.), he has held academic appointments in France, Germany, Israel, and Japan, and has been awarded research grants from the NEH, Fulbright Program, ACLS, Humboldt Foundation, and UNESCO. He is also a certified somatic educator in the Feldenkrais Method.

acknowledgements

My desire to inquire into the nature of aesthetics began during my Ph.D. studies at MIT. I would like to thank the members of my dissertation committee—Mark Jarzombek, Stanford Anderson, Sibel Bozdogan, Catherine Elgin, Diane Ghirardo, and Satya Mohanty—for encouraging me to embark on an interdisciplinary inquiry of aesthetics and architecture. I would also like to thank Katherine Solomonson, my faculty mentor at the University of Minnesota, for her intellectual guidance and for encouraging me to put together a book that would foster debates on the body and everyday aesthetics in design. I must also express gratitude to my colleague Ann Waltner, whom I came to know during a fellowship at the Institute of Advanced Studies, for her generous support of my work. I also extend sincere thanks to John Archer, Julia Robinson, Leon Satkowski, Cynthia Jara, and Ignacio San Martín, all valuable colleagues who have helped me to hone my arguments through conversations both casual and formal on this material. In addition, I want to acknowledge the painstaking efforts of my editor, Melanie Martin, who has lent valuable insights that helped me to bring this manuscript to completion.

Finally, I would like to express gratitude to my family members: my father Pramod Bhatt, my husband Vivek, and our children Jai and Anya, who have all helped me in extraordinary ways to understand the true significance of aesthetics. Without their generous, loving support, this book would not have been possible.

Introduction

rethinking aesthetics
the role of body in design

ritu bhatt

Following a phase of anti-aesthetic rhetoric in which theories and histories of art and architecture have focused primarily on political, social, or empirical interpretations, aesthetics is re-emerging as a vital arena for inquiry. Recent developments in neuroscience, phenomenology, somatics, and analytic philosophy of the mind have fundamentally reshaped the boundaries between these disciplines, and have brought to the surface the correlations that exist between aesthetic cognition, the human body, and everyday life. Drawing on these developments, the essays in this book come together to assert that aesthetic experiences can be nurtured at any moment in our everyday lives. In doing so, they contest the common view that only experiencing art entails aesthetic experience, re-opening debates about the agency embodied in aesthetic practices.

Aesthetics, as a discipline, originated in the eighteenth century when it was named the "science of sensory knowledge."[1] However, the dominance of the sense of sight and visual perception in Western epistemology has resulted in conceptualizations of aesthetics being defined primarily within visual terms. The common view that experiencing arts entails an aesthetic experience has produced a narrow definition of aesthetics as a realm that is distinct from other human experiences—the moral, practical, sensorial, and social, for instance— divorcing the body from the realm of the aesthetic. Contrary to this perspective, the essays in this book assert that the body and all its senses need to be recognized as integral to aesthetics, and that the value and force of aesthetics is not diminished but in fact amplified by recognizing their social, moral, and cognitive role. In doing so, the essays challenge the dominant claims in contemporary aesthetic and cultural theory that narrowly equate aesthetics with political complicity.

The purpose of this book is two-fold. First, it aims to bring together discourses of aesthetics and architecture—the domain of which has remained largely under-theorized, outside of a few selected publications.[2] The key challenge of initiating discourses of aesthetics and architecture in dialogue has been the continual relegation of architecture to a "lesser art," or a "mere backdrop" capable only of engaging common practical everyday experience and use, in contrast to the perception of "high art" as engaging consciousness through inspired contemplation. Second, this book aims to explore how recent debates in aesthetics that dissolve boundaries between cognitive sciences, somatics, and non-western conceptions of philosophical thought might aid in reconsidering both the body and design.[3]

The rethinking of aesthetics has been prompted by key developments in the cognitive sciences, somatics, and philosophy. This area of inquiry stemmed, in part, from the uncovering of the biological/physical basis of psychological phenomena and abstract intuitions. More recently, with the advent of functional neuroimaging methods, some neuroscientists have begun to explore the neural correlates of experiences deemed aesthetic.[4] The emergence of concepts such as neuro-plasticity in neuroscience has pointed to the extraordinary adaptive capabilities of the human brain, and the continual restructuring and reorganization that neural circuits are capable of in response to both internal

and external stimuli, in a dramatic shift from the earlier belief that the nervous system remains fixed throughout adulthood. This has led to the understanding that aesthetic processes can provide insights about the functioning of the human brain and body, and vice versa. In the words of Semir Zeki, neurobiologist, Shakespeare and Wagner are among the greatest of neurologists, "for they, at least, did know how to probe the mind of man with the techniques of language and music and understood better than most what it is that moves the mind of man." Zeki further states: "Most painters are also neurologists, as they are those who have experimented upon and, without ever realising it, understood something about the organisation of the visual brain, though with techniques that are unique to them."[5] Such insights, likening the probing of an artist to that of a neurologist, have contributed to the dissolution of traditional binary oppositions of reason and emotion, science and art, rational thought and feeling, and analytic aesthetics and phenomenology, which had until recently downplayed the role of empirical scientific studies in studying aesthetic response and emotion.

In a parallel shift, emerging critiques of western epistemological constructs have called for a re-insertion of the body into knowledge, bringing to light the role of the active agency of the body. Dissolving the conventional object-subject split, philosophers, social theorists, psychologists, and somatic practitioners, among others, have called for a reconceptualization of the body as a subject, experienced from within rather than from without, arguing for the recognition ("re-cognition") of the fact that the human body is the grounds from which one needs to explore experience. Such developments have led to newer insights about the ways unconscious processes affect cognition; the ways experiencing art and architecture affects the human brain, and vice-versa; and the ways in which human intention and agency can critically transform and deepen processes of cognition. As a result of these insights, space has opened for an exploration of aesthetics that is no longer exclusively limited to the arts and that need not only be interpreted as politically complicit, as has been the focus of the recent critiques of aesthetics.

This book is the first to bring together prominent voices in aesthetics, phenomenology, architecture, and cognitive sciences to call for a radical rethinking of aesthetics and its relationship to the body. Most importantly, by placing the body in the center of design (and vice-versa), the essays rework what both of these concepts mean, thereby opening debates about what the blurring of boundaries between aesthetics, somatics, and neuroscience may imply for knowledge in design-related disciplines. The purpose of the book is not to summarize the scientific and empirical work on aesthetics and emotion—the field is simply too large and too much in flux for that to be reasonable—but rather, to show how scholars with very different intellectual positions are exploring new frontiers for discourses of aesthetics and architecture. The chapters are organized around two broad themes: "Role of Aesthetic Response in Everyday Life" and "Modes of Aesthetic Response: Tacit Perception and Somatic Consciousness."

The first part, "Role of Aesthetic Response in Everyday Life," includes essays by Richard Shusterman, Mark Johnson, Sonit Bafna, Remei Capdevila

Werning, and Chris Abel, centering on the idea that any explanation of either mindful or un-self-conscious aesthetic responses should account for the subject's relationship with everyday surroundings. The second part, "Modes of Aesthetic Response: Tacit Perception and Somatic Consciousness," explores the idea that aesthetic responses are not merely limited to a mental or cognitive function, but involve bodily perception as well. This organization allows for the discussion to move beyond narrow distinctions, such as those between buildings and the body; between eastern and western philosophical conceptions; or between phenomenological inquiry and analytic aesthetics into a broader inquiry about aesthetics and design. The essays are based on topics ranging from an integrated mind-body approach to chair design, to Bill Hillier's theories of space syntax, to theoretical accounts of existential and contemplative relationships with buildings. As a whole, they contest the narrow perception of the everyday as mundane, arguing that deeply profound aesthetic experiences can be nurtured at any moment through the most ordinary of objects, and that increased somatic awareness of the body and its surroundings can enrich and deepen everyday experiences. Furthermore, the essays re-conceptualize the role that buildings play in cognition—above and beyond their practical, habitual everyday use—providing a richer, fuller account of how buildings affect cognition by invoking multisensory responses at different levels of engagement, both everyday and extraordinary.

Richard Shusterman's essay "Everyday Aesthetics of Embodiment" broadens the definition of aesthetics, arguing that an awakened consciousness can allow one to experience extraordinary beauty in the most ordinary of objects. By providing a transfiguring intensity of awareness, perception, and feeling of "high art" without its associated isolating elitism, Shusterman argues, an embodied conception of the everyday provides important insights for rethinking aesthetics. Shusterman calls for an integration of art and practices of living—the thoughtful, disciplined everyday actions that intertwine ethics, aesthetics, and spiritual elevation—allowing us to move beyond the perception of the everyday as mundane. In the process, he calls for recognition of the practical aspect of philosophy—its ability to serve as a deliberate way of life concerned with self-improvement rather than as a mere academic enterprise—an argument that Shusterman highlights through a discussion of the writings of the American Transcendentalists Thoreau and Emerson. The paper concludes with two concrete examples based on Shusterman's own lived experiences during his training in Zen Buddhism in Japan. The first shows how mindfulness can reveal the visual beauty in seemingly unattractive visual objects, and the second explores the beauty of mindfully coordinated movement in embodied, attentive, everyday communal actions.

Similarly, Mark Johnson's essay, "Dewey's Big Idea for Aesthetics," provides a radical critique of the marginalization of aesthetics by drawing upon John Dewey's work. Outlining parallels between Dewey's claims and recent empirical research in the cognitive sciences, Johnson argues for recognition of the central role of the aesthetic dimensions of every developed experience. Johnson writes that according to Dewey, aesthetics involves not simply visual qualities, but

also "form and structure, qualities that define a situation, our felt sense of the meaning of things, our rhythmic engagement with our surroundings, and our emotional transactions with other people and our world." Johnson argues that Dewey turned the epistemological conception of aesthetics on its head when he asserted that it should be aesthetics, above all else, that provides the basis for our account of human nature, human meaning, human knowing, and human value. This, according to Johnson, provides the basis for Dewey's seminal contribution to aesthetic theory—his Big Idea—which is that "every fulfilled experience is individuated by a pervasive unifying quality." We first engage with any aesthetic experience on an intuitive and emotional level, though philosophy has ignored the meaningfulness of this first experience, validating only the intellectual rationalizations that follow. We feel more than we can put into words, more than we can consciously be aware of, when we see a painting or engage in any other type of experience, Johnson maintains. Citing the work of Don Tucker, Johnson points to developments in the cognitive sciences that have shown how the limbic core of the brain, with its dense interconnections and strong emotional valences, seems to facilitate the emotional grasp of any given experience, while the modular, highly differentiated motor regions of the shell enable the qualities of discrimination and differentiation. Johnson asserts that the qualitative affect of unity evolves through cyclic activity between the core and the shell. Such knowledge of the cognitive dimensions of developed experiences, Johnson argues, helps to radically rethink the role of aesthetics in everyday life.

While Johnson's essay provides a comprehensive account of the aesthetic dimensions of any developed cognitive experience, Sonit Bafna's essay "Imaginative Perception in an Everyday Setting: The Modalities of Attention in Marcel Breuer's Atlanta Public Library" takes a stance against the common theorization of architecture as a "lesser art." Bafna argues that such perceptions are built upon the premise that buildings are non-representational art forms that are therefore incapable of embodying conceptual content. By focusing on mechanisms of attention and how they relate to perceptual organization, Bafna illustrates that buildings not only embody conceptual content—a sense of "aboutness"—but also can prompt active, critical, and experiential responses. Bafna's analysis focuses on a seemingly simple structure, the Atlanta Public Library designed by Marcel Breuer, to show how "uninteresting," ordinary buildings have the potential to lead users to a heightened imaginative perception while simultaneously meeting the needs of everyday users. Furthermore, Bafna argues, such analysis highlights the influence of Breuer's early formative roots in Bauhaus architectural philosophy, which holds that the visual artist's role is to give the public a new way of seeing the world, cultivated through artifacts that expressively exploit the laws of visual organization. Asserting that a building can be both everyday and extraordinary, Bafna argues that recognition of a building's ability to invoke heightened focal attention opens up possibilities for a re-conceptualization of aesthetics that moves beyond the modern functionalism-based understanding of aesthetics as well as the postmodern pastiche.

In "From Buildings to Architecture: A Construal of Nelson Goodman's Aesthetics," Remei Capdevila Werning extends the discussion to an exploration of the underlying interpretative and evaluative processes involved in experiencing buildings, through an analysis of Nelson Goodman's theories of aesthetics. Capdevila Werning distinguishes everyday experiences of buildings from aesthetic ones, which she argues happen on a more conscious level. However, she asserts, we can experience any everyday environment or object aesthetically by paying conscious attention to its symbolic meaning. Her analysis exemplifies Goodman's notion that aesthetics is a branch of epistemology inclusive of non-propositional knowledge, and that aesthetics is a "primarily cognitive endeavor" that consists of interpreting the symbolic meaning of buildings. Buildings' purposes are articulated through cohesion of design elements, she explains, showing how buildings exemplify concepts by presenting them metaphorically. When experiencing these messages relayed by buildings, she argues, we engage in multisensory, corporeal interactions with our built environments. We experience a building through numerous interactions with smaller parts of the structure, and our concept of the building as a whole is a compilation of all of these interactions. Thus, individual interpretations can vary greatly and are always open to reinterpretation. She explains, "There is no pure perception, but a cognitive construction created from prior perceptions" through the active process of cognitively interacting with a building and comparing it with previous aesthetic experiences and understanding. Capdevila Werning's essay concludes with an in-depth discussion of the concept of "right" symbolization of buildings, and "right" interpretations of users, within a pluralistic framework that allows for multiple views while maintaining that we should not fall into a total relativism that claims any view is correct.

While Capdevila Werning takes a stance against relativism by drawing upon Goodman, Chris Abel critiques relativism by developing an argument based on Michael Polanyi's concept of tacit knowing in his essay "The Extended Self: Tacit Knowing and Place Identity." In this essay on how people identify with places and the everyday objects they use, Abel argues that everyday functions and skills not only stem largely from unconscious mental processes, but they also have spatial dimensions as illustrated in recent research on body mapping in the work of neuroscientists Blakeslee and Blakeslee (2007). The science of body mapping, Abel argues, illustrates how each region of the brain is neurologically connected to a part of the body, and also how the "body schema" extends beyond the body so that when we sense other objects near us, the neurons corresponding to that region of the body begin firing. Furthermore, the mind constructs accurate but flexible spatial maps of the body from early life that remain with us, and which are vital to human survival and well-being. The "peripersonal space," Abel argues, can be extended at will to encompass tools, artifacts, and even other people, and remains in a process of constant evolution in response to changes in an individual's personal growth and development in the social and physical environment she inhabits. Abel's paper progresses to explore how architects can use this knowledge to design built

environments. Neurological connections have caused people to identify with the unsustainable environments they are accustomed to living in, he asserts, but by understanding clients' body maps, designers can create more sustainable environments with which inhabitants will be able to identify.

In her essay "Body Conscious Design," Galen Cranz calls for a reinsertion of the body into the practice of design by focusing on the pedagogical practices of somatic re-education—particularly the Alexander technique, a widely used system of re-educating the body to respond to sensory experience—as a basis for reconsidering design. Cranz asserts that there is a deep physical, emotional, and bodily basis to understanding aesthetics, and that reduced sensory awareness of the body has led to an exclusive focus on formal and visual concerns in design-related disciplines. Defining aesthetics as deeply felt sensory experience—not solely as visual experience—Cranz argues that weaving rich aesthetic experiences into our everyday lives provides a way to radically redefine art. She stresses that increased awareness of unconscious processes can facilitate constructive, conscious control of the body and mind over everyday surroundings. Through a focus on kinesthetic re-education and exercises in redesigning everyday objects of furniture, Cranz reports on studies that have influenced design students' insights about seeing and observing while strengthening and enhancing their work in environmental design.

While Cranz engages with the design of everyday objects of furniture, Yuriko Saito provides an integrated view of body and design in her essay "The Moral Dimension of Japanese Aesthetics," wherein she discusses ethical and moral aspects of everyday aesthetics. In contrast to traditional western aesthetics, Saito argues, the Japanese understanding of multisensory engagements with the everyday world involves honor and respect for the needs and interests of all experiencing agents. The respect for art objects, Saito argues, is expressed through capturing the innate characteristics of the materials and articulated as a submission of the creator to the dictates of the material. Such aesthetic strategies, which have origins in Japan's indigenous Shintoism and Zen Buddhist traditions, are currently being re-conceptualized by designers in the west as pragmatic and respectful ways of creating more sustainable designs that are at one with nature, Saito explains. Furthermore, by attending to the unfolding of experiences, Japanese aesthetic strategy focuses on determining and creating the utmost satisfying and enriching experience for the experiencing agent, which in turn fosters feelings of humility and respect in the recipient through recognition of the care taken in the creation of the object. Saito stresses that insights from Japanese aesthetics suggest that people's daily interactions with their environments and objects determine their quality of life, not only in an aesthetic sense but also in a moral sense. In doing so, Saito makes the fundamental correlation that one of the necessary ingredients of a strong society is sensitively and thoughtfully created objects and environments.

Ritu Bhatt's essay, "Traditional Knowledge for Contemporary Uses: An Analysis of Everyday Practices of Self-Help in Architecture," continues the exploration of everyday aesthetics by delving into day-to-day acts of space-making, examining popular practices that have succeeded with everyday users

but remain contested in the architectural academy. Bhatt's essay brings to the fore striking parallels shared by Christopher Alexander's pattern language and Feng shui in their emphasis on how unconscious relationships with space can be discerned, brought to the conscious realm, and improved upon. In doing so, Bhatt shows how the two systems underscore the role of normative frameworks in understanding the agency of the body. Feng shui holds that intuition can serve as a guide for what is most beneficial, Bhatt emphasizes, which aligns directly with Alexander's argument that deeply-felt human sensations and needs should guide architectural design. Furthermore, Bhatt argues, the rich correlations that Christopher Alexander and Feng shui draw between qualitative aspects of spaces and human well-being not only parallel the recent developments in somatics and the cognitive sciences, but also provide important insights for reconsidering the impasse of debates in architectural theory wherein traditional knowledge systems are either viewed with deep skepticism or legitimated through essentialist arguments. Both practices bring to light pragmatic approaches that everyday users employ when they consider, select, and experiment with traditional knowledge in search of insights about intuitive and constantly interactive mechanisms by which human bodies relate to space, she explains. In doing so, Bhatt asserts, these practices remain markers of the deep divide that persists between professional knowledge and user perceptions in architecture.

David Seamon further explores the relationships between unconscious and conscious acts of space-making in his essay, "Environmental Embodiment, Merleau-Ponty, and Bill Hillier's Theory of Space Syntax: Toward a Phenomenology of People-in-Place." Drawing upon phenomenological literature, especially Merleau-Ponty's writings, Seamon develops an account of environmental embodiment that refers to the various ways, both sensuously and movement-wise, in which the body in its pre-reflective perceptual awareness engages and coordinates with the world at hand, especially its architectural and environmental aspects. The essay focuses on examining the relationship between Bill Hillier's theory of space syntax and Maurice Merleau-Ponty's concept of the body-subject. The notion of space syntax explains how a world's underlying spatial structure, or *configuration*, as Hillier called it, contributes to particular modes of human movement, corporeal co-presence, and interpersonal encounter. The body-subject is a synergy of un-self-conscious but integrated movements, and one has learned a particular action when the body-subject has incorporated the action into its realm of pre-cognitive taken-for-grantedness. By analyzing the relationship between space syntax and the body-subject, Seamon explores how environmental embodiment facilitates place-making, drawing from his own concepts of body-routines, time-space routines, and place ballets to show how spatial arrangements and human routines merge to create ways of being in the world. Seamon's essay concludes with an important concern: whether the un-self-conscious place-making of the past can be regenerated self-consciously today through knowledgeable planning, equitable policy, and creative design.

Arguments about the cognitive potential of buildings and spaces are further honed in Juhani Pallasmaa's essay, "Mental and Existential Ecology," wherein

Pallasmaa argues that buildings provide a mental mediation between the world and human consciousness and possess a capacity to lead one to unconscious motifs, memories, desires, and fears. In addition to organizing the outside world, Pallasmaa argues, architecture also structures the inner world, and as a multisensory art form, affects people on sensorial and neural levels. Pallasmaa critiques the theorization of architecture as an art form of the eye, arguing that architectural design should address the quality of mental life. Accessing those dimensions calls for a design approach centered on embodied encounter, intuition, and empathy, Pallasmaa argues. Architectural constructions organize and structure our experiences of the world, project distinct frames of perception and experience, and provide specific horizons of understanding and meaning, he explains. Invoking the words of numerous philosophers, poets, and novelists who stress the interwoven nature of physical, mental, and emotional experience, such as Rainer Maria Rilke, Jorge Luis Borges, Salman Rushdie, and Maurice Merleau-Ponty, Pallasmaa emphasizes that architecture ideally "renders possible an intense experiential and existential self-knowledge." As buildings become increasingly similar, he asserts, artists and architects have an increased responsibility to make our world, and our experiences in it, more authentic by creating a vast array of differentiated spaces that have the capacity to mediate between ourselves and the world.

It is my hope that engaging in thoughtful contemplation of the arguments presented in this book will prompt readers to question their long-standing assumptions about the kinds of experiences that have been deemed aesthetic. The book shifts the inquiry of aesthetics from the realm of the abstract to the realm of lived experiences, enabling readers to understand emerging developments in aesthetics in the context of architecture and design. The essays may raise questions such as: "Can a subject's awakened consciousness allow one to experience extraordinary beauty in the most ordinary of objects?" "Do 'uninteresting,' ordinary buildings have the capacity to engage users in a heightened imaginative perception?" "Can somatic practices help to further sharpen and hone design abilities?" and "If the aesthetic has potential beyond its social-cultural-political implications, then how might we conceptualize emerging forms of multicultural aesthetics?" I hope such questions will stimulate, extend, and challenge readers' own thinking, rekindling a dialogue on aesthetics by exploring emerging conceptions of the body and their relationship with the art of design.

NOTES

1 Alexander Gottlieb Baumgarten, *Aesthetica*, 1750.
2 Several selected publications on aesthetics and architecture include: Nelson Goodman, *Languages of Art: An Approach to a Theory of Symbols*, Indianapolis: Hackett, 1968; Roger Scruton, *The Aesthetics of Architecture*, Princeton UP, 1979; *Philosophy and Architecture*, ed. Michael H. Mitias, Amsterdam: Editions Rodopi B.V., 1994; Richard Hill, *Designs and Their Consequences*, Yale UP, 1999; Edward Winters, *Aesthetics and Architecture*, London: Continuum, 2007; *Aesthetic Theory: Essential Texts for Architecture and Design* (edited with

commentary by Mark Foster Gage), NY: W. W. Norton and Company, 2011; *The Aesthetics of Architecture: Philosophical Investigations into the Art of Building*, eds. David Goldblatt and Roger Paden, Chichester, UK: John Wiley & Sons Ltd., 2011. Also see Nelson Goodman, "How Buildings Mean," in Nelson Goodman and Catherine Z. Elgin, *Reconceptions in Philosophy and Other Arts and Sciences*, Indianapolis: Hackett, 1988, 31–48; and Allen Carlson, "Reconsidering the Aesthetics of Architecture," in *Journal of Aesthetic Education* 20 (Winter 1986), 21–7.

3 G. Lakoff and M. Johnson, *Philosophy in the Flesh: The Embodied Mind and Its Challenge to Western Thought*, NY: Basic Books, 1999. R. Shusterman, *Body Consciousness: A Philosophy of Mindfulness and Somaesthetics*, NY: Cambridge UP, 2008; Yuriko Saito, *Everyday Aesthetics*, Oxford UP, 2008; Allen Carlson, *Aesthetics and the Environment: The Appreciation of Nature, Art, and Architecture*, London; NY: Routledge, 2000; Galen Cranz, *The Chair: Rethinking Culture, Body, & Design*, W. W. Norton & Company, 1998.

4 For studies that have inquired into the neurobiological basis of aesthetic response, see V.S. Ramachandran and William Hirstein, "The Science of Art: A Neurological Theory of Aesthetic Experience," *Journal of Consciousness Studies* 6.6–7 (1999): 15–41; Semir Zeki, *Inner Vision: An Exploration of Art and the Brain*, Oxford University Press, 1999; *Neuroaesthetics*, eds. Martin Skov and Oshin Vartanian, Amityville, NY: Baywood Publishing Co., 2009; *Aesthetic Science: Connecting Minds, Brains, and Experience*, eds. Arthur P. Shimamura and Stephen E. Palmer, Oxford University Press, 2012.

5 Semir Zeki, *Inner Vision: An Exploration of Art and the Brain*, Oxford UP, 1999, 2.

PART ONE
role of aesthetic response
in everyday life

1

everyday aesthetics of embodiment

Richard Shusterman

PHILOSOPHY AND THE ART OF LIVING

America's most important and inspirational transcendentalist thinkers, Ralph Waldo Emerson and Henry David Thoreau, have largely been neglected by academic philosophy and relegated to the status of merely literary figures. One reason for this marginalization may be their advocacy that philosophy is more importantly practiced as a deliberate way of life concerned with self-improvement than as a solely academic enterprise. As Thoreau most pointedly put it, "There are nowadays professors of philosophy, but not philosophers. Yet it is admirable to profess because it was once admirable to live."[1] Both resisted the restriction of philosophy to a mere academic subject of the pure intellect that is essentially confined to the reading, writing, and discussion of texts. If Emerson recognized that any such "life is not [mere] dialectics" and that "intellectual tasting of life will not supersede muscular activity,"[2] Thoreau later more explicitly explained: "To be a philosopher is not merely to have subtle thoughts, nor even to found a school, but so to love wisdom as to live according to its dictates, a life of simplicity, independence, magnanimity, and trust. It is to solve some of the problems of life, not only theoretically, but practically."[3]

This insistence on the practical dimension of philosophy was an inspiration for later pragmatist philosophers such as William James and John Dewey, whose exemplary path has guided my own efforts. If *Pragmatist Aesthetics* and *Practicing Philosophy* offered arguments for reintegrating aesthetic principles into the ethical, practical conduct of life, these ideas were already prefigured in Emerson and Thoreau's works.[4] "Art," says Emerson, "must not be a superficial talent" of "making cripples and monsters, such as all pictures and statues are" but "must serve the ideal" in inspiring and remaking men and women of character.[5] Thoreau provides a still more explicit formulation:

> It is something to be able to paint a particular picture, or to carve a statue, and so to make a few objects beautiful; but it is far more glorious to carve and paint the very atmosphere and medium through which we look, which morally we can do. To affect the quality of the day, that is the highest of arts. Every man is tasked to make his life, even in its details, worthy of the contemplation of his most elevated and critical hour.[6]

If in *Body Consciousness* (and prior writings) I sought to establish a field of somaesthetics that included practical bodily disciplines to enhance our experience and performance while increasing our tools for self-fashioning, I could again look to Thoreau as a prophetic forerunner:[7]

> Every man is the builder of a temple, called his body, to the god he worships, after a style purely his own, nor can he get off by hammering marble instead. We are all sculptors and painters, and our material is our own flesh and blood and bones. Any nobleness begins at once to refine a man's features, any meanness or sensuality to imbrute them.[8]

In this essay I want to go beyond these points already underlined in my earlier books and instead consider another important way in which Emerson and Thoreau characterize philosophical living that has been largely overlooked in their theories, perhaps because it seems so simple that it appears inconspicuous: to live philosophically means living in a waking rather than sleeping state. To explore what this richly ambiguous idea signifies, I will examine how Emerson and Thoreau deploy it, while noting some of its major uses in the history of philosophy. But to give this idea (which is also an ideal) a more concrete and contemporary exemplification, I will discuss how awakened life contributes both to the aesthetic enrichment of everyday experience, if not also to spiritual enlightenment. I will draw here on my personal experience of awakened living in a Japanese Zen cloister.

First, however, as background to examining the meaning of awakened life to Emerson and Thoreau, and the meaning it had for me in my experience of Zen living, we should recall some of the other major orientations in characterizing and pursuing the philosophical life. At least three key Western conceptions of philosophical living can be traced back to Plato. If the *Apology* presents Socrates' philosophical life in terms of the Delphic quest for self-knowledge and for the right way to live an examined life that would benefit both self and society, Plato, in other dialogues, offers other models. In the *Crito*, *Gorgias*, and the *Republic*, he compares the philosopher's role to the physician's. As the latter cares for the body's health, so the philosopher cares for the soul's. But as the soul is immortal and nobler than the body, Plato argues, so philosophy should be seen as the superior practice. This medical or therapeutic model of caring for the soul's health was highly influential in ancient philosophy, and has been convincingly explained by Pierre Hadot (among others), who has also highlighted its use of spiritual exercises to serve the soul's health.

In the *Symposium* (198c–213d), Plato sketches another model of the philosophical life that I have described as more aesthetic than therapeutic. Love's desire for beauty is claimed to be the source of philosophy, and the philosophical life is portrayed as a continuous quest for higher beauty that ennobles the philosopher and culminates in the vision of the perfect form of beauty itself and the knowledge to give birth with beauty to "real virtue." Plato describes this life of beauty as "the only life worth living," making the philosopher "immortal, if any man ever is."[9] To recommend the philosophical life in terms of beauty, harmony, attractive nobility, or innovative creative expression is to advocate what I call the aesthetic model of philosophical living, and in *Practicing Philosophy* I have elaborated its contemporary expression in the works of philosophers as diverse as Michel Foucault, Ludwig Wittgenstein, and John Dewey. From the passages cited above, we can also see Emerson and Thoreau as endorsing such an idea of an aesthetically noble art of living in which the subject seeks to shape himself and his environment into an attractive form "worthy of the contemplation of his most elevated and critical hour." Now, however, let us examine their injunction to live not in terms of remaking oneself, one's experience, and one's surroundings with greater beauty and attractive nobility, but rather to simply live one's life in a waking state.

PHILOSOPHY AS AWAKENED LIFE

If Emerson, the older mentor, leads the way with richly poetic suggestiveness, Thoreau is more detailed and systematic in elaborating this model of philosophical living as wakefulness. Emerson's famous essay "Experience" begins with this theme: "Where do we find ourselves? In a series of which we do not know the extremes, and believe that it has none. We wake and find ourselves on a stair; there are stairs below us, which we seem to have ascended; there are stairs above us, many a one, which go upward and out of sight."[10] Emerson's message is not addressed to the few literal sleepwalkers but to the majority of us whose conduct of life (our steps in the series that constitutes our path in life) is done not in a properly wakeful state, so that when we do wake at a particular step in time, we do not really know where we are and where we are going. Living in a state of sleep is a potent metaphor for the unexamined life that Socrates opposed to the life of philosophy. Even when we think we are awake "now at noonday" when the light is brightest, Emerson continues, "we cannot shake off the lethargy" of our somnolent consciousness.[11] "Sleep lingers all our lifetime about our eyes, as night hovers all day in the boughs of the fir-tree. Our life is not so much threatened as our perception."[12] Thoreau echoes this complaint in his critique of common sense, asking, "Why level downward to our dullest perception always, and praise that as common sense? The commonest sense is the sense of men asleep, which they express by snoring."[13] We fail to see things as they really are with the rich sensuous resplendence of their full being because we see them through eyes heavy with conventional habits of viewing them and blinded by stereotypes of meaning. Such habits of seeing, like other habits, have certain advantages of efficiency and are thus useful at certain times. But if we allow these habits to overwhelm and displace real seeing (as they will tend to do, since habits are inclined to reinforce themselves), then they will miserably impoverish perception and experience while substituting our vision of the truth with illusory stereotypes that common sense takes for the ultimately real. "By closing the eyes and slumbering, and consenting to be deceived by shows," Thoreau complains, "men establish and confirm their daily life of routine and habit everywhere, which still is built on purely illusory foundations."[14] Philosophy, however, can provide a means of reawakening us so we can see things more clearly, experiencing them more fully than we can in a state of slumber in which our eyes are closed, our senses dulled, and our minds either blank or obscured by dreams.

The concern with breaking humankind out of a slumbering dream state is a familiar topos in philosophy, both East and West. As the ancient Chinese Daoist Zhuangzi wondered whether he was a philosopher who dreamed he was a butterfly or a butterfly dreaming he was the philosopher Zhuangzi, so Descartes just as famously raised the illusion of dreams in the skeptical argument of his "Meditation I," arguing that though seemingly awake, and moving his body parts, he has often been deceived by dreams so that he feels "there are never any sure signs by means of which being awake can be distinguished from being asleep."[15] Still later, and in a different register than

dreams, we find Kant praising Hume for arousing him from his dogmatic slumbers and thus prompting him to develop his critical philosophy. Here sleep is not so much a dream state but a state of uncritical belief and action that is usually identified with a waking state but which is not truly or fully awakened to a condition of perceptive, critical acuity. The notion of awakening to a clearer, critical awareness of the nature of things is also extremely central to the philosophy of Buddhism. The name Buddha in fact means "the awakened one" in Sanskrit (derived from the root "budh," denoting to awake, arouse, or know), and it was given to Siddhartha Gautama to express not only the fact that he too awoke from the dogma and illusions of our conventional beliefs to a clearer awareness of the human conditions of suffering, of false ego consciousness, and of impermanence, but also to express the ways to escape from this suffering through precisely such heightened awareness of those conditions. Here being awake means being more aware than one normally is in one's waking hours, and the theme of mindfulness or intensified awareness remains extremely central to the Buddhist tradition.[16]

Thoreau pursues the same idea in his advocacy of early rising and his praise of morning because it is "the awakening hour."[17] In morning "there is least somnolence in us; and for an hour, at least, some part of us awakes which slumbers all the rest of the day and night."[18] Awakening means waking up to a higher consciousness than we have in ordinary daily and nightly thought and action; it is awakening "to a higher life than we fell asleep from."[19] Night, Thoreau explains, has its value in preparing us for such awakening. "After a partial cessation of his sensuous life, the soul of man, or its organs rather, are reinvigorated each day, and his Genius tries again what noble life it can make. All memorable events, I should say, transpire in morning time and in a morning atmosphere."[20] Quoting the Vedas that "All intelligences awake with the morning," Thoreau insists that this morning atmosphere of awakening is not a matter of chronological time but can and should be kept in one's spirit at all times. For the mind "whose elastic and vigorous thought keeps pace with the sun, the day is perpetual morning. It matters not what the clocks say … Morning is when I am awake and there is a dawn in me."[21]

Emerson, in his essay on "History," praises the artist for "the power of awakening other souls" while likewise affirming that ethically "nobler souls" perform the same function, because a noble character "awakens in us by its actions and words, by its very looks and manners, the same power and beauty that a gallery of sculpture or of pictures addresses."[22] Echoing the claim that art and ethics have the power to awaken us to higher life, Thoreau links this power to the spirit of morning: "Poetry and art, and the fairest and most memorable of the actions of men, date from such an hour. All poets and heroes … are the children of Aurora, and emit their music at sunrise," in the spiritual (rather than merely chronological) sense of morning that Thoreau urges.

"Moral reform is the effort to throw off sleep,"[23] Thoreau further insists, as the idea of awakening suggests the ethical effort of overcoming the agreeable lethargy or comfortable laziness associated with sleep and its reclining position. Saint Augustine, in his *Confessions*, makes this point quite clear, likening his

stubborn habit of fleshly lust to a seductively pleasurable sleepiness that is difficult to shake off.

> I was held down as agreeably by this world's baggage as one often is by sleep; and indeed the thoughts with which I meditated upon You were like the efforts of a man who wants to get up but is so heavy with sleep that he simply sinks back into it again. There is no one who wants to be asleep always—for every sound judgment holds that it is best to be awake—yet a man often postpones the effort of shaking himself awake when he feels a sluggish heaviness in the limbs, and settles pleasurably into another doze though he knows he should not, because it is time to get up. Similarly I regarded it as settled that it would be better to give myself to Your love rather than go to yielding to my own lust; but the first course delighted and convinced my mind, the second delighted my body and held it in bondage.[24]

Intellectual achievement, Thoreau maintains, likewise requires awakening from our drowsiness. "The millions are awake enough for physical labor; but only one in a million is awake enough for effective intellectual exertion, only one in a hundred millions to a poetic or divine life. To be awake is to be alive. I have never yet met a man who was quite awake. How could I have looked him in the face?"[25] Being awake is thus a special, critical, meliorative way of life, a path of self-improvement toward higher consciousness requiring a reflective self-disciplined *askesis* that is the hallmark of philosophical living as first sketched by Socrates. (But being critically disciplined and thoughtfully aware in one's life does not preclude one's practicing such disciplined consciousness in one's bodily life, and we should recall that Socrates was equally famous for his powers of physical discipline).

The sort of awakening we require, Thoreau thus insists, cannot rely on external means like drugs or other stimulants. "We must learn to reawaken and keep ourselves awake, not by mechanical aids, but by an infinite expectation of the dawn, which does not forsake us in our soundest sleep," if our dreams are also thoroughly shaped by the conscious meliorative effort of our waking life. We must, in other words, apply "the unquestionable ability of man to elevate his life by a conscious endeavor;" and Thoreau immediately continues by connecting this advocacy of awakened life with an aesthetic vision of philosophical living that is worth quoting again because of its potent argument for an aesthetics of everyday life and of the philosophical life:[26]

> It is something to be able to paint a particular picture, or to carve a statue, and so to make a few objects beautiful; but it is far more glorious to carve and paint the very atmosphere and medium through which we look, which morally we can do. To affect the quality of the day, that is the highest of arts. Every man is tasked to make his life, even in its details, worthy of the contemplation of his most elevated and critical hour.[27]

METHODS OF AWAKENING AWARENESS

If Emerson and Thoreau advocate the awakened life as key to their ideal of living, what characterizes such life apart from its greater consciousness? What methods are used to awaken it, and what goals does it serve that make it desirable? These questions are too complex to answer adequately here, but this section outlines some preliminary answers, beginning with the aims of awakened life. Emerson and Thoreau commend it for promoting great achievement or genius in the fields of art, ethics, and spiritual character. Though awakening requires sustained discipline and ascetic "elevation of purpose,"[28] they also recognize the paradox that genius is not entirely a matter of the individual's self-perfecting will but instead requires some letting go or self-abandonment to forces greater and higher than the individual so that those superior forces can be expressed through the individual's genius (which is thus always more than individual).[29] There is the further paradox that while awakened life is recommended for the inspiring gifts of artistic, ethical, intellectual, and spiritual achievements that it generates, these kinds of achievement (of beauty, virtue, knowledge, and penetrating wisdom) are precisely what in turn awaken us to the awakened life. This paradox need not be a vitiating circularity that frustrates renewed awakening and continuing creation, because past achievements in these fields of art, knowledge, and action have an enduring presence and can continuously prompt new individuals to the awakened life and thus to further achievement.

Besides the creation of distinctive works of genius, awakening is praised for the more general value of providing higher awareness or more focused consciousness in our everyday living. But is this always good? Many of our motor tasks are most effectively performed when done automatically with minimal awareness; thinking about them deliberatively and explicitly slows down the process. Even intellectual tasks involving motor control (whether playing the piano, responding impromptu to a philosophical question, or even orally reading a prepared lecture with the proper expression and intonation) are often done best when we do not think too much about our performance. Such explicit or reflective consciousness is, however, necessary for properly learning new tasks of performance or correcting bad habits of thought and action, because we must know what we are doing wrong before being able to correct it.[30]

Beyond these specific tasks of reforming bad habits or learning new skills, we should note more philosophically distinctive benefits of heightened consciousness. By being more explicitly aware of what we actually do, we improve our capacity for self-knowledge and self-improvement that is central to the idea of the philosophical life as an examined, critical, meliorative style of living. Awakened, heightened consciousness also provides a richer appreciation of the meaning in what we do, because it leads us to attend more explicitly to our thoughts, feelings, and actions. In *Body Consciousness*, I advocated skills of enhanced consciousness as a means of augmenting pleasure, citing Montaigne's claim to "enjoy [life] twice as much as others, for the measure of

enjoyment depends on the greater or lesser attention that we lend to it."[31] But the appreciation of meanings (which includes the pleasures of meaning) is a wider domain of value than pleasure, and it is evidently necessary for the pursuit of philosophical living.

What, then, are the transcendentalist methods advocated for awakening? Two distinctive points that Thoreau explicitly insists upon are simplicity and slowness. The first he emphasizes (somewhat paradoxically) by repetition (instead of a simple single mention): "Simplicity, simplicity, simplicity," he demands, because our "life is frittered away" and our consciousness is hopelessly distracted by too much detail.[32] Awareness or attention can be sharper and more sustained if it is focused on a more limited range of objects. A few lines later he repeats this message of economy: "Simplify, simplify. Instead of three meals a day, if it be necessary eat but one; instead of a hundred dishes, five; and reduce all other things in proportion."[33] Emerson likewise affirms simplicity as a key to spiritual awakening since it puts us in touch with "the transcendent simplicity and energy of the Highest Law."[34] He therefore urges that "the basis of character must be simplicity," which puts a man more in tune with "the simplicity of nature." "Nothing is more simple than greatness," he says; "indeed, to be simple is to be great."[35]

Slowness is another method Thoreau recommends as important for heightened awareness. Things that move quickly are harder to attend to with care and deliberation; they go by too fast for us to get a good grasp of them. Hence Thoreau's critique of American haste and hurry that "lives too fast,"[36] which he exemplifies with the railroad, a prime nineteenth-century symbol of rapid transit and the fast-moving life that it brings. The railroad example allows him to continue the theme of sleep and awakening by exploiting the term "sleeper," which is also the name for the wooden planks on which the rails are lain. "We do not ride on the railroad; it rides upon us. Did you ever think what those sleepers are that underlie the railroad? Each one is a man, an Irishman or a Yankee man [who spiritually slept while doing the railroad's labor] ... and the cars run smoothly over them. They are sound sleepers, I assure you." It is only when trains run over another kind of sleeper—"a man that is walking in his sleep" that anyone takes any notice or concern to "wake him up."[37] Thoreau thus exhorts us to stop our rush on the narrow rails of business and instead take the time to awaken to the wonders of experience and creative living through higher consciousness.

For Emerson, the value of slowness is linked to the virtue of patience and the fact that nature typically works its wonders through slow evolution and maturation rather than hurried explosions. "The pace of nature is so slow," he writes in praise, not in complaint. Not only do fishing, yachting, hunting, or planting teach us to be patient by attending carefully to the slow "manners of Nature,"[38] but also the scholar "must have a great patience" and examine his subject slowly so as not to overlook hidden dimensions or facts.[39] "Patience is the chiefest fruit of study," Emerson concludes, urging us to "Leave this military hurry and adopt the pace of Nature [whose] secret is patience."[40] The principle of slowness as a means to achieve more explicit, attentive, and clearer

consciousness of what we encounter is, as I have elsewhere shown, central to certain somaesthetic disciplines of heightened body awareness.[41]

Closely related to the methods of simplicity and slowness but worth articulating in its own right is the transcendentalist advocacy of focalizing attention on the here-and-now. Concentrating on the present moment heightens our attentive powers by avoiding their dispersal into the immense complexities of a past that extends unfathomably back behind us or into the vast incalculable vagaries of an undefined, unbounded future. Deliberate slowness helps us focus on the present moment by making it last longer in the sense that the activity occupying the present takes more time by being performed more slowly. Moreover, such slowness enables greater attentiveness to any activity by allowing attention to linger longer on each phase of that activity because each phase indeed lasts longer. Emerson and Thoreau thus insist on being focused on the here-and-now.

"We are always getting ready to live but never living," complains Emerson in his journal and thus boldly resolves: "With the past, I have nothing to do; nor with the future. I live now."[42] "Above all, we cannot afford not to live in the present," Thoreau echoes, in an extraordinary essay on walking. "He is blessed over all mortals who loses no moment of the passing life in remembering the past."[43] And this focus on "the now" is linked to his philosophy of morning inspiration and its power to free us from the bonds of old habits of thought and action. "Unless our philosophy hears the cock crow in every barnyard within our horizon, it is belated. That sound commonly reminds us that we are growing rusty and antique in our employments and habits of thoughts."[44] Recognizing that the past and future (through the cultural richness of history and meliorist or utopian hopes) may seem to dwarf the fleeting present in terms of narrative grandeur, Thoreau counters by affirming that the "true and sublime … are now and here. God himself culminates in the present moment. … And we are enabled to apprehend at all what is sublime and noble only by the perpetual instilling and drenching of the reality that surrounds us" in the here-and-now.[45]

Emerson underscores the same point about the sublimity of the present moment when the soul truly attends to it, even in commonplace objects or trifling events, because the attentive present moment is the window that opens us to reality in all its fullness and grandeur, both material and spiritual. Combining the themes of simplicity and thoughtful attention to the here-and-now, Emerson insists that "the soul that ascendeth … is plain and true; has no rose color; no fine friends; no chivalry; no adventures; does not want admiration; dwells in the hour that now is, in the earnest experience of the common day,— by reason of the present moment and the mere trifle having become porous to thought and bibulous of the sea of light."[46] Bemoaning that man has not awoken to attentive awareness of the present moment, "but with reverted eye laments the past, or, heedless of the riches that surround him, stands on tiptoe to foresee the future," Emerson insists that one "cannot be happy and strong until he too lives with nature in the present, above time."[47] For the present moment, though fleeting, is paradoxically also, in a sense, beyond time, when

it is appreciated in itself as fully present and thus outside the conceptual line of temporal extension that runs from past to future.

But apart from these sublime, quasi-mystical moments of grasping a timeless now, there is the simpler yet significant matter of attentive awareness to our experience, of being fully present in what we do and where we are so we can more fully profit from what our surroundings actually offer. In his essay on walking, Thoreau provides an excellent example of how one can lose one's focus in the present moment and thus lose out on the meaning it has:

> I am alarmed when it happens that I have walked a mile into the woods bodily, without getting there in spirit. ... But it sometimes happens that I cannot easily shake off the village. The thought of some work will run in my head and I am not where my body is—I am out of my senses. In my walks I would fain return to my senses. What business have I in the woods, if I am thinking of something out of the woods?"[48]

Once again, while we may regret Thoreau's language for contrasting body and spirit, we should surely appreciate his point that the senses are where the body is and that we should be appreciatively focused on what they could perceive in the here-and-now instead of filling one's mind and attention with absent, distant things. This idea of living in the here-and-now by appreciating the present moment with vivid attention and clear consciousness is central to the Zen tradition that I encountered in Japan.

Mind-directed body disciplines constitute yet another method that Thoreau recommends for spiritual awakening, explaining these disciplines in terms of ideas of purity and ascetic austerity. At one point, when discussing our habits of eating and drinking, he draws an inverse relationship between spiritual awakening and the animal consciousness of our typical sensuous culinary habits: "This slimy, beastly life, eating and drinking" in our all-too-habitual gluttonous style. "We are conscious of an animal in us, which awakens in proportion as our higher nature slumbers. It is reptile and sensual, and perhaps cannot be wholly expelled."[49] Evoking Mencius and the Vedas, Thoreau, however, claims we can increase our measure of purity by mentally dominating our brutish appetites by channeling them into disciplined and ritual restraint:

> A command over our passions, and over the external senses of the body, and good acts, are declared by the Ved to be indispensable in the mind's approximation to God." Yet the spirit can for the time pervade and control every member and function of the body, and transmute what in form is the grossest sensuality into purity and devotion. The generative energy, which, when we are loose, dissipates and makes us unclean, when we are continent invigorates and inspires us.[50]

Because, for Thoreau, "all purity is one," our conscious discipline of eating and drinking can guide us toward more mindful control of other appetites and to the rich fruits of spiritual awakening. "Chastity is the flowering of man; and

what are called Genius, Heroism, Holiness, and the like, are but various fruits which succeed it. Man flows at once to God when the channel of purity is open."[51]

Mindful somatic discipline is not meant to destroy the body but to raise it to a higher level; for the body is not simply flesh, bones, and skin but all the entrenched bodily dispositions that constitute our unreflective habits—our unconscious sleepwalking through life. By making our somatic life more consciousness, deliberate, and controlled, we are spiritualizing it. Once again, Thoreau first turns to Indian philosophical culture, where every bodily "function was reverently spoken of and regulated by law." The "Hindoo lawgiver ... teaches us how to eat, drink, cohabit, void excrement and urine, and the like, elevating what is mean."[52] But he likewise evokes a mythical American everyman John Farmer, whose only method to awaken the spiritual "faculties which slumbered in him" was "to practise some new austerity, to let his mind, descend into his body and redeem it."[53] This dualistic contrast of body and mind is unfortunate from the point of view of somaesthetics, which prefers to speak of the soma as body-mind or embodied intentionality that can experience itself as both subject and object. But somaesthetics shares Thoreau's important insight that feelings and actions that seem merely brutishly bodily can be importantly transformed in meaning and refined in quality through the greater cultivated consciousness we give them in our efforts to attend to them and reshape them in better ways.

Even the act of eating which Thoreau typically portrays as lowly, "slimy, beastly" can be raised to spiritual value through enhanced attentive consciousness that carefully discriminates the qualities of flavor and meaning in what and how we eat, thus rendering our tasting also a mental act of cognitive appreciation. "Who has not sometimes derived an inexpressible satisfaction from his food in which appetite had no share? I have been thrilled to think that I owed a mental perception to the commonly gross sense of taste, that I have been inspired through the palate, that some berries which I had eaten on a hillside had fed my genius."[54] If heightened discriminating consciousness elevates tasting from crude sensuality to spiritual refinement, then "he who distinguishes the true savor of his food can never be a glutton; he who does not cannot be otherwise."[55] Eating with the proper attitude of mindfulness (rather than blind desire) allows us to sustain our purity while nourishing the body and inspiring the soul. "Not that food which entereth into the mouth defileth a man, but the appetite with which it is eaten. It is neither the quality nor the quantity, but the devotion to sensual savors; when that which is eaten is not a viand to sustain our animal, or inspire our spiritual life, but food for the worms that possess us."[56]

Emerson likewise recognized that our most basic, humble, physical needs can be transformed through enhanced awareness into beautiful expressions of spiritual life and ideas. We should not simply eat and drink and breathe so we can thereafter have the strength to create ideal works of beauty and art that we then elevate or isolate as superior to life; we should instead "serve the ideal in [the very act of] eating and drinking, in drawing the breath, and in the functions

of life."[57] Through such heightened, appreciative awareness and the mindful movements and actions that emerge from it, one can achieve extraordinary aesthetic experience in everyday living, as I learned not so much from philosophical readings as from personal experience during my training with a Zen master at his dojo on the Inland Sea, not far from Hiroshima, where I was a visiting professor in 2002–2003.

AESTHETICS OF THE ORDINARY AND THE ZEN

Having shown how nineteenth-century American transcendentalists explain the beauty-generating vivid vision of awakened consciousness in the philosophical life, I wish to present (albeit briefly) how this everyday aesthetics of awakened living was expressed in twenty-first century Zen life, as I experienced it. Indeed it was the idea of philosophy as an embodied, enlightened, and highly conscious art of living (which I first discovered in my readings of the ancient Greeks, Montaigne, the transcendentalists, Nietzsche, James, and Dewey) that initiated my encounter with Zen. Seeking to taste such a life and finding no obvious contemporary Western alternatives available, I hoped that an interlude in Zen living might provide it. But I knew it would not be easy to find a genuine Zen dojo with an experienced Zen master who would take me on as a trainee, let alone find the time to train there.

I was therefore thrilled when Hiroshima University's Graduate School of Education invited me as a visiting research professor (with no teaching duties) to pursue my work in somaesthetics, whose project of cognitive enrichment through greater somatic consciousness and body-mind unity could promote new ways of learning. But while the study of actual Zen technique was surely pertinent to my somaesthetic research (which touts the integration of theory and practice), my Japanese hosts seemed reluctant to help me pursue an adventure in Zen living, fearing I would not only be deeply disappointed if I did not achieve enlightenment, but also even more painfully distressed by the ascetic rigors of monastic life in the Zen cloister. After more than six months of asking if a suitable teacher and dojo had been found (I did not want a Disney Zen experience in a program designed for foreign tourists), I realized that I would need to look elsewhere for help.

Fortunately, when giving a lecture at Tokyo University I met a postdoctoral scholar (Kakutani Masanori) doing research on the concept of the teacher in traditional Japanese culture. He perfectly understood my interest, found me the ideal teacher whom he knew only through that teacher's fame and published texts, and kindly arranged my first meeting with Zen Master (Roshi) Inoue Kido. Dr Kakutani, moreover, generously instructed me on how to prepare for my period of training in the dojo, patiently translating for me the daily schedule that was on the dojo's website but in a Japanese far beyond my primitive level of basic conversation. He explained the articles of clothing I needed to buy for my training and where I could procure them, and even advised me about the appropriate sum of money I should give the Roshi as an introductory gift,

noting which numbers were considered lucky rather than unlucky in Japanese culture while reminding me that I should provide only clean new bills in my gift envelope. His technical advice was wonderfully helpful but far from enough to prepare me for the sort of everyday aesthetics of living that I would experience at the dojo under Roshi's guidance.

Before trying to articulate this aesthetics (whose lived quality resists rendition in clear conceptual language), I should note two very different conceptions of everyday aesthetics. Though both are concerned with appreciating ordinary or commonplace objects and events, the first notion puts its emphasis on the ordinariness or banality of the everyday, while the latter instead highlights the heightened aesthetic character in which ordinary or everyday things can be appreciated through aesthetic perception and thus transfigured into a special experience. This second conception of everyday aesthetics emphasizes not only aesthetics' root meaning of perception but also the idea that aesthetic experience is a matter of conscious, concentrated attention that is essentially aware of itself as focused or heightened experience whose object is the focus of explicit, attentive consciousness and is appreciated as such. As the first conception of everyday aesthetics is resolutely focused on appreciating the ordinary as ordinary rather than as special (in the sense of being a special experience or perception of the ordinary), so the aesthetic quality appreciated in this first kind of everyday aesthetics would not call special attention to itself as an intense quality or powerful experience. It would instead be like appreciating dull weather with an ordinary, dull appreciation of its dullness, rather than a sudden spectacular vision or special experience of its dullness. In contrast, the second conception of everyday aesthetics is about the transfiguration of ordinary objects or commonplace experience into a more intensified perceptual experience that is characterized by explicit, heightened, appreciative awareness. I read Emerson as advocating this second view when he speaks of our appreciating "the sublime presence of the highest spiritual cause lurking" in the simple things of life ("the milk in the pan; the ballad in the street; the news of the boat; the glance of the eye; the form and the gait of the body") so that "the world no longer lies a dull miscellany and lumber room" but rather "every trifle" shines with "form and order."[58]

While recognizing the validity of the first conception, I find the second more interesting and more promising for aesthetics, especially when the latter is conceived melioristically as a field of study aimed at enriching our lives by providing richer and more rewarding aesthetic experience. From this perspective, aesthetic appreciation of ordinary objects and events serves to enhance and sharpen our perception of them so we can derive from them the richest experience and most enlightened perception they can offer. If this approach seems paradoxical because its heightened perception renders the ordinary somehow extraordinary in experience, this paradox of awakened perception of the ordinary is less problematic for everyday aesthetics than the parallel paradox in the first conception, where the ordinary is experienced in the most ordinary, habitual, unconscious, or "slumbering" way so that one does not really perceive anything consciously or aesthetically at all. Here one experiences

something ordinary in such an ordinary inattentive way that one does not truly aesthetically appreciate it in the sense of having an explicit awareness of its experience.[59]

One reason the second conception attracts me is its offering of an alternative to the principal path that fine art felt compelled to pursue to achieve the similar goal of rendering our perception more conscious and focused, and thus our experience both richer and more memorable. That path plies the method of defamiliarization or "making strange," essentially by making difficult. As Viktor Shklovsky, the Russian formalist thinker, dramatically and influentially formulated it, the special technique or "device of art" is to awaken us to fuller perception of what we see and feel "by 'estranging' objects and complicating form." This technique purposely "makes perception long and 'laborious,'" because "the perceptual process in art has a purpose all its own [is an aesthetic end in itself] and ought to be extended to the fullest."[60] Underlying this argument is the assumption that art's aesthetic forms must be difficult in order to compel the prolonged attention needed to render our perception of things conscious and clear.

Developing a comment by Tolstoy that echoes Emerson and Thoreau's complaint of how our unconscious, habitualized modes of perception and action deprive our lives of meaning, Shklovsky advocates the estranged difficulty of art as a way to shock us into awakening by obliging us to pay attention to things "in order to return sensation to our limbs … to make us feel objects" more fully and perceive them more clearly than in our "habitual" perception and behavior that "function unconsciously—automatically." One proven danger of this technique, however, is that such difficulty alienates art from the everyday lives of people, especially ordinary people who have neither the cultural education nor the leisure to learn and ponder the sophisticated difficulties that fine art imposes to make its perception "laborious." Such difficulty undemocratically confines art to a privileged elite, while also isolating it from even that elite's praxis of everyday living.

The awakened, conscious version of everyday aesthetics, I believe, offers the same sort of transfiguring intensity of awareness, perception, and feeling (and the enriched, more meaningful living this brings), but without high art's alienating difficulty and isolating elitism. Of course, this alternative path of enhanced, awakened perception of the ordinary, though it requires no special artistic erudition or access, has its own difficulty. For it requires some sort of discipline or *askesis* of perception, a special quality of attentive consciousness or mindfulness, one that opens a vast domain of extraordinary beauty in the ordinary objects and events of everyday experience that are transfigured by such mindful attention.

I learned this lesson of discipline from Roshi Inoue Kido at his Shorinkutsu-dojo, situated on a hill looking down at the tiny town of Tadanoumi, in a tranquil rural and mountainous area on the coast of Japan's beautiful Inland Sea. The dojo belongs to the Soto school of Zen, established in Japan by Dogen (1200–53), who developed this school's teaching from his experiences of sitting meditation in China as a disciple of Ti'ien-t'ung Ju-ching. In contrast to the

Rinzai school of Zen, in which there is more emphasis on literary texts and the study of *koans*, the Soto school is more strictly focused on the actual bodily practice of sitting meditation and on the strict, stern, uncompromising discipline associated with teaching it, where the teacher will sometimes resort to shouts or blows to convey his message to the student. Since my Japanese language skills were very limited and seemed far inferior to my somatic skills of body-mind attunement (developed through my training as a professional Feldenkrais practitioner and my study of yoga and tai chi chuan), I thought the body-centered Soto approach would be best for me, despite its risk of unpleasant auditory and corporeal violence.

My Roshi, a former philosophy student at Hiroshima University, was very eager to spread the teaching of Zen to a world he thought desperately needed it, and he warmly welcomed me. But his open, friendly disposition did not interfere with the strict disciplinary role he had to play as my teacher.[61] Roshi did not spare the rod on his students when he thought it would instruct them. I was somehow able to avoid his instructive boxing of the ears (which he always delivered with an affectionate smile), though probably only because my Japanese was too feeble for me to formulate a stupid question and I was so earnest in my efforts of meditation. Once, however, I was severely reprimanded for leaving three grains of rice in my bowl, a violation of his Zen commitment to eschew the slightest wastefulness but also, I believe, a failure in what he regarded as the proper art of eating, which I will soon discuss as part of his everyday aesthetics of awakened mindfulness.

Roshi's lessons in everyday aesthetics are too abundant to present here in proper detail. I shall confine myself, in the final part of this paper, to three briefly sketched examples: the first concerned with ordinary objects, the second with ordinary practices, and the third with the experience of ordinary biological functions. To put these examples in the proper context, however, I should first outline the dojo's everyday training routine to which I resolutely submitted myself, having relinquished on arrival the books, laptop, cell phone, and other personal belongings relating to my worldly activities that could distract me from Roshi's Zen training.

At five a.m. a wooden drum sounds the wake-up call and we hurry to dress and go down to the *zendo* (meditation hall) to start practicing *zazen*, where we already find Roshi or his chief assistant in meditation. The training clothes (which I purchased online through the help of Dr Kakutani) consisted of a *dogi* (white shirt), a dark-colored kimono jacket, a black *hakama* (skirt), and a black *obi* (a cord-like belt) to hold the *hakama* and *dogi* in place. The obi was very difficult to tie in the appropriate way. (It was first tied for me by Roshi's assistant priest, and I did my best to keep it tied so I would not have to retie it myself.) After an hour of meditation, there was usually a morning service at the adjacent Shounji temple, followed by another short service back at the dojo and then breakfast. Immediately after breakfast but before the post-meal prayers, Roshi would give a lecture on Buddhist philosophy or Zen practice. (He would often lecture at other meals too, though breakfast was usually the most formal and substantive one.)

After breakfast, newcomers would immediately go back to the *zendo* to continue practicing seated meditation (*zazen*), while more experienced trainees would do some work in the dojo and some *zazen*. Lunch was at noon, followed by an immediate return to Zen practice for newcomers like me, until a six p.m. supper. In the afternoons, besides work and *zazen*, trainees would have a bath every other day (each trainee taking his turn to prepare wood for the fire that kept the water hot), but newcomers would not be allowed to bathe for the first four days. Occasionally a formal tea ceremony was offered. The designated bedtime was nine p.m. with lights out at ten p.m., but the *zendo* was always open and one could practice *zazen* there throughout the night, if one had the stamina and alertness.

But Roshi wisely insisted that Zen discipline was not essentially a matter of physical endurance in sitting. He did not require that new trainees sit in the full lotus position (*kekkafuza*), but instead let them adopt a posture that allowed them to focus their mind on other things than physical discomfort in sitting. In recognizing that the alert attentiveness of one's *kokoro* (the heart-and-mind) is much more important than one's precise sitting posture, Roshi also realized that such focused concentration was tiring for beginners and that there was no point in meditating when too tired to achieve mindful awakening. Analogizing that one cannot properly cut rice plants with a dull blade, he advised me to get up from my meditation cushion at the *zendo* whenever I felt tired and go back to the sleeping hut I shared with some other trainees for a nap to refresh my soma and thus sharpen my consciousness. My powers of sustained concentration, he explained, would grow through enhanced mental acuity, not through merely stubborn efforts of willful endurance in sitting. I followed his advice, and indeed they did.

THREE ZEN EXAMPLES: SEEING, DINING, BREATHING

As a newcomer, I spent most of my time between the Zendo and the trainees' sleeping quarters. There were two different paths between these locations, and near one of them I noticed a small clearing with an especially open and beautiful view of the sea, dotted with a few small islands of lush, soft, bushy green. In the clearing was a primitive stool, rudely constructed from a round section of log on whose short upright column (still adorned with bark) there rested a small rectangular wooden board to sit on, with no nails or adhesive other than gravity to fix it to the log. A couple of feet in front of the stool stood two rusty old cast-iron oil barrels, the kind I had often seen used as makeshift open-air stoves by homeless people in America's poor inner city neighborhoods.[62] Sitting on the stool to look at the sea beneath the dojo, one's view was inescapably framed by the two corroding brownish barrels. I wondered why this ugly pair was left in such a lovely spot, spoiling the sublime natural seascape with an industrial eyesore.

One day I had the courage to ask Roshi whether I would be permitted to practice meditation for a short while in that spot overlooking the sea, though I

dared not ask him why the hideous barrels (which the Japanese call "drum cans") were allowed to pollute the aesthetic and natural purity of that perspective. Permission was readily granted, since Zen meditation can, in principle, be done anywhere, and Roshi felt I had progressed enough to practice outside the Zendo. So I sat myself down on the stool and, having directed my gaze above the barrels, I fixed my contemplation on the beautiful sea while following Roshi's meditation instruction of focusing attention on my breathing and trying to clear my mind of all thoughts. After about twenty minutes of effective meditation, I lost my grip of concentration and decided to end this meditative session. Turning my glance toward the closest of the two barrels, I discovered that my perception had awakened to a more penetrating level in which the ordinary ugly object was transfigured into something of breathtaking beauty, just as beautiful as the sea, indeed even more so. I felt I was now truly seeing that drum can for the first time, savoring the subtle sumptuousness of its coloring, the shades of orange, the tints of blue and green that highlighted its earthy browns. I thrilled with the richness of its irregular texture, its tissue of flaking and peeling crusts embellishing the hard iron shell, a symphony of soft and firm surfaces that suggested a delicious *feuilleté*.

In my awakened consciousness the drum can glowed with the fullness of vivid presence. The rusty barrel had an immediate, robust, absolutely absorbing reality that made my vision of the sea pale in comparison. The drum can's everyday proximity (in being perceived attentively as fully here-and-now) radiated the gleam and spiritual energy with which the wondrous flow and flux of our immanent material world resonates and sparkles. Conversely, I realized that it was more *the idea* of the sea that I had been regarding as beautiful, not the sea itself, which I saw through a veil of familiar thoughts—its conventional romantic meanings and the wonderful personal associations it had for me, a Tel Aviv beach boy-turned-philosopher. The barrel, without losing its status as everyday object, in contrast, was grasped as a beauty of the most concrete and captivating immediacy. But to see that beauty required a sustained period of disciplined meditative awareness. Though the disciplined mindfulness was initially not directed at the drum can, this alone was what enabled the perception of its beauty in the immediate fullness of the present moment, and I could, on subsequent occasions, recover this vision of its beauty by foregoing the seascape and directing my absorbed contemplation at the barrels themselves.

From the transfigured perception of ordinary objects through awakened perception, I turn to the transformation of everyday practices into beautiful performative arts of living through awakened attentiveness of mindful performance. My example of such mindful artistry was the eating of meals at the dojo. On the one hand, such meals were paradigmatic of ordinary simplicity. We sat on the floor on a humble low wooden table by the kitchen with no one formally serving us. The food was very plain and repetitive, though tasty enough, and was presented in the most simple and unadorned way. The crockery and cutlery were equally humble, the sort that one might find in a *hyaku yen* shop (or Japanese dollar store), old with use and sometimes even slightly chipped or damaged. In contrast with this bare ordinariness of stage

and props, the actual action of the meal was extraordinary in performative grace and thoughtful elegance, as each movement was meant to be executed and experienced as the focus of careful, mindful, loving attention. Rather than simply being necessary breaks for physical nourishment and relief from the trainee's essential activity of meditation, the dojo meals were in fact an extension of our training in awakened awareness but by other means than sitting meditation and in other venues than the Zendo. (Indeed, even in the Zendo we were sometimes told to practice walking meditation or *kinyin* as a break from constant *zazen*.) Meals were a place where we could demonstrate awakened mindfulness in active everyday movement rather than in mere meditative sitting, and do so in a challenging context where our appetites and unconscious habits were fully aroused and thus especially potent for distracting our focused attention from the present moment of our performed movements and experience, which was also a collaborative experience of eating with others. As we ate, Roshi's penetrating and authoritative gaze would discern the extent of our progress in mindful awareness from our eating behavior, from the quality of our movements—the way we handled our bowls and chopsticks, how we chewed and swallowed our food, how we passed food to our eating companions, whether we noticed when they were interested in receiving a dish that was in our reach. Knowing Roshi was judging our mindfulness in eating, we trainees would also critically examine each others' dining performance while seeking to maximize the mindful grace of our own eating style. The result was that ordinary meals became an extraordinary experience of mindful, coordinated action, a sophisticated, elegant choreography of dining movement pursued with heightened attentiveness to graceful movement and careful respect for one's comrades and one's food as well as for one's self and one's teacher.

For me, meals posed a special challenge, and not because of the rustic Japanese cuisine that is very different from typical Japanese restaurant fare and has its funky features. I was accustomed to such food, having married into a Japanese family that cherished all varieties of Japanese cuisine, and had I not been able to enjoy the dojo fare, I would have not thrived there, since one was forced to eat all that one was served. (A trainee who did not finish his raw squid of dinner found the remains on his plate the following breakfast.) The special dining challenge for me was to eat with graceful, mindful elegance, since I knew my habitual manners of eating were rather careless, casual, and sometimes sloppy. Moreover, I knew that Roshi would be paying close critical attention to my eating style, since at our first meal together he stunned me with his brutally frank critique of it. "You are technically quite skillful at using chopsticks," he noted, "perhaps because your wife is of Japanese origin. But for a professor of aesthetics you eat in a most ugly manner. You have a lot more than *zazen* to learn here." I felt my breath stop and my face flush red. I did not know what to say, but fortunately Roshi continued by explaining that my technical competence in using chopsticks was ruined by the sloppily thoughtless manner in which I picked them up and set them down, and by the graceless way I held my rice bowl and tea cup, both with respect to the positioning of my hands and the postural manner in which I brought their

contents to my mouth. He then patiently showed me what he considered the aesthetically proper way to pick up and put down one's chopsticks and to hold one's rice bowl and cup. When I tried to emulate his method, inaccurately at first, he showed me and explained again, until I grasped the principles and method, which I subsequently applied in actual practice.

Everyday dining thus became a challenging dramatic performance of mindful grace in movement, of aesthetically elegant eating through awakened appreciative awareness of all one's actions and feelings in taking one's food and drink. At first I was terrified. If my days were full of meditation, my nights were sometimes troubled by nightmarish images of soiling my new white *dogi* with food dropping clumsily from my chopsticks or dripping sloppily from my careless slurping mouth. With no other *dogi* or laundering option available to me, the shameful stain of my ugly, mindless eating would always remain exposed to Roshi's scornful condemnation and the ridicule of my fellow trainees. I thus resolved to eat as carefully, deliberately, and mindfully as I could, though haunted by the worry that my actions of eating would be rendered still more awkward, graceless, and sloppy precisely by thinking about them while performing them. My philosophical readings on body consciousness had repeatedly insisted that explicit, focused attention to movement was an impediment to its smooth and graceful execution, destroying the effective spontaneity of our habits of coordinated movement that perform our ordinary desired actions with such marvelous yet thoughtless efficacy. But after all my efforts to find a true Zen teacher, it seemed foolish to ignore his instruction while training with him, so I took the path of explicit, deliberate attention to my movements in eating, and I was not disappointed in the results. My *dogi* remained spotlessly white, but more important was the way my awakened attention enriched the satisfaction of eating. With skillfully focused purpose, my consciousness would carefully but smoothly shift its attention from the pickled plum, seaweed, or clump of sticky rice and fermented soy beans on the tips of my chopsticks to the opening of my mouth and then to the diverse feelings of tasting and chewing the food before I would swallow it with similarly heightened awareness. Not only did my attention to savoring, chewing, and swallowing enhance the sensory pleasures of these activities, but also my focused awareness on the hand and body movements involved in taking and passing the food made these movements more enjoyable and graceful, while coordinating them with those of my companions added a meaningful dimension of collaborative communal interaction that further enriched the dining experience. My mealtime anxiety gradually diminished while my gratification from this gustatory choreography burgeoned and displaced it. Because my lived experience of improved action through greater consciousness of movement so clearly contradicted the philosophical arguments against heightened body consciousness, I came to see the flaws in those arguments and subsequently articulated them in *Body Consciousness* and other texts.

The third example of aesthetic transfiguration of everyday life concerns the constant, pervasive experience of breathing. The fact that breathing is an instinctive biologically necessity does not entail that it cannot also be an

aesthetic pleasure enhanced through artistry. If Thoreau highlighted the simple yet captivating pleasure of breathing ("Of all ebriosity, who does not prefer to be intoxicated by the air he breathes?"),[63] then Zen advocates focused concentration on breathing as a tool that can provide not only pleasures of awakened awareness but also the bliss of enlightenment or satori, through greater mindfulness of the concrete reality of the present moment (what Roshi, following Dogen, calls "the now"). Since breathing is always in the present moment, concentrating on the breath helps break the habits of thought that take us away from "the now" through chains of associations that distract the mind with thoughts of past events and future projects, concealing the truth of the present with a veil of images ranging from regrets of earlier actions to worries about what lies ahead. The importance of focusing on the moment is why Roshi Kido, unlike many teachers of meditation, does not recommend the technique of counting breath (*sosokukan*), because its serialization tempts the mind to think of past and future. If we are counting our third breath, we are implicitly looking back to the second and ahead to the fourth. One reason why it is useful for Zen to work through somatic means like breathing is because the soma is always present in the here-and-now of real experience, even though it is typically absent from explicit consciousness and not (as perceptive subjectivity) defined in terms of mere physical place.

In concentrating on my breathing, I became gradually aware of many previously unappreciated aspects of my bodily experience. I noticed more precisely how my breathing changes when attention is directed to it. I discerned a difference, hard to capture in words, between thinking of my breathing (where I felt totally absorbed in its presence) and thinking of my "breathing" in a less complete way in which it seemed more like thinking about the idea of breathing or thinking *about* breathing. I felt a difference between focusing my concentration fiercely (as if gripping tightly) and attending more tenderly (as if gently holding a delicate flower). I found that the latter way of following my breath proved better for sustaining my focus and generating pleasure, making each breath taste cleaner, sweeter, and fresher than I had ever previously experienced. I not only noticed the different rhythms of breathing and the different parts of my body in which they resonated but also learned to discern those parts in which each breath was initiated. By directing attention to these different aspects of my breathing and then noticing the changes this attention introduced to it, I was able to sustain a longer, clearer focus on my breath and resist the tendency for my mind to wander elsewhere.

On the sixth day of meditation, I suddenly felt a thrilling sensation of "breathing through my ears," an experience I had never even imagined and still cannot properly understand conceptually, but which I repeatedly achieved in my meditation and which Roshi seemed to know well and appreciate. While attending to such breathing the following day, I felt a whole symphony of movement in my head, neck, shoulders, chest, and abdomen. At the center of it all were the extremely clear sound of my heart and the feeling of its quiet rhythm as I sat tranquilly. I could hear its double beat and feel its different places (and directions) of contraction, sensing the flow of blood that was

pumped out of the aorta. The heartbeat was clearest at my pauses in breathing, and I therefore lingered and prolonged those pauses, especially since it seemed to make the subsequent breath even more deliciously fresh and fragrant.

Roshi was neither surprised by my discoveries nor pleased by my manipulations. Once the mind is no longer distracted by its familiar habits of dwelling on images of the outside world, he explained, the phenomena of one's inner bodily life manifest themselves much more clearly to our consciousness. But the aim of meditation is not somatic introspection in itself nor the intensification of pleasure through such tricks as holding the breath (which he argued was unnatural). The aim is a mindful consciousness that is so fully absorbed in the reality of the moment that it no longer feels itself as separate from that reality. My breathing tricks and somaesthetic diagnoses were vestigial intellectualist handicaps to my progress, holding me to a perception of my body as a distinct place to be objectified, explored, and manipulated through a separate, inquiring scopic consciousness (thus keeping me somewhat ensnared in a body-mind duality). Though it proved very useful in strengthening my breath concentration and shutting out external thoughts, I had to learn to lose this analytic, manipulative consciousness of somatic introspection, so as to feel that I was not so much controlling my breathing as simply following and being absorbed in it.

Occasionally, by the end of my stay, I could reach this more radical experience of non-dualism where there was no longer a consciousness of self and breath but simply an overwhelming non-personal perception of breathing that pervaded all my consciousness and carried the breathing forward on its own accord, producing an intense feeling of profound fulfillment enhanced by the delicious pleasures of fresh air and rhythmic motion. I experienced my soma as a source of pleasure, but its sense of being a distinct place with well-defined borders (whether physical or phenomenological) completely dissolved into an expansively flowing field of experience, pulsating with joy and a sense of unbounded wholeness whose fullness is also an emptiness of distinctions between consciousness and its different objects and places. The now of the moment is no enduring place, but by its essence vanishes into the next moment. Though it begins as an essential place for disciplined meditative practice, the Zen soma (an integrated, focused, living, breathing body-mind) is then experienced as a no-place when that practice is successful, exemplifying, albeit in a more blissfully powerful form, the common way that the body tends to efface itself into the wider field of action when it is functioning at its happy best.

NOTES

1 Henry David Thoreau, *Walden*, in *Walden and Other Writings*, ed. Brooks Atkinson, NY: Modern Library, 2000, 14; hereafter abbreviated as W.
2 Ralph Waldo Emerson, "Experience," in *Ralph Waldo Emerson*, ed. Richard Poirier, Oxford UP, 1990, 222; hereafter RWE.
3 W, 14.
4 Richard Shusterman, *Pragmatist Aesthetics: Living Beauty, Rethinking Art*, Oxford: Blackwell, 1992; *Practicing Philosophy: Pragmatism and the Philosophical Life*, London:

Routledge, 1997. Though Dewey was my primary American inspiration in pragmatist aesthetics, I have come to realize that most of his central ideas could already be found in Emerson's writings, especially Emerson's essay titled "Art." See Richard Shusterman, "Emerson's Pragmatist Aesthetics," *Revue Internationale de Philosophie* 207 (1999): 87–99.

5 RWE, 192–4.
6 W, 85–6.
7 See Richard Shusterman, *Body Consciousness: A Philosophy of Mindfulness and Somaesthetics*, Cambridge UP, 2008, 70.
8 W, 209.
9 See John Cooper (ed.), *Plato: The Complete Works*, Indianapolis: Hackett, 1997, 481–495.
10 RWE, 307.
11 Ibid.
12 RWE, 307.
13 W, 304.
14 W, 91.
15 René Descartes, *Meditations on First Philosophy*, in *The Philosophical Writings of Descartes*, vol. 2, trans. J. Cottingham, R. Stoothoff, and D. Murdoch, Cambridge UP, 1984, 13.
16 This can be traced, for example, from the Buddha's early lectures "The Foundations of Mindfulness" to the Japanese Zen Master Dogen's "The Eight Awarenesses of Great People." Though Emerson and Thoreau were avid readers of ancient Asian philosophy, I should also note a more local religious context for the notion of spiritual awakening. The religious movement known as "the First Great Awakening" (1730–40) was influential in New England (and elsewhere in the American colonies), finding forceful expression in the work of the influential Massachusetts theologian-philosopher Jonathan Edwards. The "Second Great Awakening" (from 1790 through the 1840s) was also very influential in Emerson and Thoreau's New England, stimulating not only spiritual awakening but also social movements for reform in such areas as abolitionism and temperance that were important for Emerson and Thoreau.
17 W, 84.
18 Ibid.
19 W, 84–5.
20 W, 85.
21 Ibid.
22 RWE, 120.
23 W, 85.
24 Saint Augustine, *Confessions*, Book VIII, 5, trans. F. J. Sheed, Indianapolis: Hackett, 1992, 135–6.
25 W, 85.
26 Ibid. For the democratic Emerson and Thoreau (just as originally for Socrates) the philosophical life is in principle open to anyone willing to make the required efforts of *askesis*, and making such efforts are incumbent on everyone who properly cares about himself. This democratic openness is why they rarely characterize such life as specifically, distinctively "philosophical," since that might suggest that poets, artists, heroes, and even humble farmers cannot lead that life but only professional (or at least self-professing) philosophers.
27 W, 85–6.
28 W, 87.
29 See my essay on "Genius and the Paradoxes of Self-Styling," in *Performing Live*, Ithaca: Cornell UP, 2000.
30 I explain these points at length in *Body Consciousness*.
31 *Body Consciousness*, 9. I quote from the translation of Donald Frame, *The Complete Essays of Montaigne*, Stanford UP, 1965, 853.
32 W, 86.
33 W, 87.
34 RWE, 238.

35 Ralph Waldo Emerson, "The Superlative," in *Lectures and Biographical Sketches*, Boston: Mifflin, 1904, 174, 176; "Literary Ethics," in *Emerson: Essays and Poems*, NY: Library of America, 1996, 100.

36 W, 87.

37 W, 87–8.

38 RWE, 674.

39 Ralph Waldo Emerson, "Powers and Laws of Thought," *The Complete Works of Ralph Waldo Emerson*, vol. xii, NY: Houghton Mifflin, 1904), p. 49; "The Scholar," *The Complete Works of Ralph Waldo Emerson*, vol. x, NY: Houghton Mifflin, 1904, 286.

40 "Address at Opening of Concord Free Public Library," *The Complete Works of Ralph Waldo Emerson*, vol. xi, NY: Houghton Mifflin, 1904, 505; "Education," *The Complete Works of Ralph Waldo Emerson*, vol. x, 155.

41 See Richard Shusterman, *Body Consciousness: A Philosophy of Mindfulness and Somaesthetics*, Cambridge: Cambridge University Press, 2008; and *Thinking through the Body: Essays in Somaesthetics*, Cambridge: Cambridge University Press, 2012.

42 Ralph Waldo Emerson, entry April 13, 1834, *Journals of Ralph Waldo Emerson, 1833–1835*, eds. E. W. Emerson and R.W. Forbes, Boston: Houghton Mifflin, 1910, 276; and his later entry of September 18, 1839, *Journals of Ralph Waldo Emerson, 1820–1876*, NY: Modern Library, 1960, 255.

43 Henry David Thoreau, "Walking," *Walden and Other Writings*, 662; hereafter Wa.

44 Wa, 662.

45 W, 92.

46 RWE, 247–8

47 RWE, 143.

48 W, 632.

49 W, 206.

50 W, 207.

51 W, 207–8.

52 W 208–9.

53 W, 209.

54 W, 205.

55 Ibid.

56 W, 205–6.

57 RWE, 282.

58 RWE, 50.

59 In distinguishing between these two forms of everyday aesthetics, I do not wish to suggest that they are incompatible; accepting or preferring one does not mean that one must reject the value of the other. In fact, these two forms of everyday aesthetics can be connected. The first form of experiencing the ordinary as ordinary often seems to serve as a background or preliminary stage to the second, transfigurative or intensified form of appreciation.

60 Viktor Shklovsky, "Art as Device," *Theory of Prose*, trans. Benjamin Sher, Normal, IL: Dalkey Archive Press, 1991, 5–6.

61 Various texts of Roshi Kido, including translations into French and English, are available on the dojo's website: www.geocities.jp/shorinkutsu/

62 Readers more familiar with contemporary art might recognize them as the kind of barrels that Christo and Jeanne Claude painted and massively piled on their sides in two notable artworks—*Iron Curtain*, an installation that temporarily sealed the Parisian rue Visconti in 1962, and *The Wall* of 1999 that involved 1300 brightly painted and monumentally stacked barrels.

63 W 205.

dewey's big idea
for aesthetics

mark johnson

DEWEY'S BIG IDEA

Brothers and Sisters, in the Gospel according to Matthew, Jesus says: "Have you never read in the scriptures: 'the very stone which the builders rejected has become the head of the corner; this was the Lord's doing, and it is marvelous in our eyes'?"[1] According to traditional Christian interpretations, in Matthew's narrative, the stone that was cast out is Jesus, the Son of God, upon which the Kingdom of God will supposedly be founded. Now, in the story I'm about to tell, the stone that was cast out is Aesthetics, and the New Kingdom will be a philosophical orientation grounded on aesthetics. I shall call this view about the primacy of aesthetics the Gospel according to John (Dewey, that is), encapsulating it with: "The stone of Aesthetics that was cast out shall become the foundation of our new kingdom—our new philosophy of experience" (Book of Dewey 0:0).[2]

When I was in graduate school in the 1970s, the common wisdom was that real (manly) philosophy was epistemology, logic, and analytic metaphysics, whereas aesthetics was for the mushy minded, the intellectual weaklings, the faint of heart. Aesthetics was what you did if you couldn't cut it in real philosophical analysis. After all, the story went, aesthetic experience is a matter of feelings, feelings are subjective, and none of this can play any role in our knowledge or cognition of our world.

In response to this prejudice, Dewey turned the traditional epistemological conception on its head, arguing that it should be aesthetics, above all else, that provides the basis for our account of human nature, human meaning, human knowing, and human value. Dewey's Gospel calls for the outcast stone to become the head of the corner, the foundation of everything else.

Why has the Aesthetics Stone been cast out in Western culture? The chief reason is that aesthetics has been conceived far too narrowly as concerned with something called "aesthetic experience," which is then distinguished from other modes of experience and thought (e.g., theoretical, technical, and moral) that make up the fabric of our daily lives. This partitioning of experience into discrete types, each having its own distinctive characteristics, is one of our most problematic Enlightenment legacies. Relegate aesthetics to matters of "mere" feeling, denigrate the role of feeling in human cognition, and you can conveniently marginalize aesthetics in philosophy. Once reduced to a single type of feeling-based engagement, aesthetic experience is taken to be subjective—a mere matter of taste. Kant surely was partly to blame for this, with his impressive systematic treatment of distinct types of cognitive and non-cognitive judgments, but he is just one voice in a deafening chorus that denies aesthetic experience any significant role in cognition and knowledge.[3] Insofar as aesthetics is conceived as embracing only the sensuous, perceptual, imaginative, feeling, and emotional dimensions of experience, aesthetic experience is viewed as too subjective to serve as the basis for our shared experience and cognition of our world.

As a corrective to this drastically impoverished account of types of experience, Dewey argued that what we call "aesthetic" dimensions are not characteristics

of a single isolated type of experience, but rather are part of our ability to grasp the meaning and significance of *any and every* developed experience. He understood aesthetics, therefore, in a broad sense, as involving form and structure, qualities that define a situation, our felt sense of the meaning of things, our rhythmic engagement with our surroundings, and our emotional transactions with other people and our world. This was Dewey's thick notion of the aesthetic dimensions of experience, spelled out in great works such as *Experience and Nature* (1925),[4] *Art as Experience* (1934),[5] and *Logic: Theory of Inquiry* (1938).[6]

Two of Dewey's most important ideas were thus (1) his insistence that *philosophy should begin and end with experience taken in the richest, deepest sense*, and (2) his claims about *the pervasiveness of the aesthetic in all fully-developed experience*. Any philosophy worth its salt should arise from problems encountered in our lives, and, through a path of critical inquiry, should eventually lead to the constructive transformation of experience for the better. In other words, the test of a philosophy is its ability to reconstruct the quality of our experience.

One of the most distinctive tenets of Dewey's philosophy is his claim that the *quality* of an experience is the key to an adequate philosophical understanding of human mind, thought, language, and value. This provides the basis for Dewey's seminal contribution to aesthetic theory—his Big Idea—which is that *every fulfilled experience is individuated by a pervasive unifying quality.*

I have highly intelligent philosophical colleagues who roll their eyes and shake their heads when they encounter Dewey's reference to the pervasive qualitative unity of a situation. Some of them no doubt regard such claims as proof positive of the mushiness and untenability of Dewey's view. After all, who can make any sense of such a strange idea, and, even if you could give it any meaning, what possible difference would it make for how you live your life or how you do philosophy? Yet Dewey never ceased to regard what I call his "Big Idea for Aesthetics" as the cornerstone of his philosophy. He insisted that pervasive qualities were the foundation of all experience and thought. He argued that genuine thinking (including logic) must emerge from, and lead to, a qualitative unity. He charged philosophy with the task of rooting itself in, and then transforming, these qualitative unities of experience.

Something about Dewey's big idea resonates with me, and so I want to try to make sense of his claim, especially as it plays a fundamental role in his view of aesthetics and art. Although I cannot here address its implications for thinking in general, for logic, for knowledge, or for moral deliberation, I hope at least to show that Dewey was onto something that we are well advised to pay attention to. More importantly, I will suggest that Dewey was correct in thinking that we should put aesthetics—with its emphasis on qualities—at the heart of our philosophical inquiries.

OUR WORLD IS QUALITATIVE

Dewey's entire philosophical orientation is based on the fact that we dwell, perceive, think, feel, value, and act in and for a world of qualities:

> The world in which we immediately live, that in which we strive, succeed, and are defeated is preeminently a qualitative world. What we act for, suffer, and enjoy are things in their qualitative determinations. The world forms the field of characteristic modes of thinking, characteristic in that thought is definitely regulated by qualitative considerations.[7]

Qualities are what we live for—the fresh, soft, translucent greens of leaves in early spring contrasted with the hardened, fatigued, desiccated greens in early fall; the supple flesh of a woman's bare shoulders against the unforgiving hardness of the oak chair on which she sits; the muscular, explosive grace of a basketball player pivoting for a fall-away jump shot; the angularity of work-worn hands holding the knife as it parts the semi-resisting skin of a ripe tomato. This is the stuff of our lives.

The late poet William Stafford captures the power of felt qualities to lead us to meaning:

> *Level Light*
> Sometimes the light when evening fails
> stains all haystacked country and hills,
> runs the cornrows and clasps the barn
> with that kind of color escaped from corn
> that brings to autumn the winter word—
> a level shaft that tells the world:
> *It is too late now for earlier ways;*
> *now there are only some other ways,*
> *and only one way to find them—fail.*
> In one stride night then takes the hill.[8]

It is the corn-colored light suffusing the autumn landscape, wrapping cornrows, fences, barns, and trees in its meditative aura that awakens us to the way our failures can open new possibilities. Then night comes full on to steal away the yellow glow. Dewey's claim about the primordial qualitativeness of our lives would seem almost trivial, were it not for the fact that it is hard to think of a philosophy that does justice to this insight.[1] Even in aesthetic theory, where one might expect qualities to be central, it is striking how few theories

1 A notable exception to this dismissal of Dewey's insistence on the qualitative unity of a situation is Thomas Alexander's *John Dewey's Theory of Art, Experience & Nature: The Horizons of Feeling* (SUNY Press, 1987). I was first introduced to Dewey's aesthetic theory by Alexander, and therefore most of the points I make in this present article were first formulated while I was under his tutelage.

pay any serious attention to the phenomenon Dewey is describing. An historical survey of aesthetic theories might include factors such as *mimesis*, unity in variety, aesthetic ideas, significant form, expression of ideas, emotional communication, social context, and conceptual content, but try to identify a theory besides Dewey's that is grounded on the qualitative unity of an experience. Somehow, this whole notion has more or less escaped serious attention in most of contemporary aesthetic theory.

EXPERIENCE, SITUATIONS, AND QUALITATIVE UNITY

Behind Dewey's focus on the qualitative is his insistence that philosophy must begin and end in experience. Dewey understood experience to be a continual process of organism-environment interactions. Consequently, experience is neither exclusively an affair of "the mind" (the subjective experiencing of sense perceptions, feelings, or emotions), nor is it exclusively "in the world" (the grasping of a mind-independent reality). He states:

> Experience is *of* as well as *in* nature. It is not experience which is experienced, but nature—stones, plants, animals, diseases, health, temperature, electricity, and so on. Things interacting in certain ways *are* experience; they are what is experienced. Linked in certain other ways with another natural object—the human organism—they are *how* things are experienced as well. Experience thus reaches down into nature; it has depth. It also has breadth and to an indefinitely elastic extent. It stretches. That stretch constitutes inference.[9]

Passing over Dewey's intriguing notion of experiential inference, let us focus on his key assertion that experience is an interactive process. What we call "mind" and "body," "subject" and "object" are, for Dewey, just abstractions of what is actually an ongoing, continuous flow of organism-environment transactions. The reality of qualitative dimensions of experience results from the fact that, for creatures like us who have evolved certain modes of sentience and consciousness, there is always both a *what* is experienced and a *how* things are experienced, and the *how* is present to us as felt qualities.

Much of the time, we engage our world routinely, habitually, and inattentively, unaware of how various qualities are shaping the meaning of our lives. In other words, what we colloquially call "experience" is typically slack, not clearly unified, and it is had without any significant sense of meaning. However, in contrast with our inchoate experience, there are also moments of intensity and focused awareness, and existential moments when our world stands forth as significant and meaningful, as Dewey illustrates:

> Experience in the degree in which it *is* experience is heightened vitality. Instead of signifying being shut up within one's own private feelings and sensations, it signifies active and alert commerce with the world; at its height

it signifies complete interpenetration of self and the world of objects and events. Instead of signifying surrender to caprice and disorder, it affords our sole demonstration of a stability that is not stagnation but is rhythmic and developing. Because experience is the fulfillment of an organism in its struggles and achievements in a world of things, it is art in germ.[10]

When we are able to grasp the developing meaning of a situation, we speak, rightly, of *having an experience*. When, for example, we say to a fellow sports fan, "that was really some game last night!" we are recognizing that a dramatic sequence of related events came together for us in such a way as to be marked off in our ordinary experience as a meaningful unity.

For Dewey, the primary unit of meaningful experience is what he called a situation, by which he meant "a complex existence that is held together in spite of its internal complexity by the fact that it is dominated and characterized throughout by a single quality."[11] Few of us are in the habit of noting the "single quality" that pervades a situation. Although we often, and quite easily, select out salient qualities of a situation (as in, "That key lime pie was really tart!"), we are not accustomed to consciously noticing the qualitative unity of our whole situation. Yet it *is* there, underlying everything we experience, think, and do. There is a pervasive qualitative difference between listening to a lecture (or reading an article) in which you are intensely caught up, in contrast with the frustrated situation of a lecture that you are beginning to feel is overly simplistic, or just plain misguided. The situation, of course, is always more than you take in. It is not just a matter of your focus on the meaning of what is being said, for it expands to include the sound of the speaker's voice, her fluent gestures, the quality of light in the room, the smell of books lining the walls, and the communal energy or malaise of the audience as a whole.

Dewey explained his notion of a "pervasive unifying quality" of a situation as follows:

> An experience has a unity that gives it its name, *that* meal, that storm, that rupture of a friendship. The existence of this unity is constituted by a single *quality* that pervades the entire experience in spite of the variation of its constituent parts. This unity is neither emotional, practical, nor intellectual, for these terms name distinctions that reflection can make within it.[12]

In observing that the unity is "neither emotional, practical, nor intellectual," Dewey is avoiding any artificial partitioning or segmenting of experience. The unity is not exclusively and definitively *one* of these types or dimensions of experience. Rather, it is all of these, and more. We have a tendency to focus on just one such dimension at the expense of others, and then we miss what unifies the situation. We call something an "ethical" decision and thereby overlook the aesthetic components that played such a crucial role in our deliberation and judgment.

Our tendency to regard the world as a concatenation of discrete qualities comes from the fact that we are creatures evolved to differentiate and

discriminate. Within the qualitative unity of a situation, we immediately and automatically note distinguishing qualities, often overlooking the whole from which they emerge: "All thought in every subject begins with just such an unanalyzed whole. When the subject-matter is reasonably familiar, relevant distinctions speedily offer themselves, and sheer qualitativeness may not remain long enough to be readily recalled."[13] The unfortunate result of this is that we then lose our attention to the pervasive unifying quality, because, even if we can experience such a quality, we certainly cannot describe it, since any proffered description will involve discrimination of particular qualities of the experience, and so will lose the unifying quality itself.

Undaunted, Dewey simply reminds us that as we attend more carefully to a situation (or an artwork), our attention itself is directed—controlled—by the background out of which seemingly discrete properties arise:

> Even at the outset, the total and massive quality has its uniqueness; even when vague and undefined, it is just that which it is and not anything else. If the perception continues, discrimination inevitably sets in. Attention must move, and, as it moves, parts, members, emerge from the background. And if attention moves in a unified direction instead of wandering, it is controlled by the pervading qualitative unity...[14]

The heart of Dewey's Big Idea is that every situation comes to us first as a unified whole, prior to our carving it up through our selection of specific qualities for our attention—a process itself guided by the pervasive unifying quality. Imagine walking into a large gallery of a museum and seeing a painting on the far wall. You have never seen this particular painting before, but you immediately recognize it as a Picasso, a Van Gogh, or a Dufy. Its unifying quality is not its *Picasso-ness*, its *Van Gogh-ness*, or its *Dufy-ness*, although that is certainly part of what you are picking up on. Rather, there is a *pervasive unifying quality of this particular work*, which just happens to be, say, a Picasso. And the meaning of that work is present, as a horizon of possibilities, in its qualitative unity. Here is how Dewey puts it in *Art as Experience*:

> The total overwhelming impression comes first, perhaps in a seizure by a sudden glory of the landscape, or by the effect upon us of entrance into a cathedral when dim light, incense, stained glass and majestic proportions fuse in one indistinguishable whole. We say with truth that a painting strikes us. There is an impact that precedes all definite recognition of what it is about.[15]

ART AND THE ENACTMENT OF MEANING

When Dewey asserts that fulfilled experience is "art in germ," he is claiming that art is experience in its consummatory, eminent sense. Art reveals, through immediate presentation of qualitative unities, the meaning and significance of

some aspect of our world, either as it was, is, or might be. At its best, art shows us the possibilities of our world. However quaintly romantic this might sound, it *is* the heart of Dewey's view. He is saying that art matters, when it does, because it can be an important source of meaning in our lives, and that meaning is present in the qualitative unity of the work, not in any other way or by any other means.

Dewey's central question here is *how* art realizes meaning. His answer is that art achieves meaning by enacting in us a heightened awareness of the "pervasive unifying quality" of a given situation. It does not *re*-present some meaning already formulated; rather, it *presents*, *enacts*, and *realizes* that meaning. If it were a mere *re*-presentation, then the meaning would already be accessible in some other way, outside (and independent of) the artwork. But it is not. We are attracted to and care about works of art, not just because they can be entertaining and enjoyable, but more importantly because they afford us possibilities for meaningful experience. They enact the meaning of what has been, is now, or might be experienced. Dewey's claim is compatible with Heidegger's claim that an artwork presents us with a world and shows us how our "world worlds," so to speak. His claim is also similar to Paul Ricoeur's suggestion that an artwork shows us a world we might inhabit, dwell in, experience, take up, and carry forward in our lives.

In Dewey's words, "the undefined pervasive quality of an experience is that which binds together all the defined elements, the objects of which we are focally aware, making them a whole. The best evidence that such is the case is our constant sense of things as belonging or not belonging, of relevancy, as sense which is immediate."[16] Dewey goes so far as to say that we "intuit" this pervasive mood and significance of a work: "But the penetrating quality that runs through all the parts of a work of art and binds them into an individualized whole can only be emotionally 'intuited.' The different elements and specific qualities of a work of art blend and fuse in a way that physical things cannot emulate. This fusion is the felt presence of the same qualitative unity in all of them."[17]

Through this qualitative unity, an artwork presents a world or situation of possible meaning—possible experience—that you might inhabit. This is not limited only to representational scenes. The qualitative unity of the work can be manifest in a portrait, in abstract forms and relations in a non-representational piece, or in a color-field painting, for they are each circumscribed as an individual qualitatively unified situation.

Consider, for example, the very different worlds enacted in the paintings of Piet Mondrian as compared with any of the late cutout works by Henri Matisse. These are abstract works, with little or no obvious representational content, but they nonetheless draw us into two fundamentally different ways of inhabiting and experiencing the world. Mondrian's is a world of rectalinearities, straight lines, squares, rectangles, and precise delineations. Matisse's cutouts are populated with organic forms that float joyfully and freely in harmonious relation. Matisse's works enact organic growth and vibrant living colors. Mondrian's works can be full of life, too, as in his *Broadway Boogie-Woogie*,

but the colors are sharper, more intense, and more precisely contrasting. His is a palette of primary colors, whereas Matisse envelops us in rich, soft hues. Both painters realize basic dimensions of our lived experience, but in quite different ways, resulting in dramatically different qualitative unities. Thus, the issue is not the *representation* of a world, but rather the *enactment* of a situation—a way of being in the world. Dewey explains the sense of meaning presented via the qualitative unity:

> The resulting sense of totality is commemorative, expectant, insinuating, premonitory.

> There is no name to be given it. As it enlivens and animates, it is the spirit of the work of art. It is its reality, when we feel the work of art to be real on its own account and not as a realistic exhibition.[18]

Robert Innis has captured the correlative aspects of the process in which the viewer of an artwork experiences the unity of the work and simultaneously carries forward and transforms that unity through her exploratory perception:

> Integral experience, in Dewey's sense of the term, obtains form through dynamic organization (1934, 62) in as much as the perceiver is caught up in and solicited by the emerging experiential whole. Even while experiencing the perceptual whole as an *outcome* over which it has no explicit control, the perceiver is *creating* its own experience through continuous participation (1934, 60).[19]

SOME EMPIRICAL SUPPORT FROM COGNITIVE NEUROSCIENCE

What I've been arguing so far is that Dewey's Big Idea for Aesthetics is not "wacky." On the contrary, his account is the best available explanation of the felt sense of meaning we get from works of art that capture our attention. Dewey's argument is mostly phenomenological, focusing our attention on our felt encounter with an artwork. However, beyond the phenomenological evidence, there is at least some additional supporting evidence emerging from recent empirical work in cognitive neuroscience. In *Mind from Body: Neural Structures of Experience*, Don Tucker focuses on the evolved basic architecture of the brain as the key to the nature of our cognitive abilities, with special attention to the central role of feelings and emotions in all aspects of cognition. Tucker explores the cognitive processing that results from three fundamental architectural features of the human brain: front-back orientation, hemispheric bi-laterality (right/left organization), and core-shell relationships. For my purposes, I shall focus only on the third (core-shell) of these three architectures. Through evolutionary development, new functional layers of brain structure were added to those that were present in the brains of our animal ancestors.[20]

As a consequence, our brains currently have a core-shell architecture, with the "core" consisting of limbic structures that are mostly responsible for body-monitoring, motivation, emotions, and feelings, whereas the "shell" consists of "higher" cortical layers that perform a host of both narrow and broad cognitive tasks, such as perception, body movement, action planning, and action control.

The crucial point for our purposes is Tucker's claim that (1) structures in the core regions are massively interconnected, whereas (2) structures in the cortical shell regions are more sparsely interconnected, which means that there is more functional differentiation and modularity in brain areas in the cortical shell than in the densely interconnected and emotionally modulated limbic core. Tucker summarizes:

> *The greatest density of connectivity within a level is found at the limbic core.* There is then a progressive decrease in connectivity as you go out toward the primary sensory and motor modules. ... In fact, the primary sensory and motor cortices can be accurately described as modules because each is an isolated island, connected with the diencephalic thalamus but with no other cortical areas except the adjacent unimodal association cortex of that sensory modality of motor area.
>
> The exception is that the primary motor cortex does have point-to-point connections with the primary somatosensory cortex.[21]

Tucker's account gives a plausible explanation of Dewey's claims about the experience of a qualitative unity that gives rise to our perception of the specific qualities and structures in an artwork. The limbic core, with its dense interconnections and strong emotional valences, would present us with a holistic, feeling-rich, emotionally nuanced grasp of a situation—Dewey's felt, pervasive, unifying quality. The more modular and highly differentiated sensory and motor regions of the shell (cortical) structure would permit the discrimination and differentiation of objects, particular qualities, and relations within the artwork. Just as Dewey claimed, the meaning of a situation (here, an artwork) starts with an initial intuitive grasp of its significance and grows as we progressively discriminate more qualities and relations emerging out of the background of the pervasive unifying quality of the work.

The core-shell relationships are far more complex than I have so far suggested. Cognitive processing is ordinarily not just a uni-directional movement outward from core to shell, in which an experience runs its course and is done. Instead, through reentrant connections, what occurs at "higher" or more differentiated levels can also influence what happens in the limbic areas, which then feed back up to shell regions, and this recurrent cyclic activity continues as our experience develops.

The core-to-shell movement of cognition helps to explain why (and how) there can be pervasive qualities that give rise to acts of discrimination and conceptualization. Tucker summarizes the structural basis for this growing arc of experience that was described by Dewey as the movement from a holistic pervasive qualitative situation to conceptual meaning:

At the core must be the most integrative concepts, formed through the fusion of many elements through the dense web of interconnection. This fusion of highly processed sensory and motor information. ... together with direct motivational influences from the hypothalamus, would create a *syncretic* form of experience. Meaning is rich, deep, with elements fused in a holistic matrix of information, a matrix charged with visceral significance. Emanating outward—from the core neuropsychological lattice—are the progressive articulations of neocortical networks. Finally, at the shell, we find the most differentiated networks ... The most differentiated networks of the hierarchy are the most constrained by the sensory data, forming close matches with the environmental information that is in turn mirrored by the sense receptors.[22]

Our experience of a pervasive qualitative unity of a situation is the product, not just of core-shell architecture, but also of differential processing in the right and left hemispheres. Tucker describes the holistic, viscerally-rooted grasp of the right hemisphere in ongoing dialogue with the more modular left hemisphere:

We can see that this progression—from syncretic on the right toward differentiated on the left—is the same one that we have deduced from examining the core-to-shell progression of network organization within each hemisphere. At the visceral core, the fully distributed pattern of network organization leads to syncretic representations, within which all of the elements are fused in dynamic interaction.[23]

The chief value of Tucker's account, for our purposes, is his explanation of the way our more finely differentiated acts of experience and thought arise from our holistic, affect-rich grasp of the situations in which we find ourselves. Tucker claims that this pattern holds for *all* our experience, not just for art, but Dewey claims that it is art's intensive focus on presenting the qualitative unity of a situation that gives art its special role in our lives—the role of enacting consummatory meaning. Tucker's view gives at least one account that would show how Dewey's claims could be plausible.

WHAT ARE WE TO DO WITH DEWEY'S BIG IDEA?

In the middle of his essay "Performative Utterances," John Austin pauses to reflect on how his analysis seems to be going: "So far we have been going firmly ahead, feeling the firm ground of prejudice glide away beneath our feet which is always rather exhilarating, but what next? You will be waiting for the bit when we bog down, the bit where we take it all back, and sure enough that's going to come but it will take time."[24] One might wonder whether we've reached just such a point of breakdown where all this wonderful talk about pervasive unifying qualities of situations and the role of art in realizing such qualities seems to come to nothing. We have reached the point where we have

to explain how taking Dewey's Big Idea seriously should affect the way we do aesthetics.

The problem here is that, having observed the existence of pervasive qualitative unities, there doesn't seem to be anything more one can say about them and how they do their work. Everything we *say* will necessarily involve marking out distinct qualities or structures within a situation (the artwork), and then we will be talking about those specific qualities or structures, instead of the overall unifying quality. It might appear that we are constrained to silence about our most important insight, unless we provide a description at the level of discrimination of patterns, forms, colors, spatial relations, and so on. How else could we point someone to an experience of the unifying quality of the work?

If Dewey is on the right track, then all our cognition, all our conceptualization, all our thinking, and all our valuing ought to be tied to the working of pervasive unifying qualities. It would follow from this that *all* reasoning, insofar as it has any relevance to life, must be grounded in the qualitative unity of some situation or other. And Dewey in fact made just such a claim. The same conclusion should follow for our ethical deliberations—that they arise from and must return to some qualitative situation in the world. Our task here is only to focus on the implications for aesthetics, but a full treatment would have to explore the working of qualitative unities in both logical inference and moral reasoning. What I must do is show that Dewey's Big Idea makes a difference in how we think about art and the aesthetic dimensions of our everyday experience. Here are some of the more important implications.

The first and most important point is that it is the pervasive qualitative unity of a situation that makes an experience what we would call "aesthetic." As Dewey puts it, "In as far as the development of an experience is *controlled* through reference to these immediately felt relations of order and fulfillment, that experience becomes dominantly esthetic in nature."[25] Any experience, however vapid or undeveloped, will have whatever meaning it does by virtue of what we can call its "aesthetic" dimensions, such as qualities, structures, relations, feelings, and emotions. Dewey describes these only partially developed experiences as "inchoate," and he contrasts them with "consummated experiences" that we more properly call *aesthetic*, in order to mark those cases where experience develops and acquires meaning and direction as it reaches a certain fulfillment marked by its unifying quality. Therefore, there can be no adequate account of the aesthetic dimensions of experience without reference to the notion of the qualitative unity of a situation.

The second major implication, which is perhaps just a variation on the first, is that the main point of a work of art is its capacity to realize a distinctive unifying quality of some situation. In other words, the starting point—the central focus—for our experience of an artwork is its qualitative unity, because *that* is what defines it as the unique artwork it is. Everything we value in an artwork—its formal aspects, its expressive qualities, its sensuous textures, its "way of worldmaking" (as Goodman puts it)—depends on its unifying quality.[26]

This leads to a third major point, which is that any aesthetic theory or critical analysis that attends only to selected features of an artwork will necessarily fail

to capture what is most important about the work. It is often observed that the problem with most traditional aesthetic theories is that they select some particular aspect of an artwork and elevate it to the status of *the* essential art-constituting feature. This has given rise to our long history of successive theories that are uni-dimensional: mimetic theories, expressivist theories, formalist theories, social institution theories, minimalist theories, and so on. The obvious moral is simply to treat each traditional theory as giving us insight into important dimensions of art, and then try to see how *all* of the theories fit together, rather than taking any one as definitive.

The fourth major implication is that artworks are significant only insofar as they enact meaningful experience (grounded in the grasp of the qualitative unity) for some audience at a particular moment in history. An artwork is an occasion for an experience—an artwork *is* an experience—and there is no artwork-in-itself or for all time. The art exists only as enacted, realized, and experienced, and such experience extends over time. Consequently, there is no artwork-in-itself, existing eternally for all time. Any theory that posits the artwork as some ideal or autonomous object or quasi-object is bound to be one-sided, because it leaves experience out of the equation. At the other extreme are theories that reduce the meaning and value of an artwork to nothing more than a single present experience within a perceiving subject. This denies the ongoing temporal nature of the art-as-experience. The mistake of subjectivist theories of taste is to forget that any artwork has meaning that reaches out toward the future and develops temporally as material, social, and cultural conditions change. *There is no single meaning* of an artwork, just as there is no single, autonomous artwork. The art is the working of some event of making or doing as it contributes to the ongoing experience of a people. This is why there are so many different *Hamlets*, so many different *West Side Stories*, and so many different meanings of *Moby Dick*.

The fifth related point is that art is separated from science (to name just one other type of practice), not because of some absolute difference in kind, but rather as a matter of degree along a continuum. Science and art alike are modes of inquiry. They are both ways of exploring the meaning of our world. Dewey, like James, famously argues that even in scientific, mathematical, and logical thinking there is always a felt dimension and a pervasive quality to the character of any developed thought process. However, science typically selects features or structures of experience and then seeks explanatory generalizations over a broad range of phenomena in terms of those abstracted dimensions. Art selects, too, but art is primarily about the enactment of the pervasive unifying quality of a past, present, or future possible situation and less about the quest (as in science) for generalizations over abstract selected qualities or patterns within some domain of experience. What we call prototypical artworks focus on the immediate presentation or enactment of the felt situation. Dewey explains:

> The doing or making is artistic when the perceived result is of such a nature that *its* qualities *as perceived* have controlled the question of production. The act of producing that is directed by intent to produce something that

is enjoyed in the immediate experience of perceiving has qualities that a spontaneous or uncontrolled activity does not have. The artist embodies in himself the attitude of the perceiver while he works.[27]

Sixth, we are thus brought back to our previous observation that what we call "art" is continuous with any fully developed ordinary experience, insofar as it gives rise to meaning and value. "Because experience is the fulfillment of an organism in its struggles and achievements in a world of things, it is art in germ," and "Art is thus prefigured in the very processes of living."[28] Contrary to the otherworldly yearnings of an aesthetician like Clive Bell, who insisted that art transports us to a world beyond all time, Dewey is right to see that art is an ongoing experience of meaning, an experience typically orchestrated by an artist and/or performer for an audience that is always situated at some point in time, but whose experience of meaning can be reconfigured over time. Thus, any artwork can change over time and across cultures.

Dewey is not embarrassed to insist that art matters because it is meaningful. He would not have been impressed by postmodern denials of meaning. There are things, events, and experiences that entertain, delight, distract, or unsettle, and art can do all of these things, but what makes art an honorific term is its power to present or realize meaning:

> Art is the living and concrete proof that man is capable of restoring consciously, and thus on the plane of meaning, the union of sense, need, impulse and action characteristic of the live creature. The intervention of consciousness adds regulation, power of selection, and redisposition. ... But its intervention also leads in time to the *idea* of art as a conscious idea—the greatest intellectual achievement in the history of humanity.[29]

I want to close where I began, with the idea that what we call "the aesthetic" is not some special aspect, feature, or kind of experience, but rather the very stuff of any meaningful experience. One of the biggest errors we can make in aesthetic theory is the fetishizing of "the aesthetic," as if only certain very special kinds of experience manifest the aesthetic. That road wrongly leads to the separation of art from life, and it robs us of the means to explain the power of artworks to matter to us and to change us. It is perfectly acceptable to speak, as Dewey sometimes does, of "aesthetic experience" when we are trying to observe that certain experiences are marked out as meaningful unities, while others (the "nonaesthetic" ones) are unconsummated, undeveloped, unfulfilled. But what is not acceptable is to treat "the aesthetic" as some quality or feature that descends, we know not why or wherefrom, onto a certain select set of experiences. That way leads to just another fragmentation of human experience and to the marginalization of aesthetics.

I do not think it an exaggeration to say that Dewey's entire philosophical orientation is founded on his insight that all experience, perception, understanding, imagining, thinking, valuing, and acting begins and ends in the aesthetic dimensions of human experience. Dewey was correct in observing that virtually

all of the errors and reductionist tendencies of philosophies can ultimately be traced to their impoverished conceptions of experience, and to their ignorance and dismissal of the significance of the aesthetic. Therefore, it is fitting to end, as we began, with our passage from the Gospel according to John (Dewey, that is): "The stone of Aesthetics that was cast out shall become the foundation of our new kingdom—our new philosophy of experience" (Book of Dewey 0:0).

NOTES

1 Matthew, chapter 21, verse 42, *Revised Standard Version Bible*.
2 A version of this opening paragraph first appeared in "'The Stone That Was Cast Out Shall Become the Cornerstone': The Bodily Aesthetics of Human Meaning," *Journal of Visual Arts Practice* 6, no. 2 (2007): 89–103.
3 I do not wish to undervalue Kant's many profoundly insightful treatments of reflective judgment, imagination, and creativity. However, Kant's faculty psychology and his taxonomy of kinds of judgment led him to regard aesthetic judgments far too narrowly as non-cognitive and as strictly feeling-based.
4 John Dewey, *Experience and Nature*, in *John Dewey, The Later Works, 1925–1953*, vol. 1., ed. Jo Ann Boydston, Carbondale: Southern Illinois UP, 1981.
5 John Dewey, *Art as Experience*, in *John Dewey, The Later Works, 1925–1953*, vol. 10, ed. Jo Ann Boydston, 1988.
6 John Dewey, *Logic: The Theory of Inquiry*, in *John Dewey: The Later Works, 1925–1953*, vol. 12, ed. Jo Ann Boydston, Carbondale, IL: Southern Illinois UP, 1991.
7 John Dewey, "Qualitative Thought," in *John Dewey, The Later Works, 1925–1953*, vol. 5, ed. Jo Ann Boydston, Carbondale: Southern Illinois UP, 1988, 242.
8 William Stafford, *The Way It Is: New and Selected Poems*, St. Paul, Minnesota: Graywolf Press, 1998, 74.
9 *John Dewey, The Later Works, 1925–1953*, vol. 1, 12–3.
10 *Art as Experience*, 19.
11 "Qualitative Thought," 246.
12 *Art as Experience*, 37.
13 *Art as Experience*, 246.
14 *Art as Experience*, 192.
15 *Art as Experience*, 150.
16 *Art as Experience*, 194.
17 *Art as Experience*, 192.
18 *Art as Experience*, 193.
19 Robert Innis, *Consciousness and the Play of Signs*, Bloomington: Indiana UP, 1994, 61.
20 The addition of new "layers" required re-structuring and "re-wiring" of the earlier layers and functional structures, thereby establishing novel connections among shell and core functional assemblies.
21 Don Tucker, *Mind from Body: Experience from Neural Structure*, Oxford UP, 2007, 81.
22 *Mind from Body*, 179.
23 *Mind from Body*, 235.
24 John Austin, "Performative Utterances," 241.
25 *Art as Experience*, 50.
26 Nelson Goodman, *Ways of Worldmaking*, Indianapolis: Hackett Publishing Company, 1978.
27 *Art as Experience*, 48.
28 *Art as Experience*, 19; 24.
29 *Art as Experience*, 25.

3

attention and imaginative engagement in marcel breuer's atlanta public library

sonit bafna

sonit bafna

TWO MODES OF ATTENTION

Buildings are a natural, even paradigmatic, case for discussion of everyday aesthetics. They are artifacts of everyday use, they are present in the public environment, and aesthetics seems to matter considerably to their creation. But what seems to make them particularly pertinent to discussions of everyday aesthetics is the mode of aesthetic response that they normally engender. "Actions prompted by everyday aesthetic judgments we make are often unreflected," writes Yuriko Saito,[1] continuing, "Sometimes, they are almost like knee-jerk reactions; at the very least, we usually do not have a spectator-like experience which then leads towards a certain action. This action-oriented, rather than spectator-oriented, dimension of everyday aesthetics tends to move it outside the aesthetic radar calibrated to capture contemplative experiences." It is precisely this "unreflected," action-oriented mode of aesthetic engagement that characterizes our typical engagement with buildings.

In fact, this everyday mode of aesthetic response to buildings is so natural that the more pressing problem about their aesthetics lies in explaining the possibility of the other kind of response—the spectator-like, engaged response that people often experience with the more paradigmatic works of art such as movies, paintings, novels, and musical performances. Why should we even consider the possibility of such a response to buildings to be a matter for discussion? For one, the concern with detail and form often exhibited in architectural practice seems to call for a much more attentive form of response than the one implied by the everyday mode of aesthetic response—throughout history, architectural traditions all over the world have consistently included rules of organization and restrictions on repertoires of specific elements to be used that imply the presence of engaged and attentive spectators. Secondly, and more to the point here, the unreflective, everyday mode of aesthetic response has become accepted as not just a matter of conventional practice, but as a defining feature of architecture, seeming to preclude, in principle, embodiment of any kind of representational content within buildings, and intuitively this seems to not be correct.

The idea of unreflective aesthetic response as being a defining element of architecture perhaps originates with certain passing remarks made by Walter Benjamin early in the 20th century:

> Buildings are received [apprehended] in two ways: by use and by perception. Or, in other words, through tactile and optical modes. Such a reception cannot be described if you imagine it as a kind of collective [apprehension], for instance, of what tourists standing before a famous building are used to. Because, on the tactile side there is nothing equivalent to what, on the optical side, is described as contemplation. Tactile reception is accomplished not so much by attention as by habit. In architecture, the latter [i.e. habit] determines even optical reception to a great extent. Thus, it [optical reception] originates much less in rapt attention than in incidental noticing. This mode of reception, developed with reference to architecture, acquires canonical value under certain circumstances.[2]

As the last sentence shows, Benjamin's interest in architecture was opportunistic and incidental; it provided him with a good illustration of what he thought was a universal mode of attention that had emerged in reaction to the social and technological conditions that characterized contemporary modernity. However, the idea of the normal mode of apprehension of buildings as being dominantly habitual and inattentive has had a lasting power even where the cultural and political implications of this mode of attention have been less of an issue.

A parallel idea supporting this view is that architecture is fundamentally non-representational, drawing mainly on the premise that buildings are not designed to present subject matter for contemplation.[3] Clearly, nothing actually precludes anyone from taking a contemplative stance before a building. However—the argument goes—in works that are representational, the contemplative stance is one where the contemplation of the represented subject matter is supported by simultaneous perceptual attention to the work.[4] In buildings, because, by definition, there is no represented subject matter, if one were to attempt a contemplative stance, the most one could do perceptually is to make judgments about the appropriateness of forms or dimensions. Even if one were to use the building as a prop for imaginative contemplation, one would find one's attention soon directed away from perceptual aspects of the building to the imagined subject; the experience would be one of an imaginative reverie rather than of a contemplative perceptual absorption of the kind that is so easy to experience with a good book or a painting.

This point of view leads to the conclusion that architecture is a somewhat lesser form of art.[5] Not being able to support a contemplative stance, architecture provides, at best, a backdrop for life, but does not really have anything profound to express about any other aspect of it. What puts architecture apart from other arts, then, is not that it is utilitarian in its essence, but rather that its forms are abstract and not capable of functioning as elements of a representational system, and this precludes architecture from any possibility of having a conceptual content.

Clearly, the crux of the matter is the nature of attention toward buildings. If one were to show that it is possible for buildings to invite and sustain perceptual attention, such that the thought accompanying this attention has a distinct conceptual content not confined to the specific building, then one could posit for architecture a role that parallels other artistic forms or media. This is essentially what I intend to do in what follows.

In order to argue how buildings, in principle, can support such an attentive engagement, I will work demonstratively with an example: in this case, Marcel Breuer's design for the Atlanta Public Library. This is partly because attention is an unusually elusive topic—there is a great deal of disagreement about what attention is and what it does within those who work on its psychophysical or neurological aspects, as well as its nature and its relationship to other phenomena such as awareness, noticing, and consciousness; and, in fact, its very definition has resisted philosophical clarification.[6] Working with an example will let me side-step problematic conceptual issues and focus on the

question most directly relevant to this paper: what exactly does one attend to when one attends contemplatively to buildings with an aesthetic interest?

I shall proceed by attempting to elucidate the difference between what one notices of the building when one is attending to a specific task in the building or its vicinity—of the kind an everyday user or a passerby would attend to— and what one notices if actively taking a spectator-like position before the building. The point is not simply that an attentive viewer will notice more than the inattentive, distracted one, but rather, that the mode of attention will be motivated by a very different sense of purpose, and so the significance of what one notices will change. Seeing is, as writers on visual perception never fail to remind us, not a simple, passive sorting and processing of patterns of light intensity received by our eyes, but an active and meaning-driven construction of the world around us. This means that any description of the activity of the spectator-like response will require an understanding of the relationship between attention and vision, and so I shall bring to my account some findings from recent empirical work on the psycho-physics and the neuroscience of attention and perception.

To some extent, the two modes of apprehending buildings that I discuss seem to be a reiteration of Benjamin's distinction between apprehending buildings through use and through sight, but it is important to note some critical differences. For one, the distinction that I am advocating is not so much between activities like using/inhabiting and seeing/contemplating (or even optical and haptic modalities, which, despite Benjamin's assertion, is not equivalent to the use-sight distinction), but between different kinds of attention directed toward a building. In both cases, vision comes into play; it is just addressed to different tasks. I do not wish to claim, either, that one mode of perception is aesthetic and the other not. The everyday user or passerby has as much potential to have an aesthetic response to the building as the contemplative, attentive spectator does; the difference is rather in the object of the aesthetic response. The distinction between these two modes of perception, as many readers will have noticed, is close to Arthur C. Danto's distinction between a work of art and an everyday object.[7] But to say this is not to hold that as a work of art the Atlanta library becomes a special artifact, with distinctive perceptual qualities, and less capable of everyday use—just that it responds in a particular way to a careful visual scrutiny supported by a particular mode of attention.

AN INSCRUTABLE AESTHETIC

The Atlanta Public Library, located in downtown Atlanta, was constructed in 1981.[8] The idea of a new library was conceived as part of a modernization project in the late 1960s by Carleton Rochelle, director of what was then the Atlanta Public Library System. The point was to replace an existing building, a classical affair in the École de Beaux Arts-inspired academic tradition, which had been constructed through a Carnegie bequest in the early years of the last century. Having convinced the patrons of the library system—a group of

progressive and public-minded Atlanta citizens who had organized a support group called Friends of the Atlanta Library—not just of the need for a new building, but of the need for an iconic, attention-attracting, state-of-the-art facility that would present the idea of the New South to the rest of the country, Carleton traveled to New York, and after interviewing Paul Rudolph and Marcel Breuer, commissioned Breuer to draw up a set of plans for a library building. Breuer, working with Hamilton Smith, one of the four partners in his New York office, duly completed a set of drawings as well as a model in the fall of 1971. It was only in 1977, after a referendum on issuing public bonds for the library had successfully passed, and a number of local citizens and institutions had begun to actively promote the new library, that the construction finally started. Breuer, meanwhile, had retired in February of 1976, leaving his firm, Marcel Breuer and Associates (MBA), in charge of his former associates. Smith took over the project, and after making a few substantial changes to the interior of the building in response to changing programmatic requirements, finally saw the building to its ultimate construction, using the services of the local firm of Wilkinson and Stevens as the architects of record. What is remarkable, and particularly relevant for our purposes, is that the exterior shell of the library was constructed almost exactly as conceived by Breuer; Smith's modifications were largely in the interior, and even there, the basic organization of the library

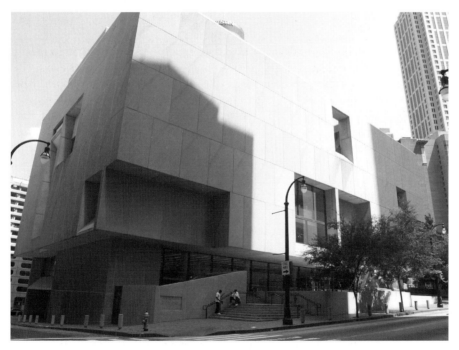

Figure 3.1 View of the library from the corner of Williams and Forsyth Streets, looking directly north. The entrance façade, on Forsyth, shows the deep set-back of the glazed front, and the steps to the elevated plaza in front of the building. Forsyth gradually rises to the plaza level toward the right. (Photo credit: Myung Seok Hyun.)

remained intact. On the exterior, however, Smith did make one significant contribution: Breuer had conceived of the building as a structure of steel framework, concrete floor-slabs, and stone veneer, but Smith, for various reasons including economy, deployed structurally-active precast concrete panels, which are distinguished by a finely, and actually quite subtly, tuned pattern of diagonally incised grooves. This point is worth noting because as we subject the building to a critical scrutiny, we will have to keep in mind that for all Breuer's initial authorship, a significant feature of the visual design of the library was entirely Smith's idea.

At first glance, even in photographs, the library has a stark and somewhat uncompromisingly severe look (Figure 3.1). The entire building is clad in gray concrete panels. There are large expanses of windowless surfaces, relieved only by a few large overhangs and insets. The few openings, wherever they occur, consist of very large expanses of glazing inset a foot or so into the surface of the façade, and they do help in relieving both the monotony and the severity of the look. The uniformity of the facing panels, which turn the corners and so do not reveal their actual depth, gives the building a sculpted, monolithic feel. But what the photographs do not often reveal is that the building is deceptively large; the 20,000 square feet of its built-up floor area not only occupies an entire block (roughly 200 feet × 200 feet) in a dense part of Atlanta's downtown, it actually expands outward as it rises eight stories in inverted, asymmetrical steps, looming over the surrounding narrow streets. All this makes the building difficult to like at first glance. John Raymond, introducing the newly completed building to readers of the *Atlanta Journal-Constitution*, on May 18, 1980, found the new library "massive, stark, and geometric on the outside; expansive, imaginative, on the inside," something, he thought, "may take some getting used to."

Raymond was right in his guarded optimism because, despite its severity, the building is neither ugly nor banal. To a great extent, Hamilton Smith's thoughtfully detailed concrete panels add some measure of delicacy to its proportions; at half-inch intervals, the diagonal grooves making up the surface patterns are just the right size to give the building an unexpected delicacy of proportion, and as photographs often capture beautifully, the bush-hammered panel surfaces modulate light subtly and produce a softened matte tonality that contrasts the highlighted sharp edges with the dark shadows of the deep reveals. The strategically located large openings, which are all glazed with expansive un-partitioned panes, open up the building to interesting views of the inside, and further counter the severity. But still, the dominant note is that of a monumental permanence combined with an uncompromising aesthetic.

The clients—the librarians—wanted an open, flexible, lively building. Among the publicity materials in the archives of the library from the period, one can find several references to expectations of a new kind of library, which would work, experientially, more like a department store for a variety of information than as a solemn place of learning. Judging by the reactions of users and visitors in the immediate aftermath of its construction and occupation, the library was largely successful in creating such an image. Alicia Griswold, reporting for

Creative Loafing, a neighborhood paper, wrote on August 23, 1980, "The overall atmosphere of the library is busyness, congregational lightness and air, and there is none of the woody mustiness many associate with libraries from our pasts." In the same piece, we also find her quoting the public relations officer of the library, who describes it as a "book-bank," a "town-hall," and a meeting place. There is, then, an apparent mismatch in what the experiential quality of the building was expected to be, and the kind of character it actually presents on its exterior. The architects themselves, however, did not quite see this as a concern. Breuer, in an article written for *The Georgia Engineer* around the time that construction was to begin, explained:

> It was our initial instinct and remains our considered belief that to fill the block from property line to property line would be to leave unfulfilled the potential for the spatial independence given by the site; and that to make this space eloquent, it is necessary that it expand in some manner beyond the confines of the building lines as defined by other structures. We believe it also to be necessary that the building designed for this site be more dimensional—more "in the round"—than would be the case were it to present only a flat wall plane toward the street. [9]

He continued:

> The result is a composition of large-scale forms defined by relatively uninterrupted planes, which, involving more than one façade simultaneously carries the eye around corners recognizing that the building is frequently approached from diagonal viewpoints along Forsyth Street. The result is also to make dynamic the envelope of space surrounding the building. For example, the inward flow of space beneath deep corners toward the main entrance generates a definite "pull" on the passer-by, inviting him to enter. It is important to note, however, that the unpunctuated continuity of the exterior wall surfaces is a response not only to the internal organization of the building space, but represents, equally, a deliberate contrast with the external background against which the building is seen. This background is, and will likely remain complex—a random montage of small-scale elements: windows, piers, parapets, signs.

Note that this statement carries a sense of a larger intentionality at work. Over and above answering to the specific requirements of the Atlanta library, Breuer was concerned with creating a formal solution to a more general problem—that of designing a civic institution for a modern city. The essay actually begins with a clear statement of the problem:

> The urban texture of the central business district in Atlanta can be predicted to grow denser and more continuous in the years ahead. … Amidst this heterogeneous downtown texture, the Library building must, somehow, be given an architectural significance appropriate to one of the chief cultural

resources of a major city. The achievement of this distinctness and clarity is considered a key design challenge by the architects.

Only after suggesting an appropriate response, in the first paragraph quoted above, does he move to the specifics of the program: "At the same time, the building must satisfy a complex and comprehensive program of Library functions and interior space needs. These criteria are reconciled in a design which carefully relates setbacks to floor area requirements."

Breuer's approach to the overall planning was characteristically pragmatic. The programmatically distinct elements in what was conceived to be a large multifunctional institution—the children's section and the auditorium—were relegated to the semi-basement, enabling them to function independently; and a smaller "sampler" library was supposed to occupy much of the ground floor, while the main library was placed on the upper three floors, under two floors of offices. With a core of functional areas located along Fairlie Street, Breuer was able to design almost all of the upper floors as large open spaces, to be planned as the librarians required. Ancillary rooms of different sizes were to be located on the periphery as needed, but their location does not seem to have driven the façade design. Although the scheme remained unchanged in its broad pattern, there was a fair amount of change in the programming and layout of these rooms as Smith developed the program for construction, but the composition of the façades remained virtually unchanged in the process.

These observations help to define the scope of this paper. Practically speaking, the design of the exterior was a more or less autonomous exercise. This is not, of course, to imply that Breuer designed the exterior without giving any thought to the activities, functions, or spaces that might be located behind it, but rather, to accept that specific design decisions regarding the façade were likely to be influenced far more by compositional considerations than by any moves concerned with the programmatic organization or the spatial design of the interior. Nor does this mean that Breuer's design intentionality ceased in the interior, or even that the interior of the library is not a suitable object for an interpretive exercise. There are, in fact, enough features of interest in the interior design to formulate several worthwhile interpretive theses, but given the relative independence of the design of the interior from that of the exterior, they need not concern us here. In what follows, then, I can focus my interpretive efforts on the exterior without being unduly concerned about reasoning deriving from the planning of the interior.[10]

Breuer's statement of intent about the visual design of the exterior seems to respond to two requirements. The first was his own intent to design a building whose look maintained "distinctness and clarity" against a rapidly changing and visually distracting urban environment. The second was an implicit charge from the clients to create a new image of the library as a modern institution—a lively social place for exchange of information, rather than a conservative repository of knowledge. His statement explains a part of his response—an open plan, with an offset core and peripheral circulation, and a sculptural exterior that contrasts strongly with its surroundings. In the latter half of his

Georgia Engineer piece, Breuer described how the same formal treatment that gave him the desired expression would also allow the proposed building to fit seamlessly into the flow of day-to-day life in the city, drawing patrons in toward the front entrance, engaging passersby with peripheral landscaping elements, and using strategic setbacks to minimize the disruptions caused by services and access around the building.

But all this still keeps Breuer's explanation of his intentions very general, and anyone comparing this stated intentionality with the kind of concern actually manifested in the design of the building is left with the sense that there is more here than meets the eye. The façades of the building, particularly the one fronting Williams Street, are careful compositions. They cannot be comprehended at a glance, nor seem to follow a predictable formula, but are not visually complex. And for all the care in composition, they are not designed to immediately and unequivocally please. There remains, especially, the puzzle about the ambivalent popular reaction to his building, which as we have seen was praised for its functionality and modernity, but left viewers more circumspect about its appearance. Why design a building that is so difficult to like? Breuer—the chief designer of the UNESCO offices in Paris, and of the sculptural abbey church of St. John's in Minnesota—was certainly capable of particularly elegant and expressive buildings.

Now I may be making more of the issue than is necessary; it is perhaps simpler to cast the building as a not-quite-successful example of brutalism, a period style that routinely produced buildings that, in retrospect, have been judged to appear inelegant or dismal. But such a quick judgment misses some rather remarkable qualities of the building, and to see these qualities, one needs to attend to the building in particular ways. This is one building whose aesthetic experience changes markedly if viewers assume an attentive, contemplative mode of perception. In order to show this, I will first need to establish the difference in perception that is entailed by different modes of attention. This calls for a brief, but useful, digression into our understanding of attention and its role in perception.

UNDERSTANDING ATTENTION

The published literature on attention is large and multidisciplinary, and differentiates between varieties of attention. Our focus will be mainly on the relationship between attention to visual stimuli and the organization of visual perceptions; we will not deal with other aspects of attention, such as maintaining an alert state, or attending to ideas, nor will we consider attention to other sensorial modalities such as hearing. The main point that I want to make here is that there is much difference between what is available to the eye—what lies geometrically in our field of vision—and what is actually registered by our visual system. This difference arises from two sources—the first is the physiology of the eye and the way information registered through the light falling into our retina is successively processed through the different components of our visual

system; the second is our mode of attention which determines how the information processed through our visual system is to be weighted, selected, and compiled, so to speak. I'll discuss them in order.

As we attend to the visual world around us, we can roughly think of our visual activity as a searchlight, constantly moving about and exploring the world. Because of the physiological structure of the human eye, our eyesight has differing sensitivity, or acuity, toward the different areas of the field of vision.[11] These areas may be thought of as being roughly concentric. At the center of vision, within a circle of roughly 2° angular diameter, our eyesight is the most acute. The light rays entering the eye from within this field fall on the fovea—the part of the retina that has the highest concentration of cones. The cones are the photosensitive cells in the retina that respond to specific colors, and the rods are those cells that respond to differences in the amount of light. The concentration of cones falls sharply with increasing eccentricity with respect to the central foveal region, and in the surrounding concentric area of the retina—the para-foveal region that corresponds to the field of vision within a subtended angle of 15°—it is the rods that dominate. This area of the retina, therefore, still has a high acuity for light, but a much reduced sensitivity to changes in color. Beyond that, in the peripheral regions of the retina (that is, for light entering the eye beyond a subtended angle of 15° in the field of vision), both cones and rods become far less dense; the eye gradually loses acuity for both color and light contrast, with increasing eccentricity of the image on the retina.

This variation of acuity carries over into the way information is transmitted from the retina to the visual areas of the cortex. An important feature of our visual system is that several independent takes of the information received on the retina, each with a specific degree of resolution of detail, are transmitted simultaneously through the visual system. This is achieved by the ability of the visual system to perform something like a linear systems analysis of the information received and filter it into channels tuned to specific frequencies, with the low-frequency channels carrying large-scale information about the perceived scenes—essentially identifying the layout and orientation of surfaces that broadly characterize a scene—and higher frequency channels carrying information about finer details.[12] Most importantly for our purposes, information from the foveal region is transmitted through channels tuned to all frequencies, but with increasing eccentricity away from the fovea, information is transmitted almost entirely through lower frequency channels. In addition, the size of the average receptive fields of the cells in the visual cortex (the specific area of the retina to which a cell responds) increases with the eccentricity of the retina—cortical cells connected to central areas of the retina respond to light falling over a much smaller area compared to those connected to the peripheral areas.[13] Thus, foveal vision is better in all respects—it has the greatest acuity, color perception, and resolution, and it processes an optimum balance of local and global information—but its reach is extremely limited. Interestingly, under some conditions peripheral vision actually performs better than foveal vision; acuity for closed and solid polygons, for instance, is greater in peripheral vision.[14]

Our visual system uses these differences to create redundant and overlapping maps of the scenes before us. The independent channels that transmit information at different frequency bandwidths, for instance, transmit information covering the entire scene. In other words, our visual system constructs multiple takes of any given scene, with each take offering a complete description of the scene at a different degree of detail, which means that what we see before us, we see simultaneously at different degrees of resolution. Naturally, coarse takes from a single glance can cover the entire visual field, while very fine takes are limited to more focused vision, extending at its extreme to 15°around the foveal axis. But, by and large, our visual system uses the coarse peripheral takes to construct a general stable ground for the perceived scene, locating broad features and objects with reference to which individual objects or features of interest can be identified by bringing foveal or para-foveal areas of the eye into play.[15] As we scan a scene, therefore, our eyes make constant movements, called saccades, across the perceived scene, allowing the foveal vision to linger, or fixate, on specific areas in between these saccades.

It is in making appropriate use of these qualities of our visual apparatus that attention comes into play. Attention can vary in its degree and focus. One can attend to something with more or less focus, divide attention between distinct objects, or even not attend to any physical, sensory stimuli by withdrawing attention to one's self. The essential point is that what one is aware of seeing depends a great deal on the degree and focus of attention.[16] If we are not attending to anything in particular, or our attention is directed elsewhere, we typically have no awareness of what we see. Often, in cases of inattention, we can fail to notice large objects or details, even if present in foveal vision, a phenomenon known as inattentional blindness. However, experiments have shown that some aspects of the visual environment do register even in this situation, although this happens below the threshold of conscious awareness.[17] At the most, figures can be distinguished from the background as regions of topological connectedness, but they cannot be identified.[18] Under the condition of distributed attention, which is attention directed over many objects in a field, not only can locations of objects be detected, but also more complex forms of organization, such as groupings of various kinds; and the phenomenon known as pop-out, wherein we suddenly notice a dissimilar object within a field of otherwise similar objects, can occur. But only when attention is focal (i.e. focused on a particular region of space), do complex properties of individual objects, including shape, become discernible. In fact, focal attention is necessary for any kind of identification, even if identification depends only on a single property such as the orientation of a line.

To further complicate matters, not only does attention determine what we notice and therefore consciously attend to, it also controls the way in which we deploy our gaze. Again, a few salient points need to be noted. First, to fixate on anything (i.e. to bring foveal vision to bear on any part of a scene before us), we need to attend to that object.[19] However, attention can shift independently of fixation—that is, covertly—as we can attend to a specific part of the visual field even when our foveal vision is fixated elsewhere. Second, as we shift our

attention around the visual field, the area we attend to can be larger or smaller, depending upon our interest and the nature of attention we bring to bear on the scene. It is obvious that if we attend to larger areas, or areas further removed from foveal or para-foveal vision, our ability to discern detail will be accordingly attenuated.

All this leads to the observation that in order to see specific degrees of detail, to recognize shapes, or to bring particular modes of seeing such as seeing-as or imaginative seeing into play, we need to deploy focal attention—if we do not consciously attend to anything, we are liable to see very little of it, and certainly not with any awareness. Even if we bring divided attention to specific parts of the scene before us, we are likely to only see what can be produced with basic perceptual organization: groupings, contours that can help distinguish figures from ground, and pop-out of particularly distinctive figures, without being able to recognize their shapes precisely. To attend to something focally requires us to dynamically control our gaze, bringing different parts of the scene intermittently under foveal and peripheral vision. But what adds an additional layer of complexity here, and one that is essential to our purposes, is that adopting a mode of attention is not exclusively a voluntary business. It is true that our attention can be willed toward specific modalities or aims—a condition described as endogenous control—but it is also true that external stimuli can override any operative attentional state and direct it elsewhere (a phenomenon called exogenous control of attention). There is not much empirical work on this issue, but common phenomenological experience—of, say, being completely immersed in a particular task—alerts us to the fact that exogenous control of attention can lead seamlessly into an endogenous form of attention.

LIMITED DISCERNMENT OF THE EVERYDAY VISITOR

Armed with this understanding of how attention influences what we see, we can now more precisely think through what the Atlanta Library provides a viewer who brings a particular kind of attention to the building. If we think of architecture largely as an art of the everyday, providing an aesthetic experience of a general, distracted kind, the subject of such an experience is by definition a visitor engaged in some activity related to the building, but not actively giving it spectator-like attention. He may be approaching the library either as a user, or as a member of the staff going to work; he may even be just a casual passerby having no business in connection with the library. In any of these cases, if such a visitor directs attention to the building, the attention will be directed to the building's individual features, and will very likely be controlled endogenously; that is, the features to which the visitor attends will be selected on the basis of the task at hand, which is very likely to be navigational.[20] There will be deliberate direction of the viewer's gaze, of focal attention, to those features of the building that are relevant for negotiating one's approach—to steps or changes in level, to obstacles on the way, and, if approaching the building, to features such as the entrance doors. Such a user is likely to perceive the rest of

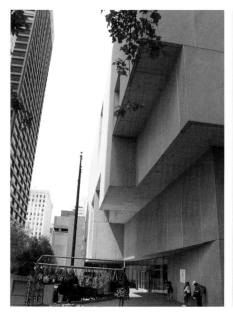

Figure 3.2 The approach toward the southwest along Forsyth, from Peachtree, left; and a diagram approximating progressive attenuation of medium- to high-frequency components with increasing retinal eccentricity of the field of view. (Photo credit: Myung Seok Hyun.)

the building largely through the low-frequency channels of extra-foveal vision, and also, importantly, in a pre-attentive state. This means that the bulk of the building, if it registers at all, will register mainly in its broad massing (Figure 3.2).

The modified view in Figure 3.2 is only an approximation, of course, but a more precise sense of the information transmitted through different frequency channels can be obtained by running the image of the building through a frequency filter, achieving, to an extent, the equivalents of high and low-frequency takes (Figure 3.3). Note that Figures 3.3 b, c, and d are not a depiction of what is actually perceived (since even the peripheral vision contains a few channels tuned to higher frequency band-passed filters), but rather a representation of the kind of information transmitted through the different frequency channels of the visual system. It would also not be surprising for a more everyday kind of visitor to direct some attention to those parts of the building that are not of practical relevance to the task of approaching the building, directing idle glances at something that may catch her attention. In other words, if the task at hand is not especially onerous, a viewer's attention to her task will be peppered with moments of attention to the building itself that could lead to brief registrations of finer detail. Such glances may be enough to ensure that phenomena such as illusory contours and associated phenomenal transparency can emerge within what is otherwise a very coarse take of the building. But for all that, the critical point is that these glances will be piecemeal and uncoordinated, and details registered are very unlikely to be pursued with

any systematic scrutiny. The experience of the everyday visitor is something like that of a spectator experiencing a Turner watercolor—of subject matter presented in broad swathes, impressionistically, with a few key details emphasized—rather than the experience of someone actually present before the depicted landscape and scrutinizing it with engrossed attention.

It is important to emphasize that the point here is not to deny aesthetic experience to the everyday visitor. If fact, if we revisit Breuer's own description of the effects he intended to create in the potential viewer, the experience of the everyday visitor is likely to validate Breuer's intentions. The clarity of "large-scale forms defined by ... uninterrupted planes"; the awareness of being

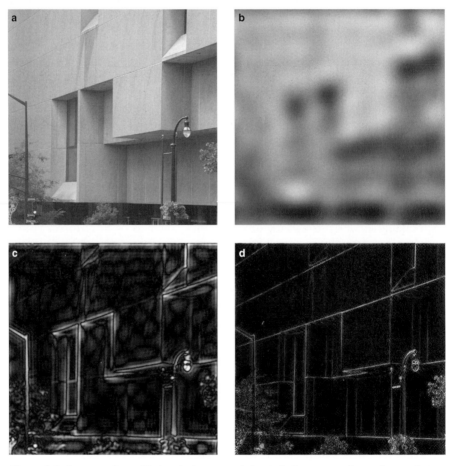

Figure 3.3 A re-creation of information passed through frequency channels tuned to different frequency bandwidths using discrete fourier transform on a raster image (576 × 576 pixels) of a partial view of the library. (a) original image; (b) information transmitted by a low-pass filter (transmitting frequencies only up to 8 cycles/image (cpi); (c) information obtained through a band-passed filter operating between 8–64 cpi, and (d) information obtained from a high-pass filter (frequencies of 64 cpi or more). (Source: author.)

surrounded by "a dynamic envelope of space" in the streets around the building, the promised pull of the entrance when passing by on the side streets—all these are very much present in the coarse peripheral takes that the everyday user directs at the building. The everyday visitor will, very likely, come away with a general impression of looming volumes, vast gray surfaces, and large glazed openings, and these impressions are quite likely to carry some emotional charge or even an association of values—of a depressing bleakness, the disappointment of a dated style, an appreciation of institutional permanence, or even the thrill of encountering the engineering hubris so manifest in the building.

The point, rather, is that neither such an experience, nor Breuer's own stated intent, clarifies much of what is going on in the design of the library. We'll see in the next section that there are aspects of the design not revealed to the passing, distracted gaze of the everyday user. There is, for instance, Breuer's lifelong concern with details, very well manifested in the painstaking construction of the building. And, we'll see that the façade has a compositional complexity that is unprecedented within Breuer's own oeuvre. But, above all, nothing in the passing gaze of the everyday user gives us evidence to address the puzzle that we encountered earlier (p. 59): why does the library have such a rugged, unforgivingly austere, and forbidding appearance—an appearance that makes it intriguingly resistant to providing an immediate perceptual aesthetic response?

NATURAL CAUSAL INTEREST OF THE ATTENTIVE SPECTATOR

The distracted, and intermittently attentive, stance of the everyday user, which we have seen above, can be contrasted with the spectator-like stance that comes with the focused attention and contemplative attitude that one takes before works of art. What exactly would such a stance reveal of the library? Even if such a stance were to be brief, and not entirely contemplative, it would immediately reveal to the observer several features that the quick distracted glances of the everyday visitor would have failed to pick up (Figure 3.4). Several distinct compositional moves, for instance, would become apparent in the front façade: distinctive contours would be seen to repeat, a notional axis of bilateral symmetry would perhaps be discerned running down the center of the façade, and openings would be seen playing a game of visual balance with each other. And as the viewer would note these moves, it would become clear very soon that all this is obviously quite deliberate and calculated, and the building appears designed as if to invoke such a viewing—the care given to the strategic compositional handling of the façade simply does not make sense unless one assumes it to have been done for the sake of a spectator subjecting the building to an attentive scrutiny. And if the viewer would acknowledge this deliberate intent, there would be the question of why Breuer took such care in the building's design.

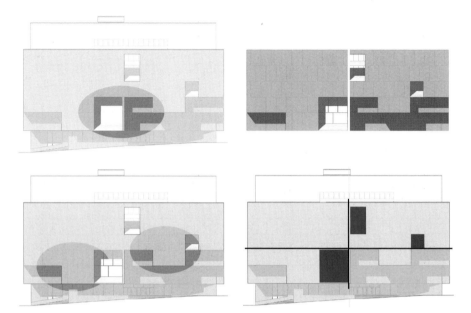

Figure 3.4 Asymmetry, balance, repetition, contrast, transparency, and other compositional devices deployed in the visual design of the front façade. The figural elements brought into play in these strategies are often visually unstable, as figures emerge and then dissolve into the ground, relationships are suggested but not confirmed, and any impression of centrality is often counteracted by peripheral details or eccentrically placed elements. The result is that the compositional strategies overlap and the entire façade, despite its sparsity of figural elements, appears compositionally tight. (Source: author; base drawings courtesy of David Yocum and students in graduate options studio, Georgia Tech, Fall 2009.)

It is worth attending to this question as a general issue, not just in the context of the building. What is really the point of devoting so much care to the detailing of buildings, and so much effort in creating compositional patterns—which can only be revealed to the spectator-like gaze of the attentive viewer—if any building is quite capable of providing an aesthetic experience to a visitor occupied otherwise and attending to it in a state of distracted habitual engagement?[21] Put this way, from the designer's perspective, the question exemplifies a general challenge for aesthetics of architecture: any theory of aesthetics should account for not just the nature of the experience of reception, but for the concerns and activities that constitute design practice. Now, through history, and in different architectural traditions, much effort has been placed in describing and codifying details—exact forms and measurements of moldings are specified, restrictions are set on formal variation, and formal types are described and codified. Such practices assume, and, in fact, could not have survived in the absence of, a spectatorship that would attend consciously to these matters. These practices assume, in other words, that of their viewers, some will take a spectator-like approach and critically reflect on issues like

choice of forms, appropriateness of details, and their correctness and success. It is true that some of the codified rules and principles of practice could have functioned well without a consciously attentive viewership; the visual corrections in ancient Greek temples were arguably conceived to produce specific visual effects in unguarded, inattentive viewers, and they work much like the details of individual letters such as shapes of serifs, sizes of extenders, and leading distances work in the perception of fonts. But, by and large, the major rules and conventions—the codification of the orders in the Western classical tradition, to take an easy example—make sense only if one assumes an active, critical, and attentive viewership for the buildings of the tradition. Spectator-like viewers, critically looking at buildings, have been a part of architecture throughout history.

The answer that I intend to pursue to the question of why buildings seem to be designed in expectation of a spectator-like attentive viewing is that, if successful, such a design can lead to what Danto has termed transfiguration of an object into a work of art.[22] It is only to the spectator-like attentive viewer that the building can acquire the character of a work with a specific conceptual content—that is, a work that has a sense of being about something.

But we have already seen in the first section that several writers have argued against the idea of a building having any conceptual content. Buildings, to restate the argument, are not representational artifacts by their very nature— the elements of buildings are not symbols or characters that stand for anything, and even where they seem to do so, such reference is explicitly dictated, and more importantly, can never be intrinsic to their function as buildings. Their use does not demand any understanding of them as representational artifacts. If this is so, firstly, they cannot in principle be "about" anything, and so the idea of someone viewing them as having conceptual content seems nonsensical. Secondly, the lack of an intrinsic representational function implies that a spectator-like position will be impossible to maintain toward them. The main attribute of such a spectator-like position is its distinctive mode of attention. It calls for the viewer to attend to the building focally. But focal attention can only be maintained if there is a purpose to it. One cannot merely keep looking *at* something; one must be looking *for* something, in order to hold attention to it. As we have seen, in the absence of a specific task, attention will tend to wander, either endogenously, as one's thoughts wander, or exogenously, if something in the field of view catches one's eye. And, unless a deliberate and somewhat unnatural effort is made to resist it, the eyes will follow where attention leads. If the spectator-like position is to be maintained in any productive way, it needs to be driven by a task or purpose that will maintain attention on the building. In order to argue for a spectator-like attention to a building, then, we need to determine the attentive task that the viewer needs to be engaged in.

As it stands, given that there is no depicted subject matter in a building, there seem to be only two possible reasons for a viewer to maintain attention to the building. One is reflection on the perceptual qualities of the building itself, and the other, a causal interest in the shaping of the building—that is, an interest in

finding out why the building is shaped the way it is. Of these, the former reason seems more natural, but not so pressing, and indeed, it is quite volitional; a user may choose to engage or not engage in such a task. The latter, however, is surprisingly less volitional, in that it is driven by a combination of two basic human tendencies. The first, as we have already noticed, is the tendency of our visual system to resolve what we see into a cohesive organization. Faced with a complex artifact like a building, we cannot help but see it as a specific configuration irrespective of its actual constitution. The second tendency, hinging on the fact that the building figures in our operative belief system as an artifact, is to read intentionality into this configuration; if the building is read as being organized in a particular way, that is, as a particular configuration of smaller elements, and if it is a deliberately produced artifact, the organization appears as being intentional, even if the actual intention may not be easy to discern. Due to the influence of these two tendencies, we are naturally rather sensitive to signs of overt intentionality, of patterns of decision making we can detect when we look at a structure. In short, faced with a building (with any artifact, actually), our natural tendency is to make causal conjectures about how it was shaped. A designer, if suitably aware of such perceptual tendencies, can thus control a viewer's perceptual attention and the causal reflection on his design by creating a sense of intentionality in its visual appearance. The Atlanta Public Library gives us a good illustration of how this may be done.

FAÇADES THAT RESIST SYSTEMATIC CAUSAL INTERPRETATION

As an attentive spectator begins his scrutiny of the Atlanta Public Library, seeking to develop a causal description of it, he soon finds that the building is rather unexpectedly resistant to simple causal readings. This is unexpected particularly for a spectator familiar with Breuer's work because Breuer's designs in the decade and a half immediately preceding this building are distinguished by a very clear logic. In all of these projects, the main form-giving element is the actual structural element—often, and characteristically in his office buildings, a simple framework of columns, beams, and floor-plates; in other projects, the main form-giving element is a singly-curved reinforced-concrete shell, which acts as a large roof. As the façade of the Armstrong Rubber Company factory and office building (Figure 3.5) trenchantly illustrates, the openings of the buildings—windows, doorways, skylights, and so on—are articulated simply as the voids in-between the structural elements; very rarely do windows read as if they were holes punched in wall surfaces. Even where there are no windows, Breuer's tendency is find an expression of the structural frame by sculpturally articulating the infill panels. Visually, therefore, the dominance of the structural elements over the infilled ones is never counteracted, so that the muscular expressive effects that characterize these projects are derived almost entirely by finding ways to manipulate the shapes of the elements that leave the structural logic clear—thus beams may be shaped in expressive

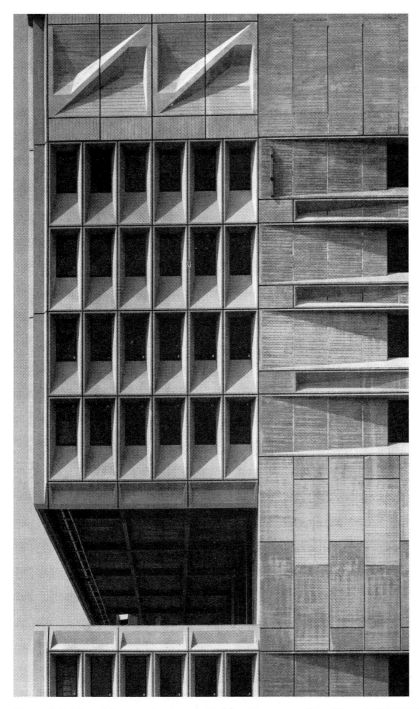

Figure 3.5 Marcel Breuer, Armstrong Rubber Company, West Haven, CT (1965–69): detail of façade. (Source: *Tician Papachristou, Marcel Breuer: New Buildings and Projects, 1960–70*, Praeger, 1970.)

forms, or infilled panels tilted and faceted to create shadows, but never in such a way that vertical lines on the façade indicating the load-bearing columns and beams are disturbed. In fact, cast shadows, shapes, and textures that are created as a result of manipulating these elements actually enhance the readings of these elements as delineating the flow of structural forces. The result is to imbue the visual expression with a causally clear structural logic that matches the natural organizational efforts of our visual system.

Only three major projects of Breuer's post-sixties work actually depart from this generic, but creatively open, formula—the Whitney, the Cleveland Museum of Art extension, and the Atlanta Public Library. Even among these buildings, the massing and formal expression of the Whitney and Cleveland museums are still ordered by a kind of logic, although not structural this time, but programmatic. In the volume of either building, but particularly unambiguously in the Whitney, one can easily discern the schematic arrangement of programmatic spaces in the interior (Figure 3.6).

In the Atlanta library, however, no such visual logic is immediately apparent. The trouble starts at the very moment one begins to parse the overall volume into its component parts. In the front (Figure 3.1), the left side of the façade appears to read as a layered block floating on top of a recessed block. As one's attention shifts toward the center, the surface of the horizontal cut on the left corner seems to continue unseen below the main face, into the glazing of the window, and then under the fin, once more as an opaque plane inside the panel

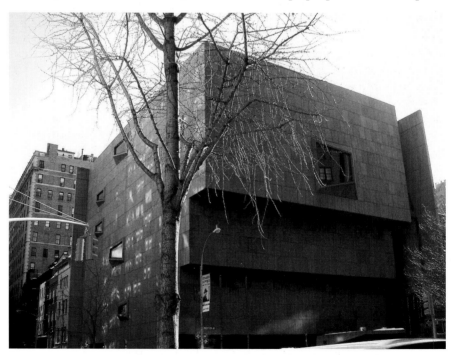

Figure 3.6 Marcel Breuer, Whitney Museum of Art, New York (1963–66): view of main façade on Madison Avenue. (Photo credit: author.)

next to the window. But this entire reading of the layered façade collapses with further movement toward the right, as the lower infill layer turns out to be the next step of an inverse stepping of floor height volumes, reminiscent of the Whitney. Nor is this new reading of stepped volumes more stable, for as one turns the corner, the stepping gives way to a much freer organization of volumes of the Carnegie Way façade, while returning to the layered theme (Figure 3.7). A similar situation repeats on the opposite façade, where the bottom layer of the left half of the front façade is now revealed to be the side of a tube that issues into a window, low on the right corner of this façade. Throughout, on each façade there is consistent equivalence between flat panels and glazed surfaces of windows that infill frames, and so the sight of a window cut into the infill-panel on the Williams street façade comes with a moment of perceptual dissonance.

We have seen earlier (Figure 3.4) how Breuer seems to be using conventional compositional strategies to organize the front façade. What we see now is that the elements that come into play in such strategies are curiously unstable. Figures that are created on one part of the façade dissolve into the background in others, so that as one goes around, one finds no unique way to visually parse its entire volume, which, therefore, continues to maintain a perceptual unity. The observer begins to experience an Escheresque performance in the building, seeking constantly for the seams where one kind of interpretive parsing yields to another, but never finding it. In fact, it becomes clear that it is the building's very resistance to being parsed into component volumes, while at the same time keeping the viewer's parsing mechanisms activated, that keeps focal attention active.

If all this seems to be purely a formal game, its consequences become more tangible as one realizes how the design of the façades brings the human body, with its specificities of scale and the peculiarities of its visual system, into play. The success of its visual performance depends to a great extent upon its actual dimensions and angles of viewing. The front façade, which, it will be recalled, extends almost 200 feet, can only be seen from relatively close distances. To add to this, the building actually invites close scrutiny. Seen from further away, when it can be only seen in sharply raking views up and down its surrounding streets, the mutual occlusion created by the protruding blocks and recessed surfaces does not reveal enough of the façade for the viewer to gain a satisfactorily comprehensive picture (Figure 3.2 and Figure 3.7). Seeking better comprehension, the attentive spectator is impelled to move closer. But curiously, as the spectator begins to scrutinize the building at these distances, the impression gained is of having seen the façades (particularly the front) in parts rather than in their entirety: the façades appear as if they have been put together in the mind, rather than being perceptually available as a whole.

This last statement needs some clarification, for the 200° field of view of the eyes is certainly wide enough to cover the long Forsyth façade, even from the closer locations available. But recall that within this field of view, we do not see everything equally precisely at once. Rather, what we perceive consciously is put together by combining the information from peripheral vision with that from a series of sharper and more focused takes whose location, size, and duration are determined by the kind of attention we employ. Normally, we are

Figure 3.7 The Williams Street (a), Fairlie Street (b), and Carnegie Way (c) façades. Extended scrutiny of these façades will begin to produce multiple and overlapping schemes of organization, as figures emerge through horizontal and vertical alignments. None of the multiple schemes of organization is dominant, and as they overlap, they create perceptual depth that interacts ambiguously with the actual depths of the panels. The sharply raked views on the right show other alignments and compositional features that come into play for a visitor on the site. (Photo credits: Myung Seok Hyun, author; base drawings courtesy of David Yocum and students in graduate options studio, Georgia Tech, Fall 2009.)

so habituated to constantly moving our eyes and even our heads that we do not consciously register impressions produced by the independent focal takes, and are not aware of what we see as being fragmentary or partial. If the visual scrutiny of the Atlanta library leaves the impression in the viewer of having perceived the façades partially, but never having a fully comprehensible sense of the whole, the visual system must be de-emphasizing peripheral vision.

Consider again our analysis of the front façade's component frequencies. Again, the low-frequency image (Figure 3.3b) provides a good approximation of the kind of information that would be available to the visual system if one's sight were restricted to peripheral vision, and the higher frequency images show additional information provided by the higher frequency channels, most of which originate in the central areas of the retina. The point to note, though it is not obvious immediately, is how little of the information necessary to the geometrical configuration of the façade is actually contributed by the low-frequency parts of the image. This is not a quality of the visual system, but rather, a consequence of the design of the façade. Our understanding of this characteristic of the Atlanta library is sharpened if we compare the analysis of its façades to the information contained in frequency components of another Breuer building, the façade of the Armstrong Rubber Company (Figure 3.8). In this case, the low-frequency component contributes its own distinct quality of organization, owing essentially to the phenomenon that the Gestalt psychologists had identified as grouping, and which has been shown to work in low-frequency takes[23]: the dark areas of the windows combine together to create strong horizontal bands, so that even a casual glance with essentially peripheral vision easily registers the entire façade. To add to this, the information from the high-frequency channels is dominated by the more numerous vertical edges of the fins. This implies that as one encounters the building, peripheral vision highlights the horizontal, floor-by-floor reading of the building, but as one begins to focus attention on specific areas, vertical emphasis takes over. The consequent impression is that of a complex layered façade, in which a light vertical pattern constantly overrides a more elusive but still consistently present horizontality. This is the quintessential type of plastic experience provided by the façades of many of Breuer's multi-storied institutional buildings, particularly the ones housing offices.

In the Atlanta library, in comparison, because of the combination of the design of the façades and the limitations of the viewing angle, peripheral vision does not contribute so usefully to the comprehension of the organizational features of the façade (Figure 3.3). It still provides an anchor for mentally aligning different foveal takes into a perceptually unified image of the building, and helps demarcate broad areas of light and shadow, but is otherwise quite redundant as far as attention-maintaining information is concerned. An attentive viewer thus finds himself much more dependent on focal vision to help understand the logic of the façade. At closer distances, the angular sizes of the emergent figures conform nicely to the angular extent of para-foveal vision (Figure 3.9), and this explains why the overall impression of the building is one that is registered in the mind, put together from different foveal and para-

foveal takes, rather than gained directly in perception. Compared to this façade, a façade like the Armstrong office building is easy on the eyes. A large peripheral component of a single glance contributes enough organizational information that one need not move one's eyes to apprehend the façade. Focal glances help more to enrich the basic organization of the façade, and to provide a counterpoint to it. The ease of looking at the Armstrong building also means that the visual scrutiny of this façade is much more quickly exhausted than that of the Atlanta library.

Figure 3.8 Partial façade of the Armstrong Rubber Company offices filtered through different frequency filters: (a) orginal image, (b) image filtered through a low pass filter of 8 cpi, (c) image filtered through an intermediate filter passing images from 8–32 cpi, and (d) image filtered through a high frequency filter letting through frequencies from 32–128 cpi. Note how the façade appears to have a dominantly horizontal organization at the low frequency levels, but at high frequencies appears to be dominantly vertical. In actual experience, this switch is registered between peripheral and central takes as the eye scans the façade. (Source: author.)

Figure 3.9 The front façade with the fields of view of the foveal region (small circles); the para-foveal regions (middle circles); and the peripheral visions (dotted circles) from three different points of view superimposed. The largest set to the left is associated with a vantage point across the street fixating on the central mullion in the large front window; the smaller set to the right, with one of the few longer distance vantage points available across Peachtree; and the ellipse with a vantage point across the Carnegie Way, fixating on the entrance door at a very raking angle to the building. Note how the size of the compositional elements roughly matches the para-foveal field from the close-quarter frontal locations. (Source: author; base drawing courtesy of David Yocum and students in graduate options studio, Georgia Tech, Fall 2009.)

AN INDEFATIGABLE LATE-STYLE WORK

All this is still a partial description of the modality of attention that we have been pursuing. Our discussion of the way the design of the façades responds to an attentive observer has largely been a recounting of *effects*—of the way the design of the building interacts with our visual system to produce specific forms of organization. But the attention of our spectator is maintained with a concern, as we had noted above, that is essentially *causal*. The attentive observer, in other words, seeks intentions. What can we say about the intentionality that could be read into the building?

It is worth reminding ourselves that the actively attentive stance toward the building has led the observer to ascend a level in his reading of intentionality— the observer is liable not only to seek the reasons why certain elements of the façade are designed to appear as they do, but also to ask why Breuer would have designed the entire façade to respond to an attentive scrutiny, instead of

one capable of being registered with passing glances, and why, in particular, the façade has such an emphatic bias toward focal vision. What the viewer has achieved through his attentional stance, therefore, is a sharper restatement of the initial puzzle that we started out with—why is the exterior of the Atlanta library designed to be so resistant to easy appreciation?

The answer to this puzzle cannot be found exclusively in a perceptual scrutiny of the building, of course. The causes in play here are a complex mix of historical circumstance and personal proclivities. But to assert the key point again, it is the attentive and causally oriented perceptual scrutiny that guides the observer to the appropriate question. What, then, are the reasons for the distinctive focal-vision-dominant perceptual performance of the Atlanta library?

Causal intentionality is most reliably captured, if one is able to reconstruct what Popper calls the situational logic of the design, or if one prefers, what Collingwood has called reenactment of the problem situation, and this is what I will attempt—although rather schematically—in what follows.

It is well known that the Atlanta Public Library was, at the request of the clients, specifically modeled after Breuer's design for the Whitney (Figure 3.6). At the Whitney, Breuer had specifically broken with his structure-determined approach to façade design in order to create a distinctively iconic image for a cultural institution. It is very plausible that, to Breuer, the programmatic lack of requirements for windows in a museum would have made the structural-frame based organization of façades somewhat redundant. In any case, a façade of an ordered grid of windows within a structural frame would not have adequately distinguished his design from the surrounding brownstones and newer office buildings. For all these reasons, the ingenious stepped profile of the Whitney makes considerable contextual and programmatic sense. The Whitney was, it is interesting to note, a very rare occasion in which Breuer designed and executed an institutional building on a densely built-up city block; the project has no other precedents within Breuer's post-sixties ouevre.

At the Atlanta library, as we have seen, the situation was quite similar, if less charged, and Breuer initially approached this project with the same schematic design—a core at the back, entrance areas behind a glazed wall on the ground, and programmatic areas distributed between the major functions on the lower floors and administrative offices on the top. Following this scheme, his next move would have been to project out the floors in shapes that were not particularly constrained by any structural frame. But it is here that he would have run into a problem. In the Whitney, he could simply let his floors project at different lengths according to the size of the rooms they enclosed, the iconic form emerging almost naturally. But in Atlanta, where the corresponding front façade would have to run an awkward 200 feet and turn both corners, the emergent form would have been ponderous and inelegant. The use of the repetitive, structural-frame-based façade being already ruled out, he dug into his own stylistic resources to come up with a strategy. He divided the façade conceptually into two halves—a very *un*classical modern move—and then, as we have seen, used a sophisticated compositional strategy of playing the form of one against the other. At the Whitney, the iconic form was complete enough

that the windows could be treated as an extraneous element of the façade, adding interest, but not necessary to its compositional integrity. But at the Atlanta library, the large size made it necessary to find elements to help articulate the different sides of the façade, and Breuer deployed his window openings much more integrally within his compositional strategy. Once understood this way, the remarkable economy of elements (three openings, apart from the floor profiles) with which Breuer was able to create façades of such visual complexity combined with compositional tightness becomes quite apparent. On the other smaller façades, the problem was less severe, but because the articulation of floor profiles was less dramatic, he deployed a third element: framed panels in low relief.

However, all this still does not explain the visual performance of the façade— its intransigence toward visual scrutiny or toward an easy assimilation into a discernible visual logic. It will help to recall that this project was one of the last of Breuer's career. He began it in 1971, and as his health worsened, he survived several heart attacks—including a massive one while in Kabul in 1973—and finally retired in 1976. It makes sense, then, to approach the library critically as a late-style project. One of the characteristics of late-style projects is that they are inward-looking; they are from a period in the artist's life when he or she is no longer interested in addressing the broader world as much as following his or her own preoccupations—one thinks of Wright with his obsessive Marin County Civic Center, of Claude Monet with his large paintings of water lilies, or of Mark Rothko working on the dark paintings for what is now the Rothko Chapel.[24] There is good reason to believe that this attitude comes, to some extent, from a change in motivations—there is less interest in changing the world, or seeking to play a greater role within it, and far more concern with defining one's legacy. In line with this goal, the work becomes broader in scope, immediate practical issues matter less, its scale increases, considerations of spectators or audience cease to be strong determinants, and often rigor is sacrificed to ideas, and performance to experimentation.

Not all of this applies to Breuer, of course, but still it provides a good filter through which to consider his approach to the library. What personal concerns could have motivated his late work? His last decade of practice was a bittersweet one. On the one hand, this was a time of public recognition—the 1968 AIA gold medal; the 1968 Thomas Jefferson Foundation Medal; and honorary doctorates from Harvard University and the University of Budapest in 1970; the universal acclaim gained by the Whitney as a masterpiece of modern architecture. On the other hand, this was also a period in which he began to find signs of his own irrelevance within the profession at large. Commissions for two projects that he valued very highly—a memorial for Franklin Delano Roosevelt and an office tower over the Grand Central Station in New York—fell through, accompanied by both public and professional criticism. The values he held fundamental to architecture were being challenged within the profession as postmodern concerns began to replace the high modernist ideals that he had championed.

Many have seen Breuer as an arch-modernist, an architect who, by the early seventies, had become somewhat of an anachronism. But for all the dedication

toward the ideals of modernism in his beliefs, at the end of his career, Breuer was becoming something of a skeptical believer.[25] This ambivalence seems to lie at the heart of the Atlanta library, and determines the qualities that it carries as a work of late style. The schematic spatial planning of the library is pragmatic, function-driven, and illustrative of the fact that Breuer continued to believe in this aspect of modernism. However, in its visual aspects we can see him, if not quite renouncing, then at least questioning the modernist precept that architectural form not only needs to be functional but should express its functionality as well, and that a logic of some sort—either that of construction, or of the structure, or even of programmatic organization—should explain the composition of the façade. Such an attitude did not just follow from modernist principles at large, but was specifically grounded in Breuer's Bauhaus roots—in the idea that the role of the visual artist was to enable in the public a new way of seeing the world, cultivated through visual design of artifacts that expressively exploit the laws of visual organization.[26] Engagement with artifacts that used complex compositional devices to achieve visual clarity would lead people to habits of seeing and organizing that would define a new age. But toward the end of his career, by the time he had come to work on the Atlanta library, Breuer seems to have become unsure about these ideas—not so much in the capacity of artifacts to achieve their visual aims, but in the efficacy or even the value of their socially ameliorative qualities.[27] The visual qualities of the artifacts and buildings of a culture did not merely express the latent forms of organization that characterized the culture, they could be used to conceal its less palatable aspects and create a false and dishonest sense of clarity, stability, and emancipation. For a pragmatically skeptical architect such as Breuer, this realization should have come not merely as a matter of philosophical disquiet, but rather of an immediate practical problem: what aim should visual design satisfy if not to achieve a combination of visual interest and clarity? Breuer could have taken many different attitudes toward this problem, but what is remarkable is that late in his life, he did not seek to strike a note of pessimism, or of intransigence, but rather of optimistic self-criticism. The active effort required to apprehend the formal arrangement of the library façade, and the consequent difficulty of finding easy delight in it, are reflections not of failed efforts, but of a deliberate attempt to transmit a belief against easy solutions or sensational effects in architecture.

It was not, so to speak, the architectural means of the visual language that he was questioning, but rather, the direct association between the means and the ends to which they might be put. Even where the compositional devices are the most successful, the difficulty of attaching an obvious justification to them makes it difficult to reduce the compositional moves to instrumental devices— facilitating movement, or clarifying purpose, or providing appropriate symbolic dignity. The logic behind them seems inexorably internal, perhaps even ineffable. As the reflective viewer attends to the intricacies of the plastic composition, and becomes aware of the problem of its perceptual intransigence to easy resolution, and as he tries to seek causal intentionality in this quality of form, this is the thought that confronts him—that the visual expression of the

building need not be explained as a means to achieve some functional or symbolic end, but can be its own justification.

Furthermore, it is, I think, not too much of a stretch to claim that the emotional impact of the building that is available to even the less attentive everyday visitor—the impression of a looming mass, and the uncompromising austerity that is registered so easily as aloofness and distance—is directly related to this thought. It is this look that gives the library, which functionally has the programmatically required quotidian familiarity of a department store, a counteracting weight in its public presence in the city even for the casual visitor, and it is the inscrutability of the compositional details that further bolsters this sense if such a visitor brings a contemplative engagement to bear upon it. Sufficiently informed and fully engaged, the reflective viewer is brought face-to-face not just with an institutional building that Breuer designed, but with the personal way in which he conceived of the world more broadly—a world in which public institutions acquire their seriousness not from reference to tradition but from an enigmatic presence created by the ineffability of their expressive forms.

RECONCILED MODES OF ATTENTION

This is, of course, only one way to understand Breuer's design for the library. Other approaches can be offered, particularly those that focus on the library as an institution, and on Breuer's approach to designing in urban situations. My intent, to remind my readers, was not to argue for this specific approach to interpretation, but to demonstrate its possibility, and the consequence of adopting a spectator-like stance before a building. Such a stance, as I have emphasized, can succeed if it is invested in a causal inquiry, and if it results in the reading of a specific conceptual content in the making of the building. From what I have demonstrated, three points emerge about the nature of aesthetic response to buildings.

First, insofar as specific conceptual content is present in a building, it is not depicted in the building, but rather embodied in the work that the building represents. What makes such content appear embodied in the work, and so available to an attentive observer, is the natural tendency of our visual system to organize what we see in a systematic, predictable way, and to see in such a phenomenal organization a causal intent. Both of these activities—to organize the scene, and to assign a causal intent to it—although volitional, are natural tendencies; once we put ourselves in an appropriate attentional mode, we find ourselves engaging in them as a matter of default, and require a force of will to prevent ourselves from doing so. Therefore, they lend themselves naturally to exogenous control; what can easily direct them, in other words, are the visual qualities of the artifact presented to us, and this allows the designer to control both the observer's visual apprehension of the building and to transmit specific intentionality through such moves. The only requirement for the observer in this situation is a willingness to engage, and to the extent possible, some prior knowledge of the history and context of the work.

The second point is regarding the nature of the engagement with the embodied thought. The spectator's engagement does not end with the understanding of the thought embodied in the building. Although I have been making a case for reading an embodied conceptual content in a building, I do want to emphasize that, ultimately, the aim of the building is not to convey some thought, much less to bring home a philosophical point, or even to invite the spectator to engage in philosophical speculation. Rather, the thought acts as a means to promote further perceptual engagement and to lend meaning to such exploration. Once we see in the visual form of the library the embodiment of the thought that the visual design is not to be understood as a means to a functional or symbolic end, this thought becomes the criterion with which to judge the efficacy of each move and of the final ensemble. In fact, the thought offers a conceptual framework that not only enriches the perceptual exploration of the building, but affects our perceptual engagement with other buildings as well.

This brings us, finally, back to the difference between everyday aesthetics and aesthetics involving special artifacts. I began by observing that the difference between the two was founded on the mode of reception toward their respective objects. But our study of the Atlanta library leads us to see that this may have been a bit too simplistic. The difference between the two stances is rather that the spectator-like stance is a much more complex affair, not one that is intended to end in either a judgment or in some kind of understanding. There is no particular end to it, and it is much better thought of as a relatively open-ended activity. As our description of the spectator's performance before the Atlanta library shows us, this activity involves a mix of specific tasks—there are tasks of purely perceptual scrutiny, of finding emergent figures and reconstructing the logic of the shape, and combined with them are the more cognitive tasks of finding associations, making comparisons, guessing at causes. In addition to these, there are the purely aesthetic tasks—noting whether proportions, sizes, and compositions look right, making discriminations, and judging appropriateness. These tasks all interact, of course, and in many cases, particularly the aesthetic ones, they are colored by emotional responses. But the point to note is that the aesthetic tasks involved in this activity do not seem to be different from what, in recent discussions, has been cast as the aesthetics of the everyday. These aesthetic responses are snap judgments; they are action oriented, in that they lead to choices about further scrutiny; and they seem to be carried out in a partially distracted state, while the spectator's attention may be focused on some other aspect of the broader engagement with the building.

What we seem to have, therefore, is not two distinct modes of aesthetic response, but a *single* one, of the kind exemplified in day-to-day activities, and which on relatively rare occasions is deployed as a crucial part of the complex activity that constitutes an engagement with a work of art. Such a theory sounds reasonable, if for no other reason than the simple fact that it offers an economy of explanation—one only need posit a single cognitive mechanism to explain our aesthetic response.

What is interesting is that, if this is true, then it is perhaps also possible to see that this generic aesthetic response comes into play not just as a part of the

activity of engaging with a work of art, but is directed at the entire activity itself. A spectator-like engagement with a building like the Atlanta library leaves us not only with individual judgments about specific aspects of the building's form, but also about the quality of our engagement with it—and this judgment is much more emotionally involved, potentially meaningful, and longer lasting because its subject is our own activity.[28]

In the end, then, this rather extended description of our engagement with a building has left us with a potentially unifying account of aesthetics. It is all quite speculative, of course, but perhaps opens the door for a more thorough analytical account of analytical aesthetics, and, because it is more basic and simpler, can be more easily grounded in accounts of human perception and vision.

NOTES

1 Yuriko Saito, *Everyday Aesthetics*, Oxford UP, 2007, 4–5.
2 Walter Benjamin, "The Work of Art in an Age of Mechanical Reproduction," *Illuminations*, ed. Hannah Arendt, NY: Schoken Books, 1968, 240. I have modified the translation in places to reflect more literally certain critical terms and specific turns of phrases, referring to the following text in the German version of the 1939 (third and last authorized) version of the paper. "Bauten werden auf doppelte Art rezipiert: durch Gebrauch und durch Wahrnehmung. Oder besser gesagt: taktil und optisch. Es gibt von solcher Rezeption keinen Begriff, wenn man sie sich nach Art der gesammelten vorstellt, wie sie z. B. Reisenden vor berühmten Bauten geläufig ist. Es besteht nämlich auf der taktilen Seite keinerlei Gegenstück zu dem, was auf der optischen die Konternplation ist. Die taktile Rezeption erfolgt nicht sowohl auf dem Wege der Aufmerksamkeit als auf dem der Gewohnheit. Der Architektur gegenüber bestimmt diese letztere weitgehend sogar die optische Rezeption. Auch sie findet von Hause aus viel weniger in einem gespannten Aufmerken als in einem beiläufigen Bemerken statt. Diese an der Architektur gebildete Rezeption hat aber unter gewissen Umständen kanonischen Wert." ("Das Kunstwerk im Zeitalter seiner technishen Reproduzierbarkeit," *Schriften*, ed. Theodor W. Adorno, vol. I, Frankfurt am Main: Suhrkamp, 1955, 366–405.)
3 Roger Scruton, *The Aesthetics of Architecture*, Princeton UP, 1979; among other recent writers articulating similar views on this point, Richard Hill, *Designs and Their Consequences*, Yale UP, 1999, and Edward Winters, *Aesthetics and Architecture*, London: Continuum, 2007.
4 This is essentially Scruton's argument: "The subject of a representational work of art is the subject of the thoughts of the man who sees or reads it with understanding ... We see too why we should want to distinguish the quite different kind of aesthetic interest in which attention to the work of art is *not* bound up with an interest in its subject ... And however much we may be persuaded that, in some cases, a *knowledge* of a 'subject' may be necessary to architectural understanding, it is hard to argue that architectural understanding can itself be a mode of *interest* in a subject." (*The Aesthetics of Architecture*, 186–7). Winters (*Aesthetics and Architecture*, 141–2) makes a similar argument by questioning the ability of buildings to represent a subject matter in a way that exploits the medium in order to bring out some essential aspect of the depicted subject matter.
5 Again, Scruton provides the most explicit instance of this position (*The Aesthetics of Architecture*, 5): "It is natural to suppose that representational arts, such as painting, drama, poetry, and sculpture, give rise to an interest unlike the interest aroused by such abstract arts as music and architecture. But it is also natural to suppose that music has expressive, sensuous, and dramatic powers in common with the representational arts. Only architecture seems to stand apart from them," thus leading him to conclude that, "in proposing an aesthetics of

architecture, the least one must be proposing is an aesthetics of everyday life. One has moved away from the realm of high art towards that of common practical wisdom." (17).

6 See, for instance, Alan White, *Attention*, Blackwell, 1964, for an attempt at clarifying the nature of attention and related concepts in a way that is sensitive to ordinary language use. For a critique of the conceptual confusion surrounding the term in neuroscience, see M. R. Bennett and P. M. S. Hacker, *History of Cognitive Neuroscience*, Chichester, England: Wiley-Blackwell, 2008, 44–74.

7 Arthur C. Danto, *The Transfiguration of the Commonplace*, Harvard UP, 1981. This point is elaborated later (see p. 67).

8 Very little has been published about the Atlanta Public Library. Of mentions in scholarly publications, the most reliable and complete is a one-page description in Isabelle Hyman, *Marcel Breuer, Architect: The Career and the Buildings*, NY: Henry N. Adams, 2001, 189. Critical notices in periodicals when the library was constructed include *Architectural Record* (March 1981): 83–7 and *AIA Journal* (May 1981): 192–7; the material in both of these publications is also found in a Breuer retrospective in *Process Architecture* 32 (Sept., 1982): 70–3. Most overviews of Marcel Breuer's work intended for a general audience skip mention of the library altogether. Robert Gatje, *Marcel Breuer: A Memoir* (NY: The Monacelli Press, 2001), provides a very useful description of the projects and other incidents, as well as the climate in Marcel Breuer & Associates (MBA) around the time the library was designed. The Atlanta Public Library itself has a rich collection of published and unpublished material related to its design and construction. Some useful material is also located in both Breuer archives, one in the Special Collections Department of the Syracuse University Library, and the other in the form of the *Marcel Breuer Papers*, 1920–1986, collected at the Smithsonian Institution's Archives of American Art. My account draws on all these sources, and from information provided very generously in personal conversations by Robert Gatje and Hamilton Smith.

9 Marcel Breuer, "The Atlanta Library Building," *The Georgia Engineer* XXXIV (Sept./Oct., 1976): 9–13. Breuer had already retired by this time, and it is very likely that the article was written at MBA and published under Breuer's byline. In the following, I'll use "Breuer" to mean Breuer and his team, only distinguishing Smith's work if there is specific evidence for it.

10 There is a larger reason behind my decision to treat the exterior design of the library as being autonomous. Buildings were not always thought of as single works, unified in both their interior and exterior. Even in buildings considered exemplary works of architecture, the relationship between interior and exterior is not always aesthetically significant—the Parthenon is an example that readily springs to mind, and conversely, there are several buildings (not just in the Islamic world), including well-known examples such as the Pantheon, where much of the exterior bears no aesthetic significance.

11 This is described in various handbooks on vision; my main reference is David Hubel, *Eye, Brain, and Vision*, NY: W. H. Freeman, 1995.

12 The term "frequency" refers to the frequency of regular sinusoidal waves that are the basis for representing information received and transmitted by the retina. The main theory here, drawn from linear systems analysis, is that any complex wave-form such as one produced by variation of light intensities (which is to all practical purposes what is received on the retina) can be completely described as a sum of several regular sine waves, each of which has a particular frequency, amplitude, and phase. Thus, a scene can be described with as much accuracy as is required by a set of sinusoidal wave-forms, such that the greater the number of component waves, the finer the detail that can be captured. Information from individual component wave-forms is filtered and transmitted in parallel through the visual system such that some channels transmit only low-frequency waves, some middle, and others high, which means that any scene before the eye is processed simultaneously in several independent takes of coarse and fine detail. The individual channels appear to be around two octaves in bandwidth (i.e. a range of frequencies in which the upper frequency is twice the size of the lower one), and range in frequency from one to a maximum of around sixty cycles for every degree of angle covered by our visual field. All this is described in comprehensive detail in Russel L. De Valois and Karen K. De Valois, *Spatial Vision*, Oxford UP, 1988. Also useful is

Arthur P. Ginsburg, "Spatial Filtering and Visual Form Perception," *Handbook of Perception and Human Performance*, eds. K. R. Boff, L. Kaufman, and J. P. Thomas, NY: John Wiley, 1986, 34.1–34.41.

13 De Valois and De Valios, *Spatial Vision*, 99–100.

14 J. Thurmond and G. Menzer, "Form Identification in Peripheral Vision," *Perception and Psychophysics* 8 (1970): 205–9.

15 Julian Hochberg, "Gestalt Theory and Its Legacy," *Perception and Cognition at the Century's End*, ed. Hochberg, San Diego: Academic Press, 1998, 252–307. See also Dov Sagi and Bela Julesz, "'Where' and 'What' in Vision," *Science* 228 (June 7, 1985): 1217–9.

16 This framework is largely drawn from Irvin Rock and Arien Mack, "Attention and Perceptual Organization," *Cognitive Approaches to Human Perception*, ed. Soledad Ballesteros, Hillsdale, NJ: Lawrence Erblaum, 1994, 36–7. The discussion in Hochberg's "Gestalt Theory," particularly section IV A, "The Behavior of Visual Inquiry" (279–81), supports this account as well. It is also important to remember that much of this discussion is focused on early vision; phenomena of visual organization are also produced by higher-level features such as reflectances or differences in tonality, but these are not immediately relevant to our discussion here.

17 Arien Mack and Irvin Rock, *Inattentional Blindness*, Cambridge: MIT Press, 2000, particularly 227–8; Mack and Rock are forceful in arguing that no perception can happen without attention, provided perception is limited to *conscious* perception, and not to an un-self-aware perception, which is logically necessary for exogenous direction of attention.

18 S. Palmer and I. Rock, "Rethinking Perceptual Organization: The Role of Uniform Connectedness," *Psychonomic Bulletin and Review* 1 (1994): 29–55.

19 J. E. Hoffman and B. Subramaniam, "Saccadic Eye Movements and Visual Selective Attention," *Perception and Psychophysics* 57 (1995): 787–95. See also E. Kowler, E. Anderson, B. Dosher, and E. Blaser, "The Role of Attention in the Programming of Saccades," *Vision Research* 35 (1995): 1897–916.

20 An interesting complication, here, is the case of the well-habituated user, or inhabitant, who can navigate the building without consciously attending to it; there is much argument within the literature on perception about whether such a person has conscious awareness of the building—after all, she must be attending to some aspect of the building, given that she successfully navigates it. Many observers dissociate attention from consciousness to account for this, and at least one has claimed that there is a background consciousness at work here (S. Iwasaki, "Spatial Attention and Two Modes of Visual Consciousness," *Cognition*, 49 (1993): 211–33); but what is important to our case here is that even if this is the case, the background consciousness works largely with low frequency, coarsely detailed, peripheral vision. Such a visitor might have some aesthetic response to the environment in her background consciousness, but it is not one that will require any attentive recognition of, let alone discernment of what is seen.

21 A crucial point to bear in mind here—and this will become even more evident as we describe the visual functioning of the building in further detail a bit later—is that the kind of concern that underlies the architect's design efforts, and the kind of scrutiny that is expected, both have an aesthetic foundation. The decisions that are of concern here are not related to the day-to-day use of the building, or to its structural or environmental performance—they fall squarely under the purview of aesthetics.

22 This is a major theme in Danto's writing, and best articulated in *The Transfiguration of the Commonplace*. Danto's main point, which I find persuasive, is that a work of art is distinguished from a mere object not because of any distinguishing physical or perceptual characteristics, but in how it is read. Although this position seems to lead to relativism, Danto takes care to point out that, first, the reading has to meet certain structural criteria (addressing rhetoric, style, and expression; 165–208) and, second, such readings can only emerge in a particular context of ideas and practices—arguments that seem to me to preclude anyone from unilaterally declaring any object a work of art. In the context of this essay, the argument is that the criteria require an attentive, spectator-like viewer, and that shift in the mode of

attention will lead to the transfiguration of a day-to-day object like a building into a work of art.

23 Ginsberg, "Spatial Filtering and Visual Form Perception," 34. 17–34. 24.

24 Rudolf Arnheim, "On Late Style," in *New Essays on the Psychology of Art*, Los Angeles: California UP, 1896, 285–96, provides a good summary of some characteristics of late style.

25 For Breuer's skepticism, or at least an ironical attitude, see the description of the day-to-day functioning of Breuer's office, and references to Breuer's mood in Gatje's *Marcel Breuer*, particularly pages 242–9.

26 A telling example of such a program of visual education can be seen in György Kepes, *Language of Vision*, Chicago: P. Theobald, 1944. See, for instance, page 13, "The language of vision, optical communication, is one of the strongest potential means both to reunite man and his knowledge and to re-form man into an integrated being. The visual language is capable of disseminating knowledge more effectively than almost any other vehicle of communication. With it man can express and relay his experience in object form. ... But the language of vision has a more subtle, and to a certain extent, an even more important contemporary task. To perceive a visual image implies the beholder's participation in a process of organization. The experience of image is thus a creative act of integration." Kepes, a Bauhaus graduate like Breuer, was one of the small group of European émigrés in the U.S. who were to prove influential in mid-twentieth century design education, and with whom Breuer had close professional and personal ties.

27 An instructive instance of Breuer's shifting concerns can be found in the sequence of talks he gave in the late sixties. In April 1966, in a piece for *The Architectural Record* titled "The Faceted, Molded, Façade: Depth, Sun and Shadow," he sounds enthusiastic about the potential of visual expression through sculptural form: "What about aesthetics? A new depth of façade is emerging; a three dimensionality with a resulting greatly expanded vocabulary of architectural expression." By 1968, in his address on receiving the AIA Gold Medal, with the fiasco of the Union Station Project still fresh, he was more circumspect: "Mesa Verde's cubistic cave towns are great sculptural compositions; they have also been amongst the most inhuman fortifications ever conceived by man. The aesthetic quality of architecture is of the first order, but not sufficient for a total justification." He finished the talk not by extolling the possibilities of the visual, but with a request that "the limitless dominion of the eye should be balanced." These writings and talks are published in Adrian Papachristou, *Marcel Breuer: New Buildings and Projects 1960–70*, Praeger, 1970, 11–23.

28 It is perhaps the experience of this judgment on our own activity of contemplative engagement with works of art that appears to us to have the character of what John Dewey calls a consummated or fulfilled experience, which is discussed in this volume by Mark Johnson (Chapter 3, "Dewey's Big Idea for Aesthetics", pp. 37–38).

from buildings to architecture

construing nelson goodman's aesthetics

remei capdevila-werning

Buildings are ubiquitous in our everyday lives: we inhabit and use them for practical purposes, and most of us are constantly exposed to the built environment, both urban and rural. Our relationship with buildings, however, is not only practical, but also cognitive. We are constantly learning what buildings mean and symbolize: palaces, parliaments, and city halls refer to certain political systems; temples, churches, synagogues, and mosques stand for different religions; museums, hospitals, jails, schools, and universities refer to cultural and social structures; factories, warehouses, markets, banks, and malls point to certain economic systems; apartments, housing tracts, townhouses, mansions, huts, and tents reflect various ways of life. Apart from these social, cultural, and historical meanings, we appreciate the artistic features of buildings, we judge and evaluate them, and we also learn about ourselves when interacting with them. Our aesthetic and cognitive experience may involve any kind of building, from the simplest warehouse to the most sophisticated museum. How do buildings function cognitively? How is it possible that one and the same building can be considered simply as a building, as a construction with social or historical meaning, and also as a work of architecture or art that we experience aesthetically? How and what can we learn from buildings? How can buildings mean? How do buildings contribute to the advancement of understanding?

These questions can be answered by considering that, as Nelson Goodman suggests, buildings are symbols.[1] As such, buildings convey meaning and bear interpretation. Symbols belong to symbol systems and, to understand them, one needs to know the system's features. Aesthetic experience of the built environment consists mainly of interpreting buildings as symbols, and is a dynamic process that "involves making delicate discriminations and discerning subtle relationships."[2] Thus, aesthetic experience is a primarily cognitive endeavor and, for that reason, aesthetics is a branch of epistemology, which focuses on the broader field of understanding rather than on only propositional knowledge.[3]

This theoretical framework, based on the consideration that buildings are symbols, accounts for the cognitive aspects of architecture and of any object in general, and has both epistemological and metaphysical consequences. Aesthetic experience is not limited to art; rather, anything is suitable to function as an artistic symbol, including all the artifacts we encounter in our everyday lives: anything can potentially function as a symbol, and consequently be meaningful, and contribute to understanding in a unique way with the same relevance as the understanding conveyed by the natural and social sciences and the arts. The ontological counterpart to this epistemological stance is that, if any object can be a symbol, it is possible to explain why anything can be considered as art without the consent of the institution, and it is also possible to explain why the distinction between high and low no longer carries great weight. In the wake of post-structural critiques, an account like Goodman's provides an explanation of the complexity inherent in buildings that does not return to essentialism and its single and narrow understanding of the built environment, but instead accounts for the plurality of meanings and interpretations and grants the

interpreter a key role in the process of unveiling and creating meaning without falling into a total relativism. In a certain sense, Goodman's philosophy can be described as a "precise map of common-sense … that shows us things common sense could never have seen by itself," and in that way explains also how our everyday cognitive interactions work.[4]

To explain how buildings function cognitively and to discuss the consequences of this assumption, I will first address the conception that buildings are symbols, and the ways in which buildings symbolize and mean; second, I will comment on the aesthetic experience of architecture; and third, I will examine the interpretative and evaluative processes that take place when aesthetically experiencing buildings. In this way, I hope to show the constitutive cognitive aspect of buildings and their role within understanding in general, as well as explaining how any building can potentially function as an artistic symbol and be aesthetically appreciated, how any building can become architecture.

BUILDINGS AS SYMBOLS

Buildings have the practical function of sheltering human activities, and they serve as symbols when they refer to or stand for something else, conveying meaning.[5] There is a difference between using a building and aesthetically appreciating one: when we use it, we focus on the building's functional features; when we experience it aesthetically, we focus on its artistic qualities. This is not to say that the building's practical features do not influence our aesthetic appreciation of a building, but rather, that we may approach buildings in different ways: we can use them and we can also consider them as works of art or architecture. This does not mean, either, that architectural works lack practical functions, but that, in addition to these, works of architecture function aesthetically. So, when a construction is considered as art, it is architecture; otherwise, it is simply a building. The very same construction can sometimes be considered a building and sometimes a work of architecture. Saltbox houses, the earliest New England homes, have a primary function of providing shelter, and now they are also considered artistic examples of American colonial architecture; much the same has happened to the *masies*, the typical Catalan country houses. This shift also implies that potentially any building can be architecture, and that potentially any object can function as a work of art or, in other words, that art may be everywhere. Hence, the status of art or architecture does not need to be permanent but, rather, this status is relative to the functions it performs as a symbol at a given time. Therefore, it makes no sense to search for an essence that would distinguish simple buildings from architecture, for one and the same building can function as both. Thus, it is inappropriate to ask "*What* is architecture?" One should ask, instead, "*When* is architecture?"[6] The answer is a functional one:

> Just as an object may be a symbol … at certain times and under certain circumstances and not at others, so an object may be a work of art at some

times and not at others. Indeed, just by virtue of functioning as a symbol in a certain way does an object become, while so functioning, a work of art.[7]

Here is the key notion of Goodman's philosophy: a work of art or architecture is a symbol with particular characteristics. As a symbol it bears interpretation, and the symbol's meanings are brought to light by interpreters. There are many kinds of symbols, but an object is an artistic symbol only when its functioning fulfills certain conditions. A building may just be a building that does not symbolize at all; it can also be a symbol but not necessarily an aesthetic symbol. Buildings can symbolize social values, personal incidents, and cultural and historical episodes, but this symbolic functioning is not aesthetic. To function as an aesthetic symbol (i.e. to be a work of architecture), a building has to be a symbol of a certain sort, symbolizing in determinate ways that differ from other non-aesthetic symbols. Symbolization is aesthetic when it is based on the building's artistic properties: a skyscraper aesthetically symbolizes its structure, the color, temperature, and texture of the cladding, the transparency of the glass windows, its verticality and grandiosity, and it may also symbolize abstract properties, such as being imposing or daring.

The aesthetic functioning of buildings can be defined as follows: "[A] building is a work of art only insofar as it signifies, means, refers, symbolizes in some way."[8] Architecture is thus placed in a cognitive context and, to the extent that it functions cognitively, what we learn from buildings may be a relevant and unique contribution to understanding, irreducible to other ways of comprehension. Let me show how. Take three different ways to symbolize proportion: a building, a musical piece, and a mathematical formula. Palladio's Villa Rotunda symbolizes harmonic proportions, for the size of the rooms and the relationships of the porticoes to the other elements of the composition correspond to the proportions established by harmonic intervals.[9] These harmonic proportions can be mathematically represented as follows: 1:1, 1:2, 2:3, 3:4, 4:5, 5:6, etc. The ground floor of Villa Rotunda is a square that corresponds to a proportion of 1:1; the sizes of the rectangular rooms at each corner correspond to a proportion of 2:1 (two double squares); the smaller rectangular rooms adjacent to the larger rooms correspond to a proportion of 3:4 (a square plus a third). Musical intervals also correspond to these proportions: unison is produced when making two strings of the same length vibrate (1:1), the octave is produced by two strings in which one is twice as long as the other (2:1), and a perfect fourth (the chord of C and F, for instance) sounds when the relationship between the two strings is 3:4. All three—architecture, music, and mathematics—symbolize in different ways, and each provides a unique understanding of harmonic proportion. Architecture provides a spatial comprehension of proportion, music an acoustic one, and math an arithmetical one. Most importantly, these ways of understanding are not interchangeable; something would be lost in the translation.

How do buildings convey their meanings? Works of architecture and, in general, any symbol, do not function in an isolated way, but within symbol systems with specific features.[10] To understand what they mean or symbolize,

one needs to interpret them in relation to the system to which they belong. We are constantly learning how symbol systems work. Take, for example, a traffic light, which is a symbol within a basic symbol system: green symbolizes "go," and red, "stop," as established by the system's features. But green can also refer to "envy" and red to "embarrassment" within a system that associates colors with moods. We need to know the system to interpret these colors properly. The same happens with buildings: they may belong to one or more symbol systems, which are generally more complex than the color systems just discussed. So, Frank Gehry's Stata Center at the Massachusetts Institute of Technology symbolizes an academic building within a system that classifies buildings according to the activities they shelter; it symbolizes a green building within a system that categorizes environmentally friendly buildings; and within artistic symbol systems, it refers to certain forms, materials, an architectural style, and many more abstract features, such as creativity and exploding ideas. Interpretation of a building's meaning is a more intricate process because, first, a building can function within several systems and, second, because artistic systems are not as straightforward as other systems. An artistic symbol system is usually ambiguous and vague, which means that there is no unique correlation between symbol (or some of its parts) and meaning, but that multiple connections are possible. The more we know, the more dimensions of a building's meaning we can recognize: Works of art and architecture are like samples of the sea, which are different every time they are taken; one never knows what will be found in them.[11] Hence, works of architecture are open to a continuous process of interpretation and of revealing meanings. The great works are precisely those that can be permanently reinterpreted and whose meanings are never conclusive. The interpreter has the creative task of bringing to light all of these potential meanings, which are not uniquely determined by the architect or the creator, and thus we are constantly learning and understanding.

Within a symbol system, buildings (and symbols in general) refer in various ways or modes. With relatively few modes, all possible meanings can be conveyed. The following explanation of the ways of referring and the further architectural examples show the manners in which buildings mean. The main modes of reference are denotation and exemplification. The other modes— expression and indirect modes of reference—are combinations of these two. Denotation is the relation between a label and what it labels.[12] A name denotes its bearer; a predicate denotes the objects of its extension; a picture denotes what it represents (if it represents at all); a passage denotes what it describes. "Taj Mahal" denotes a building; "building" denotes several objects; Monet's paintings of the Cathedral of Rouen denote the Cathedral of Rouen; certain passages of Thoreau's *Walden* denote the hut next to Walden Pond. There are relatively few cases of buildings that denote, the most common being buildings representing other buildings (i.e. copies and reproductions, such as the Parthenon in Nashville and the various Eiffel Towers spread around the world), and buildings representing certain objects (for example, the Sydney Opera House depicting a group of sails, and buildings depicting the food sold within them, such as donuts or apples).

On the other hand, exemplification runs in the opposite direction of denotation, from what is denoted to that which denotes. A symbol exemplifies when it both instantiates and refers to some of its possessed properties. Hence, exemplification requires possession plus reference.[13] However, a symbol that exemplifies makes reference to only some of the properties that it actually possesses, but not to all of them; exemplification is selective. A swatch of cloth possesses multiple properties, but it only symbolizes some of them: it exemplifies texture and color, but not size.[14] A model house usually exemplifies the number of bedrooms and bathrooms, the house's distribution, the size, and the construction materials, but not its placement, accessories, or wall color. Buildings may exemplify any of the properties they possess, depending on the symbol system to which they belong. They may exemplify form (roofs exemplify triangles, pyramids and obelisks their respective shapes, and high-rise buildings verticality), structure (like the John Hancock Tower in Chicago or the Eiffel Tower), construction elements (like the Centre Pompidou in Paris, which exemplifies the service elements), materials (wood, iron, glass, steel, brick, stone, and their corresponding properties are exemplified by many buildings) and function (buildings representing ice cream, hot dogs, burgers, donuts, clam boxes, or milk bottles usually exemplify their function of selling these foods; here, exemplification is achieved through a prior denotation of these objects).

One architectural way of making these features stand out and facilitate exemplification is articulation, which can be defined as some sort of joint that structures design elements in a construction.[15] The purpose of articulation is to bring together the several parts of a building into a whole and, at the same time, make each of these parts stand out. In the Hancock Tower, for example, the structure is articulated by being placed in the building's exterior and covered with a cladding so it stands out in contrast with the glass walls. This articulation further enables exemplification of the structure. However, although articulation may contribute to exemplification, it is neither necessary nor sufficient for symbolizing. Many exemplified features (such as being an academic building or being an original or groundbreaking one) do not require articulation and, on the other hand, the mere presence of articulation does not assure exemplification (the emergency exits of a building are clearly articulated, but not referred to by the building).

Denotation and exemplification can be both literal and metaphorical. Metaphorical properties, like literal ones, are actually possessed by the symbol and thus can be exemplified.[16] So, the Stata Center metaphorically exemplifies being a green building, for it is environmentally friendly, but it does not literally exemplify being green, because it is not that color. When metaphorical exemplification occurs within aesthetic systems, it is termed expression.[17] As architectural works, the Stata Center may express exploding ideas, the Hancock Tower an imposing presence, and a bank a sinister nature.

Finally, there are complex and indirect modes of reference, such as allusion, variation, and style. A building alludes to another when it refers to it at a distance, via a chain of reference composed by denotation and exemplification. For example, the Pantheon in Paris alludes to the one in Rome.[18] Variation

upon a theme is a typical mode of reference in music and consists of referring to another piece (a theme) by symbolizing certain features of the piece while altering others.[19] Again, the Pantheon in Paris may be considered a variation of the one in Rome. Even though allusion and variation are distinct modes of reference, whether a building is referring in one way or another is a matter of interpretation. One has to interpret whether the Pantheon in Paris is alluding to or is a variation of the one in Rome. Style can be considered a mode of reference inasmuch as there is a series of exemplified or otherwise symbolized properties which all together refer to a certain author, school, period, or region.[20] A museum may refer to the architect's style, a church may symbolize Romanesque style, and a house may symbolize the vernacular style of a region.

All of these modes of reference are central in the process of creating meaning. When new features are symbolized, or known features are symbolized in a new way, our understanding is enhanced and reconfigured. So, the Vanna Venturi House puts on display the conventionality of architecture's elements and by this symbolization our understanding of architectural forms is enhanced; and when the Villa Rotunda refers to harmonic proportion in a spatial way, we gain a three-dimensional comprehension of a mathematical and audible relationship: the notion of proportion is reconfigured.

To answer the questions posed earlier, buildings can be simple constructions and also works of architecture because they are symbols. Also because they are symbols, buildings can function cognitively and convey meaning. From buildings and what they symbolize we acquire a particular comprehension of the world, of ourselves, and also of abstract notions, which is irreducible to other kinds of knowledge. This comprehension contributes to the advancement of understanding in a unique way. Buildings mean when they are inserted in symbol systems, and they mean by referring in various ways. All these meanings are brought to light when interpreting and aesthetically experiencing a building.

AESTHETIC EXPERIENCE OF ARCHITECTURE

Aesthetic experience is a dynamic and cognitive process. Aesthetic attitude is not a state of passive contemplation wherein an object is aesthetically perceived, but rather an active process wherein the appreciator interacts with an object, looking for meanings and contrasting it with her previous experiences and knowledge. That aesthetic experience is cognitive does not mean that feelings and emotions are excluded, or that this experience cannot be pleasant or unpleasant. It means that emotions and feelings are already cognitive and they are central for aesthetic experience insofar as they contribute to the advancement of understanding.[21] When aesthetically experiencing a work, emotions and feelings, like our senses, serve to discern the work's symbolic functioning. Whereas through the senses we perceive certain qualities of a building, the feelings it awakens (when looking up the edge of a skyscraper from one of its corners, or experiencing a sense of oppression in a small crypt, for example) can help us to distinguish certain features of the building that we otherwise

would not experience. These emotions do not function independently from the rest of our cognitive and sensorial faculties, but are one element among the many others engaged in aesthetic experience. As Goodman says, "emotion and cognition are interdependent: feeling without understanding is blind, and understanding without feeling is empty."[22] If we could not retain what we feel when entering a small, dark crypt, this emotion would be useless; with no emotion, there is nothing to retain. This does not mean, however, that emotions are being intellectualized, but rather that cognition is being sensitized.[23] Most importantly, through these feelings and emotions we learn something about the building and its cultural, social, and physical context as well as something about ourselves that we could not have learned in other ways. The understanding conveyed through emotions does not fully translate into propositional knowledge: what one actually feels inside a crypt is not the same as describing what one feels inside a crypt with words. Through the aesthetic experience of buildings and of any other object, a particular kind of understanding is conveyed that could not be achieved otherwise.

Aesthetic experience of architecture presents some particularities that need to be discussed, bearing in mind, however, that there are several exceptions.[24] First of all, architecture is a public and quotidian art, and hence we perceive and experience it in our collective everyday life. Buildings impose themselves and cannot be ignored: we can decide whether to go to a museum, but we cannot keep our eyes closed in front of our primarily built environment. Hence our experience of architecture, or at least our contact with buildings, remains constant. The experience of a building generally starts with the perception of the work (although it can also begin with an image, a description, or a plan). While in other arts one sense generally prevails over the rest (vision in visual arts, hearing in music), architecture can be experienced and perceived through all the senses interacting with each other. Perception of architecture is multisensory and corporeal in that we interact with our entire body while appreciating the building: Through vision, we perceive form and space; through hearing, the acoustics of a building; through touch, smell, and even taste, we perceive temperature, humidity, and qualities of the constructing materials. That our experience is kinesthetic is also clear if we consider that all our senses are conditioned by our body and movements. To see something, we have to move our head, and our perspective is constantly changing when moving; furthermore, at a more primary level, our perception depends on our particular physical features, such as our size and the speed at which we move.[25]

Moreover, there is a difference in size between an architectural work and the appreciator, which determines the perception of the work. While paintings are generally experienced as a whole, a building cannot usually be perceived at once (which is the case also with monumental sculpture and other oversized works).[26] We perceive a building as surrounding us or, conversely, we perceive the building by surrounding it. Our perception of an architectural work is thus a necessarily temporal and sequential experience. We perceive interior and exterior, front, back, and lateral façades, the several floors. All of these perceptions become unified, creating a whole that we have actually never

perceived as such. Hence, perception is already a construction. There is no pure perception, but a cognitive construction created from prior perceptions. That this perception is cognitive is clear if one considers that it is also influenced by prior knowledge. Our perception of a building may be shaped by specific knowledge provided by plans, models, projections, drawings, photographs, aerial views, virtual walks, and so on. These prior conceptions and knowledge of all kinds, as well as experiences of other works, can help us to distinguish formal features or details of the work. Familiarity with architectural styles, for example, can help us to recognize an arch as Romanesque or Gothic, and in that way predetermine our perception of the building. Thus, cognitive processes permanently intervene in perception.

The building's site or location also shapes our aesthetic experience, for architecture is generally site specific.[27] Apart from mobile homes, tents, and other transportable structures, buildings are bound to a site both physically and culturally. Hence, when approaching a building its surroundings should be taken into account as a factor that can modify or complement our experience as well as the building's meaning. By comparing a specific building with the adjacent buildings, we can establish size relations: for example, we can realize whether it is well proportioned to the other buildings, and whether it fits in where it is built. In some cases, the site may become a constitutive element of the building, as in Frank Lloyd Wright's Fallingwater. The cultural environment may play a role, too, in our appreciation of a building, for some aspects may be pointed out and others minimized depending on the cultural context. The four remaining Corinthian columns of the Temple of Augustus in Barcelona (first century BC) are not surrounded by other Roman relics, but are inside the patio of a Gothic house. Thus, they are not perceived as part of a temple in the middle of the old Roman Barcino, but rather as a structural part of the later house placed just behind the cathedral of Barcelona, providing us with an insight into how Roman remains were appreciated in medieval times. The columns were rediscovered in 1835, when they were again appreciated as artistic artifacts, and therefore isolated from the building's structure and displayed to the public. The cultural environment influences our appreciation of the columns and, in that way, enhances and alters both appreciation and meaning.

Finally, the building's practical function may prevail over its aesthetic one. As said, that buildings can be aesthetically appreciated does not mean that they lose their practical function. On the contrary, the elements of a building that are determined by its function may be key when aesthetically experiencing it. The difference is one of change in attitude rather than a change in the building itself. Architecture is present in everyday life, and our interaction with buildings is almost permanent. We occupy and use them for many purposes that usually have nothing to do with aesthetics. To perceive a building aesthetically requires a certain detachment from its practical function, though this practical function can influence its aesthetic functioning.[28] A person working in the Seagram Building in New York probably only perceives this skyscraper as her office space and pays attention to the practical features that influence her work: she

knows whether the heating system is too strong in the winter and the air conditioning too weak in the summer, she knows which elevator is faster, and she complains that the window blinds only have three positions—fully open, halfway open, and fully closed—which makes it quite difficult to control the amount of natural light in the office room. Only by detaching herself from her everyday experience of the Seagram Building is she able to aesthetically appreciate it. In doing so, the building's structural elements become visible and, hung on them, she sees glass curtain walls with no structural function; the window blinds' three positions, annoying when working, are now understood as a way to achieve a regular pattern in the façade and avoid the appearance of disorganization that would result from employees drawing the blinds to different heights. Thus, the building's practical function may influence its aesthetic function and the aesthetic function may influence its practical function. The possibility of distinguishing our everyday experience of a building from our aesthetic experience is what enables one and the same building to be considered both a simple building and an architectural work.

INTERPRETATION AND EVALUATION OF BUILDINGS

If, as stated, any building can potentially function as a symbol, particularly as an aesthetic symbol, and hence be architecture, and if, as symbols, buildings are open to multiple interpretations, are there any criteria to discern between right and wrong interpretations? How do we judge and evaluate the building's aesthetic features? How do we assess the cognitive functioning of buildings? These issues are crucial to further determine the contribution of architecture to understanding in general and to avoid a radical absolutism as well as a radical relativism. On the one hand, as the examples have shown, there is not only one correct interpretation of a given building.[29] The creator's interpretation is not privileged, but one among many possible interpretations. The same is valid for the expert's interpretations. On the other hand, even though a building remains open to multiple interpretations, it is not the case that anything goes. A church may symbolize a certain style, materials, and devotion, but it does not stand for atheism, no matter how hard we try. Interpretations cannot be extraneous to the building; they must align with the building's symbolic functioning.[30]

Instead of total absolutism and total relativism, buildings can be evaluated within the framework of a constructive relativism.[31] Symbols are open to an indefinite number of interpretations, but there is a criterion for discerning between right and wrong ones: interpretations have to be tenable once compared to the symbol's features. Interpretation is then a matter of fit, "of some sort of good fit—fit of the parts together and of the whole to context and background," as Goodman says.[32] There are no true or false interpretations, but rather, right or wrong, adequate or inadequate to the work's symbolic functioning, for the meaning conveyed by works of art is part of the broader context of understanding and not limited to propositional knowledge. Whereas knowledge is conveyed only by propositions (i.e. verbal statements),

understanding also comprises nonverbal meaning, which is provided by nonverbal symbol systems. Knowledge is limited to literal truth or falsity, but understanding also comprises that which admits no truth value, such as works of art and architecture. Both the rightness of a work and our interpretations of it are measured according its "fitness" or "aptness," and not their truth value.[33] So, we can interpret the Sydney Opera House as resembling a group of white sails, a cluster of shells, seagulls' opened wings, or even an old man's messy hair on a windy day; all of these interpretations can be sustained and considered right once juxtaposed to the building's symbolic functioning. But it would be very difficult to maintain that it is right that the Sydney Opera House resembles a ripe red tomato, for its symbolic features do not allow us to interpret it as such, or, more specifically, a very complex interpretative process would be required to present a convincing construal of the Sydney Opera House as a ripe red tomato.

A building considered as an artistic symbol requires interpretation, and this implies also that it can always be misinterpreted. However, misinterpretations can be disregarded as soon as they are compared to the work's functioning as symbol. Interpretations are relative to the symbol. To affirm that the criterion of rightness of an interpretation is the symbol itself and that there can be multiple correct interpretations of the same work implies that there are no external reasons to privilege certain interpreters above others. The social, historical, or cultural causes that prompted certain interpretations are in themselves irrelevant for establishing the rightness of each interpretation. Feminist or postcolonial interpretations of a work are not right or wrong because they are feminist or postcolonial, nor superior or inferior to others because they have a certain origin; being interpretations of a certain kind does not invalidate or validate them. Rather, some interpretations are adequate to a work—and thus, privileged—and others are not, based on the work's symbolic functioning. This entails also that anybody who contributes to the advancement of understanding through novel insights of a work may be a proper interpreter. The task of unveiling and creating meaning is not exclusive to experts but is open to everyone and, moreover, this process may take place at any time and in any context, which includes also our everyday life.

Apart from the adequacy of an interpretation, we judge and evaluate buildings. There are buildings that symbolize in a proper way and others that do not. In familiar language, some works are better or worse than others. How can we determine this? There are some indications that may help to determine the adequacy of architecture's symbolization within a broader conception of rightness, which includes "standards of acceptability that sometimes supplement or even compete with truth where it applies, or replace truth for nondeclarative renderings," in Goodman's words.[34] Works of art and architecture are not true or false; rather, their symbolization is fair or unfair, right or wrong, depending on how they symbolize within a given context. In the framework of constructivist relativism, where there is no last reality that serves to contrast the rightness of interpretations and further meanings, the only way to assess the buildings' cognitive functioning is by a series of tentative indications, which serve as clues,

and not definitive criteria. These indications serve also to evaluate the contribution of architecture to the advancement of understanding.

First of all, buildings may rightly symbolize when they enable projectibility and extrapolation, as happens with a model house that perfectly refers to the features that are to be found in the houses built based on the model. Secondly, buildings rightly symbolize when they are representative, when they contain and symbolize a series of features that make them a good exemplar of a certain style or conception. Thus, Le Corbusier's Villa Savoye is a right symbol in this sense, because it clearly shows his five points of architecture, which are the basis of his formulation of architectural modernism and are found in many of his other works. Some of his other buildings, such as Villa Stein, certainly contain and are built following these points, but do not refer to them is such a proper way. There are hence degrees of rightness. Thirdly, buildings may rightly symbolize when they refer to features that had previously only been possessed and not referred to. This is the case of the Centre Georges Pompidou in Paris through its symbolizing of the building's service elements. Fourthly, buildings rightly symbolize when they refer to features in a new way or through innovative articulations. Such is the case of the addition of Harvard's Science Center, which employs a series of glass channels and windows in its façade. Because this façade is translucent and the windows transparent, light penetrates it in different ways throughout the day, and thus the different qualities of the glass (transparency, translucency, and opacity) are symbolized. Finally, buildings rightly symbolize when the features to which they refer contribute to the advancement of understanding. This is what happens at Le Corbusier's Carpenter Center at Harvard University or la Maison du Brésil in the Cité Université in Paris, whose windows symbolize musical rhythm through a visible and not audible structure, or Palladio's Villa Rotonda, which symbolizes harmonic proportions. In these cases, rhythm and proportion are symbolized spatially in a way that contributes to a better comprehension of these concepts.

Novelty, originality, and innovation seem to be relevant criteria when evaluating the rightness of a building's symbolization and the subsequent advancement of understanding. Fallingwater incorporates a waterfall in its construction, thus including site in the building and establishing reference to it. The Centre Georges Pompidou is one of the first buildings to symbolize utilities (ventilation, heating, electricity pipes) by making the building "inside out." Today, if a building were to incorporate a waterfall or articulate the utility elements, it would still symbolize them. However, this symbolization would not be as successful or appropriate, for it would not be groundbreaking, it would certainly refer to features that previously had only been possessed, but it would not contribute to the reconfiguration or advancement of understanding.

If, as said, articulation may contribute to the symbolization of certain features of the building, then it needs to be considered, too, when determining the rightness of architectural works. Firstly, articulation is right when it contributes to the correct symbolization of a certain property. This contribution may vary depending on the property and on the building. In some cases, such as in the symbolization of the structure of the Hancock Tower, the symbolized property

is rightly articulated when it is clear and distinguishable from the rest of the building, making reference to it possible. In other cases, such as the symbolization of curvature and smoothness at the Guggenheim Museum in Bilbao, the symbolized property is rightly articulated when the joints are continuous. In contrast, curvature would be wrongly articulated in buildings whose joints break the curves. Second, novelty, originality, or innovation seem also to be relevant factors when evaluating articulation. The ways in which glass is treated or articulated at Harvard's Science Center are appropriate for making those features stand out, and at the same time they are original and innovative. Finally, the success of a certain architectural articulation lies in the detail and accuracy of the construction. Two buildings may exemplify the same feature and one may be more successful than the other in symbolizing it, because one articulation—or rather, the elements that constitute the articulation, such as the materials, the finishing, or the details—is better built and designed than the other.

Thus, rightness, fairness, success, and adequacy of symbols depend on their context and on their interpretation. Broadly, we can distinguish between two sets of criteria. On the one hand, there are those buildings (such as model houses) that are fair when, first, they clearly and properly symbolize the features possessed by pointing them out and making us focus on them. Second, buildings rightly symbolize when they are accurate and enable a proper projectibility and extrapolation to other instances (such as Le Corbusier's Villa Savoye). These aspects are closely related to the third point: buildings rightly symbolize when they are representative or exemplary of a certain style, author, or period. On the other hand, there are those buildings (such as the Centre Pompidou or Fallingwater) that are successful when they include novel features or refer to features that had previously only been possessed; this new symbolization provokes a reselection and advancement of our understanding, because a domain has been reconfigured. In those cases, obvious properties are illuminated or unexpected features are brought to light and, either way, these properties can be extrapolated. In addition, since symbols are subject to constant interpretation and they permit multiple right interpretations, the rightness of a symbolizing building is constantly tested. There is not a permanent and established truth, but rather a process of comprehension and understanding whose correctness is provisional.

CONCLUSION

All of these indications help us in judging and evaluating the rightness of a building's symbolization, its meanings, and our interpretations of it. For this reason we do not fall into a total relativism, where anything is allowed, nor into a total skepticism, where there are no evaluating criteria. Rather, these general indications suffice for determining rightness within a pluralistic framework, where many possible interpretations and meanings may be equally right. Interpretation of an architectural work occurs while aesthetically

experiencing the building. Aesthetic experience is mainly a cognitive endeavor that brings to light the building's meanings. The interpreters carry out this continuous process of creating and unveiling meaning and, while doing so, they also learn about themselves. Through buildings, we gain a unique comprehension. Buildings convey meaning and can be interpreted because they are symbols. They symbolize in many ways and their meanings depend on the symbol systems to which they belong. Because they are symbols, it is clear why buildings are sometimes architecture, why sometimes they function as other kinds of symbols, and why they are also simple constructions, without entering into essentialist quarrels. Not only may buildings become architecture, but anything suitable of being aesthetically appreciated may become art. Thus, any object we encounter in our everyday life may become an aesthetic symbol. As such, it functions cognitively and is open to a never-ending and open-ended process of construing and constructing meaning, and it contributes distinctively to the advancement of understanding.[35]

NOTES

1 Nelson Goodman, "How Buildings Mean," in Nelson Goodman and Catherine Z. Elgin, *Reconceptions in Philosophy and Other Arts and Sciences*, Indianapolis: Hackett, 1988, 31–48.
2 Nelson Goodman, *Languages of Art: An Approach to a Theory of Symbols*, Indianapolis: Hackett, 1968, 241.
3 Nelson Goodman, *Ways of Worldmaking*, Indianapolis: Hackett, 1978, 102.
4 Mitchell, W.J.T, "Review: How Good Is Nelson Goodman? Reviewed Work(s): *Of Mind and Other Matters* by Nelson Goodman," *Poetics Today* 7 (1986): 111-5; 113.
5 Goodman explains, "'Reference' as I use it is a very general and primitive term, covering all sorts of symbolization, all cases of *standing for*." Nelson Goodman, *Of Mind and Other Matters*, Cambridge: Harvard UP, 1984, 55.
6 Nelson Goodman, "When Is Art?" *Ways of Worldmaking*, 57–70.
7 Ibid., 67.
8 Goodman, "How Buildings Mean," 33.
9 For a detailed discussion of harmonic proportions in Palladio's work (his writings as well his buildings) see Rudolf Wittkower, "Principles of Palladio's Architecture," *Journal of the Warburg and Courtauld Institutes* 7 (1944): 102–22; Rudolf Wittkower, "Principles of Palladio's Architecture II," *Journal of the Warburg and Courtauld Institutes* 8 (1945): 68–106; and Deborah Howard and Malcolm Longair, "Harmonic Proportion and Palladio's 'Quattro Libri,'" *The Journal of the Society of Architectural Historians* 41 (1982): 116–43.
10 Goodman's theory of symbols is much more complex than what is discussed here. For a thorough discussion, see Goodman, *Languages of Art*, and Catherine Z. Elgin, *With Reference to Reference*, Indianapolis: Hackett, 1983. In what follows, I refer to some of the passages where specific notions are discussed.
11 Goodman, *Ways of Worldmaking*, 137.
12 Goodman, *Languages of Art*, 3–6; Goodman, *Of Mind and Other Matters*, 55–9.
13 Goodman, *Languages of Art*, 52–3.
14 Goodman, *Ways of Worldmaking*, 63–5.
15 Francis D. K. Ching, *A Visual Dictionary of Architecture*, NY: Wiley & Sons, 1995, 52.
16 Goodman, *Languages of Art*, 85–6.
17 Goodman, *Languages of Art*, 85.

18 Goodman, *Of Mind and Other Matters*, 65–6; Goodman, "How Buildings Mean," 42–3; Elgin, *With Reference to Reference*, 142–6.

19 Goodman, "Variations on Variation—or Picasso Back to Bach," in *Reconceptions in Philosophy and Other Arts and Sciences*, 66–81.

20 Goodman, "The Status of Style," in *Ways of Worldmaking*, 23–41.

21 Goodman, *Languages of Art*, 245–52.

22 Nelson Goodman, "Replies," *Journal of Aesthetics and Art Criticism* 39 (1981): 274. Also see Goodman, *Of Mind and Other Matters*, 8. A very similar passage is found in Goodman, *Ways of Worldmaking*: "Although perception without conception is merely *empty*, perception without conception is *blind* (totally inoperative)" (6).

23 Goodman, *Of Mind and Other Matters*, 8.

24 The particularities of aesthetic experience of architecture discussed below have been also explored by several other authors. See especially the following works: Steen Eiler Rasmussen, *Experiencing Architecture*, Cambridge: MIT Press, 1959, in which the author introduces the layman to the perception and experience of architecture throughout a series of examples historically ordered; Roger Scruton, *The Aesthetics of Architecture*, London: Meuthen, 1979, in which the author defends, based on Kantian principles, the idea that the aesthetic experience of architecture is mainly an intellectual pleasure; Michael Mitias, "The Aesthetic Experience of the Architectural Work," *Journal of Aesthetic Education* 33 (1999): 61–77, in which the author maintains that the aesthetic experience brings into actuality the aesthetic qualities of a building in potentiality; Michael Mitias, "Expression in Architecture," *Philosophy and Architecture*, ed. Michael Mitias, Amsterdam, Atlanta: Rodopi, 1994, 100–1, for a discussion of the same argument; and Allen Carlson, "Existence, Location, and Function: The Appreciation of Architecture," *Aesthetics and the Environment: The Appreciation of Nature, Art, and Architecture*, NY: Routledge, 2000, 194–215, in which the author provides a description of the process (in his terms, path) of appreciating architecture, starting with the physical approach from exterior to interior and finishing with the reflection on the path undertaken.

25 For a characterization of the bodily experience of architecture, see Fred Rush, *On Architecture*, London: Routledge, 2009.

26 Goodman, "How Buildings Mean," 32.

27 Ibid., 32.

28 Ibid., 32.

29 Ibid., 44.

30 Ibid., 45.

31 Ibid., 45.

32 Ibid., 46.

33 Goodman, *Languages of Art*, 264.

34 Goodman, *Ways of Worldmaking*, 109–10.

35 I am thankful to Catherine Z. Elgin, Lydia Goehr, and Peter Minosh for their insightful comments and suggestions. This essay is part of the research project FFI2008-01559. The research received financial support from the "Comissionat per a Universitats i Recerca del Departament d'Innovació, Universitats i Empresa" of the Catalan Government.

5

the extended self

tacit knowing and place-identity

chris abel

The identification of individuals and groups with specific places, whether they are family homes, villages, cities or landscapes, is one of the most commonly accepted yet profoundly significant aspects of everyday life. The complex interrelations between the built and natural environment and the personal and cultural identities of populations, have likewise been widely studied by philosophers, anthropologists, psychologists, sociologists and human geographers, as well as by architects, planners and other design professionals engaged in the process of building and giving form to human habitations. Only recently, however, have advances in the neurosciences confirmed the central role of the body in cognition and spatial awareness. In this essay I shall explore what these new discoveries mean for our understanding of the relationships between people and the places they identify with. Beginning with an examination of the meaning of place-identity and related ideas of urban space and form, the essay then provides a more focused look at the writings of two modern philosophers of the last century on the body as the fulcrum or nucleus of human experience. Next, I examine what insights the neurosciences have to offer us on the same subject, what they tell us about the structure and function of "body-maps" and other discoveries, and how scientists' findings compare with the more speculative ideas discussed previously. In the final sections, I shall explore the implications these findings have for what we know of the nature and development of the self, and of the role of familiar artifacts and places in that process, and ultimately, what influence these findings might have on the way architects and other designers shape our world.

THE COMMON BOND

There are as many interpretations of place-identity and its significance in human development as there are approaches to the issue.[1] "Sense of place," "*genius loci*," and "spirit of the place" are commonly used terms that describe much the same idea, though the meaning varies according to the context. For environmental psychologists like Maxine Wolfe and Harold Proshansky,[2] place-identity is inextricably linked with personal identity:

> The self-identity of every individual has elements of place in it – or as we have said elsewhere, all individuals have a "place-identity." They remember, are familiar with, like, and indeed achieve recognition, status, or occupational satisfactions from certain places. Whether we are talking about "the family home," "the old hangout," "my town," or some other place, it should be obvious that physical settings are also internalized elements of human self-identity.[3]

Everyone, for example, has their own personal stories of places they grew up in or spent time in that left an indelible mark on their lives, or even places they associate with fictional characters. In popular culture, one thinks of Scarlett O'Hara in the movie *Gone with the Wind*, and her beloved Tara, the grand

plantation house in the South where she was raised and eventually returned to after the Civil War. Or one might recall the extravagant mansion built as an expression of personal power and wealth by the ruthless tycoon played by Orson Welles in *Citizen Kane*. Inspired by an actual building in California, Hearst Castle, Welles's character in the movie was also controversially based on the building's obsessive creator, William Randolph Hearst, a newspaper magnate.[4]

Award winning designers like the Australian architect Glenn Murcutt have also captured people's imagination with iconic houses carefully set into the landscape (Figure 5.1). In such cases, a single design, like Frank Lloyd Wright's earlier houses, may come to represent, not only an idealized form of dwelling, but a sense of place and preferred way of life for a whole country.[5] However, even the most ordinary suburban home can evoke strong responses in their present or former occupants, whatever the building looks like, so long as it has the requisite features of the type: functional and comfortable rooms sufficient for all the family, a substantial garden or backyard, a garage, etc. In her essay "The House as Symbol of the Self," Clare Cooper[6] quotes a touching poem called "O JOYOUS HOUSE," written by a twelve-year-old about a suburban family home, the title for which speaks for itself.

As common as such bonds are, critics have generally been slow to acknowledge their strength or meaning. Robin Boyd[7] lampooned suburban aesthetic styles and tastes in Australia in the 1950s and 1960s, as did others in Europe and North America during the same period,[8] but like them had no effect whatsoever on the popularity or appearance of suburban homes.[9] Dismissing such reactions

Figure 5.1 House on the outskirts of Sydney by Glenn Murcutt, 1983. Source and photograph: Glenn Murcutt.

as irrelevant to the people who actually live in suburbia, the American sociologist Herbert Gans[10] found that, far from being the social and cultural wasteland depicted by its detractors, suburbanites enjoy a full social life with their neighbours, who share the same family-centered values and lifestyles. Postmodern critics like Charles Jencks[11] also eventually accepted and even celebrated suburban aesthetics. From *I Love Lucy* onwards, countless television sitcoms confirmed the continuing popularity and deep cultural roots of the suburban lifestyle, inviting viewers into their oversized but otherwise ordinary looking living rooms to share the tastes and day-to-day antics and problems of their favorite families.

Cities often exert a similar hold on individuals, both in fiction and in real life. James Joyce,[12] a voluntary exile in Europe for most of his life, evokes a powerful sense of place in his novel *Ulysses*, following Leopold Bloom and his other characters through the real streets and alleyways of Dublin. The novel testifies to the enduring impression Joyce's early years in the city had on his consciousness, despite his rebelling against the dominant Catholic culture and moving elsewhere. Neither, while *Ulysses* was a unique achievement in many other respects, was Joyce alone in capturing the essence of a city between the pages of a novel. In her study of the city in literature, Diana Festa-McCormick[13] analyses the pivotal role played by major cities in ten novels by different authors, including Honore de Balzac and Emile Zola (Paris), Marcel Proust (Venice), Lawrence Durrell (Alexandria) and John Dos Passos (Manhattan). Most authors, she explains, express ambivalent attitudes towards the cities in their novels, acknowledging their darker aspects, including ubiquitous poverty, corruption and injustice, as well as their capacity to inspire. In every case, however, the city is presented as an enduring, dynamic force—a protagonist in itself—shaping and directing the lives of the characters in the novels as much as, if not more than the other characters around them:

> The city often is a catalyst, or a springboard, from which visions emerge that delve into existences unimaginable elsewhere. The city there acts as a force in man's universe; it is a constant element, immutable in its way while constantly renewing itself. It serves as a repository for miseries, hardships, and frustrations, but also for ever-renascent hopes.[14]

PLACE IN ARCHITECTURAL THEORY

Amongst architectural theorists, Christian Norberg-Schulz has done much to focus attention on the nature of place-identity and its psychic origins. In *Genius Loci*,[15] he attributes his phenomenological approach to the philosophy of Martin Heidegger, and to the collection of essays on language and aesthetics, *Poetry, Language, Thought*,[16] in particular. In a widely quoted essay from the same collection, "Building Dwelling Thinking," Heidegger argues that "building" and "dwelling" have an older and far deeper significance beyond their common meanings as activities or a form of habitable shelter:

What then, does *Bauen*, building, *mean*? The Old English and High German word for building, *buan*, means to dwell. This signifies, to remain, to stay in a place. The real meaning of the verb, *bauen*, namely, to dwell, has been lost to us. ... The way in which you are and I am, the manner in which we humans *are* on the earth, is *Buan*, dwelling. To be a human being means to be on earth as a mortal. It means to dwell.[17]

Accordingly, for Heidegger, to build or to dwell implies a fundamental *act of engagement* with the land we live upon. While habitable buildings as we commonly know them are included within the scope of Heidegger's meaning, he also includes any form of human activity or construction, like a bridge, that modifies the landscape and reflects our presence within it:

[The bridge] does not just connect banks that are already there. ... It brings stream and bank and land into each other's neighbourhood. The bridge *gathers* the earth as landscape around the stream.[18]

Elaborating on Heidegger's concept of dwelling, Norberg-Schulz argues for a broader appreciation of architecture, not just as a practical art fulfilling various social and cultural functions, but as "a means to give man an 'existential foothold.'"[19] Thus, "dwelling above all presupposes *identification* with the environment."[20] Similarly, a "place" implies more than a simple spatial or geographical designation and describes somewhere with a distinct *character* of its own. This can include ambient qualities related to different activities, such as "protective," for dwellings, "practical" for offices, "solemn" for churches, and so forth. Character may also be a function of time and the changing seasons, together with the different light conditions that go with them. More generally, it "is determined by the material and formal constitution of the place."[21] The purpose of architecture is defined accordingly as the "creation of places," of bringing forth and expressing the *genius loci*.

However, having made the case for an existential understanding of architecture and place, Norberg-Schulz devotes most of his treatise to describing the physical and spatial properties of places that generate the kind of character he suggests people can identify with, which he illustrates with numerous examples drawn from widely different cultures around the world. For instance, he notes that a common feature of such places is a strong "inside-outside" relationship; buildings and settlements are tightly grouped and provide a tangible sense of enclosure, differentiating them sharply from the extended spaces and landscapes beyond (Figure 5.2). Notably, except for a handful of exceptions—he includes the skyscrapers of Chicago amongst them[22]—all his exemplars are of a historical or traditional nature, including many of the indigenous settlements that Bernard Rudofsky describes in his own related study, *Architecture without Architects*.[23] Only in a closing section titled, "The loss of place" does he turn his attention to more recent architectural and urban developments. Bemoaning the widespread lack of any clear definition between town and country, he writes: "Spatially, the new settlements do not anymore

Figure 5.2 The historic streets and squares of Valletta, Malta, are typical of the well-defined urban forms and spaces described by Norberg-Schulz. Source and photograph: Chris Abel.

possess enclosure and density."[24] Buildings are separately scattered about in open spaces or spill out into the countryside while streets and squares as we know them from older towns and cities no longer exist: "The continuity of the landscape is interrupted and the buildings do not form clusters or groups."[25]

Notwithstanding Norberg-Schulz's sincere attempts to explain the meaning of place-identity to us, or the undoubted attractions of his exemplars, the criteria he sets out for what makes a place worth identifying with exclude a large section of humanity who do not necessarily share the same values or live the same way, but who may nevertheless be equally attached to their environments—and not only Western suburbanites. To take an extreme counter example, according to Amos Rapoport,[26] an anthropologist who has focused on the relations between built form and culture,[27] buildings play no significant role in the way Australian Aborigines identify with the land they inhabit. Aboriginal tribes in different parts of the country make use of a number of forms of basic shelter, including simple windbreaks and several varieties of huts made from bark and simple wooden frames. A few dwellings with low walls of stone and arched roofs of saplings covered with bark and grass are also known. However, none of these shelters offers any substantial protection against the climate, which varies from one extreme to another across the continent, or compares with the more elaborate dwelling forms of indigenous cultures elsewhere.[28]

Neither, as Rapoport explains, do Aboriginal dwellings fulfill any discernable symbolic function, as might be expected from studies of other cultures.[29] To understand what is important to Aboriginal culture, Rapoport continues, we have to look elsewhere, to the land itself. Instead of imbuing dwellings or any other form of human construction with symbolic values, as other peoples do, Aboriginals invest the *whole landscape* with meaning derived from a highly complex cosmology and cosmogony:

> Many Europeans have spoken of the uniformity and featurelessness of the Australian landscape. The aborigines, however, see the landscape in a totally different way. Every feature of the landscape is known and has meaning—they then perceive differences which Europeans cannot see. These differences may be in terms of detail or in terms of a magical or invisible landscape, the symbolic space being even more varied than the perceived physical space. ... It is thus a likely hypothesis that aborigines *humanize* their landscape, that is take possession of it conceptually, through symbols—as we do. But whereas our symbols are material— buildings, cities, fences, and monuments—aboriginal symbols are largely non-material.[30]

There are, therefore, good reasons for the insubstantial nature of Aboriginal dwellings, but we can only understand them by inversing "normal" Western perceptions and values. Where we conventionally build to *separate* ourselves from nature, both symbolically and materially, or to *take possession* of some part of it, Aborigines eschew any form of shelter or construction that might

possibly get in the way of their complete identification with the land in which they live. As difficult as it is for most of us to grasp, making buildings—so central to other cultures, both technologically primitive as well as advanced—hardly counts for anything in Aboriginal culture:

> Other cultures create a new physical landscape in keeping with their creation myths. Aborigines structure their *existing* physical landscape mentally, mythically and symbolically *without building it* [my emphasis].[31]

In a sense, therefore, the simple constructions that pass for dwellings in Aboriginal culture *do* have a symbolic value, if only of a negative kind, in so far as they indicate that the full symbolic weight of the culture has been firmly placed elsewhere.

IMAGEABILITY

From the 1960s onward various professional students of the built environment have attempted to resolve such issues by adopting a more empirical approach, often borrowing their ideas and methods from the human sciences, with varied results. Most of this work revolves around the concept of a mental "image" by which individuals anticipate events and actions and generally find their way about in the world. In a key early work by Kenneth Boulding, *The Image*,[32] the author uses the term to denote the integration of discrete mental "schemata,"[33] including social, economic and political issues, into a coherent whole—a kind of subjective model or picture of the world that helps a person to make sense of it all. David Canter,[34] who helped to establish environmental psychology as a new discipline in the UK, traces the concept still further back, through Frederick Bartlett's experiments in the early 1930s,[35] to the work of Sir Henry Head,[36] a neurologist, a decade earlier. Bartlett showed that, after being briefly shown an abstract drawing of a face, subjects would invariably recreate a more human image conforming to their *expectations* of what the image should look like. Passed along to another subject, the changed image would undergo a similar transformation, and so on in a sequence of transformations until the final image was much closer to a real human face than the original drawing.

As Canter relates, Bartlett's explanation of his subjects' behaviour was strongly influenced by Head, whose work on motor actions and the sensory cortex of the brain has special relevance to our interests, as we shall see in later sections:

> As a neurologist, Head was concerned with how we are able to take into account changes in bodily posture and movement in order to carry out effective motor actions, *how we know where our limbs are* [my emphasis]. To explain our abilities Head proposed that we must carry in our brains a model of our body which is being continually modified on the basis of information received about each action. He gave the analogy of a taxi

meter which accumulates the distance travelled and presents it to us "already transformed into shillings and pence."[37]

However, it would be another decade before other neuroscientists would begin to find solid evidence for Head's theoretical speculations, and many more years before his fundamental ideas were applied to environmental issues. In his groundbreaking work, *The Image of the City*, Kevin Lynch[38] was the first to apply psychological theory and empirical methods of analysis to the study of urban form. Hitherto, judgments on the merits of one urban form over another had been the exclusive province of city planners and urban designers, according to whatever theoretical or historical model they favoured. Lynch took the bold step of eliciting the impressions of city dwellers themselves, using field surveys and interview techniques familiar to sociologists and psychologists but new to his own profession. In doing so, he purposefully limited his studies to the physical and visual aspects of urban form on the assumption that, not only were these the most accessible impressions that might be solicited from his interviewees, but that urban form in itself had major impacts on other aspects of urban life. Lynch theorized that everyone builds their own "mental picture" or internal "map" of the cities and places where they live and work, and the more distinctive the visual character of the buildings and spaces in the city are, the stronger the "image" and the more memorable they will be to their inhabitants:

> A workable image requires first the identification of an object, which implies its distinction from other things, its recognition as a separable entity. This is called identity, not in the sense of equality with something else, but with the meaning of individuality or oneness. Second, the image must include the spatial or pattern relation of the object to the observer and to other objects. Finally, this object must have some meaning for the observer, whether practical or emotional.[39]

Lynch focused his interviews within the central areas of three major American cities: Boston, Jersey City, and Los Angeles. Each area was carefully surveyed for its major landmarks and other distinctive features by a professional observer, providing a basis for comparison with the different interviews, which included personal sketches of the area by each interviewee, as well as verbal descriptions and accounts of frequent journeys from one part to another. While the samples involved were all relatively small and mainly taken from the professional and managerial classes, Lynch found considerable overlap between individual perceptions of the same areas, amounting to what he calls a "public image" of the city. The same data revealed repeated characteristics, or "image elements," which he subsequently named "path," "landmark," "edge," "node," and "district." While freely acknowledging the small size of the study, Lynch claimed the results confirmed the importance of "imageability" or "legibility" (Lynch uses the two terms interchangeably) in urban design, and that his methodology and list of image elements provided a potentially objective

basis for ensuring those attributes would be given more attention by city planners and designers in the future.

Despite Lynch's efforts to establish the objectivity of his ideas and methods, like Norberg-Schulz, who frequently quotes Lynch's work in support of his own approach, he reveals a strong personal preference in his writings for familiar historic urban models like Venice, and a disdainful, even condescending view of American cities and their inhabitants' aesthetic tastes:

> A beautiful and delightful city environment is an oddity, some would say an impossibility [in America]. Not one American city larger than a village is of consistently fine quality, although a few towns have some pleasant fragments. It is hardly surprising, then, that most Americans have little idea of what it can mean to live in such an environment.[40]

Lynch's urban values and aesthetic preferences, which he shared at the time with many of his peers, were subsequently challenged by other leading American urban theorists like Melvin Webber[41] and Robert Venturi,[42] as being Eurocentric and out of touch with American urban culture. Just as Gans had argued for an understanding of suburbia on its own terms, so Webber and Venturi maintain that American cities are fundamentally different from historic European cities. The latter, with their compact spatial patterns and pedestrian-friendly streets and squares, had mostly evolved before the invention of the automobile. By contrast, since the early twentieth century, modern American cities, with their low-density suburbs, freeways and commercial "strips," have grown around the exclusive use of private transportation. Venturi went so far as to urge architects to stop looking to Rome for inspiration and look to the commercial aesthetics and colorful roadway signs of Las Vegas instead for appropriate models of design for the contemporary American city (Figure 5.3).

Lynch's ideas and methods nevertheless had a considerable influence, not only on architectural theorists like Norberg-Schulz, but on workers within other fields as well, stimulating whole new areas of interdisciplinary research.[43] In an essay on cognitive mapping titled "Architecture in the Head," David Stea[44] explains that, much like the graphical maps we use to find our way around a city or transport system, the maps we hold in our heads of the places we live in tell us what to expect around the corner: "To be useful, a cognitive map must 'predict' something—it is not enough to have a network of images; images of our present surroundings must be associated with images of those objects and events likely to come next."[45]

However, not all of the work that followed supported Lynch's own findings. Aside from advances in survey and interview techniques, Stea points to a contrary outcome in the research since Lynch's pioneering work, namely, the "recognition of a simple fact with which architects have become quite concerned: the responses of various subgroups of our population to a given environment are different; that is, *there seems to be no 'universal aesthetic'* [my emphasis]."[46] Lynch himself had stressed that he was less interested in the psychology of personal differences in perception than in the shared perceptions

Figure 5.3 The "Strip," Las Vegas, as it was in 1980. Source and photograph: Chris Abel.

that constituted what he claimed as the public image of the cities he studied. However, according to Stea's observations, subsequent research would appear to undermine Lynch's conclusions, suggesting that either Lynch's small sample or his interview techniques may have prejudiced the outcome.

The complicated picture of the nature of place-identity that emerges thus far from all these debates and researches, is that the qualities associated with particular places—including but not confined to aesthetic issues—may vary significantly according to a person's mental image or map of the area concerned, which may in turn be influenced by many other psychological and cultural factors affecting a person's experience and perception of that area. The degree to which those images may be shared likewise depends on which of those many other factors an individual may share with others. Clearly, to use Lynch's terms, what is "legible" about a place to one group or culture may be totally obscure to another. While Lynch and Norberg-Schulz might find ideal models for places that many people can identify with in historical architecture and urban form, other people can and do identify strongly with buildings and cities—and even just landscapes—in ways that do not conform to the same criteria or cultural values.

However, one inescapable factor that every human being shares with every other human being on the planet in his or her day to day experience of the world—regardless of background or culture—but which is generally taken for granted, is the human body, the key role of which we now turn to.

TIMELESS RELATIONS

While architects may have been tardy in acknowledging aesthetic tastes different from their own, they have long recognized the importance of the human body in their work. From the familiar Vetruvian images by Leonardo da Vinci and others,[47] of a naked figure with outstretched arms encased within a circle and a square to Le Corbusier's Modulor,[48] a proportional scale of measurements based on the human body (Figure 5.4), architects have been fascinated by the relations and tensions between abstract geometric form and the human figure. Anthropomorphic references have also shaped architectural form and history across time and different cultures, both directly, as in the layouts of Dogon villages in Mali, Africa (Figure 5.5), which are also based on the human body,[49] and the "symbolic expression of Christ crucified"[50] in the Latin Cross plan of Christian churches, or indirectly, as in the Japanese concept of "movement space"—that is, space as experienced from the viewpoint of a moving observer.[51] Yi-Fu Tuan,[52] a prominent geographer, also presents numerous examples from different peoples, both in their language and in their buildings, where the body image has influenced the way they relate to and shape their environment. The upright, forward-facing human body itself, Tuan argues, is the basic source of all our spatial coordinates:

> Upright, man is ready to act. Space opens out before him and is immediately differentiable into front-back and right-left axes in conformity with the structure of his body. Vertical-horizontal, top-bottom, front-back and right-left are positions and coordinates of the body that are extrapolated onto space. ... What does it mean to be in command of space, to feel at home in it? It means that the objective reference points in space, such as landmarks and the cardinal positions, conform with the intention and the coordinates of the human body.[53]

A frequent criticism directed at orthodox modernism in the last century was that architects had neglected the timeless relations between architecture and the body, and had consequently lost the ability to create engaging and memorable places. Even Le Corbusier's Modulor failed to humanize his urban schemes, and has been ignored by architects at large. Charles Moore, whose "Sea Ranch," a cluster of second homes he and his partners designed on the Californian Coast in 1965, was widely praised as a landmark in modern place making (Figure 5.6), has been a leading voice in the movement to restore the body to centre stage in architectural theory and practice. In *The Place of Houses*, Moore and his co-authors[54] attempt to show how designers can restore a sense of place to residential architecture, not only through careful attention to the relations between building and landscape, of which "Sea Ranch" is a paradigmatic example, but also by creating intimate spaces within the houses themselves that people can identity with, and feel they belong to. In a later co-authored study, *Body, Memory and Architecture*,[55] Moore writes: "We believe that the most essential and memorable sense of three-dimensionality originates

chris abel

in the body experience and that this sense may constitute a basis for understanding spatial feeling in our buildings."[56]

More recently, Juhani Pallasmaa[57] makes the case that modern architecture has been dominated by the visual sense at the expense of other sensory and bodily experiences, particularly the tactile sense, but also the acoustic and oral senses. Pallasmaa traces the problem in Western culture back to antiquity, and the association of vision with thought and certainty—seeing things clearly, so to speak. However, he argues that the bias towards the visual sense, or "ocularcentrism" as it has been called, has been greatly exacerbated in modern times with the invention of photography and the exponential growth in the printed and televised images that now permeate all aspects of our lives.

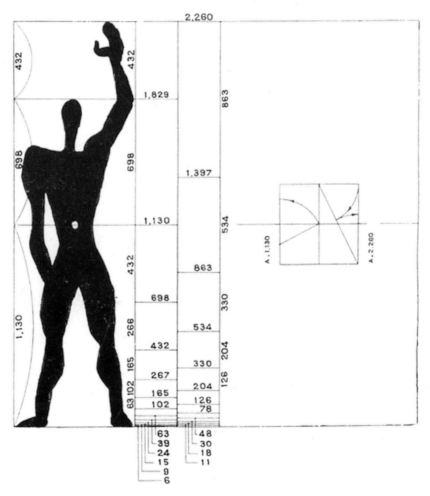

Figure 5.4 Source: Artists' Rights Society (ARS), New York/ADAGP, Paris/F.L.C

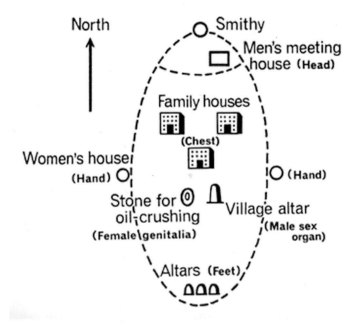

Figure 5.5 Diagram of Dogon village, Mali. Source: Douglas Fraser, 1967, George
Braziller, New York.

Figure 5.6 "Sea Ranch" condominium near San Francisco by Moore Lyndon Turnbull
Whitaker, 1966. Source and photograph: Chris Abel.

THE BODY NUCLEUS

To a greater or lesser extent, the last three authors all reflect the influence of Maurice Merleau-Ponty's *Phenomenology of Perception* on their approaches.[58] Together with Michael Polanyi's contemporary writings on "tacit knowing,"[59] which inspired this essay, Merleau-Ponty's work offers the most illuminating study of the period on the interrelations between consciousness, bodily experience and spatial awareness. While neither author wrote directly on architecture or urban form, their work has impacted environmental theory in significant ways.[60]

Of the two, Merleau-Ponty is the better known author and a philosopher in the same school of thought as Heidegger, both of whom acknowledge Edmund Husserl[61] as their intellectual father. Following Husserl, Merleau-Ponty is also careful to distinguish phenomenology from the explanatory sciences as a purely "descriptive psychology": "[Phenomenology] tries to give a direct description of our experience *as it is* [my emphasis] without taking account of its psychological origin and the causal explanations which the scientist, the historian or the sociologist may be able to provide."[62] Merleau-Ponty was also particularly influenced by Husserl's assertion of what the latter called "the privileged position" of the human body. According to Husserl, the human body is the one thing that is never experienced independently or at a distance, but is always: "the persisting point to which all spatial relations appear to be connected."[63] Likewise, for Merleau-Ponty the body is the very centre and origin of human existence:

> Our body is not merely one expressive space amongst the rest, for that is merely the constituted body. It is the origin of the rest, [of] expressive movement itself, that which causes them to begin to exist as things, under our hands and eyes. ... *The body is our general medium for having a world* [my emphasis].[64]

Spatial awareness, and the awareness of objects in space, he explains, are only possible by virtue of our having a body at all. When a person circulates a room or an apartment, for example, the different aspects of the scene are not experienced separately, or as the mere conjunction of different views, but as a sequence of views, the totality of which originates in the moving body from which each view is experienced, and which retains its own identity throughout the sequence. Similarly, an object on a table may have an abstract description attached to it, but our actual experience of it *as an object* will depend upon our own position in relation to it in space and our ability to move around it. If, say, the object on the table is a cube, we know from its geometric description that all the faces are equal. However, as we move around it and above it, the faces of the cube present themselves to us differently, according to the angle at which they are viewed. But our personal awareness of it as a cube is an outcome of our having a stable reference point in our bodies, from which we are able to integrate the different facets into a whole. In the same way, our awareness of

time itself derives from our being able to experience one thing *before* or *after* another, in some kind of sequence, whether we ourselves are moving about, or events are changing *around* us. In either case, the stable reference point and ultimate origin of the experience is again our own body.

For Merleau-Ponty, the conventional Cartesian treatment of the body as simply yet another physical object in space viewed dispassionately by detached minds, denies the unity of consciousness and bodily experience:

> Consciousness is being towards the thing through the intermediary of the body. ... We must therefore avoid saying that our body is *in* space, or *in* time. It *inhabits* space and time.[65]

In the same way, he contends, we also inhabit our own bodies. We do not experience our body objectively as a collection of adjacent limbs and organs—we are in unique *possession* of our body and are aware of the relation of one part or limb to another "through a *body image* in which all are included."[66] Here, though, while assimilating the term for his own purposes, Merleau-Ponty takes issue with its then current interpretation by psychologists as a simple compendium of mental images of different body parts, or even the Gestalt "whole" favoured by some. Crucially, for Merleau-Ponty, the body image is *purposeful*. It has intentional and situational aspects:

> My body appears to me *as an attitude directed towards a certain existing or possible task* [my emphasis]. ... In the last analysis, if my body can be a "form" and if there can be, in front of it, important figures against indifferent backgrounds, this occurs in virtue of its being polarized by its tasks, of its *existence towards* them, of its collecting together of itself in its pursuit of its aims; the body image is finally a way of stating that my body is in-the-world.[67]

Perception is defined accordingly: "The theory of the body image is, implicitly, a theory of perception."[68] Finding support for once in empirical psychology, Merleau-Ponty cites the now familiar responses of subjects to the perception of different colors. Red and yellow, for instance, evoke "an experience of being torn away, of a movement away from the center," while blue and green commonly evoke feelings of "repose and concentration."[69] In both these and other similar cases, some kind of bodily association is directly involved in the perception of the color itself, in this instance either with a body in motion or a body at rest. In a manner remarkably similar to some of Polanyi's examples of tacit knowing, Merleau-Ponty also suggests that getting accustomed to an item of clothing or a tool or any other personal possession involves a virtual *extension* of the body image to encompass the thing itself: "To get used to a hat, a car or a stick is to be transplanted into them, or conversely, *to incorporate them into the bulk of our own body* [my emphasis]."[70]

Neither is the role of the body confined to gathering in various sensory experiences; it is also the unique and indispensable vehicle through which one person relates to another, and to any other people or objects within a shared

field of vision: "To say that I have a visual field is to say that *by reason of my position* [my emphasis] I have access to and an opening upon a system of beings, visible beings."[71] Sharing the same basic physiological and sensory apparatus, Merleau-Ponty suggests, allows us to *identify with others*, by analogical extension of our own bodies and the way they shape our experience of the world, in a fashion that is inconceivable if we were all built differently. Thus, for all the obvious variations of race and culture that may and often do get in the way of that process, the shared universal fact of the human body acts as a natural, if fragile impediment to seeing others as mere objects. Moreover, the same process of identification extends beyond the individual or group of persons concerned, to take in any physical and cultural objects within the same field:

> No sooner has my gaze fallen upon a living body in process of acting than the objects surrounding it immediately take on a fresh layer of significance: they are no longer simply what I myself could make of them, they are what this other pattern of behaviour is about to make of them.[72]

SPATIAL DYNAMIC

While Polanyi's own background in science—he was a notable organic chemist before turning to philosophy and epistemology—sets him apart from Merleau-Ponty and other philosophers, the work of both thinkers overlaps in key respects, most obviously in their related treatments of the body as the nucleus of human experience. Significantly, while Polanyi had the advantage of understanding the work of scientists as an insider, he was also driven to philosophy by his own deep dissatisfaction with the assumed detachment of scientists from their work, and the consequent denial of any personal commitments in the way they conducted their researches or approached their subjects, whether human, organic or otherwise. Like Merleau-Ponty, he also firmly rejected the Cartesian split between mind and body and the stereotypical thinking—objectivity versus subjectivity, rationality versus irrationality—that went with it.[73]

Seeking a new cognitive synthesis, Polanyi found it in his theory of tacit knowing. Polanyi's argument commences with the acknowledgement of a simple but fundamental principle of human knowledge: "We can know more than we can tell."[74] Even such a common task as the recognition of a human face involves a complex process of cognitive extension, or "indwelling," as Polanyi calls it, only part of which manifests itself at a conscious level. Asked to describe a person's features from memory, for example, most people would fail to provide a convincing picture. However, provided with an "identikit," they can usually reconstruct the face from a selection of eyes, noses, jaws, and other features to a fairly accurate degree, sufficient to identify a police suspect. As with any complex task, Polanyi explains, the recognition of the face involves not one but two sorts of cognition: "subsidiary awareness" and "focal awareness." The former is just as much a vital part of cognition as the latter. However, as its name implies, subsidiary awareness is constantly out of focus, a subliminal backdrop and

source of assimilated knowledge that is only *activated indirectly* by an act of concentrated attention on the point of focal awareness. The term "tacit knowing" itself therefore refers not just to the unconscious parts of cognition, but also to the complementary relations between both conscious and unconscious processes. The key is in understanding how the two work together. In the following example, Polanyi explains how the use of a simple tool comes to feel, without our being fully aware of it, like an extension of our selves:

> When I use a hammer to drive a nail, I attend to both, but quite differently. I watch the effects of my strokes on the nail as I wield the hammer. I do not feel that its handle has struck my palm but that its head has struck the nail. In another sense, of course, I am highly alert to the feelings in my palm and fingers holding the hammer. They guide my handling of it effectively, and the degree of attention that I give to the nail is given to these feelings to the same extent, but in a different way. The difference may be stated by saying that these feelings are not watched in themselves but that I watch something else by keeping aware of them. I know the feelings in the palm of my hand *by relying on them for attending to the hammer hitting the nail*. I may say that I have *a subsidiary* awareness of the feelings in my hand which is merged into my focal awareness of my driving the nail.[75]

The above example illustrates a critical feature of tacit knowing—namely, that it has a *spatial dynamic*, or as Polanyi describes it, the two forms of cognition have an intrinsic "from-to-relation": the first, subsidiary awareness, or the "proximal term," as he also calls it, feels close to us, while the second, the point of focal awareness, or the "distal term," is at a distance from us. Only by relying tacitly on the specific details or "particulars" of the proximal term, as we keep our attention firmly fixed on the distal term, are we able to draw upon all the subsidiary knowledge we need to accomplish a task, no matter what it is. In the same manner, Polanyi also restores the body to its central place in human experience and cognition:

> Whenever we use certain things for attending from them to other things, in the way in which we always use our own body, these things change their appearance. They appear to us now in terms of the entities to which we are attending from them, just as we feel our own body in terms of the things outside to which we are attending from our body. In this sense we can say that when we make a thing function as the proximal term of tacit knowing, we incorporate it in our body—or *extend our body to include it* [my emphasis]—so that we come to dwell in it.[76]

Or again:

> While we rely on a tool or a probe, these instruments are not handled or scrutinized as external objects. Instead, *we pour ourselves into them* [my emphasis] and assimilate them as part of ourselves.[77]

Put another way, tacit knowing involves an unconscious process of *immersion* in whatever we are doing. Whether it is hammering in a nail, hitting a ball in a game of tennis or any other sport (Figure 5.7), driving a car down the road ahead or communicating with another person, all of which require special skills we rely upon totally to perform well but which we are only ever partly aware of at any time, we *extend ourselves to absorb the objects or subjects we need in order to complete a task or action.* Thus, we absorb the racket or bat in order to hit the ball, absorb the car in order to drive down the road, absorb the other person in order to communicate with him or her, and so forth.[78]

Figure 5.7 Tennis champion Andre Agassi in action. Source: Sports-Photos.com.

The same subliminal processes apply to learning even the most complex forms of knowledge. While both Merleau-Ponty and Polanyi share the same disdain for the prevailing scientific culture, as a former scientist himself Polanyi was better positioned to identify the commonalities as well as the differences, which he believed to be largely unfounded, between science and other forms of knowledge. Personal beliefs and a commitment to a particular vision of reality, together with a consensus amongst a community of workers on the value and moral purpose of their endeavor, he argues, are just as important to scientists as they are to anyone else—a view subsequently strongly supported by Thomas Kuhn in his landmark study of science and scientists, *The Structure of Scientific Revolutions*.[79] Language teachers have also long acknowledged the value of immersion techniques in their field, whether it is living amongst native language speakers or simulating dialogues in language labs. Similarly, I have previously argued that comparable cognitive processes underlie the way both scientists and architects acquire knowledge of their respective fields, either, as in the former case, through replicating key historical experiments, or studying key buildings and engaging in simulated design projects in the latter.[80] In either case, "learning by example," rather than being taught by abstract rules alone, is the crucial factor.[81] Translated into Polanyi's terms, the novice scientist or architect immerses himself or herself in the exemplary experiment or project as the proximal term of tacit knowing, by which he or she "enters into" a whole body of knowledge (the very phrase itself has suggestive connotations): i.e. the distal term, which would otherwise be inaccessible.

For Polanyi, there is no form of personal knowledge that does not have its origins in the same fundamental process. In a passage that echoes the primacy of bodily experience in Husserl's and Merleau-Ponty's thought, he states:

> Our body is the ultimate instrument of all our external knowledge, whether intellectual or practical. In all our waking moments we are relying on our awareness of contacts of our body with things outside for attending to these things. Our own body is the only thing which we never normally experience as an object, but experience always in terms of the world to which we are attending from our body.[82]

However, whereas both Husserl and Merleau-Ponty mostly highlight the differences between science and everyday experience, Polanyi is more concerned about building bridges between science and other familiar ways of engaging with the world, a view substantiated by other writers on Polanyi's work. C. P. Daly,[83] for example, finds parallels between Polanyi's approach to scientific rationality and the later work of Ludwig Wittgenstein:

> Polanyi pursues his relentless critique of positivism by showing that science cannot be isolated from other forms of human knowing, living, loving, valuing. He shows that science cannot be understood apart from the "form of life" of the scientific community, and indeed of the rational human community in general. ... Rationality in science is not unique. It is akin to

rationality in ethics. It is akin to rationality in politics, in jurisprudence and law. Creative thinking in science is not dissimilar to intuition in art and literature. Formal intellectual beauty is a criterion of truth in science, as it is of excellence in aesthetics.[84]

Polanyi does not therefore deny the rationality of science, but rather seeks to remind us that, notwithstanding other differences between culture-forms and belief systems, scientists are not alone in deferring to some shared concept of reality, or, more importantly, to a shared language and criteria of evaluation; i.e. in Wittgenstein's terms, a "form of life."[85] Moreover, in the same collection of essays, Marjorie Grene[86] suggests that the common roots of rationality and rational behaviour lie in the purposeful nature of tacit knowing itself. As Polanyi explains:

> We can assimilate an object as a tool if we believe it to be actually useful to our purposes and the same holds for the relation of meaning to what is meant and the relation of the parts to the whole. The act of personal knowing can sustain these relations only because the acting person believes that they are apposite: that he has not *made them* but *discovered them*. The effort of knowing is thus guided by a sense of obligation towards the truth: by an effort to submit to reality.[87]

The ambiguity of being part of reality and yet somehow distanced from it, so that we always move "toward the truth," extending ourselves *outwards*, Grene argues, is inherent in the from-to-relation between the two terms of tacit knowing. For Grene, Polanyi's from-to dynamic offers:

> The resolution, indeed, the dissolution of the mind-body problem. ... To comprehend is to rely on myself as bodily in order to envisage a coherent, intelligible spectacle *beyond* myself. ... The dichotomy, or, more truly, the complementarity of self and world, inner and outer, is not that between a secret, inner, significance-conferring consciousness and a public, outer, meaningless "reality." *It is the polarity of a bodily self and an intelligible world* [my emphasis].[88]

EMBODIED MINDS

While, as we have seen, Merleau-Ponty also posits some kind of analogical extension of the bodily self by which people identify with others and the worlds they inhabit, having deliberately restricted his own enquiry to a description of human experience "as it is," his analysis falls short of offering an explanatory theory that might enable us to better understand the cognitive processes involved.[89] Polanyi's theory of tacit knowing convincingly fills that gap, offering a potential explanation, not only for how people identify with others, but also for how they identify with the homes, cities and other places they inhabit, and

which help to shape their lives. At this point, in the spirit of Polanyi's philosophy, further to my previously mentioned studies in the education of architects and scientists, I should also declare my own earlier personal commitments to his theory as a fruitful source of relevant ideas:

> How is it that some architects can comprehend the regional attributes of both a people and a local architecture without explicit training? What is the role of tacit knowing and indwelling in the processes of orientation and identification with a place? It may be surmised that place-identity itself is a function of tacit knowing, by which individuals come to dwell in a place not only physically but also by metaphoric extension of their own bodies. By implication, people communicate with other people also in large part by making use of their architecture, much in the same way they make use of their own bodies, as the proximal term of tacit knowing.[90]

Significantly, since the time of writing the above passage, Polanyi's mind-body synthesis has also been substantially validated by numerous experiments in the relatively new science and technology of "body mapping," confirming the explanatory power of his theory. As Sandra and Matthew Blakeslee explain in their lively and wide-ranging study, *The Body Has a Mind of its Own*,[91] like most discoveries in science, body mapping itself has a long history. The authors trace the verification of body maps back to a series of experimental operations in the 1930s and 1940s by Wilder Penfield, a surgeon treating patients for epilepsy at the Montreal Neurological Institute. The highly delicate procedure involved probing the exposed cerebral cortex of the brain, where most body maps are located, with an electrode for several hours in different spots in order to locate any abnormal tissue for treatment. The patient, who was necessarily kept awake during the whole operation (fortunately, while the brain receives signals from pain sensors everywhere else on the body, it has no sensors of its own so a local anaesthetic suffices to protect the patient), would report any bodily responses to the probe—where they were located and what they felt like—as it touched different parts of the brain, moving across the cortex in tiny steps. Touching one spot elicits a tingling sensation in the left hand; touching another spot in the same area gets a response on the left wrist; yet another on the left forearm, then the left elbow, and so on. Step by step, case by case, Penfield built up a comprehensive picture of which parts of the brain were linked to which parts of the body. Each tiny region of the brain he probed, Penfield deduced, provided a neurological representation of the corresponding body part or surface. Notably, while some maps, like those representing the hand and face, overlapped to some extent, most "are remarkably discrete."[92] Moreover, the location of one map in relation to another in the brain did not always correspond with the actual spatial relation between the different body parts being represented; for example, the map of the face is located next to the map of the hand, and not the neck, as might be expected. Some parts of the body, especially the lips and tongue, were also much more sensitive to the electrode's contact with the brain than other parts, from which Penfield

concluded that bodily sensors were concentrated heavily in some areas of the body, and more lightly in others.

Putting it all together, Penfield created a complete neurological "touch map" of the body, which he named the "homunculus," after the Latin for "little man." Similar explorations of patients' motor cortexes yielded movements of different body parts, from knee jerks to raised eyebrows, rather than sensations, from which he also constructed a complete map. Again, some parts, including the lips, reacted more strongly to the probe than others. Exploring other parts of the brain, Penfield also found evidence of both secondary and *higher-order* maps, signifying different levels of neurological complexity. One such map was located just in front of the primary motor cortex, in a region subsequently designated the premotor cortex, "where action plans are made."[93] Though smaller than the primary map, when stimulated it produced movements of far greater complexity than any movements produced by the former. More than that, some patients' responses offered early neurological evidence of intentionality:

> Penfield's patients reported that the movements induced through the primary motor cortex felt involuntary—like something that had been done *to* them. But the actions produced by stimulation to the premotor cortex were accompanied by an inkling of intention—like something being done *by* them. Or sometimes Penfield would stimulate a spot and no movement would be produced, but *the patient would report a sudden desire to perform some simple gesture or action* [my emphasis].[94]

Penfield's pioneering operations and discoveries established many of neuroscience's basic premises concerning the location, type and purpose of body maps. However, boosted by advances in non-surgical as well as surgical techniques, scientists have since considerably broadened their studies of body maps and how they work, with often startling results. Crucially, while Penfield's findings present a largely fragmented picture of relatively discrete maps, new research pinpoints two more vital regions of the brain, both of which operate in an entirely unconscious way, that help to link the rest together. One region collects signals from *inside* the body; the other reads signals from the inner ear, the delicate organ that provides us with a sense of balance. Combined with each other they provide the sensory means for pulling all our body maps into a unified *body schema*,[95] or what the Blakeslees call the "body mandala," after the Hindu and Buddist symbolic map of the universe:

> Whenever they sense change, these sensors send the information up to your brain to update your sense of where you are in space and how your body map is configured. The signals are first mapped in your primary touch map, then branch and filter upward through other, higher-order maps in your body mandala. *These maps guide your body movements and expectations about those movements* [my emphasis].[96]

It is this awareness of our bodies *within space*, or, as Merleau-Ponty would insist we say, *inhabiting* or occupying space, directing our movements at will—circumstances permitting—through space *toward* some object, destination, or goal, that gives each one of us our sense of autonomy, or "me-ness." Note, too, the clear parallels with Polanyi's two terms of tacit knowing. The sense of wholeness originates literally from *inside* the body (i.e. the proximal term), and communicates itself to us in totally *unconscious* or tacit ways, of which we only become consciously aware by the actions we precipitate toward some *external* objective (i.e. the distal term).

However, there are still more striking parallels with Polanyi's theory than even these similarities would suggest. The body schema, it turns out, extends *beyond* the human body itself to embrace the clothes we wear, the objects in the surrounding space we touch or interact with, and even those we have intimate relations with, in a harmonious blending of individual body maps.[97] Neuroscientists call this extended and flexible spatial domain the "peripersonal space," every part of which is also mapped by our brain cells: "When you observe or otherwise sense objects entering that space, these cells start firing."[98] There is also evidence, some of it gleaned from patients suffering from the disabling effects of heart stroke, that the brain distinguishes between peripersonal space and the space further out, called "extrapersonal space." For example, asked to perform a simple task with a laser pointer within their personal space, the stroke patients have no problem, but fail the same task if it involves reaching further out.

However, it seems the dividing line between personal space and the space beyond is neither fixed nor even always close into the body. On the contrary, as with Polanyi's claims for the power of tacit knowing, peripersonal space is *highly elastic* and can be stretched at will to embrace tools or baseball bats, objects coming our way, and even the actions of other people in the vicinity. More like an expandable "bubble" of space than a stable aura, peripersonal space behaves much like an invisible and highly sensitive muscle, flexing with our every movement. No less significant, the neurological structures responsible for body maps and personal spaces are equally plastic, and are forever evolving throughout our life-spans:

> The old picture was of body maps settling into a fixed configuration like fired clay. *The new picture is one of dynamic stability* [my emphasis]. Neuroplasticity continually reshapes your brain in response to experience; the fact that it seems static merely reflects the consistency of your experiences throughout most of your adult life.[99]

Neither are we alone as a species in possessing a personal space. In fact, we owe many recent discoveries in the neurosciences to experiments with primates—our closest relatives, genetically speaking[100]—from which scientists are able to extrapolate their findings. The Blakeslees recount one such series of experiments with monkeys' body maps in 1994 by Michael Graziano and Charles Gross, two Princeton University neuroscientists. Exploring the body maps located in

the monkeys' premotor cortex, the researchers found that moving an object to within a few inches of a spot on the monkey's hand while the monkey watched the action fired exactly the same brain cells that fired when the hand had been previously touched. Alone, one might suspect the response was simply connected with the monkey's recent memory of the touch. However, moving the object closer or further away from the monkey's hand also produced corresponding changes in the *speed* at which the cells fired: the closer the object was moved in, the faster the cells fired. When the object was withdrawn, the cells fired more slowly. The authors conclude: "In other words, these cells were mapping not just touch, but the nearby bubble of space around the body."[101]

In another series of experiments into the peripersonal spaces of monkeys conducted at Japan's RIKEN Institute by Atsushi Iriki, the scientist was astonished to find that, when trained to use a rake to pull in bits of food from the far side of a table to within the monkey's reach, the brain cells mapping that part of the monkey's body responded to visual signals well beyond the monkey's hand, taking in the whole rake as well: "The hand's peripersonal space, which for the monkey's entire life prior to rake training had never extended to more than a few inches beyond its fingertips, had now billowed out like an amoeba's pseudopod to include a lifeless foreign object."[102]

Polanyi himself could hardly have designed a better experiment to demonstrate his theory of indwelling. However, extraordinary as these findings are, current research points to further likely revelations of a complete mind-body synthesis in what are called "place cells" and "grid cells"—space-mapping neurons located in the hippocampus, where memories are formed. Though much older in evolutionary development than the cortex, where space and body maps originate, both parts of the brain are vital to bodily experience and spatial awareness. However, the neurological systems associated with each part also differ in significant ways. While body maps are self-directed or *egocentric*, place cells and grid cells are *geocentric*, or outer-directed. The cells themselves also behave differently from each other. The former are "context-dependent" and respond to specific features and objects in our immediate environment, mapping the actual space around us at any one time and everything of any significance to us within it. The latter cells, however, are "context-independent." As the name suggests, they provide a constant reference space around the body, independent of the changing contents of that space, so we can always accurately locate ourselves and anything else within the same measurable framework.

Place cells were first discovered in 1971 by two neuroscientists, John O'Keefe and John Dostrovksy, while they were monitoring the hippocampus in the brains of mice to find out how the memory functions. As the mice moved around their enclosure, the researchers noticed that different brain cells in the hippocampus fired according to which part of their enclosure the mice moved into. Moreover, the same cells fired up again if the mice moved back to the same place. Each mouse, it seems, had formed its own accurate mental map of the enclosure, which it had previously memorized when it was familiarizing itself with its new home.

Grid-cells were only discovered in the last few years by a Norwegian group of researchers led by Edvard Moser. Operating at a higher level in the brain than place cells, grid cells function as though every fraction of the space around us is marked out with a regular triangulated grid, stretching far beyond us. Only firing up as the body moves into the vertex of one of the triangles in front, grid cells remain inactive for any locations in between the vertices. No matter where we are, it seems, our brains are always carefully pacing out the space around us in the same measured steps.

Initially surprised at his findings, Moser concluded that the invariant spatial environment mapped out by grid cells necessarily complements the variable spaces mapped by place cells. Anticipating further research, he speculated that gifted sportsmen and women possess highly developed versions of both types, enabling them to strike a speeding ball with repeated accuracy or track the movements of numerous other players on the field. Venturing further, Moser suggests the two cell functions may be interconnected in other, still more significant ways: "There are many reasons to believe that *place cells are sums of grid cells* [my emphasis]."[103] As with the generative grammars common to all human languages identified by Noam Chomsky[104], it seems that spatial awareness may have something like its own subconscious formal logic underpinning the infinite variety of mental maps we all create and use in our everyday lives.

GRASPING OTHER MINDS

Whatever support new research provides for Moser's speculations about place cells and grid cells, the neurosciences have already yielded ample empirical evidence of a tacit mind-body synthesis to substantiate many of Polanyi's fundamental ideas, as well as those of Merleau-Ponty and other prominent writers discussed in this essay, if sometimes only in part. The basic idea that we all create internal models of the world about us—that help us to find our way around, integrate different aspects of that world, anticipate what lies ahead, make decisions and identify with specific places—is broadly sustained. However, our knowledge of how those internal models are created has drastically changed as a result of the research described above. From an understanding of images and maps as a product of purely mental processes, as presented by Boulding and Lynch *et al.*, we have moved closer to the more complex picture painted by Polanyi and Merleau-Ponty in which the human body itself plays an integral role in those processes, without which we would literally have no place at all in the world, or indeed, any sense of our own selves. In particular, as we have seen in the above experiments, the inherent spatial character of tacit knowing is strongly supported by the research on body mapping and peripersonal space, as is Polanyi's account of the way we incorporate a tool or anything else into our own bodies, by extending ourselves outward, "so that we come to dwell in it."[105]

A research team at the University of Parma in Italy, led by Giacomo Rizzolatti, has also now revealed that much the same thing goes on when people identify with others.[106] Again, we have to thank our primate cousins for helping to complete another key link in the recent chain of neurological discoveries. Set up with electrodes in preparation for an experiment into the part of the brain involved with planning and movement, the waiting monkey was observed to be following the actions of a research student with rapt attention. The student had entered the room eating an ice cream cone, and the monkey was jealously eyeing the hand holding the cone. Normally, previous experiments had shown that the relevant brain cells of the monkey would fire up whenever it grasped or moved an object itself. But now the monitor was showing the same brain cells firing up, though the monkey itself remained perfectly still. What it was actually doing, Rizzolatti concluded, was mimicking the actions of the student— not by any movements of its own, but by *mentally simulating the same movements* it had visually observed the student making.[107]

Experimenting on human subjects with the latest imaging techniques, Rizzollati discovered they possessed even more complex mirror circuits than his primate subjects, capable of simulating the emotions and intentions of others as well as their actions. In due course, after numerous further experiments, the brain cells responsible for this remarkable feat were dubbed "mirror neurons." Summarizing the radical implications for understanding human behaviour and communication, the Blakeslees write:

> You can think of mirror neurons as body maps that run simulations of what other people's body maps are up to. In this way, they serve to link our body schemas together across the otherwise tremendous gulf that separates one person's subjective world from another's. *They allow you to grasp the minds of others* [my emphasis], not through conceptual reasoning, but by modelling their actions, intentions, and emotions in the matrix of your own body mandala.[108]

Critically, as Merleau-Ponty intimated in his own thoughts on the subject, the capacity for indentifying with the minds of others depends upon already having an equivalent sensory schema; i.e. a body map, or at least the same kind of map, as the other person. The monkey in the laboratory in Parma could not have simulated the student's movements in its own brain so accurately if it did not also have arms and hands, and body maps of those limbs, like all humans. Likewise, the more developed those similar maps are, the more sensitive a human subject will be to another's actions and concerns. Thus a football or tennis fan who also regularly plays the game with his or her friends on weekends will react to the deft movements of professional players with greater sensitivity and emotion—identifying with their actions and moments of triumph or defeat—than someone who does not play the game himself.

According to some scientists, the importance of the discovery of mirror neurons cannot be overestimated. V.S. Ramachandran, a neurologist at the University of California, has argued that mirror neurons not only account for

how infants acquire language, by mimicking the sounds and lip movements of their parents and others, [109] but also how we acquire any kind of cultural trait:

> Mirror neurons provide an alternative explanation for human brain design. Your brain is unique not because it has evolved highly specialized modules, but *because it is parasitic with culture* [my emphasis]. ... Mirror neurons absorb culture the way a sponge sucks up water. [110]

FIELD OF BEING

The same findings directly contradict culturally enshrined concepts of the self as a distinct, irreducible entity, capable, according to most religious conventions, of an after-life of its own. Instead, we are presented with the idea of a number of separately identifiable neurological processes somehow coalescing to form a dynamic and, possible brain damage notwithstanding, [111] reasonably stable picture we have of ourselves and our place in the world, all of which is entirely dependent upon having a body to mediate those processes. Summarizing those findings, the Blakeslees write:

> The illusion of the self is that self is a kernel, rather than a distributed, emergent system. ... [However] the mind has no kernel, no "little man" sitting at the centre of the fray directing the action. But it is teeming with noncentral "little men," the brain's motley team of homunculi, who form the backbone of the whole production. [112]

Presenting his own verdict on the same issue, the German philosopher Thomas Metzinger, author of *The Ego Tunnel: The Science of the Mind and the Myth of the Self*, [113] suggests that we are only now beginning to catch up with Buddhist philosophy of 2,500 years ago, and that there is no single permanent entity we can legitimately call a self: "a first approximation could be to say that what we have called the self in the past is not a thing in the brain and not a thing in some metaphysical realm beyond the brain, but it's a process." [114] A process, Metzinger argues, of *representing* what is going on in our minds and the world about us, which produces an image of ourselves during consciousness, but which *has no existence outside consciousness*.

As we have learned, the mind is not only dispersed amongst several neurological systems, but the evolution of mind and self together involve myriad spatial extensions into the world around us, absorbing the things and other minds we interact with on an everyday basis. William Barrett [115] comes close to describing the elusive fusion of mind, self and world when he likens Heidegger's theory of man to a "Field Theory of Being," analogous to Einstein's Field Theory of Matter or a magnetic field, except that unlike the latter, it has no centre: "Think of a magnetic field without the solid body of the magnet at its centre; man's being is such a field, but there is no soul substance at the centre from which that field radiates." [116] However, while there may be no single

chris abel

origin of the self, as both Merleau-Ponty and Polanyi correctly argued and neuroscience has now confirmed, the self *does* have an identifiable working nucleus and focal point in the human body, through which all our experience and self-images are mediated: a field of being, therefore, held together, not by any physical force, but by an *existential force*, with the body at its center. As always, Polanyi has his own special way of expressing such ideas:

> We may say, in fact, that to know something by relying on our awareness of it for attending to something else is to have the same kind of knowledge of it that we have of our own body by living in it. *It is a matter of being or existing* [my emphasis].[117]

EVOLVING TACIT SKILLS

In the same way, we can also now finally begin to answer those earlier questions I raised concerning architects' tacit knowing skills.

Like any human being, the future architect's own body maps and related tacit skills will have been evolving from the moment of his or her birth.[118] From the first intimate touches between infant and mother, the basic neurological structures that will develop into the primary touch and motor areas of the brain and their associated body maps would already be rapidly forming. As those body maps evolve, so also will the infant's bubble of peripersonal space, extending outwards to absorb a milk-bottle or favourite toy, merging with its parents' personal spaces whenever it is held and probably extending further still to take in its bed. Perhaps, if the analogy between grid cells and generic grammars holds up,[119] the logical structures required to generate the measured spatial field beyond will already be firmly in place as just one of an infinite number of genetically transferred features that will shape his or her future growth into adulthood. The infant's place cells will also be forming and doing their own work building up ever more detailed maps of its surroundings, as it becomes accustomed to the space and objects around it. From the very beginning, the child's nascent mirror neurons will have been equally busy as it learns to recognize and respond to its parents' smiles and gestures. The same vital mirror neurons will also be responsible for the apparent ease with which the child picks up its first words—essentially learning by example, as it will do with practically everything else it learns as it grows.[120]

All this will go on mostly subconsciously as an *inevitable consequence* of the way the child is exploring and interacting with its surroundings and the people in its life. Similarly, the same processes will occur in the act of exploring beyond the confines of the home. From the first wheeled excursions outside the house by pram, bus or automobile on shopping expeditions with its parents or visits to friends and relatives, the child will have become at least vaguely aware that there are different *kinds* of places: all those stranger and sometimes overwhelming buildings and other places the child briefly experienced on those excursions, and the more familiar place it always returned to with its parents—

home, or "my house" as the young poet described it—where it got fed, first learned to walk and felt most comfortable. Eventually, the growing child will instinctively recognize and find his or her way about the most frequented buildings and places, assimilating the complex relations between their component spaces and other parts with their place cells and body maps at the same time and repeating the whole process all over again should the family change their location.

Like the separate pieces in a jigsaw puzzle slowly coming together, the child's emergent sense of self will have been pieced together from many different external as well as internal sources, including such personal possessions and artifacts as have an impact on impressionable young minds: favourite items of clothing, the family automobile, and of course, if the child is old enough and the family affluent enough, a personal laptop and mobile phone, extending its bubble of personal space to absorb each item in use. Most important, hopefully the child will have soon found a "best friend" and maybe a larger circle of other children inside and outside school who all share their experiences, honing their mirror neurons and practicing their tacit skills of indwelling with every exchange.

This is a process that will go on throughout the child's future lifespan, as he or she encounters new experiences, people and places. Yet by the time the child grows up and finally begins architecture studies, he or she will already be well equipped to communicate with other selves and get inside future clients' heads, or to soak up and absorb the special qualities and character of a landscape or urban neighbourhood in preparation for a project. The novice student will be so qualified, as Merleau-Ponty and Polanyi both intuited, by something resembling a process of analogy: being able to literally simulate the body maps, intentions, and emotions of clients, or of the people who inhabit the places and landscapes the student will come to absorb as a part of his or her task.

However, just how much the beginning student of design will be encouraged to capitalize on such natural talents for identifying with other people's minds and habitations will depend very much on his or her future education and professional training. Sadly, such instinctive talents probably will not be recognized as such by many design teachers, who, if the history of architectural education is anything to go by, are more likely to be intent on converting students to their own or prevailing professional values and design approaches, rather than building on those remarkable gifts of nature (oddly, beginning students of architecture are invariably treated as though they know nothing about the subject, whereas in fact they will all have had at least eighteen years of living with it day by day). Likewise, the separation of architects' education from that of other construction professionals like engineers, is just as likely to create life-long impediments to mutual understanding, rather than nourish students' initial talents for indwelling. As in other professions, in many ways, conventional design education, especially in the form it took during the more dogmatic phases of orthodox modernism and subsequent fashions, involves as much indoctrination and conformity as any more creative activities.[121]

Fortunately that situation is now improving, if only slowly. Postmodernism broadened the accepted limits of aesthetic taste, though not without its own

downside, including the promotion, following Venturi's lead, of a superficial façadism.[122] In the meantime, modern architecture has also evolved into an open and diverse movement, casting aside the earlier rigid rulebooks while retaining key social and technological commitments, combined with a genuine concern with place-making.[123] As we noted, cultural differences can also result in wide disparities in the perception of personal space and other factors,[124] presenting special challenges to overseas architects, who need all their own skills in overcoming such issues. Amongst the positive outcomes of the period, the resurgence of modern regionalism in the 1980s encouraged architects to rediscover their tacit skills and tap into the minds and cultural values of others, especially when handling projects in different parts of the world.[125] Studio projects, such as the tried and tested "in the manner of" exercise, in which a student designs a building in the specific style of a well known architectural figure, also purposefully draw upon and develop students' innate capacities for identifying with others.[126] Collaborative attitudes and methods are also now displacing entrenched differences in professional ways of thinking and working, especially within cutting edge design schools and practices, where students and practitioners now routinely work together in multidisciplinary teams.[127]

SELF-EXPRESSION OR SELF-DESTRUCTION?

Significantly, there has also been a notable change in critical focus from the debatable aesthetic and social merits of suburbanism to the far more serious and self-destructive environmental consequences of urban sprawl and pollution. Boyd's contempt for suburban tastes may have carried weight amongst his peers in the middle of the twentieth century, but they look increasingly trivial in the face of the potentially catastrophic consequences of forms of urban growth and transportation almost totally dependent upon fossil fuels. Worrisomely, the same neurological processes that explain how people come to identify so strongly with the homes and places they grow up in also explain why they might stoutly resist any changes to their lifestyles, even when those same lifestyles become life-threatening.[128] In his seminal work, *Steps to an Ecology of Mind*, Gregory Bateson,[129] one of the few radical thinkers in the last century, who, like Polanyi, argued convincingly for an understanding of mind as a distributed phenomenon, warned of the perils of becoming so attached to a particular culture and way of life that it might prevent us from seeing the dangers it presented to our survival. Following the window neuroscience has opened upon mirror neurons and other wonders of the mind, we are now beginning to comprehend exactly how those attachments are formed, and just how strong they might be, to the point where we cannot reject or separate ourselves from the environments we have created and grown up in, without threatening our core identity.

Not so many years ago, such knowledge might well have been used to justify the more extreme forms of aesthetic relativism encouraged by some postmodernists.[130] However, the driving force for universal or objective

environmental standards no longer comes from designers and critics disdainful of suburban architecture and life-styles but from anxious citizens of all shades who fear for the future of the human race as a consequence of unsustainable ways of life.[131] Whatever one might think of Venturi's aesthetic values or the seductive commercial signage of Las Vegas, therefore, it is the uncritical acceptance of the automobile-dependant civilization that those roadway signs symbolize which designers need to be more concerned about now.

Regrettably, residential architects, like most of their clients, have generally been slow to accept the need for change, especially in North America and Australia, where the single family home is deeply engrained in the national psyche.[132] The "Sea Ranch" showed how homely features normally associated with detached family houses might be incorporated into condominiums, increasing densities, and enhancing the natural landscape, but for the most part Moore and his partners remained wedded to the detached model. Recent projects by practices like Troppo Architects in Australia, who made their reputation for modern regionalism designing lightweight detached houses suited to the country's northern tropical regions, indicate a move toward slightly higher densities, but do not break the basic suburban pattern, with all its drawbacks.[133] Conversely, for all the controversial aspects of skyscrapers or any other urban features and values associated with such places, Manhattan and Hong Kong are now widely recognized as amongst the most sustainable urban concentrations in the world, simply by virtue of their inhabitants' reliance upon public transportation and the other energy saving benefits that go with ultra high-density forms of dwelling.[134]

Similarly, while in the light of the above discoveries from neuroscience and other preceding arguments the preferred urban aesthetics of Norberg-Schulz and Lynch might appear subjective and backward looking, if not un-American, their mutual support for compact, high-density urban forms and spaces makes increasingly good sense from a broader environmental perspective—a view reflected in the work of some of the most forward-looking architects and urban designers around the world today (Figure 5.8).[135] Although, as we have learned, human beings are remarkably adept at extending their peripersonal spaces to embrace even large artifacts like vehicles, a return to pedestrian-friendly cities offers significantly more opportunities to exercise bodily spatial awareness, and all the tacit skills that go with it, not to mention the important health benefits.[136]

Nevertheless, despite the mounting objective evidence of harmful environmental effects, weaning people out of their suburban homes and vehicles, with all their attractions of personal identification and mobility, will not be easy. If there is one simple but vital lesson the neurosciences teach us about the way people identify with their physical surroundings, it is that *habituation and familiarity* with the dwelling forms and personal possessions individuals live with daily counts for more than anything else—a fact marketing executives have long known and exploited for their own purposes.[137] The challenge for designers is to make the best use of such knowledge to create alternative and more sustainable forms of dwelling that people can learn to identify with just as strongly as the low-density homes and cities they now

Figure 5.8 Private automobiles are excluded from the shaded pedestrian streets of Masdar, a compact new city in Abu Dhabi inspired by traditional Arab settlements, designed by Foster + Partners, 2007. Instead, various forms of public transportation, including an underground network of fully automated, electrically driven vehicles for hire, moves people around the city. Source: Foster + Partners.

inhabit. However, bearing in mind the failures of previous generations of architects and planners to remake the world without equivalent social and economic changes, the probable outcome is that, like it or not, events beyond their control will eventually compel people to reinvent their dwelling habits.[138] In so doing, they will be necessarily reinventing themselves.

NOTES

1 For the sake of brevity, the following discussion on the meaning of place-identity is focused on a selection of key authors who helped to focus attention on the concept and who represent the main strands of thought relevant to this essay. For further reading on philosophical approaches to the subject, see Edward Casey, *The Fate of Place: A Philosophical History*. Berkeley: University of California Press, 1998. Also see J. E. Malpas, *Place and Experience: A Philosophical Topography*. Cambridge UP, 2007. For approaches in human geography, see Phil Hubbard, Rob Kitchen, and Gill Valentine, ed., *Key Thinkers on Space and Place*, London: Sage Publications, 2004. Also see Tim Cresswell, *Place: A Short Introduction*, Oxford: Blackwell, 2004.

2 Maxine Wolfe and Harold Proshansky, "The Physical Setting as a Factor in Group Function and Process," in *Designing for Human Behaviour: Architecture and the Behavioural Sciences*, ed. J. Lang, C. Burnette, W. Moleski, and D. Vachon, Stroudsburg: Dowden, Hutchinson & Ross, 1974, 194–201.

3 Ibid., 196.

4 *Herst Castle*. State of California and Hearst San Simeon State Historical Monument publication, no date.

5 Philp Drew, *Leaves of Iron: Glenn Murcutt, Pioneer of an Australian Architectural Form*. Pymble: Angus & Robertson, 1985.

6 Clare Cooper, "The House as Symbol of the Self," *Designing for Human Behaviour*, op cit., 1974, 130–46.

7 Robin Boyd, *The Australian Ugliness*, 2nd revised edition. Melbourne: Penguin, 1980.

8 The attack was led by the London-based journal, *The Architectural Review*, beginning with the December 1950 issue, which focused on American suburban culture, followed by the June 1955 issue, "Outrage," guest edited by Ian Nairn, which focused on suburbia in the UK.

9 Some of the suburban archetypes scorned by Boyd, like the "Californian Bungalow," are in fact very well suited to the Australian climate and remain popular to this day, both in Australia and in California, from where the type originated. The design was also strongly influenced by the work of Greene and Greene, two of America's most renowned residential architects of the early twentieth century.

10 Herbert Gans, *The Levittowners*, NY: Pantheon Books, 1967.

11 Charles Jencks, *The Daydream Houses of Los Angeles*, NY: Rizzoli, 1978.

12 James Joyce, *Ulysses: The 1922 Text*, Oxford World's Classics, 2008.

13 Diana Festa-McCormick, *The City as Catalyst*, London: Associated University Presses, 1979.

14 Ibid., 15.

15 Christian Norberg-Schulz. *Genius Loci: Towards a Phenomenology of Architecture*, NY: Rizzoli, 1979.

16 Martin Heidegger, *Poetry, Language, Thought*, NY: Harper Colophon Books, 1971.

17 Ibid., 146–7.

18 Ibid., 152.

19 Norberg-Shulz, op cit., 1979, 5.

20 Ibid., 20.

21 Ibid., 14.

22 Norberg-Schulz is mainly attracted toward the "cliff" of tall buildings lining Lake Shore Drive, rather than toward any individual structures, although some of those structures also have a considerable impact on the city's popular image.
23 Bernard Rudofsky, *Architecture Without Architects*, NY: Doubleday, 1964.
24 Norberg-Schulz, op cit., 1979, 189.
25 Ibid., 189.
26 Amos Rapoport, "Australian Aborigines and the Definition of Place," in *Shelter, Sign & Symbol*, ed. Paul Oliver. NY: The Overlook Press, 1977, 38–51.
27 See, for example, Amos Rapoport, *House Form and Culture*, Englewood-Cliffs: Prentice-Hall, 1969.
28 For a comprehensive survey, see Paul Oliver, *Dwellings: The Vernacular House Worldwide*, London: Phaidon, 2003.
29 Oliver, op cit., 1977.
30 Rapoport, op cit., 1977, 42–3.
31 Ibid., 47.
32 Kenneth Boulding, *The Image: Knowledge in Life and Society*, Ann Arbour: University of Michigan Press, 1956.
33 The term "schemata" is similar to "schema," a term coined by Jean Piaget to refer to cognitive structures that relate to classes of similar interrelated actions or sequences of behaviors. See J. Flavell, *The Developmental Psychology of Jean Piaget*, NY: Van Nostrand Reinhold, 1963.
34 David Canter, *The Psychology of Place*, NY: St. Martin's Press, 1977. Canter himself posits a theory of place-identity as a conjunction of at least three major factors: "activities," "conceptions," and "physical attributes," all of which may interact with each other according to an individual's own role and perceptions within the building or area concerned. Anticipating Norberg-Schulz's definition of the purpose of architecture, Canter also proffers the slogan, "The Goal of Environmental Design is the Creation of Places," suggesting a number of ways that planning and design professionals might enhance their skills toward that end.
35 Frederick Bartlett, *Remembering*, Cambridge UP, 1932.
36 Sir Henry Head, *Studies in Neurology* (1920), quoted from Bartlett.
37 Canter, op cit., 1977, 15.
38 Kevin Lynch, *The Image of the City*, Cambridge: MIT Press, 1960.
39 Ibid., 8.
40 Ibid., 2.
41 Melvin Webber, "The Urban Place and the Nonplace Urban Realm," in *Explorations into Urban Structure*, ed. Webber *et al.*, University of Pennsylvania Press, 1964, 79–183. See also John Worthington, "What's Wrong With the American City Is That We View It Through European Eyes," *Arena* 82, no. 010 (1967), 210–13.
42 Robert Venturi, Denise Scott Brown, and Steven Izenour, *Learning from Las Vegas*. Cambridge: MIT Press, 1972. See also Grady Clay, *Close-up: How to Read the American City*, London: Pall Mall Press, 1973.
43 For an overview, see Amos Rapoport, *Human Aspects of Urban Form: Towards a Man-Environment Approach to Urban Form and Design*, Oxford: Pergamon Press, 1977.
44 David Stea, "Architecture in the Head: Cognitive Mapping," in Lang *et al.*, op cit., 1974, 157–68. Also see Robert Downs and David Stea, *Maps in Minds*, London: Harper and Row, 1977.
45 Ibid., 166.
46 Ibid., 165.
47 Da Vinci's drawing was one of a series of Vitruvian figures produced by Renaissance artists during the sixteenth century, including several by Francesco di Giorgio. See Rudolf Wittkower, *Architectural Principles in the Age of Humanism*, London: Alec Tiranti, 1962.
48 Theo Crosby, editor, *Le Corbusier*, London: Whitefriar's Press, 1959.
49 Douglas Fraser, *Village Planning in the Primitive World*, London: Studio Vista/Braziller, 1967.

50 Wittkower, op cit., 1962, 30.

51 Mitsuo Inoue, *Space in Japanese Architecture*, trans. Hiroshi Watanabe, Tokyo: Weatherhill, 1985.

52 Yi-Fu Tuan, *Space and Place: The Perspective of Experience*, London: Edward Arnold, 1977.

53 Ibid., 35–6. For a survey of right-left symbolism in widely different cultures, see *Right and Left: Essays on Dual Symbolic Classification*, ed. Rodney Needham, University of Chicago Press, 1973.

54 Charles Moore, Gerald Allen and Donlyn Lyndon, *The Place of Houses*, NY: Holt, Rinehart and Winston, 1974.

55 Kent Bloomer and Charles Moore, *Body, Memory and Architecture*, New Haven: Yale UP, 1977.

56 Ibid., 1977, x.

57 Juhani Pallasmaa, *The Eyes of the Skin: Architecture and the Senses*, London: Wiley-Academy, 2005.

58 Maurice Merleau-Ponty, *The Phenomenology of Perception*, trans. Colin Smith, London: Routledge & Kegan Paul, 1962. Both Tuan and Pallasmaa make explicit if only brief references to Merleau-Ponty's thought. However, while Moore does not include any direct mention of the latter's works, his general approach can be said to be very much in the spirit of Merleau-Ponty's phenomenology, and may have been influenced indirectly by it. Tuan's claim that the basic spatial coordinates emanate from the human body also echoes the earlier writings of Edmund Husserl on the body, as quoted by Casey. See note 63 below.

59 Michael Polanyi, *Personal Knowledge: Towards a Post-Critical Philosophy*, University of Chicago Press, 1958. See also Polanyi, *The Tacit Dimension*, NY: Doubleday, 1966, and Polanyi and Harry Prosch, *Meaning*, University of Chicago Press, 1975.

60 For further reading on the impact of Merleau-Ponty's phenomenology on architectural theory, see Steven Holl, Juhani Pallasmaa, and Alberto Perez-Gomez, *Questions of Perception: Phenomenology of Architecture*, San Francisco: William Stout, 2006. For the impact of Polanyi's thought, see Chris Abel, "Function of Tacit Knowing in Learning Design," *Design Studies* 2, no. 4 (1981): 209–14. Also see Chris Abel, "Cyberspace in Mind," *Architecture, Technology and Process*, Oxford: Architectural Press, 2004, 33–60.

61 For an introduction to Husserl's thought, see Quentin Lauer, *Phenomenology: Its Genesis and Prospect*, NY: Harper Torchbooks, 1958. For an extended discussion of Husserl's thought on the significance of the body in human experience, see Edward Casey, ibid., 1997, especially 217–20.

62 Merleau-Ponty, op cit., 1962, vii.

63 Quoted in Edward Casey, op cit., 1998, 217.

64 Merleau-Ponty, op cit., 1962, 146.

65 Ibid., 138–9.

66 Ibid., 98.

67 Ibid., 100–1.

68 Ibid., 206.

69 Ibid., 210.

70 Ibid., 143.

71 Ibid., 216.

72 Ibid., 353.

73 Polanyi makes no mention of Merleau-Ponty in his early works, the first of which preceded the English translation of *Phenomenology of Perception*. However, reflecting on Merleau-Ponty's thought in Polanyi and Prosch, op cit., 1975, 47, the authors observe: "Merleau-Ponty anticipated the existential commitment present in tacit knowledge but did so without recognizing the triadic structure which determines the functions of this commitment—the way it establishes our knowledge of a valid coherence. The contrast between explicit inference and an existential experience imbued with intentionality is not sufficient for defining the structure and workings of tacit knowing. We are offered an abundance of brilliant flashes without a constructive system." Polanyi does however acknowledge a

kinship between his concept of indwelling and Heidegger's "Being-in-the-world,"or "dwelling." See note 46 in Marjorie Grene, "Tacit Knowing and the Pre-reflective Cogito," in *Intellect and Hope: Essays in the Thought of Michael Polanyi*, ed. Thomas Langford and William Poteat, Durham: Duke UP, 1968, 19–57. However, as he goes on to show, Polanyi uses the term in a far more precise way than Heidegger does, and yet also applies it to a far wider spread of behavior. Grene herself also expresses doubts about the similarity between the concepts.

74 Polanyi, ibid., 1966, 4.

75 Polanyi and Prosch, op cit., 1975, 33.

76 Polanyi, op cit., 1966, 16.

77 Polanyi and Prosch, op cit., 1975, 36.

78 While Polanyi acknowledges the work of German thinkers like Wilhelm Dilthey on empathy, he also takes pains to distinguish his own theory of indwelling from the latter: "Indwelling, as derived from the structure of tacit knowing, is a far more *precisely defined act than is empathy* [my emphasis], and it underlies all observations, including all those described previously as indwelling," Polanyi, op cit., 1966, 17.

79 Thomas Kuhn, *The Structure of Scientific Revolutions*, University of Chicago Press, 1962. Also Kuhn, *The Essential Tension*, University of Chicago Press, 1977. Explicit parallels are drawn between Polanyi's and Kuhn's theories of the way scientists work, together with the theories of other key thinkers, in C. B. Daly, "Polanyi and Wittgenstein," *Intellect and Hope*, op cit., 1968, 136–68.

80 Abel, op cit., 1981.

81 The key role of exemplars and models in scientific development is elaborated in Kuhn, op cit., 1977. For a related approach to understanding creativity in the arts, see George Kubler, *The Shape of Time*, Princeton: Yale UP, 1962. The relevance of both thinkers to architectural theory is discussed in Chris Abel, "Tradition, Innovation and Linked Solutions," op cit., 2000, 131–7.

82 Polanyi, op cit., 1966, 15–6.

83 Daly, op cit., 1968.

84 Ibid., 151.

85 It was Wittgenstein's aim in his later work to clarify the social and linguistic basis of different forms of human understanding in particular kinds of contexts—what he called "forms of life." Ludwig Wittgenstein, *Philosophical Investigations*, 3rd edition, London: Macmillan Publishing, 1958. For the impact of Wittgenstein's thought on social theory, see Peter Winch, *The Idea of a Social Science and its relation to Philosophy*, London: Routledge & Kegan Paul, 1958. For his impact on the arts, see Richard Wollheim, *Art and its Objects*, Harmondsworth: Penguin Books, 1975.

86 Grene, op cit., 1968.

87 Quoted in Grene, op cit., 44.

88 Grene, ibid., 42–3.

89 It might be argued that by equating his theory of the body with a theory of perception, Merlau-Ponty is in fact offering an explanatory theory of some kind. However, it is clear from his repeated assertions of the different goals of science and phenomenology that he does not see it that way himself, nor does Polanyi. See note 73 above.

90 From the republished and edited version of the 1981 essay, "Function of Tacit Knowing in Learning to Design," in Chris Abel, ibid, 2000, 113. The wording in the original publication is as follows: "Briefly, Polanyi's theory of knowledge and learning as 'indwelling' suggests that 'place identity' is explicable in the terms of tacit knowing and that it is a function of tacit knowing, by which persons come to dwell in a place by metaphoric extension of their own bodies. According to this theory, persons interact with other persons in large part by making use of their architecture, much in the same way they make use of their own bodies, as the 'proximal' term of tacit knowing."

91 Sandra Blakeslee and Matthew Blakeslee, *The Body Has a Mind of Its Own*, NY: Random House, 2007.

92 Ibid., 17.

93 Ibid., 23.

94 Ibid., 23.

95 While the Blakeslees make no direct reference to Merleau-Ponty's related concept of the "body image," the thinker is mentioned in their acknowledgments as one of several philosophical references, including Husserl that the authors omitted for the sake of writing the text for a general audience.

96 Ibid., 29.

97 Ibid., 109. The Blakeslees recount a story told by an anthropologist at a conference of a tribe in Namibia in Africa who believe each person is born with their own flexible bubble of space around the body, which constantly merges with that of other members of the tribe, so nobody ever feels alone. Apparently they feel sorry for Westerners who think of themselves as isolated points in space. From the accumulating evidence of neuroscience, it seems the tribe has got it right, and Westerners have got it wrong.

98 Ibid., 110. The concept and study of peripersonal space was anticipated by Edward T. Hall, anthropologist, to which he gave the name "proxemics." Hall found considerable cultural variations in the way individuals regulate the spaces around themselves and between others, according to the nature of the relationship and situation. He also found similar variations in the territorial habits of different animal species, suggesting common patterns of behavior relating to the body. Hall, *The Hidden Dimension*, NY: Anchor Books, 1969.

99 Blakeslee and Blakeslee, op cit., 2007, 87.

100 A study by an international group of scientists subsequently published in *Nature* found that the genomes or genetic codes of humans and chimpanzees are 96 percent identical. S. Lovgren, "Chimps, Humans 96 Percent the Same, Gene Study Finds," *National Geographic News*, August 31, 2005.

101 Blakeslee and Blakeslee, op cit., 2007, 117.

102 Ibid., 141–2.

103 Ibid., 132.

104 Noam Chomsky, *Aspects of the Theory of Syntax*, Cambridge: MIT Press, 1965. Chomsky has considerably modified his theory of generative grammars since the former publication and no longer distinguishes between "deep structures" and "surface structures." See Chomsky, *The Minimalist Program*, Cambridge: MIT Press, 1995. Though widely accepted by linguists, Chomsky's early theories did not go unchallenged. See Rudolf Steiner, *After Babel: Aspects of Language and Translation*, Oxford UP, 1975. The debate also carried over into linguistic analogies in architecture. See Chris Abel, "Architecture as Identity," in *Semiotics 1980*, ed. M. Herzfeld and M. Lenhart, NY: Plenum Press, 1980.

105 Michael Polanyi, op cit., 1966, 16.

106 Blakeslee and Blakeslee, op cit, 2007, 163–4.

107 Such experiments remind us that vision cannot be treated separately from the other bodily senses without a critical loss of meaning. While agreeing with Pallasmaa (see note 58) that the visual sense may be abused in many ways, one therefore needs to understand all the other factors involved.

108 Blakeslee and Blakeslee, op cit., 2007, 166.

109 According to Ramachandran, mirror neurons do not necessarily rule out a role for special areas in the brain in the formation of language. Nevertheless, in a clear challenge to innate theories of language, he also suggests that such regions do not have to be functional "at the moment of birth to explain how they develop" (Blakeslee and Blakeslee, op cit., 2007, 171). On the other hand, the evidence for invariant neurological structures like grid cells points to innate factors of some kind.

110 Ibid., 171.

111 Ibid., especially chapter 6, "Broken Body Maps," 98–108. The Blakeslees describe many possible injuries and other conditions that can seriously upset normal brain functions, demonstrating just how fragile the idea of a self is.

112 Ibid., 208.

113 Thomas Metzinger, *The Ego Tunnel: The Science of the Mind and the Myth of the Self*, NY: Basic Books, 2009.

114 Quoted from "All in the Mind," ABC Radio National, 10 October, 2009.

115 William Barrett, *Irrational Man: A Study in Existential Philosophy*, NY: Doubleday Anchor Books, 1962.

116 Ibid., 218.

117 Polanyi and Prosch, op cit., 1975, 127.

118 It has been acknowledged since Piaget's early research that many of the basic cognitive structures essential to human well-being, including those motor functions and schemata we now know to be involved in the formation of body maps, are formed during the early years of a child's development. See Flavell, op cit., 1963.

119 Given the continuing debate over innate language skills, the analogy provides at best a tentative stop-gap, pending further experimental evidence.

120 The existence of mirror neurons strongly supports the arguments by Kuhn and others for the primacy of learning by example over abstract description in science and other fields. See note 81.

121 For a critical history of architectural education in the UK, see Mark Crinson and Jules Lubbock, *Architecture: Art or Profession?* Manchester UP, 1994. Unfortunately, the authors undermine their case against the more regressive aspects of modernism by advocating a superficial historicism of the sort promoted by the Prince of Wales, thus replacing one dogmatic approach with another.

122 For a critique of the more superficial aspects of postmodernism and a defense of an authentic modernity, see Chris Abel, "The Essential Tension," *Architecture and Urbanism*, no. 250 (1991): 28–47.

123 This is now widely acknowledged by most architectural historians and theorists, as evidenced in the standard works. See, for example, William Curtis, *Modern Architecture Since 1900*, 3rd edition, London: Phaidon, 1996. Also Kenneth Frampton, op cit., 1992.

124 Among other examples, the Blakeslees cite the extensive work of Hall, op cit., 1969.

125 For relevant discussions and examples of modern regionalism, see Chris Abel, "Regional Transformations," *The Architectural Review* 1077 (1986): 37–43. Also see Kenneth Frampton, *Modern Architecture: A Critical History*, 3rd edition, London: Thames and Hudson, 1992, and Alexander Tzonis, Liane Lefaivre, and Bruno Stagno, *Tropical Architecture: Critical Regionalism in the Age of Globalization*, London: Wiley-Academy, 2001.

126 Abel, op cit., 1981.

127 Chris Abel, "Networking the Studio: Architectural Education and the Virtual Practice," *Environments by Design* 2, no. 1 (Winter 1997/98): 71–85.

128 Living close to the "bush," as Australia's forests are called, has long been part of the national psyche. However, worsening droughts and deadly bush fires now threaten large sections of the population living in small towns and on the edge of cities. Chris Abel, "Death of the Great Australian Dream," *Architectural Review Australia* 109 (2009): 137–8.

129 Gregory Bateson, *Steps to an Ecology of Mind*, NY: Ballantine Books, 1972. Also Bateson, *Mind and Nature: A Necessary Unity*, NY: E. P. Dutton, 1979.

130 See, for example, Jean-Francois Lyotard, *The Postmodern Condition: A Report on Knowledge*, trans. Geoff Bennington and Brian Massumi, Manchester UP, 1984. As Fredric Jameson explains in his foreword, Lyotard's views on aesthetics were much influenced by Paul Feyerabend's "anarchistic" philosophy of science, summed up in the credo "anything goes," as well as by Thomas Kuhn's theory of competing paradigms (Feyerabend, *Against Method*, London: Verso, 1975; Kuhn, op cit., 1962). Jencks also promoted an extreme relativism in architecture in his early writings on postmodernism, but subsequently changed his views in favor of a rejuvenated modernism, influenced by more recent developments in the sciences. For the author's earlier views, see Charles Jencks, *The Language of Postmodern Architecture*, London: Academy Editions, 1975. For the later views, see Jencks, *The Architecture of the Jumping Universe*, London: Academy Editions, 1995.

131 The most recent assessments confirm that, contrary to the arguments of so-called skeptics, scientists have in fact repeatedly underestimated the speed and catastrophic effects of

unchecked climate change. See, for example, Clive Hamilton, *Requiem for a Species: Why We Resist the Truth About Climate Change*, Sydney: Allen & Unwin, 2010.

132 Seventy-nine percent of Australians live in detached dwellings. Moreover, there has been a sharp tendency in recent years toward ever-larger houses on smaller sites, with a consequent loss in garden space and a considerable increase in energy use. At 269.5 square meters, the average size of new homes in the state of New South Wales is now the largest in the country, and possibly the world, exceeding the size of new American houses at 202 square meters. Peter Martin, "The Incredible Colossal Homes: Bigger Than Ever," *The Sydney Morning Herald*, April 1, 2010.

133 For details see David Bridgeman, "Local Hero," *Architectural Review Australia* 111 (2010): 102–9. For more on the work of the practice, see Philip Goad, *Troppo Architects*, Sydney: Pesaro Publishing, 1999. In a lecture in 2008 to architecture students at the University of Sydney, Lindsay Johnston, an award-winning Australian architect and teacher, explained that despite all the energy-saving features he had designed into a former home of his own that he had built on the edge of the city, a professional energy audit revealed that any savings from the design of the house itself were all canceled out by the greenhouse gasses released during the daily commuting by automobile between home, workplace, school, and shops. See also Chris Abel, "Too Little, Too Late? The Fatal Attractions of 'Feel Good' Architecture," *Architectural Review Australia* 092 (2005): 78–81.

134 For Manhattan, see David Owen, *Green Metropolis: Why Living Smaller, Living Closer, and Driving Less are the Keys to Sustainability*, NY: Riverhead Books, 2009. For Hong Kong, see John Sidener, "Creating the Exuberant City: Lessons for Seattle From Hong Kong," *Arcade* XV, no. 4 (1997): 32–5.

135 For examples of high-quality, medium-density apartments in Australia, see Anna Johnson, *Alex Popov Architects: Selected Works 1999–2007*, Balmain: Pesaro Publishing, 2008. For a discussion of new high-density urban forms, see Chris Abel, "The Vertical Garden City: Towards a New Urban Topology," *Journal of the Council for Tall Buildings and Urban Habitat*, issue II (2010): 18–28.

136 Obesity has now overtaken smoking as the leading cause of premature death and illness in Australia (60 percent of adults and 20 percent of children are overweight or obese), creating a healthcare crisis. Despite the negative health effects, which are generally attributed to poor diet and lack of exercise, many of the same people regard their weight as normal. Amy Corderoy, "Obesity is Now More Deadly Than Smoking," *The Sydney Morning Herald*, April 9, 2010.

137 The manipulation of consumers by commercial markets is well documented. See, for example, Michael Shermer, *The Mind of the Market: How Biology and Psychology Shape Our Economic Lives*, NY: Henry Holt, 2008.

138 See Terry Macalister and Tim Webb, "US Military Sees Serious Oil Shortages By 2015," *The Guardian Weekly*, April 16–22, 2010.

PART TWO

modes of aesthetic response
tacit perception and somatic
consciousness

somatics and aesthetics
the role of body in design[1]

galen cranz

INTRODUCTION

Aesthetic experience is available to us not only when looking at works of art. It is also available through direct physical perception in everyday experience. My contribution here is to reinforce this premise from a somatic point of view. Somatics is a relatively new field that builds on the observation that physical sensations, emotional feelings, and cultural conceptions are usually fused. Hence, a somatic perspective contends that aesthetics is part physiological, part emotional, and part cultural, and is an experience that develops long before we learn to look at culturally recognized works of art. Changing any one part of the aesthetic experience necessarily involves transforming the other parts: the body, the emotions, and the intellect. Change itself can be viewed as an aesthetic process, rooted in physiology. To ground this claim, I draw upon my own experience of restructuring the body-mind, physically, emotionally, and cognitively, through the Alexander Technique.

AESTHETICS AND ART DEFINED

The term aesthetics was first used by eighteenth-century philosophy scholar Alexander Baumgarten as "a general theory of sensory knowledge" intended to complement logic in order to produce a complete theory of knowledge.[2] In other words, humans know things through both direct sensation and logical inference. The term is now used more narrowly to describe a theory of fine art, natural beauty, and taste. If we refer to the three layers of the brain—reptilian (pure sensation), mammalian/limbic (social-emotional), and neo-cortex (rational-technical thought)—we can see that the definition of aesthetics has moved to the second and third layers, which encompass mental associations as well as social and political affiliations. For example, knowing who legitimates something as art may have become more important than our direct physical sensations and perceptions. Similarly, liking the same things our friends like or our knowledge of the meaning of the artwork in the history of art might have become more influential than our own direct experience. I revive the older concept of aesthetics rooted in physical experience, sensory knowing, and the body's reptilian brain. Accordingly, in this essay I define aesthetics as referring first to our sensory experience.[3] One can choose to tune into the sensory and the perceptual and let social-emotional and ideational-rational-technical knowledge and awareness recede to the background.

Others have also insisted on retaining the physiological component of aesthetics as its base. The philosopher Terry Eagleton sees the basis of aesthetics as emotion, which is ultimately physical movement.[4] Emotions serve as guides between pure sensation and action; they direct us to turn away from or toward a stimulus. Linguists George Lakoff and Mark Johnson show that all metaphors are based on bodily physical experience.[5] Art educator Burton acknowledges "the presence of the body in art and its pervasiveness in the working of materials."[6] Architect Geoffrey Scott also argued that the basis of architectural experience is in the

body. He defined architecture as "the transcription of the body's states into forms of building."[7] Teachers of the Alexander Technique and other somatic practitioners share this non-dualistic perspective on body-mind and hence cannot divide the aesthetic from the everyday sensory-perceptual experience.

The somatic perspective provides a basis for aesthetic experience that is more profound than one based solely on (visually) experiencing art, depending on how we define art. If art is defined by socially accepted convention as artwork (e.g. a painting), then somatics offers an aesthetic experience that is beyond or outside of art. However, if we define art as intrinsic human development, as does Burton, then somatics is at one with art. Burton argues that "the seeds of image-making lie in infancy, in the first engagements of body and material, and that the embodied origins of imagination and understanding arise from and remain rooted within these and later experiences with materials."[8] Somatic practitioners would agree with her conclusion that "meaning for the maker is constructed out of a dialogue among body, material, and mind."

In contrast to our everyday aesthetic experience, viewing artwork is already one step *removed* from aesthetics, if we define aesthetics as the study of our sensory and perceptual experience. Much of the conventional notion of aesthetics is associational, having to do with meaning, both emotional and cognitive, rather than being first and foremost about sensation and perception. Ideally, a work of art uses sensation and perception at the sub-cortical, pre-verbal layers of our brains to support emotional and cognitive messages. While human perception can never be completely free from cultural shaping, it certainly is prior to, and underlies, the experience of looking at a culturally legitimated painting or sculpture. Conventional notions of aesthetics create a separation between the mundane everyday world and the high aesthetic of painting or the arts. My redefinition integrates the two and allows for an understanding that profound aesthetic experiences can and do exist at the everyday level. In this essay I will discuss several ways in which aesthetic experience is both prior to and can shape works of art and design.

SOMATICS DEFINED

Somatics is a relatively new field (named by Thomas Hanna in 1979) that has emerged from the observation that the physical, emotional, intellectual, and cultural components of experience cannot be separated from one another.[9] Paul Linden has defined somatics as involving "the whole human being, focusing in a practical way on the interactions of posture, movement, emotion, self-concept, and cultural values" (1994). As a term, somatics covers many specialized practices including Trager, Hellerwork, Bonnie Bainbridge Cohen's Body-Mind Centering, Rolfing (also known as Structural Integration), Rosenwork, the Feldenkrais Method, and the Alexander Technique.[10] Linden, who practices aikido and Feldenkrais, offers the example of working with a pianist in a way that required bridging several fields without giving primacy to any one of them.[11] The pianist wanted help because of disabling pain in his upper right arm when he played.

Linden helped him balance his posture, but when asked to play, he tensed his body because he believed that by trying *hard* his playing would have more strength; his attention shifted to his head and hands because he believed the rest of his body was inconsequential to his musical being; and he believed hunching was necessary for jazz improvisation in order to listen for the next notes to play, rather than acknowledging that his musical thought actually came from deep within himself. Once the pianist recognized all of these assumptions, he was able to create a new, balanced, and expansive shape, perform with more power and sensitivity, and reduce the strain on his arm. Linden concludes:

> The pianist came with a legitimate physical trauma, but one that was not treatable medically because it was not really a *physical* problem. It involved numerous cultural, emotional, and spiritual elements. However, it could not have been treatable psychologically because it was indeed a physical problem, and the musculoskeletal analysis was a key to solving it. In actuality, it was a somatic learning problem and only somatic re-education could have solved it[12] [emphasis in original].

SOMATICS AND DESIGN

As a sociologist, designer, and teacher of the Alexander Technique, I have explored somatics (the integrated body-mind-culture educational perspective) as a basis for architectural and product design in the context of a study about the consequences of sitting on chairs.[13] That critique provided the intellectual basis for redesigning a familiar object, the chair, in a way that is both daring and new. In this paper, I seek to generalize the somatic basis of chair design for application in other scales of environmental design. These principles may help the individual designer think in new ways about how the body meets the environment. These principles, discussed below, constitute what I have come to call "body conscious design."

Of course all designers have a body, and we can think about our own physical experience as a basis for empathizing with the imagined users of the designed object, building, or place. Often a designer does start from introspection, looking within the self to gauge the consequences of one design versus another. Surprisingly, this process is not spontaneous or natural; perceiving one's own experience improves with training. Somatic practices (like the Alexander Technique, Body-Mind Centering, or the Feldenkrais Method) can heighten our physical experience by strengthening this awareness and thereby improving design quality, as I will discuss.

THE ALEXANDER TECHNIQUE DEFINED

I focus on the Alexander Technique because it has been called the grandfather of somatic practices[14] and because it is the system of which I have the greatest

knowledge. I started taking lessons in the late 1970s and became a certified teacher of the technique by 1990. The Alexander Technique is a system of posture and movement, developed by a Shakespearean reciter, Frederick Mathias Alexander, in Australia at the end of the nineteenth century. He and the teachers who have followed him have applied the technique therapeutically to those in pain, or for augmentative purposes to those in the performing arts. However, the technique is not first a therapy or art form, but rather, a form of education. It focuses on kinesthetic education—specifically, how we use our bodies.

Teachers of the Alexander Technique prefer the word "use" rather than "posture" because "use" implies movement over time and a pattern of coordination, whereas "posture" may connote a fixed position. Furthermore, the term "use" has a mental as well as physical connotation when referring to how we as persons use our bodies. Thus, the term "use" means overall coordinated use of the body working in concert with thought.[15] Use is shaped by culture, including family, class, shared mores, and technologies (such as shoes, chairs, pens, and laptops).

Because my aim in this paper is to explore the aesthetic implications of somatic practice, grounded in the Alexander Technique, a summary of its major physical and intellectual principles is in order.[16] I will define each principle and then discuss its implications for the design of the environment. Sometimes the design implications will change the near environment, the part that we touch with our bodies, and sometimes they will change larger-scale environments as well.

SOME SOMATIC PRINCIPLES AND THEIR DESIGN IMPLICATIONS

1. The Importance of the Head/Neck/Back Relationship

The scientific basis of the Alexander Technique is that all vertebrates initiate activity with their head. The first principle that a student learns is to "let the neck be free, so that the head can go forward and up and the back can lengthen and widen." This principle, called "primary control," is the focal point of the system.[17] Freeing the connection between head and neck should come first, and then realignments in the rest of the body can follow through adjustments in the spine, pelvis, knee, and ankle joints.

This principle has implications for the design of the near environment. The built environment, especially the common chair, can interfere with the proper coordination of the head, neck, and back. The right-angle seated posture typically rotates the pelvis backward, thereby flattening the lumbar curve. The spine then moves into a "C" shape, and the neck extends forward, but the weight of the head falls back and down onto the neck rather than forward and up, away from the neck. The problems that flow from this pattern include backache, neck ache, problems with vocal production, eyestrain, sciatica, and

Figure 6.1 The back cushions are low enough not to interfere with the windows, but are raised up off the seat level so as to support the lumbar curve at the correct height. If the arc of the bolster were lower, the pelvis would be pushed forward and the spine rounded. The flat upholstered pieces that elevate the round bolsters can be used separately. Note the storage drawers under the *divan* (raised seat against the walls furnished with cushions). Enough floor space is kept clear to allow use of the floor for physical activity. (Source: author.)

shallow breathing. No wonder then that chairs, even the modernist classics that some see as beautiful sculptures, look ugly to me. Rather than sculptural beauty, I see the pain and deformity that is built into most modernist chairs. How can something look good if it doesn't feel good?

The support for sitting needs to be rethought. Taller seats that create an open angle between thighs and trunk are in order, and that in turn requires taller work surfaces for most, but lower ones for others. This requires adjustable work surfaces (e.g. hydraulic table tops), or several different sizes of workstations in homes, offices, libraries, universities, and production lines.

Maintaining a free relationship between the head and neck has implications for how to use the rest of the body. For example, when we bend over to see, read, or pick up an object, we should use what Alexander calls the "position of mechanical advantage." This action sends the knees forward as one pivots over the hips without slumping or curving the spine. Like the "horse" in the martial arts, this position requires using the big hipbones and sockets, rather than the smaller, more delicate neck vertebrae, for bending over to see or reach. Too often we stand without flexing our legs and expect the joint between head and neck to do all the bending, when in fact it should not be opened excessively. Rotated in space, this position becomes a "lounge" position with flexed knees

Figure 6.2 The divan is hinged to allow reading in the preferred lounge configuration of an open angle between thigh and trunk. Reading close to natural light is another benefit; at night recessed lighting in the ceiling offers a full spectrum substitute. (Source: author.)

and the same open angle between thigh and trunk, which is much better than conventional right-angle sitting.

Many workstations, including kitchen and bathroom sinks, do not allow space for the flexed knees to move forward, though this space should be essential. Similarly, many work surfaces are at the wrong height, forcing people to misuse their bodies. Most are two low, but some are too high, which, again, argues for adjustable work surfaces to accommodate people of different heights.

2. *Recognition of the Force of Habit—the Power of the Unconscious— Including Culture*

Because so much of our daily movement is habitual, it is largely unconscious. One of the functions of culture is to provide us with templates for action so we do not have to think deliberately about every move and decision. Both personal habits and cultural practices make us largely unaware of how we move. From a learning point of view, becoming aware of what we do is essential if we seek to change it. We need to acknowledge that changing habits is difficult, and cannot be achieved simply with cognitive understanding. Physical repetition, emotional commitment, and a teacher who is outside of one's subjective pattern are necessary to change lifelong habits.

For chair design, this means that hardware alone is not enough to change undesirable habits like slumping or tensing. Better chairs can help support

better habits, but a refined style of physical education is also required. Imagine an economy based on the exchange of services like massage, kinesthetic education, and design rather than the buying and selling of goods based on planned obsolescence with high social and environmental costs. When more people become somatically educated, they will want chairs that do not impose distortions, and chairs that facilitate movement. Such changes in seating are likely to lead to changes in architecture, as architecture follows human behavioral patterns. For instance, in those cultures where floor sitting is more common than chair sitting, architecture responds by bringing the height of window openings down lower to the floor.

Change is one of the most common reasons for humans to become conscious of something. Hence, borders are more memorable than undifferentiated planes. The fact that consciousness can be stimulated by variety has direct implications for the design of workplaces including individual workstations, nurseries, schools, hospitals, and other healthcare centers. The modernist aesthetic exultation of factory processes, especially repetition and extrusion, would not be a somatic preference. Sensory shifts in material texture, temperature, scent, reverberation, and posture stimulate the experience of presence. Being present means sensing what is happening *now*, not reliving the past or anticipating the future. Worrying about or even luxuriating in the past or future disconnects us from the vividness of the present. Our experience then becomes dull, or fragmented, or anxious. Aesthetics has been called "varied experience," and we need it to feel alive.[18]

3. Acknowledging that We Don't Know What Feels Good

Alexander observed that a person may not be able to tell what is happening in his or her own body because years of improper use has made it impossible to read internal feelings accurately. He called this "debauched kinesthetic awareness." Faulty sensory awareness has direct practical design implications. For a start, it explains why subjective measures of comfort are extremely unreliable. Ergonomic seating researchers have reported that what one person thinks is comfortable will be different from what someone else thinks, and worse, what the same person says is comfortable on one day will not necessarily be what he or she judges as comfortable the next. The ergonomic literature about the subject of comfort, whether subjectively or objectively defined, lacks consensus because this profession has not yet acknowledged *why* feeling is not an accurate guide to action.

Reduced sensory awareness reinforces our general culture's visual dominance, and the visual dominance in design education in particular. It makes us accept discomfort at work, on airplanes, in restaurants, in libraries, and in classrooms.

Because one's *own* experience is not always a reliable guide to action, a designer can closely observe other people's physical behavior in their environments—the ethnographic approach, sometimes known as old-fashioned observation. From a somatic point of view, close observation of what people actually do with their bodies in relation to the designed world can corroborate

or challenge one's own experience and, in either case, inspire new designs. For example, seeing that people often cross their legs when seated helps us appreciate the intrinsic instability and strains of traditional right angle sitting, and points to the need for seating designs based on movement with balls, rockers, and the like. Similarly, watching people slide the pelvis out to the edge of the seat corroborates the importance of the open angle between spine and thigh and suggests tilting the seat pan forward, rather than opening the back, which is the more conventional way to create an oblique angle between spine and thigh.

Faulty kinesthetic awareness can be corrected through somatic education. Teaching somatics to art, architecture, and design students helps them in many ways. Their products become more original and appealing. They develop their sense of three-dimensionality directly through their own bodies. Their empathy for others increases. Furthermore, they develop an authentic base of authority— their own experience.

4. Sending Directions—the Role of Cognition

In order to correct distorted sensory perception, we must cognitively accept a normative standard, derived from scientific analysis of efficient movement. Teachers of the Alexander Technique and other somatic educators base their teachings on the knowledge that the body needs, and will respond to, mental concepts. Thoughts—in particular, intentions—serve as powerful and effective guides to action, without employing force. In this way our aesthetic (sensory-perceptual) experiences have a cognitive component.

Obviously, the physical environment and objects cannot think or send directions, but they were produced by people who designed purposes and attitudes into them. A designer's consciousness sets intentions for the use and experience of a space. Thus, objects carry intentions.[19]

The designed environment can support or interfere with people's ability to sense and carry out correct directions for coordination and alignment. Supporting good use might entail widespread cultural change. For example, humans need to rest their spines rather than droop them when tired, so all places that people use for most of the day should accommodate what somatic practitioners call "constructive rest position." This means having a safe, clean place to lie flat on one's back with knees up. But right now most schools, factories, and offices lack these places. A cultural change is thus in order, and designers can facilitate that change by designing such places. As the movie *Field of Dreams* put it, "Build it and they will come."

Designers must also be aware that any object or environment that distorts the poise of the head, neck, and spine creates stressful movement rather than the reflexive ease of non-doing. Environments need to be evaluated from this point of view. A somatic critique of architectural projects could also ask how many different postures are accommodated in every setting. Options provide opportunities for change, for movement, and for meeting one's individual sensory needs. Another somatic critique could ask about the amount of sensory

stimulation: does the environment offer too much or too little stimulation for the circumstances? What is the sequence of movement? How many senses are addressed? At what level of analysis does a project work—ideational/ideological, institutional, bureaucratic, behavioral, or technical?[20] Does the project make claims to express the ideals of society (like higher learning or justice) through symbolism, but forget to address the psycho-physical level that includes comfortable doorknobs, a place to rest, and clear orientation and way-finding?

Somatic artists share two ideas about the environment with the embodied cognition school of thought: 1) humans off-load cognitive work onto the environment via calendars, writing, and other memory aids, and 2) the environment is part of the cognitive system because the information flow between the two is so dense and continuous.[21] No wonder, then, that the somatic worldview invites us to take everyday living, including our beds, chairs, tables, sightlines, and pathways, seriously. A practitioner must ask, will a standard office setup do? What do you feel if there is no place to lie down, or if you cannot see the outdoors from your seat? If you are a long-legged, tall man, sit in a restaurant in a chair that is too low, should you ask for a fat phone book to sit on? Or if you are a petite woman, should you use that same phone book as a footstool? From a somatic point of view, you would not be accused of being a fussy princess on a pea if you want to get it just right. Rather, you would be a somatic aesthete, literally a connoisseur, one who knows what feels right.

5. Inhibition and Non-Doing

Learning to pause, however momentarily, to deliberately and consciously choose how to respond to a stimulus, is what Alexander called "inhibition." Pausing allows for choice rather than a knee-jerk reflex. Practicing inhibition has nothing to do with being sexually repressed or emotionally inhibited. On the contrary, inhibiting unconscious reactions increases an individual's capacity for choice. Reflexes require no thought, but responses are more considered. Physiologically, humans have a few nano-seconds between a thought and action. Inhibition (or, more simply, "pausing") gives us access to that brief interval. The Alexander Technique allows us to use inhibition to experience directly what feels best, rather than letting the cultural assumptions built into habitual responses prevail. One can choose to inhibit old patterns of interference in order to let the reflexes that make us an upright species reassert themselves.

This special kind of attention to "letting" reflexes reassert themselves is sometimes called "non-doing." (Here one must give a nod to the similarities with Zen philosophy, although Alexander himself allied his work exclusively with scientific reasoning.) Generally when people try to "do" something, they narrow their focus of attention and end up narrowing and compressing their bodies. Non-doing does not mean that one should give up caring to the extent of slumping, collapsing, and losing volume. Non-doing uses a distinct part of the brain where one sees things in perspective and proportion while remaining

alert, in the world, experiencing desire and an interest in things without grasping at them, literally or figuratively. Meditation practices around the world have observed that posture is important to achieving this mental state. Among other requirements, the head-neck joint has to be free and open. Any chair or other arrangement that distorts the poise of the head and spine creates stressful movement rather than the ease of non-doing.

Inhibition requires seeing what is in the moment, now. Paradoxically, the acceptance of what is can lead to change. We can change only by first acknowledging what is. Is there any place for this paradox in the art and design worlds that are necessarily bound up with intentionality and artifice? I think so. In general, artists report and observers concur that the product of work that was done with an attitude of non-doing and attention to process is preferable to work done with a narrow focus on the product and getting it done.

6. Perceptions of The Horizontal, Vertical, and Sagittal Planes Elicit Different Qualities in Human Feeling and Behavior

This principle from Body-Mind Centering complements the Alexander principles. We first experience the horizontal plane as infants on the ground learning to roll from side to side. As adults, when we look from side to side, we connect with others and the environment, evoking feelings of equality. The vertical plane evokes feelings of independence and individuality and helps us to assess our place in the world as we look up and down. The sagittal plane is experienced as forward movement, usually toward a goal. By emphasizing one plane over the other or by keeping them in balance, the architect has a direct influence on mood and behavior. The circular coliseum, the upright tower, and the directional nave would be archetypal expressions of these three planes. These archetypes have been evoked by architecture in service of particular political and religious regimes, but they can always be evoked in the service of new regimes. These developmental phases are universal patterns that evoke our primal common experience as humans.

Another somatic principle is that organs are as powerful, or more powerful, than the musculo-skeletal system because they are developmentally prior to it, bigger, more expansive, and more continuous. In short, contents shape the container.

Applied to the design process this might mean that we could first understand the activities that take place within a space and the life of the inhabitants before starting the designing. We might conceive of the architectural work as the exoskeleton shaped by the social.[22] The most important single idea somatics puts forth is that a person's mind, including emotions and cultural ideas, is embodied physically in his or her body, and the body informs the mind. The idea of embodied cognition has been part of design education in fits and starts since the emergence of the Bauhaus school, and could be more fully developed now that neuroscience is becoming an important influence in our culture.

Figure 6.3 One of the "storage drawers" can be pulled out for use as a coffee table or as a dining table for Japanese-style sitting on the floor on *zabutons* and *zafus*. (Source: author.)

AESTHETICS AND POLITICS

Has aesthetics become completely subordinated to politics? Can artists and architects claim that their motivation to design or draw extends beyond the political? A somatic response is that designers can indeed claim to draw on bodily experience that is prior to or beyond the political, but to do so—that is, to reclaim the body—is itself a political act. It changes the locus of authority. Experience, rather than institutionalized norms, becomes the basis for evaluating good and bad; decision-making in the home, at school, and in the workplace becomes egalitarian rather than authoritarian. Who says a four-year-old should not fidget? Who says we have to show respect for teachers by lining up or sitting still? Who says lying down at work is unprofessional?

Somatic design has political sympathies with the ecological movement. As I have written elsewhere, body-conscious design and ecologically sensitive design interlock comfortably; what is good for the human body is good for the earth. Both social movements "demonstrate respect for the organism—ours and Gaia's."[23] Sustainability could easily be pursued through the lens of the senses: breathe clean air, eliminate foul odors, eat uncontaminated and nutritious food, drink pure water, protect our ears and brains from noise pollution, invite vision to move freely from close to far distance, do not use chemicals that hurt our skin.

Somatic design can also learn from a variety of cultures. The editor of this volume, Ritu Bhatt, asked the question in a conference on aesthetics: "What are the new emerging forms of multicultural aesthetics?"[24] As I see it, a somatic point of view would make greater use of furnishings from around the world—

Figure 6.4 A cushion that rests inside the table can be set on top of it, which converts the table to an ottoman that can be used to create an extension of the divan where two people can lounge. (Source: author.)

firm, planar platforms and floors, along with stools, benches, lounges, and perches.[25] I echo anthropologist Gordon Hewes' call for industrial culture to learn from the developing world in regard to postural variety and the environments needed to support such variety.[26]

Stylistically, the look is open and unlimited. New forms and arrangements could draw on vernacular traditions, such as Turkish raised platforms, low Indian *charpai*, the Japanese floor-oriented *tatami*, the Chinese heated *k'ang*. A rather different stylistic possibility is the high-tech look. Body-conscious design can harmonize with the high-tech emphasis on smooth surfaces and planes. Alternatively, one could use embroideries, vibrant colors, and a variety of textures to create a rich, lush atmosphere. In other words, multicultural styling draws diverse elements together—austere and intellectual, sensual and erotic, comfortable and cozy, old-style corporate and newly-playful corporate. These different looks can be integrated into environments that are first and foremost body-friendly. A fusion of Japanese, Italian, Indian, Turkish, European, and American styles might yield platforms for sitting cross-legged or Western style, bolsters that serve as yoga props, low tables that do double duty as ottomans or benches, floors that provide seating for dining or surfaces for constructive rest and children's play, and *tokomonos* (Japanese niches) for art and sculpture display. Designers can forge a new synthesis of elements from various cultures in response to the needs of each person and each social situation.

POSTSCRIPT

Aesthetics could be said to be a science—the science of how we learn and know through our senses. This return to the root meaning of the term allows aesthetics to become a powerful tool for creating and assessing experience, as opposed to mere superstructure that is subordinate to economics and politics. By using a somatic interpretation of aesthetics—which understands aesthetics as an indivisible blend of sensation, emotion, and knowledge—we can be active agents who chose what is best for each of us.

NOTES

1 An earlier version of this paper was initially presented at the conference "The Aesthetic and the Anti-Aesthetic in Art, Architecture and the Humanities," organized by Ritu Bhatt at the University of California at Berkeley, February 14, 2003.
2 Richard Shusterman, "Somaesthetics: A Disciplinary Proposal," *Pragmatist Aesthetics: Living Beauty, Rethinking Art*, NY: Rowman, 2000, 264.
3 I define aesthetics as focused on sensation and perception, even though I am aware that there is no such thing as pure perception. Sensation is always filtered by perception, which is in turn shaped by cultural experience. The somatic perspective shares with the social sciences the doubt that there really is such a thing as pure perception. Human perception may never be free from cultural shaping. Those who try to get to a state of "pure perception" usually practice for years, if not decades, often in a form we know as meditation. Seeking pure

perception is a discipline, a goal that we may reach in peak experiences. Sensation is prior to perception but hard to notice without the filters of perception.

4 Terry Eagleton, *The Ideology of the Aesthetic*, Cambridge, MA: Basil Blackwell, 1990. Bonnie Bainbridge Cohen, *Sensing, Feeling, and Action: The Experiential Anatomy of Body-Mind Centering*, Northampton, MA: Contact Editions, 1993.

5 George Lakoff and Mark Johnson, *Metaphors We Live By*, University of Chicago Press, 1980. George Lakoff and Mark Johnson, *Philosophy in the Flesh: The Embodied Mind and Its Challenge to Western Thought*, NY: Basic Books, 1999.

6 J. M. Burton, R. Horowitz, and H. Abeles, "Learning in and Through the Arts: Curriculum Implications," *Champions of Change*, ed. Ted Fisk, Washington, DC: Arts Education Partnership, 3.

7 Geoffrey Scott, *The Architecture of Humanism: A Study in the History of Taste*, Constable, London: 1924, 216.

8 Judith M. Burton, "Materials and the Embodiment of Meaning," *Crafts and Education*, Dear Isle, Maine: Haystack Monograph Series, 1999, 3–4.

9 Thomas Hanna, *The Body of Life: Creating New Pathways for Sensory Awareness and Fluid Movement*, Vermont: Healing Arts Press, Healing Traditions International, 1979.

10 I draw especially upon the principles taught by F. M. Alexander about how to improve the quality of bodily experience in ordinary everyday activities, and upon the principles of Body-Mind Centering taught by Bonnie Bainbridge Cohen about how sensation, perception, and action cumulatively shape experience.

11 Paul Linden, "Somatic Literacy: Bringing Somatic Education into Physical Education," *Journal of Physical Education, Recreation and Dance* (September, 1994): 15–21.

12 Ibid.

13 Galen Cranz, *The Chair: Rethinking Culture, Body and Design*, NY: W. W. Norton, 1998.

14 Michael Murphy, *The Future of the Body*, NY: Tarcher, 1993.

15 F. M. Alexander, *The Use of the Self*, Downey, CA: Centerline Press, 1984.

16 Patrick MacDonald, *The Alexander Technique as I See It*, Brighton, UK: Rahula Books, 1989.

17 Alexander, op. cit.

18 Donald W. Fiske and Salvatore R. Maddi, *Functions of Varied Experience*, Oxford: Dorsey, 1961.

19 The agency of non-humans is a premise shared by actor-network theory, also known as the material-semiotic method.

20 Galen Cranz, "Levels of Analysis," *Environmental Design Research: The Body, the City and the Building in Between*, San Diego: Cognella, 2010, 541–8.

21 See en.wikipedia.org/wiki/Embodied_cognition, based on Margaret Wilson's "Six Views of Embodied Cognition," *Psychonomic Bulletin & Review* 9, no. 4 (2002): 625–36.

22 Two other examples are that one side learns from another, and that quality movement is reversible movement.

23 Cranz, op cit., 217–8.

24 Bhatt, op cit.

25 Cranz, op cit., 216.

26 Gordon W. Hewes, "The Anthropology of Posture," *Scientific American* 196, no. 2 (February, 1957): 122–32.

7

the moral dimension
of japanese aesthetics

yuriko saito

After Westernization began in Japan in the late nineteenth century, the discourse on Japanese aesthetics went through several developments. It started with the introduction of traditional Japanese aesthetic concepts and art forms that are considered "purely" or "uniquely" Japanese to the Western world. This introduction was followed by popularizing art forms, such as the tea ceremony, haiku, and martial arts, and aesthetics concepts, such as *wabi* and *sabi*, which celebrate simplicity, rusticity, and sometimes imperfection. Finally and most recently, many scholars started providing a historical context for these developments, particularly by suggesting the link between modern Japanese aesthetics and the formation of nationalism.[1]

Despite these efforts to introduce, popularize, or contextualize Japanese aesthetics, uncharted territories remain. In this chapter I explore one such area: the moral dimension of Japanese aesthetics. Although both the moral and aesthetic dimensions of Japanese culture have received considerable attention by scholars, I do not believe enough work has been done on the relationship between the two. I characterize the long-held Japanese aesthetic tradition as morally-based because it promotes respect, care, and consideration for others, both humans and non-humans. This aspect of Japanese aesthetics has not received much attention, partly because there is no specific term to capture its content. Furthermore, although this moral dimension of aesthetic life is specifically incorporated in some arts such as the tea ceremony and haiku, it is deeply entrenched in people's daily, mundane activities and thoroughly integrated with everyday life, rendering it rather invisible. Similarly, contemporary discourse on morality has not given much consideration to this aesthetic manifestation of moral values, despite the emergence of feminist ethics, ethics of care, and virtue ethics. While they emphasize humility, care, and considerateness, discourses on feminist ethics primarily address actions or persons, not the aesthetic qualities of the works they produce.

Japanese aesthetics suggests several strategies for cultivating moral sensibilities. In what follows, I focus on two principles of design in particular: (1) respecting the innate characteristics of objects and (2) honoring and responding to human needs. Exploring them is important not only for illuminating this heretofore neglected aspect of Japanese aesthetics, but also for calling attention to the crucial role aesthetics can and does play in promoting a good life and society, whatever the particular historical/cultural tradition and artistic heritage may be.

RESPECT FOR OBJECTS

The Japanese aesthetic tradition is noted for its sensitivity to, respect for, and appreciation of the quintessential characters of objects. This attitude gives rise to a guiding principle of design that articulates the essence of an object, material, or subject matter.[2] I will illustrate how Japanese garden design, flower arrangement, haiku composition, and painting, as well as cooking and packaging, embody this attitude.

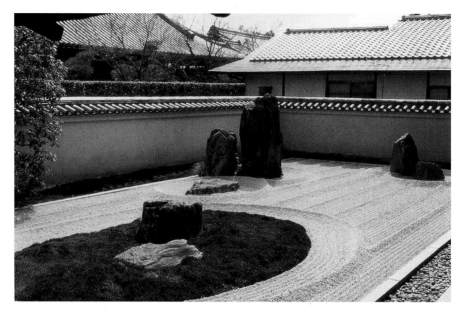

Figure 7.1 The innate characteristics of the main rock determine the placement of the other stones, following the principle of *kowan ni shitagau*. (Source: author.)

Its earliest expression can be found in the oldest extant writing on garden design, *Sakuteiki* (*Book on Garden Making*), written by an eleventh-century aristocrat. The author states that the art of garden making consists of creating *the scenic effect* of a landscape by observing one principle of design: *kowan ni shitagau*, which means obeying the request of an object. Referring specifically to rocks here, this principle suggests that the arrangement of rocks be dictated by their innate characteristics. For example, the gardener "should first install one main stone, and then place other stones, in necessary numbers, in such a way as *to satisfy the request* [my emphasis] ... of the main stone." (Figure 7.1)[3]

In later centuries, the same design strategy extended to the placement and maintenance of plant materials. Instead of allowing their unmitigated growth, inevitable death, or destruction by natural processes, Japanese gardeners meticulously shape and maintain trees and shrubs by extensive manipulation.[4] Unlike topiary in European formal gardens, however, where shapes are imposed on the plant materials regardless of their own characteristics, a tree or a shrub in a Japanese garden is shaped according to its individual form. A fifteenth-century manual, for example, instructs the gardener to "observe the natural growth pattern of the tree, and then prune it *to bring out its inherent scenic qualities* [my emphasis]." The gardener should express the essential features of a particular material through elimination of inessential and irrelevant parts.[5] The whole art-making process here requires the artist to work closely *with*, rather than *in spite of* or *irrespective of*, the material's natural endowments.

Similar principles also govern the art of flower arrangement (*ikebana*), which was elevated to an artistic status during the sixteenth century. While this art

form begins paradoxically by cutting off a living flower or branch, thereby initiating its death, its primary aim is to "let flower live," the literal translation of *ikebana*, or to "let flower express itself" (*ikasu*).[6] This can be achieved by further cutting of branches, leaves, and blossoms so that only the essential parts defining the particular plant can be clearly delineated. One contemporary commentator summarizes that "the ultimate aim of floral art is to represent nature in its inmost essence."[7]

The same design principle applies to the art of representation. For example, in composing a haiku, a 5-7-5-syllable verse form, its founder Matsuo Bashō (1644–94) emphasizes the importance of capturing the essence of nature by entering into and identifying oneself with it. Sometimes referred to as "the slenderness of mind" or "impersonality," the ideal of haiku-making should be object-centered, rather than subject-driven.[8] This attitude is summarized in Bashō's well-known saying: "Of the pine-tree learn from the pine-tree. Of the bamboo learn from the bamboo."[9] When successful, the poet's effort is said to "'grow into' (*naru*) a verse," rather than "'doing' (*suru*) a verse."[10]

The art of painting is also guided by the same principle. As Tosa Mitsukuni (1617–91) claims, a painting should represent "the spirit of the object," rather than providing its exhaustively faithful rendition.[11] Toward this end, the painter can and should omit certain elements, making the overall effect "incomplete" and "suggestive," facilitating more readily the presentation of the essential characteristics of the subject matter, such as bird-ness.[12] Probably conscious of the teachings by Bashō and Mitsukuni, another painter, Tsubaki Chinzan (1800–54), also claims: "Even when painted with black ink, bamboo is bamboo; with red ink, bamboo is also bamboo. If the spirit of bamboo is embodied in the brush, the *ambience* [my emphasis] of bamboo will naturally arise. This is the essence of painting."[13]

This principle for respecting the innate characteristic of an object or material also applies to producing objects of everyday life, including packaging and food.[14] Traditional Japanese packaging materials are designed not only for protecting the content, but also for emphasizing their innate characteristics. The design is suggested by the qualities of the material itself. For example, Japanese paper lends itself to folding, twisting, layering, tearing, and forming into a cord by tight twisting. A bamboo stalk can be sliced into thin strips that are both flexible and strong; they can then be woven. Or it can be cut into sections in order to take advantage of its natural section dividers. Bamboo leaves and bark can be used for wrapping food items because of their thinness and flexibility, as well as their gentle aroma. Similarly, some wood material, such as cedar, imparts a distinct, pungent aroma to a package's contents. Straw can be tied, woven, or bound. Creatively utilizing these native characteristics of the materials, Japanese packaging includes ceremonial envelopes made with layers of folded paper tied with paper cord, bamboo baskets, cedar boxes for pound cake and preserved seafood, bamboo leaf wrappers for *sushi*, and straw strings woven to hang eggs.[15] These designs are not only practical and economical, but they also express an attitude of quiet respect and humility toward the material.

The aesthetics involved in Japanese food, which engages all the senses, is also well known. In addition to various forms of sensory attraction, such as its careful arrangement and choice of container, an important focus of Japanese food is its preparation of the ingredients. In general, each ingredient is manipulated through specific cutting, cooking, seasoning, and mixing so that the best of its inherent qualities can be brought out. For example, fish is sometimes presented without cooking, or grilled whole with a skewer weaving through the length of the body in order to create a wavy shape suggestive of its movement in the water. Various condiments and ornaments, such as herbs, blossoms, leaves, and seaweed, are arranged individually so their individual characteristics are retained and showcased. In *nimono*, a Japanese version of vegetable stew, each vegetable is cooked and seasoned separately to retain its respective color, taste, and texture. They are then arranged carefully in a bowl so that each can be presented in the best light, instead of being dished out as a heap of mixture. The outcome of such labor-intensive fussiness is that each ingredient preserves and expresses its own characteristics, complementing the others, while we the consumers enjoy the symphony with each instrument playing its own tune, as it were.

Taking the Japanese lunchbox as a microcosmic illustration of this Japanese aesthetic sensibility and worldview, Kenji Ekuan, a noted industrial designer, describes its content as follows: "Our lunchbox ... gathers together normal, familiar, everyday things from nature, according to season, and *enhances their inherent appeal*. ... The aim of preparation and arrangement revealed in the lunchbox is to include everything and *bring each to full life* [my emphasis]." In short, the mission of Japanese "culinary artifice" is "to render fish more fishlike and rice more ricelike."[16]

This attitude of respect toward the innate characteristic of objects and materials is not limited to the Japanese aesthetic tradition. We find a similar attitude underlying the late nineteenth-century arts and crafts movement, which extols "truth to materials," initiated by John Ruskin and developed by William Morris.[17] Some contemporary artists, such as David Nash, Andy Goldsworthy, and Michael Singer, also embrace this respectful attitude toward their materials. The environmental artist Alfio Bonamo can be taken as speaking for many of them when he describes the particular challenges and lively tensions that are created by "working ... directly with natural materials ... not knowing exactly where the process will lead you, *feeling and listening to what they have to say*," and trying to maintain "*the essence of its [each component's] identity* (my emphases)."[18]

Whether it regards traditional Japanese arts and crafts or contemporary art projects, this principle of artistic production has an important moral dimension. If pre-requisites for our moral life include understanding, appreciating, and respecting the other's reality, the capacity to experience and appreciate things on their own terms can contribute to nurturing this sensibility. As Yi-Fu Tuan puts it, "one kind of definition of a good person, or a moral person, is that that person does not impose his or her fantasy on another"; instead, such a person is "willing to acknowledge the reality of other individuals, or *even of the tree*

or the rock [my emphasis]" and "to stand and listen."[19] The sensitivity and respect for the objects' essential characteristics, which underlies the attitude toward design and creation discussed above, help to cultivate this moral capacity for relinquishing the power to impose our own ideas and wishes on the other.

Japanese art and design practitioners, for whom their vocation determines their way of life in general, were deeply influenced by Zen Buddhism, transmitted to Japan in the late twelfth century to early thirteenth century by priests Eisai (1141–1215) and Dōgen (1200–53). Its thoroughgoing admonishment of egocentric and anthropocentric viewpoints is summarized by Dōgen as follows: "Acting on and witnessing myriad things *with the burden of oneself* is 'delusion.' Acting on and witnessing oneself *in the advent of myriad things* is enlightenment." He continues, "studying the Buddha Way is studying oneself. Studying oneself is *forgetting oneself*. Forgetting oneself is *being enlightened by all things* (my emphases)."[20] This transcendence of ego is facilitated by our recognizing and overcoming all-too-human schemes of categorizing, classifying, and valuing. Once we succeed, Zen is optimistic about our ability to experience directly the thus-ness or being-such-ness (*immo*) of the other. At this level of direct, unmediated encounter with the raw reality of each object and phenomenon, our ordinary valuation and hierarchy disappear, rendering "a horse's mouth," "a donkey's jaw," "the sound of breaking wind," and "the smell of excrement," equally expressive of their respective realities, or Buddha nature, as other more noble or elegant objects and phenomena.[21] We are thus encouraged to recognize and appreciate a diversity of objects, not just those that we ordinarily enjoy and cherish. Thus, the respectful attitude toward the object, material, or subject matter inherent in the Japanese artists' and designers' practice, guided by the Buddhist transcendence of ego, is not only an aesthetic strategy, but also a moral virtue characterizing enlightenment.

This aesthetic expression of a respectful attitude toward materials also has pragmatic ramifications, particularly today as we struggle to find an alternative to our problematic attitude toward nature. One example is our attraction to natural objects and environments with scenic appeal, resulting in our indifference toward "unscenic" aspects of nature, such as invertebrates, weeds, and wetlands, leaving them vulnerable to destruction. Since aesthetic appeal of an object is a powerful incentive for its protection, many environmentalists, beginning with Aldo Leopold, are concerned with cultivating a different aesthetic sensibility toward those seemingly unattractive aspects of nature.[22] The willingness to cast aside our ordinary standard and expectation of aesthetic values and appreciate each object and material for its own sake can thus contribute to nurturing this sorely-needed sensibility.

There is a further pragmatic benefit in appreciating each natural object on its own terms. Today's designers, who are committed to promoting sustainable design, work on the same principle of listening to and working with the materials. For example, Sim Van der Ryn and Stuart Cowan, early advocates of sustainable architecture, encourage "listening to *what the land wants to be*," rather than imposing a design upon nature irrespective of its own workings and

patterns.[23] The same principle underlies an agricultural practice that mimics the working of the native land, such as the prairie, in designing a sewage treatment system that assimilates wetland, and a program of re-meandering de-meandered streams. Commenting on their river restoration project, Marta González del Tánago and Diego Garcia de Jalón stress the importance of engaging in a "dialogue" with the river, and developing a grasp of "what the river wants to do" and "the aesthetic canon of ecological processes."[24]

These "green designers" often derive inspirations from the moral outlook shared by Taoism and Buddhism. Van der Ryn and Cowan, for example, emphasize the importance of "humility" in design practice and point to Taoism for providing them with a model.[25] Victor Papanek, another early advocate of green design, also recommends that designers "find sorely needed *humility*, [my emphasis]" deriving his own inspiration from Buddhism.[26]

The Japanese aesthetic activities described above are often intended to articulate and enhance the inherent characteristics of materials. This respectful attitude toward the other, in this case the non-human, is valuable not simply for sharpening aesthetic sensibility but also for developing a moral perspective, particularly needed today as we struggle to formulate a morally sound relationship with nature.

RESPECT FOR HUMANS

There is another way in which Japanese aesthetics contribute to moral life: cultivation of a respectful, caring, and considerate attitude toward others, in this case other humans. Of course, cultivating such an attitude toward other humans is not limited to the Japanese tradition. In the Japanese tradition, however, it is often cultivated through *aesthetic* means.

The Japanese practice of expressing one's sensitive, caring, and considerate attitude through artifacts and actions has a long tradition, dating back to the court culture of the Heian period (794–1185). Dubbed the "cult of beauty" by Ivan Morris, Heian aristocrats' lives revolved around communicating their moral status *aesthetically*, as expressed in the composition and writing style of poems, one's attire, and the customs surrounding love-making.[27] Exchanging poems was the primary vehicle of courtship in this culture, and a person's moral worth was assessed aesthetically, not only by the content of the poem but also by its style of calligraphy, choice of paper, accompanying fragrance, and attachment, such as a branch or a flower. Sei Shōnagon, a court lady writing in the tenth century, describes one such courtship letter that "is attached to a spray of bush-clover, still damp with dew, and the paper gives off a delicious aroma of incense."[28] She also contrasts a lover's elegant leave-taking with a clumsy one, criticizing the latter as "hateful." "Elegant" behavior consists of taking time and lingering as he prepares to leave the lady, with wistful longing. In contrast, a man's behavior is "charmless" and "hateful" if he makes a big commotion as he looks for things when getting dressed and hurriedly gets ready for the day; in short, he is concerned only with what he has

to do (get up, get dressed, and leave) with no regard for the lady's feelings. Sei Shōnagon thus declares: "One's attachment to a man depends largely on the elegance of his leave-taking."[29]

It is true that aesthetic choices involved in letter writing and love-making are motivated by one's desire to win the prospective partner's heart. It may also be the case that the specific aesthetic choices, such as the color and fabric combination of a lady's many-layered kimono to indicate her suitability as an object of love, can be dismissed as historical trivia.[30] However, the foundation of such sensibility is the other-regarding nature of aesthetic choices. This requires us to go outside of our ego-oriented world and to put ourselves in the other's shoes by *imagining* what it would feel like to receive a letter written in a certain style and infused with a certain incense, or to see the lover leave with a certain manner after love-making. Action based on imagining what others feel is an indispensable requirement of moral life, not merely a psychological possibility.[31]

This attitude of other-regarding consideration, cultivated by Heian aristocrats, was further enhanced by the subsequent adoption of Zen Buddhism by warriors. I explained in the previous section how the Zen teaching of transcending one's egocentric worldview is manifested in the design strategy of "obeying the request," "entering into," or "listening to" the object, whether it be physical material or subject matter such as a haiku. The same consideration applies to other humans as experiencing agents. The constant admonishment by Zen masters, like Dōgen, to "forget," "overcome," or "transcend" oneself is a reminder that a person's worldview is necessarily limited by her particular viewpoint, whether it is guided by her self, gender, historical/cultural circumstance, or species, and as such, should not be taken as the true or only picture of the world. Other beings have their respective worlds, and enlightenment is possible only when she recognizes this possibility of many worlds and overcomes the tendency to impose her worldview onto others.[32] Recognizing and respecting the other's reality is the starting point for any kind of moral sensitivity.

The best aesthetic expression of a caring attitude toward other humans through such transcendence of one's self is found in the art of the tea ceremony, usually credited for providing the model for civilized behavior and rules of etiquette that are still alive and well in Japan today. The almost excessive fussiness of the host's preparation for the ceremony is guided by the host's desire and obligation to please the guests. This includes not only the obvious, like preparing tea and snacks and choosing the tea bowl, but also such considerations as (1) when to refill water in the stone basin and sprinkle water on plants in the garden; (2) what implements and decorations to choose for providing a cool feeling in the summer and warmth in winter; (3) whether or not to brush off the snow accumulated on trees, rocks, and basins; and (4) how to leave water droplets on the kettle's surface to allow for appreciation of the way they gradually dry over the hearth.[33]

Decisions regarding these minute details are guided by imagining what would make the guests feel most comfortable and entertained. Interpreting *Nambōroku*, the compilation of teachings of Master Sen no Rikyū (1521–91)

by his disciple Nambō Soseki, contemporary commentator Kumakura Isao notes Nanbō's frequent use of the term "*hataraki*," literally meaning "function." Kumakura explains that it refers to the way in which the host's heart and intention are expressed in his body movements, his manner of tea making, and various objects' appearance.[34] Another Japanese philosopher, Hisamatsu Shin'ichi, comments on the moral dimension of tea etiquette: "Inherent in the way of tea is the morality that goes beyond everyday life. Thoughtfulness toward the guest is the foundation of tea manners, which realize this attitude in the formal manner". This heartfelt consideration is both profound and elevated in its moral dimension.[35] What is relevant for our purpose here are not the specifics of the hosts' aesthetic decisions, but rather, the fact that the host's concern for the feelings of guests is expressed through aesthetic means.

Japanese garden design also responds to the visitor's experience, in addition to respecting the innate characteristics of the materials discussed in the previous section. Stepping stones and stone pavements, both ubiquitous features of Japanese gardens, illustrate this attitude most effectively. For example, the selection and arrangement of stepping stones are guided not only by practical considerations, but more importantly, by the desire to provide an optimal aesthetic experience to the visitors.[36] Normally, we seldom take note of the ground under our feet when walking, but in the case of stepping stones in Japanese gardens, the juxtaposition of rocks with differing sizes, shapes, textures, and colors (both when dry and wet) forces us to look down and pay attention. Their variety delights our senses and heightens aesthetic experience. So too does the stark contrast sometimes created by the placement of natural stones with their irregular shape and rough texture alongside geometrically-shaped and smooth-surfaced hewn stones or temple foundation stones and millstones that are reused (Figure 7.2).

Care is also taken to avoid an *impression* of instability, regardless of the actual stability of the stones. This means, among other things, that the *appearance* that the pavement may fall apart must be avoided by making the line-like space between stones to be about 1.5–1.7 cm in width. Furthermore, such line-like space that runs uninterrupted for more than four stones, called "potato vine," should also be avoided because of its impression of looseness.[37] Similarly, in the case of stepping-stones, the space between stones should not run repeatedly in the same direction. Moreover, the side of the stones facing each other should be complementary and "attuned to" each other, such as a convex side responding to a concave side of the next stone, in order to provide a more stable impression. If facing sides are both convex, they appear as if they are repelling each other.

While the choice and arrangement of stepping stones and pavements explained above concern their spatial dimension, their composition also responds to the temporal aspect of our sensual experience by affecting, or sometimes dictating, the sequential order in which our experience unfolds. Some sequences, such as those accentuated by anticipation, surprise, or fulfillment of expectation, are more likely to satisfy us by holding our attention and interest than other sequences characterized, for example, by repetition and monotony.

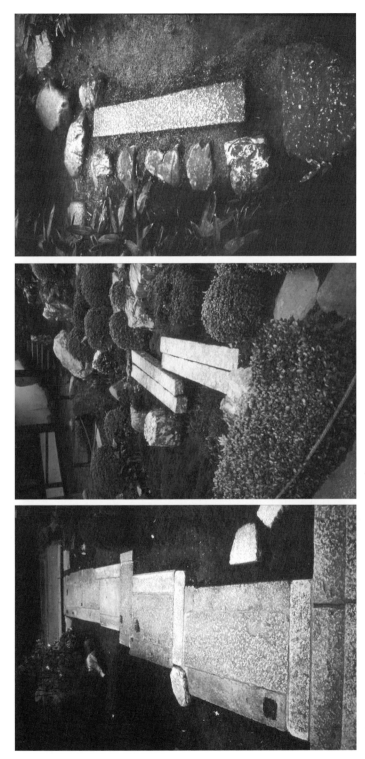

Figure 7.2 Stepping stones not only serve a practical purpose in Japanese gardens but also heighten the aesthetic experience of walking in a garden through their variety and placement. Pathways in Japanese gardens avoid straight lines in favor of meandering walkways, providing a varied view of the garden to enriching the experience of walking. (Source: author.)

One frequently employed strategy for making the walking experience enriching and stimulating is to make the path marked by stepping stones and pavements meandering rather than straight.[38] Stepping stones that use the same kind of stones repeatedly are placed in an almost random-looking manner, encouraging the walker to slow down and savor the constantly and subtly changing view of the garden. Another method of avoiding a straight line is to place long rectangular pavements, planks, or slates in a staggered manner to create a path or a bridge. This avoidance of a strictly straight line is an application of another principle of design articulated in *Sakuteiki*, the principle of *suji kaete*, changing the axis. It originally referred to how a bridge over a pond in the middle of a courtyard garden in an aristocrat's residence must avoid lining up with the axis extending from the center of the building. This design strategy was subsequently generalized for any garden pathways, including bridges and stone pavements. The effect of such an arrangement is that the walker is encouraged to pause and slightly alter the direction in the middle of the otherwise straight path or bridge, which provides a different view of the garden (Figure 7.2).

Sometimes stepping stones are followed by pavement or *vice versa*. While stepping stones generally force us to look down, pavement facilitates easier passage, thus enabling us to look up. This way, the experience of a garden shifts, sometimes focusing downward while other times freeing us to look up and around. This constantly shifting sequential experience, facilitated by the arrangement of stepping stones and pavement stones, is described by one practitioner as "accumulated layers in the garden" and "sensory experience or scenic views layered in space."[39] Our experience becomes a gradually unfolding panorama, a synthesis of multi-perspective views, rather than a one-dimensional and one-directional view. The same practitioner states: "Through careful design of the paths, the gardener controls not only the cadence of motion through a garden but what is seen as well. Paths are not simply an element of the overall plan, but a technique the garden designer utilizes to control how the garden will be revealed."[40]

It is true that stepping-stones made with a variety of stones, meandering paths, and staggered placement in pavements and bridges compromise easy walkability, *if* we are solely interested in getting from point A to point B in the most efficient manner. However, the primary role of Japanese garden paths is to provide a rich multi-sensory aesthetic experience of the objects and environment surrounding the walker, after certain practical requirements, such as safety, are met. These design strategies are calculated to slow down our walk and encourage us to pause and attend to the stone underneath our feet and the subtly changing view of the garden.

I should note, however, that sometimes strict geometry and straight line of pavements *are* favored, when the primary purpose of the walker is not aesthetic enjoyment. Paved paths leading to temple buildings are often straight, composed of geometrically-shaped stones arranged in a stiff and formal manner. Here the purpose of the stone pavement is to help the religious practitioners concentrate on preparing for a religious practice, rather than taking in the rich aesthetic

tapestry of the surrounding environment. The formally arranged stone pavement helps them assume the composure and fortitude required for a rigorous religious discipline.

Another design strategy often employed in Japanese gardens in order to maximize the aesthetic experience is *miegakure*, literally meaning "now you see it, now you don't," sometimes also referred to as "Zen view" by Western designers.[41] This is achieved by intentionally blocking or partially obscuring the scenic view or a tea hut with dense planting, giving us only hints and glimpses. Anticipating a full view excites us and invites us to proceed, and the final, usually sudden, opening of the full vista is quite dramatic. A series of gates found in tea gardens as well as in temple or shrine compounds also accentuate the sequentially ordered spatial experience. Gates make us conscious of the unfolding layer of spaces along the passageway into *oku*, translated as the innermost, the remote depth, or deep recess, invoking a sense of "unwrapping."[42] The choreography of these devices that enhance the temporal dimension of our experience in Japanese gardens can result in stunning effects (Figure 7.3).

These examples indicate that Japanese garden design takes into consideration the desired experience for the garden visitor or religious practitioner. That is, the garden designers empty their own ego and imaginatively experience the space from the visitor's point of view, in addition to paying respect to the materials by honoring their native characteristics. The respectful attitude is directed both to the materials themselves and the people who experience them. Praising the stepping stones in a contemporary garden, one gardener remarks:

> When walking on the stepping stones, I did not feel "I was walking on the stepping stones," but instead I felt that "the stepping stones are gently inviting my legs and directing them forward quite naturally." As I followed the stepping stones, I felt heartened and touched by the maker's warm heart. The maker's thoughtfulness and care was beautifully expressed ... (and) the resulting design bears his considerateness.[43]

Sensitivity to the temporal nature of our experience expressed by spatial arrangement is also a feature of food-serving, as well as packaging. In addition to accentuating the innate characteristic of each material, as noted earlier, the meticulous arrangement of various ingredients invites us to dismantle it by chopsticks one morsel at a time in our desired sequence. Furthermore, the order of eating often has to be selected from several dishes. A typical Japanese meal consists of several dishes, including a bowl of rice, a bowl of soup, a pickle plate, and two or three other plates of vegetables, fish, and meat, all served at once (Figure 7.4). Sometimes in a resort hotel or an upscale Japanese restaurant, dinner is served on one, sometimes two, individual tray table(s), holding so many dishes that we stare at them for a moment before deciding with which plate of food to begin our feast. Even when there is one container holding everything, as in a lunch box, the Japanese version of "fast food," so many ingredients are packed in with thoughtful arrangement that we must also take time to survey the entire box in order to decide on the order of eating.

Figure 7.3 A series of gates creates a sense of "unwrapping," making one conscious of moving along the pathway to *oku*, the innermost space. (Source: author.)

Figure 7.4 A typical Japanese meal involves an assortment of dishes meticulously arranged in sensitivity to one's eating experience. (Source: author.)

The overall effect of such a spatial arrangement is that it accentuates the temporal sequence of the eating experience. The cook's sensibility is reflected in the spatial arrangement on the plate or in the box, which sets the stage for us to compose our own gustatory symphony. Such an experience would not be possible if the food were haphazardly mixed or heaped onto one plate, or, paradoxically, if each dish were served in a Western "linear" manner. Graham Parkes explains:

> Most of the meal is served at one time, rather than course by course as in the West. The advantage of this "nonlinear" way of eating is a remarkably wide range of tastes, as one gradually works one's way through the various combinations of flavors afforded by a large number of small dishes laid out at the same time. ...[44]

Japanese gift packaging is another example of sensitive design attuned to the temporal sequence of the recipient's experience.[45] In addition to the respectful use of the materials discussed in the previous section, Japanese packaging provides an aesthetic experience by inviting us to engage our bodies and to take care and time in unwrapping it. Sometimes the maneuver needed for opening consists of one step: untying the cord made of straw, opening a bag of bamboo sheath, peeling off bamboo wrapping, or removing the lid of a wooden box. However, often more than one step is needed. In Japan, when we receive a gift, sometimes it is wrapped in *furoshiki*, the traditional square-shaped carrying cloth, so the first thing to do is to untie its corners to reveal a gift inside that is also housed in a box. To get at some candies, we may then open a box and untwist the thin paper inside that surrounds the individual candies. A piece of pottery is usually first wrapped in a cloth, then placed in a wooden box with

the potter's signature in calligraphy on the lid, which is then tied by a cloth cord, requiring at least three steps for opening. Finally, when opening a ceremonial envelope containing money, we first have to remove the ornamental paper cord and then carefully open the envelope made with a distinctive fold, only to find another piece of paper that needs to be unfolded. Joy Hendry characterizes these "layers of wrapping" as "a way of expressing *care* for the object inside, and therefore *care* [my emphasis] for the recipient of the object."[46]

Of course other kinds of packages, such as the plastic blister packaging familiar to us today that wraps everything from pens, scissors, and toothbrushes to batteries, also require time (and at times skill or sheer strength!) for us to open, engaging our bodies. However, we normally don't derive an aesthetic satisfaction from opening these packages. One difference between this experience and opening Japanese gift packages is that the task required for the former can be rather taxing, as we wonder whether the thick plastic protecting its content is meant not only to be child-proof but also adult-proof as well. Furthermore, opening these packages sometimes requires tools, such as scissors and a staple remover, whereas opening Japanese gift packages requires only gentle movements of our hands, inviting us to *take care* in opening. Finally, because force is often necessary for opening blister packages, its aftermath is messy: packaging materials are ripped and torn apart. In contrast, Japanese gift packages are aesthetically pleasing after opening because nothing is destroyed, prompting us to save and savor them either for their own sake or for some other use. Although it is possible to destroy those Japanese gift packaging materials just as we destroy plastic bubble packaging, we are led to feel that the respectful sensitivity toward the material and the recipient embodied in the beautiful packaging requires reciprocal respect and sensitivity on our part during and after opening.

Care and sensitivity evident in the design of Japanese packaging, aesthetically manifested, carries over to an unlikely dimension of everyday life: disposal of garbage. A Japanese manual for non-Japanese business people, for example, when discussing "aesthetics and perfectionism," notes that: "When eating a mandarin orange, many Japanese will remove the peel in one, unbroken piece, and place segment membranes inside the outer peel, so that the leftover materials end up in a neatly wrapped little package."[47] I find the same sensibility underlying this familiar practice in the way my parents stuff their garbage bags for pick-up. Because their municipality mandates that garbage bags be transparent, they try to hide the unappetizing-looking content, such as food debris, by using innocuous-looking garbage, such as unrecyclable plastics and papers, as a buffer between the bag and the food debris. (In Japan, unlike in the United States, the garbage bags are placed in a designated community spot.) This seemingly superfluous gesture is motivated by their thoughtfulness in not giving an unpleasant visual experience to the neighbors and passersby, even for a short time.[48]

Finally, some of today's cutting-edge design practices in Japan also continue this tradition of other-regarding consideration. For example, Kenya Hara, a contemporary designer well-known as the director of MUJI ('no mark') design group, relates his thoughts on emptiness:

"Emptiness" (*utsu*) and "completely hollow" (*karappo*) are among the terms I pondered while trying to grasp the nature of communication. When people share their thoughts, they commonly listen to each other's opinions rather than throwing information at each other. In other words, successful communication depends on how well we listen, rather than how well we push our opinions on the person seated before us. People have therefore conceptualized communication techniques using terms like "empty vessel" to try to understand each other better.[49]

A similar point is made by his designer colleague at MUJI, Naoto Fukasawa, who also claims: "If a designer believes that people and time have created a form, then they want to *get rid of the ego* [my emphasis] that says, 'I designed this object.'"[50]

Of course, this other-regarding attitude toward materials and people is hardly unique to Japanese tradition. Particularly in the field of design today, there is an increasing attention to and call for "care" and "thoughtfulness," paralleling the aforementioned demand for respect for nature and materials. It is noteworthy that such a plea is a reaction against the prevailing design process, which the designers themselves admit has not paid enough attention or respect to the experiences of users and inhabitants. They take recent designs to task for exuding the qualities of "ego trips," such as "arrogance," "narcissism," "impudence," "formal authority," and "showiness."[51] Himself an architect, Juhani Pallasmaa criticizes the contemporary architectural profession as encouraging the super-stardom of individual "geniuses" whose creations exist for the sake of self-aggrandizement, alienating the users and inhabitants.[52] Similarly, Victor Papanek writes that designers and architects tend to think of themselves as artists whose mission is to make artistic "statements." As a result, he observes that "a good deal of design and architecture seems to be created for the personal glory of its creator."[53] Van der Ryn and Cowan express a similar sentiment by criticizing the architect in Ayn Rand's *The Fountainhead*, depicted as a hero committed to the "'pure' process" that is not "'contaminated' by any real-world constraints or needs: social, environmental, or economic."[54]

These critics offer an alternative model of the design process that reflects other-regarding attitudes, such as "courtesy," "responsiveness," "humility," "patience," and "care." These qualities are embodied in an appropriate size for humans, with a spatial arrangement sensitive to the bodily-oriented experience as well as its temporal sequence, and design features that are simply delightful to the senses. Resulting design not only provides a positive aesthetic experience, but also leads to a pragmatically serious consequence, such as a healthy environment instead of a "sick" building. The degree of healthfulness is commensurate with the way in which our sensory experience is affected. For example, consider the recently emerging "green" buildings that utilize the benefits of such sustainable materials as sunlight, fresh air, breeze, rain water, and vegetation. Such a building "honors" the senses, one critic points out, and it is "comfortable, humanising and supportive," "healthy and healing," "caring for the environment," "nourishing to the human being"; in short, it is where

we feel "at home."[55] Humans are sensory as well as conceptual creatures, and designing and creating objects and environments that respect the users and inhabitants would necessarily have to respond to their bodily experiences. Papanek quotes the adept Zen teaching to "think with the whole body," and reminds us that "we need to come to our senses again."[56]

The aesthetic value of designed objects and built environments that respond to our multi-sensory and temporary sequential experiences is not only in the enhancement of pleasure. It also communicates a moral attitude affirming the importance of others' experiences. "Good design," Donald Norman writes, "takes *care*, planning, thought," and "*concern* [my emphasis] for others."[57] Similarly, in discussing the importance of "care" in architecture, Nigel Taylor points out that a building that appears to be put together thoughtlessly and carelessly, without regard to our experience as users or its relationship to its surroundings, "would offend us aesthetically, but, more than that, part of our offense might be ethical. Thus we might reasonably be angered or outraged, not just by the look of the thing, but also by the visible evidence that the person who designed it didn't show sufficient *care* [my emphasis] about the aesthetic impact of his building."[58] He cites Roger Scruton's discussion of "appropriateness" as a criterion of architectural criticism, which Scruton calls "an embodiment of moral thought." Commenting on Scruton's praise of a railway wall in London, Taylor points out that "the anonymous designers of this wall *cared* about the wall they designed" and "'caring' is a moral concept." He concludes by stating that "to care like this for how something looks, and thereby for the people who will look at it, is to exhibit not just an aesthetic but also a moral concern. Or rather, it is to exhibit an aesthetic attentiveness which is itself moral."

We should note that this other-regarding attitude expressed aesthetically, whether in traditional Japanese culture or today's design practice, requires a corresponding sensibility on the part of those who experience the object to recognize and gratefully appreciate the sensitivity and considerateness embodied in the object and the act of producing it. As noted earlier, a beautifully and thoughtfully wrapped gift encourages respect and care in opening it. The aforementioned manual for people doing business in Japan correctly advises that "if the situation makes it desirable for the receiver to unwrap the gift, he or she will do so carefully, keeping the wrapping paper in a hypothetically reusable condition before admiring the gift. This derives from a concern for appearance as well as *an expression of gratitude to the giver*."[59] Writing in the same vein on the etiquette of eating a Japanese meal, the author first establishes the cardinal principle of etiquette: "The most important rule is to be grateful for the cook's thoughtfulness and consideration … and to humbly acknowledge the cook's sincere heart while savoring the food. … Failure to do so would not only diminish the taste but also ignore the thoughtfulness of the host."[60] Of course, "thanks-giving" for food is hardly unique to Japanese culture, but in Japan this "thanks-giving" is not simply directed toward the nourishment provided by the prepared food, but also toward its sensuous dimension.

From the Japanese aesthetic point of view, a person who rips apart a beautifully wrapped gift or gobbles up a Japanese lunch-box meal without

savoring each ingredient is considered not only deficient in aesthetic sense and manner but also lacking in moral sensibility. In this sense, thoughtful design, such as Japanese gift package and food presentation, functions as a vehicle of communication. Communication here, however, is not that of a certain emotion, idea, ideology, or religious feeling, as in the communication or expression theories of art espoused by Tolstoy and Collingwood. It is rather a moral virtue, such as thoughtfulness and consideration, conveyed and acknowledged through specific design features. In order for this communication to occur, the experiencing agent must possess both a keen aesthetic sensibility and a moral capacity to gratefully acknowledge, and reciprocate, the consideration and respect conveyed aesthetically.

In all of these examples, the distinction between the aesthetic and the moral is blurred. A person's aesthetic sensibility, whether in providing or receiving an aesthetic experience, can be an important measure of his or her moral capacity. The aesthetic considerations in our lives are thus neither mere dispensable luxuries nor, to borrow Yrjö Sepänmaa's phrase, "high cultural icing."[61] Nor are they confined to works of fine arts that tend to encourage or facilitate our disengagement from everyday life. Rather, promotion of and support for sensitively designed objects and environments is an indispensable ingredient of what Sepänmaa calls "aesthetic welfare."[62] He points out that a true welfare state should guarantee not only "health care, education, and housing," but also "an experiential aspect of welfare. An aesthetic welfare state should offer a beautiful living environment and a rich cultural and art life" because they provide "the basic conditions of life." Such environments and artifacts provide an experientially verifiable indication that people's needs and experiences are taken seriously and responded to with care. They exemplify moral qualities such as respect, care, sensitivity, and considerateness through their color, texture, size, arrangement of parts, smell, and acoustics. To the extent that these moral qualities are expressed by sensuous means, it is an aesthetic matter, and cultivating those moral virtues aesthetically, I believe, is as important as practicing them through our actions.[63]

Care, respect, sensitivity, and consideration toward the other, whether human or non-human, should be the moral foundation of a good society, as well as a good life. Being able to enjoy the ease, comfort, and aesthetic pleasure provided by artifacts induces a sense of belonging. It confirms that our needs, interests, and experiences are important and worthy of attention. In turn, it encourages us to adopt the same attitude toward others, not only in our direct dealings with them, but also in creating an environment that is reflective of care, thoughtfulness, and mindfulness.

People surrounded by poorly and wantonly designed artifacts will despair that nobody pays attention to or cares about their experiences. They will be demoralized and feel that it does not make any difference if they remain indifferent and insensitive to other's experiences. "Why bother? Nobody else seems to care," they would say.[64] This attitude is not conducive to developing moral sensitivity and civility. Or, alternatively, they might be spurred on to become activists for cleaning up the surroundings and promoting more humane

environments and better artifacts. If they react in this second way, it is because they feel that the creation of an aesthetically sound environment and artifacts is an important social agenda.

Concern for aesthetics in our everyday lives is neither frivolous nor trivial. It has a close connection to the moral dimension of our lives. Marcia Eaton points out that, ultimately, there is a "connection between being a person who has aesthetic experience and being a person who has *sympathies and insights of a kind required for successful social interaction* [my emphasis]."[65] Finally, Arnold Berleant characterizes a "humane" urban environment as one that "assimilates human perceptual characteristics, needs, and values to a functional network of human dimensions, that engages our imaginative responses, that symbolizes our cultural ideals and evokes our unspoken understanding, ... that, in short, enlarges the range, depth, and vividness of our immediate experience."[66] He then observes that "such an urban environment acts at the same time as an aesthetic one" and points out that in this instance "the moral and the aesthetic join together." Japanese aesthetics provides a rich tradition and diverse examples of this morally-sensitive dimension of our aesthetic lives.[67]

NOTES

1 This paper originally appeared in *The Journal of Aesthetics and Art Criticism* 65, no. 1 (Winter 2007): 85–97. I have revised it according to the theme of this anthology. I explore this modern development of Japanese aesthetic discourse in more detail in the original journal article.

2 I explore this aspect of Japanese aesthetics further in "Representing the Essence of Objects: Art in the Japanese Aesthetic Tradition," in *Art and Essence*, eds. Stephen Davies and Ananta Ch. Sukla, Westport: Praeger, 2003, 125–41.

3 Tachibana-no-Toshitsuna, *Sakuteiki: The Book of Garden-Making, Being a Full Translation of the Japanese Eleventh Century Manuscript: Memoranda on Garden Making attributed to the Writing of Tachibana-no-Toshitsuna*, trans. S. Shimoyama, Tokyo: Town & City Planners, 1985, 20. The other places with reference to the notion of "obeying the request" are 7, 10, and 13. I explore this principle of Japanese garden design in "Japanese Gardens: The Art of Improving Nature," *Chanoyu Quarterly* 83 (1996): 40–61.

4 The methods of manipulation include pruning, clipping, shearing, pinching, plucking, using various gears such as wires, ropes, poles, and weights, and even the application of retardant to stunt the growth of some parts.

5 Zōen, *Illustrations for Designing Mountains, Water, and Hillside Field Landscape*, trans. D. A. Slawson, in D. A. Slawson, *Secret Teachings in the Art of Japanese Gardens: Design Principles, Aesthetic Values*, Tokyo: Kodansha International, 1991, Sec. 56. Allen Carlson uses the expression "a look of inevitability" to refer to this design principle for the Japanese garden ("On the Aesthetic Appreciation of Japanese Gardens," *British Journal of Aesthetics* 37, no.1 (January 1997): 47–56). It is interesting to note that William Morris refers to the same term in his instructions on how to design a pattern after a plant: "above all, pattern, in whatever medium, should have the inevitability of nature." (William Morris, "Textiles," in *Arts and Crafts Essays*, originally published in 1893, Bristol: Thoemmes Press, 1996 (reprint), 36.

6 For the paradox involved in the art of *ikebana*, see Ryosuke Ohashi's entry on "Kire and Iki" in *Encyclopedia of Aesthetics*, ed. Michael Kelly, NY: Oxford UP, 1998, vol. 2, 553. Throughout this paper, for Japanese names, I will follow the custom of putting the family name first, *unless* the writing is in English, as in the case here.

the moral dimension of japanese aesthetics

7 Makoto Ueda, *Literary and Art Theories in Japan*, Cleveland: Case Western Reserve UP, 1967, 86.

8 Makoto Ueda explains this notion of impersonality as follows:

> The poet's task is not to express his emotions, but to detach himself from them and to enter into the object of nature. A pine tree has its own life, so a poet composing a verse on it should first learn what sort of life it is by entering into the pine tree: this is the only way by which he can learn about the inner life of the pine. (Ueda, op. cit., 158)

9 Recorded by Bashō's disciple, Hattori Dohō, in *The Red Booklet*, first published in the eighteenth century, trans. Toshihiko and Toyo Izutsu, in Toshihiko and Toyo Izutsu, *The Theory of Beauty in the Classical Aesthetics of Japan*, The Hague: Martinus Nijhoff Publishers, 1981, 162–3.

10 Ibid., 134. "Doing" a verse is an awkward expression, but it is the literal translation of the original term, *suru*, and the translators gave a literal translation, which I am using here. "Making" or "composing" a verse will be a better term to use insofar as English is concerned.

11 Ueda, op. cit., 137.

12 Ibid., 138–9. Ueda explains Mitsukuni's view by stating that "the painter can give spirit to his painting only by *growing into the object of the painting himself*—that is to say, by *identifying his spirit with the spirit of the object*" in his painting" (138, emphasis added).

13 Tsubaki Chinzan, *Chinzan Shokan (Correspondence of Chinzan)*, from the nineteenth century, my translation, in *Nihon no Geijutsuron (Theories of Art in Japan)*, ed. Yasuda Ayao, Tokyo: Sōgensha, 1990, 251.

14 I explore the aesthetics of Japanese packaging further in "Japanese Aesthetics of Packaging," *The Journal of Aesthetics and Art Criticism* 57, no. 2 (Spring 1999): 257–65.

15 The discussion here is best accompanied by the visual images from Hideyuki Oka's *How to Wrap Five Eggs: Japanese Design in Traditional Packaging*, NY: Harper and Row, 1967, and *How to Wrap Five More Eggs: Traditional Japanese Packaging*, NY: Weatherhill, 1975, as well as from *Package Design in Japan*, ed. Shigeru Uchida, Köln: Benedikt Taschen Verlag, 1989.

16 Kenji Ekuan, *The Aesthetics of the Japanese Lunchbox*, translated by Don Kenny, Cambridge: The MIT Press, 2000, the long passage from page 6 and the "fishlike ... ricelike" passage from page 77. Short of allowing readers to actually experience the Japanese lunchbox, Ekuan's book offers abundant photographic images of Japanese lunchboxes, as does *Ekiben: The Art of the Japanese Box Lunch* by Junichi Kamekura et al., San Francisco: Chronicle Books, 1989. Kamekura shows not only the food arrangement but also various forms of packaging for box lunches sold on train stations. This Japanese design principle of respecting and taking advantage of the materials' native characteristics is not limited to more traditional, natural materials. Contemporary designers apply it to new materials. For example, Tadao Andō's architecture often emphasizes the concrete-ness of concrete, while Issey Miyake, in his apparel design, explores synthetic materials and rubber.

17 For discussion of the moral/aesthetic principle of "truth to materials," see Nigel Whiteley, "Utility, Design Principles and the Ethical Tradition" in *Utility Reassessed: The Role of Ethics in the Practice of Design*, ed. Judy Attfield, Manchester UP, 1999; Nigel Whiteley, *Design for Society*, London: Reaktion Books, 1993; Gillian Naylor, *The Arts and Crafts Movement: A Study of Its Sources, Ideals and Influence on Design Theory*, Cambridge: MIT Press, 1971.

18 Alfio Bonanno, *et al.*, "Materials," in *Ecological Aesthetics: Art in Environmental Design: Theory and Practice*, ed. Heike Strelow, Basel: Birkhäuser, 2004, 96 and 98.

19 Yi-Fu Tuan, "Yi-Fu Tuan's Good Life," *On Wisconsin* 9 (1987). I develop the aesthetico-moral implication of this view as it applies to nature appreciation in "Appreciating Nature on Its Own Terms," *Environmental Ethics* 20 (1998): 135–49.

20 Dōgen, *Shōbōgenzō: Zen Essays by Dōgen*, trans. Thomas Cleary, Honolulu: Hawaii UP, 1986, 32.

21 The specific examples of a donkey's jaw and a horse's mouth come from the chapter on Busshō ("Buddha Nature"), the sound of breaking wind and the smell of excrement from the chapter on Gyōbutsu Iigi ("The Dignified Activities of Practicing Buddha") from *Shōbōgenzō:*

The Eye and Treasury of the True Law by Dōgen Zenji, trans. Kōsen Nishiyama, Tokyo: Nakayama Shobo, 1975.

22 I explore this challenge to environmental aesthetics in "The Aesthetics of Unscenic Nature," *The Journal of Aesthetics and Art Criticism* 56, no. 2 (Spring 1998): 101–11.

23 Sim Van der Ryn and Stuart Cowan, *Ecological Design* (Washington, DC: Island Press, 1996), 35.

24 Marta González del Tánago and Diego Garcia de Jalón, "Ecological Aesthetics of River Ecosystem Restoration," in Strelow, op. cit., 192.

25 Van der Ryn and Cowan, op. cit., 7 and 136. Zen Buddhism incorporates many aspects of Taoism.

26 Victor Papanek, *The Green Imperative: Natural Design for the Real World*, NY: Thames and Hudson, 1995, 12. This attitude underlying ecological design raises an important question, which I will simply mention without trying to answer. How can one decipher "what the river wants to do" and "what the land wants to be"? These metaphorical expressions need to be supported by riparian hydrology and prairie ecosystem studies, so specific design strategies can be formulated. Whether such knowledge comes from formal scientific investigation or local wisdom accumulated over many generations, it is based upon some kind of human organizational scheme.

27 Ivan Morris, *The World of the Shining Prince: Court Life in Ancient Japan*, NY: Kodansha International, 1994, Chap. VII. Also see Donald Keene's "Feminine Sensibility in the Heian Era," *Japanese Aesthetics and Culture: A Reader*, ed. Nancy Hume, Albany: SUNY Press, 1995, 109–23.

28 Sei Shōnagon, *The Pillow Book of Sei Shōnagon*, trans. Ivan Morris, Hammondsworth: Penguin Books, 1981, 62. Readers learn the extent to which these aesthetic concerns permeated the aristocrats' daily life by the description of a fictional princess who rebelled against them. This "lady who admired vermin" in *Tsutsumi Chūnagon Monogatari* (*The Riverside Counselor's Stories*), written between the end of the Heian period and the beginning of the Kamakura period that marks the age of warriors, is depicted as breaking all the codes of proper behavior in aesthetics. She uses "very stiff and coarse" paper on which she writes poems full of imagery of "vermin and caterpillar fur" with *katakana* script that is more angular and reserved for male courtiers and monks rather than "the beautifully flowing *hiragana*" script. Her attire and appearance are also the opposite of what were considered to constitute feminine beauty at this time. See pages 63–4 of Michele Marra's *The Aesthetics of Discontent: Politics and Reclusion in Medieval Japanese Literature*, Honolulu: Hawaii UP, 1991.

29 Sei Shōnagon, op. cit., 49. During Heian period, female aristocrats were supposed to remain hidden inside their residence or inside a carriage, allowing only a glimpse to the male suitors. This required the male suitor to gain entry into the lady's residence as well as her heart, by showing his aesthetic sensibility in poems. Even after the relationship began, couples never lived together and the man had to commute to her place for the night of love-making. This makes the time of morning leave-taking another test of his moral-aesthetic sensibility. In a way, when it came to love affairs and setting the aesthetic standard, women at this time had an upper hand.

30 For this point, see page 222 of Liza Crihfield Dalby's *Kimono: Fashioning Culture*, New Haven: Yale UP, 1993, and 194–5 of Morris, op. cit.

31 I thank the editor and anonymous referees of *The Journal of Aesthetics and Art Criticism* for pointing out that what is important is the exercising, rather than the mere possession, of such capacities.

32 Dōgen repeatedly points out that "we see and comprehend only what the power of *our* eye of contemplative study reaches" (Dōgen, *Shōbōgenzō: Zen Essays by Dōgen*, 34, emphasis added) and that the human experience of the world is one among many possible worlds, which today can be rephrased as denying the primacy of an anthropocentric viewpoint. See also pages 70, 93, and 96 for the same point.

33 These items were culled from remarks scattered throughout *Nanbōroku* in *Nanbōroku wo Yomu* (*Reading Nanbōroku*), ed. Kumakura Isao, Kyoto: Tankōsha, 1989.

34 Kumakura, op. cit., 242.

35 Hisamatsu Shin'ichi, *Sadō no Tetsugaku* (*The Philosophy of the Way of Tea*), Tokyo: Kōdansha, 1991, my translation, 53–4. By "formal," he means sensuous, rather than the contrary of "informal" or "casual." Eiko Ikegami makes a sociological interpretation of the social and political role served by the aesthetic expression of hospitality, sociability, and civility in the tea ceremony and other traditional Japanese arts in *Bonds of Civility: Aesthetic Networks and the Political Origins of Japanese Culture*, Cambridge UP, 2005.

36 Some of the practical considerations are as follows. For obvious reasons, relatively flat-surfaced stones must be chosen. In particular, concave surface should be avoided, as they retain water and can be messy or dangerous when frozen. To provide easy movement, a stride should be calculated a little shorter than the usual ergonomic measurement, because walking on stepping stones is by necessity slower and more measured. The space between stones should not be too wide, because it will force the walker to stretch too much or jump, hence making the pathway dangerous, particularly when the stone surface is slippery from rain or snow. By the same token, the stone should be set with roughly 3–4 cm above ground, high enough to provide protection from muddy soil while low enough to prevent tripping. Because traditional Japanese footwear includes *geta*, wooden sandals, stones should not be too hard, in order to soften the sound of footsteps, while at the same time they cannot be soft like sandstone and tuff, either, because they have to withstand being constantly stepped on. For these reasons, andesite is generally regarded as the best material. Finally, for the so-called pivotal stone which indicates the juncture of two separate paths, a large stone is chosen so the walker can pause, look around, and decide on which path to pursue.

37 Katsuo Saito and Sadaji Wada, *Magic of Trees & Stones: Secrets of Japanese Gardening*, NY: Japan Publication Trading Company, 1970, 49.

38 It is interesting to note that William Hogarth's explanation of designating a serpentine line as the line of beauty refers to the fact that it "leads the eye a wanton kind of chace." *The Analysis of Beauty* (1753), in *A Documentary History of Art*, ed. Elizabeth G. Holt, Garden City: Doubleday, 1958, vol. II, 271.

39 Marc Peter Keane, *Japanese Garden Design*, Rutland: Charles E. Tuttle, 1996, 172.

40 Ibid., 143.

41 Donald A. Norman, *Emotional Design: Why We Love (or Hate) Everyday Things*, NY: Basic Books, 2004, 109–10. He derives his discussion of "Zen view" from Christopher Alexander et al., *A Pattern Language: Towns, Buildings, Construction*, NY: Oxford UP, 1977, 642–3.

42 See Fumihiko Maki's "Japanese City Spaces and the Concept of *Oku*," *The Japan Architect* 264 (1979): 50–62 on the discussion of the concept of *oku*. A good general discussion and various examples of *oku* can be found in Joy Hendry's *Wrapping Culture: Politeness, Presentation and Power in Japan and Other Societies*, Oxford: Clarendon Press, 1993.

43 Ryūkyo Teien Kenkyūsho, *Arukukoto ga Tanoshikunaru Tobiishi Shikiishi Sahō* (*How to Make Stepping Stones and Pavement for Enjoyable Walking*), Tokyo: Kenchiku Shiryō Kenkyūsha, 2002, 71 (my translation).

44 Graham Parkes, "Ways of Japanese Thinking," in Hume, op. cit., 80.

45 The examples discussed here are primarily types of gift packaging, not packaging for everyday items that we buy for ourselves, such as pens, toothpaste, noodles, coffees, and the like. However, Japan is a gift-giving culture. In addition to two annual gift-giving seasons, the Japanese give gifts for every conceivable occasion; hence, gift packaging does not occupy a special place in people' lives. Its frequency and prevalence make it a common occurrence for everyone.

46 Hendry, op. cit., 63.

47 Yasutaka Sai, *The Eight Core Values of the Japanese Businessman: Toward an Understanding of Japanese Management*, NY: International Business Press, 1995, 56.

48 This other-regarding sensitivity expressed in design is not free from criticism. In comparing Japanese and Western automobile designs, designer Hara Kenya admits that the former invites the criticism that it lacks strong self-expression and manufacturers' passion because it is made to accommodate Japanese consumers' desires, rendering it warm, kind, and obedient. However, ultimately he is more critical of European and American design for being

"egotistical" and "selfish." See Hara Kenya, *Dezain no Dezain* (*Design of Design*), Tokyo: Iwanami Shoten, 2003, 133–4.

49 Kenya Hara, *White*, trans. Jooyeon Rhee, Baden: Lars Müller Publishers, 2010, Prologue.

50 Naoto Fukasawa and Jasper Morrison, *Super Normal*, trans. Mardi Miyake, Baden: Lars Müller Publishers 2008, 116.

51 These terms are culled from Juhani Pallasmaa, "Toward an Architecture of Humility," *Harvard Design Magazine* (Winter/Spring 1999), Van der Ryn and Cowan, op. cit., and Papanek, op. cit.

52 Pallasmaa, op. cit.

53 Papanek, op. cit., 203.

54 Van der Ryn and Cowan, op. cit., 147.

55 David Pearson, "Making Sense of Architecture," *Architectural Review* 1136 (1991): 70.

56 Papanek, op. cit., 76 and 104.

57 Donald A. Norman, *The Design of Everyday Things*, NY: Doubleday, 1990, 25 and 27.

58 Taylor, op. cit. 201–2. Citations in the next three sentences are from pages 203, 205, and 205.

59 Sai, op. cit., 57.

60 Shiotsuki Yaeko, *Washoku no Itadaki kata: Oishiku, Tanoshiku, Utsukushiku* (*How to Eat Japanese Meals: Deliciously, Enjoyably, and Beautifully*), Tokyo: Shinchōsha, 1989, 12. The awkward, but literal, translation of the title is mine.

61 Yrjö Sepänmaa, "Aesthetics in Practice: Prolegomenon," in *Practical Aesthetics in Practice and in Theory*, ed. Martti Honkanen, Helsinki: University of Helsinki, 1995, 15.

62 Ibid., 15. The next three passages are also from page 15.

63 Tangible examples of "aesthetic welfare" can be seen in a number of projects by Auburn University's Rural Studio. Building or restoring structures in one of the most impoverished communities in the United States, the students have to make do with low or non-existent budgets, forcing them to come up with creative solutions by reusing available materials. However, instead of the cheap and crude-looking structures that are common among impoverished communities, their efforts often result in stunning structures that also respond sensitively and humanely to the residents' and communities' needs and lifestyles. Those structures embody respect and celebration, rather than a patronizing attitude, toward the economically disadvantaged residents' humanity and dignity. Descriptions and photos of their projects are compiled by Andrea Oppenheimer Dean and Timothy Hursley in *Rural Studio: Samuel Mockbee and an Architecture of Decency*, NY: Princeton Architectural Press, 2002 and *Proceed and Be Bold: Rural Studio After Samuel Mockbee*, NY: Princeton Architectural Press, 2005.

64 This may happen in a run-down neighborhood where there is no attempt at clean-up or beautification either by the residents themselves or the municipality.

65 Marcia Muelder Eaton, *Aesthetics and the Good Life*, Rutherford: Fairleigh Dickinson UP, 1989, 175.

66 Arnold Berleant, *The Aesthetics of Environment*, Philadelphia: Temple UP, 1992, 80. The next two passages are also from 80.

67 I thank the editor and anonymous referees of *The Journal of Aesthetics and Art Criticism* for their helpful comments on the original paper. I also thank Steve Rabson for editing the final version for the journal article, as well as for his insightful suggestions. I am also indebted to the fine editing work done by Ritu Bhatt and Melanie Martin to prepare this piece for inclusion in this anthology.

8

traditional knowledge for contemporary uses

an analysis of everyday practices of self-help in architecture

ritu bhatt

ritu bhatt

INTRODUCTION

During the last thirty years of the millennium, a critical turn in architecture transpired in which inquiries into the history, theory, and criticism of architecture increasingly shifted their concerns from form-making to exploring the social, cultural, and political factors that inform built form. During this phase, architectural theory shifted from what might be termed theory's earlier normative concerns—such as, what architecture should be, how architecture informs social change, and how architecture affects human behavior—to interpretive and discursive analyses that focus on examining tacit ideologies and assumptions that have informed the discipline. One of the key theoretical insights of this epistemic shift has been how "conscious" decisions cannot be attributed to individuals alone, but need to be understood as consequences of socio-cultural-political discourses. Similar debates expressing skepticism— around authorship, the use of tradition, the politics underlying the writing of colonial as well as post-colonial histories, and the impossibility of knowing the "other"—have brought to the fore an epistemology that views all references to a subject's experience, or references to traditions, as mere myths or inventions.[1]

This critical project, which coupled Marxian critical theory, post-structuralism, orientalism, and post-colonial theory with readings of architectural modernism, continued from the publications of Manfredo Tafuri's books in the late 1960s to the turn of the millennium. For many theorists and architects, this emphasis on underlying politics would eventually allow for a form of self-consciousness that would lead to emancipatory action. More recently, however, this skeptical stance toward critical theory has been redirected through a series of influential essays loosely labeled under the rubric of the "post-critical turn." The essays written by Sylvia Lavin, Sarah Whiting, Robert Somol, Stan Allen, and Michael Speaks have opened a provocative examination of the operative role of theory and the relevance of "critical" or "neo-critical" positions;[2] in addition, they have attempted to probe deeper into architecture's active agency to play a broader social and cultural role. An important concern of this debate is the "post-critical," or what might be termed "non-skeptical," attitude toward "other" traditional (often pre-modern) knowledge systems. This focus on the non-skeptical is especially relevant in light of our contemporary society's inherently contradictory attitudes wherein traditions (in the conventional sense) no longer constitute the basis for our actions, yet traditional modes of knowledge are freely re-conceptualized through "self-help" practices that range from oral communications to self-help books to DVDs etc. This cultural phenomenon of "self help" also includes a broad range of traditional pre-modern somatic practices such as yoga, tai chi, and meditation, among others, that are currently being re-modified for contemporary uses. Such an attitude of self-determinism brings to light a transformed subjectivity in which we begin to choose and control parts of our everyday lives, wherein, as Anthony Giddens says, "we are not what we are, but what we make ourselves into."[3]

In order to further understand the complex role that traditional knowledge plays in the formation of contemporary subjectivity, I examine here the

everyday practices in architecture that refer to pre-modern/traditional thought and that have remained marginal in academic discourses. These practices include the contemporary practice of Feng shui, the Chinese art of placement; and Christopher Alexander's contested work in *A Pattern Language* (1977) and *The Timeless Way of Building* (1979).[4] I compare these disparate modes of thoughts because they share striking parallels in their emphasis on unconscious relationships with space, day-to-day cognition, and normative frameworks of knowledge. Ironically, both also argue for a contested claim in architecture: that qualitative aspects of spaces directly correlate with human well-being, and that day-to-day acts of designing can contribute to qualitative improvement in people's lives. My aim here is *not* to posit these popular practices as solutions to the predicaments of contemporary architectural theory. Rather, through a close examination of these practices, I wish to explore the role that intention, active agency, and normative philosophical claims play in the pragmatic approaches that everyday users employ when they consider, choose, and experiment with traditional knowledge systems, and how those insights might inform the current impasse between essentialism and skepticism in architectural theory.

Pattern language and Feng shui have evolved historically in very different contexts. Christopher Alexander wrote *A Pattern Language* and *The Timeless Way* during the 1970s, when critiques of modernism were exploring a deeper understanding of pre-modern traditional environments. During the 1970s and 1980s a surge of interest in Alexander's pattern language transpired in academia that focused on user empowerment, the use of patterns in the design process, and community participatory design. Later, however, this interest leveled off to a quiet, punctuated by the occasional laudatory or disparaging review, mainly criticizing Alexander's work for its determinism and authoritarianism.[5] Since its publication, however, *A Pattern Language* has continued to find enduring success with builders and contractors as well as do-it-yourself homeowners who use it mainly as a self-help practice.

Feng shui, on the other hand, originated many centuries ago in China. The earliest trace of it dates from the Chou Dynasty (1030–722 BCE). It has continuously been transformed and reformed over dynastic rules, communist regimes, and democratic revolutions. Geographically, too, the practice is varied and is practiced differently in different parts of the world. During the Communist revolution, Feng shui was banned in China and practitioners were forced to either leave China or practice secretively. As a result, in China, traces of the practice are found more in rural areas. In *Feng Shui in China: Geomantic Divination Between State Orthodoxy and Popular Religion* (2003), Ole Bruun points out that throughout its history, Feng shui has evolved into an agglomerative tradition, adopting various popular currents and defying any singular categorization.[6] Furthermore, due to various historical reasons, Feng shui has come to acquire an anti-authoritarian force—practitioners operate outside established institutions, offering an alternative worldview that deals with almost any aspect of life.[7] Recently, however, Feng shui has been interpreted in various ways from fashion to trustworthy cosmology, practical

science, superstition, and quackery, and receives much criticism for the ways in which it is currently being popularized as a self-inventive, self-help practice in parts of North America, Europe, and Asia, particularly in Hong Kong, Singapore, Shanghai, and Beijing, among other places. It has primarily been disseminated through self-help books and well-respected schools, the most popular of which are the Form School, the Compass School, and the Black Hat sect of the Tantric Buddhist school of Feng shui.

Practitioners of Feng shui, who re-contextualize ancient knowledge of space-making for contemporary uses, have flourished outside of established architectural institutions, allying more with alternative holistic medicine. Despite the inevitable distortions inherent in the ways Feng shui is currently practiced as a freestyle inventive practice, I argue that insights can be derived from the methods of analysis that contemporary Feng shui practitioners use to understand buildings. I delve into Feng shui's unique cognitive framework that allows for multiple correlations to be drawn between space perception, mind-body cognition, and human well-being. I also present an analysis of key techniques that Feng shui practitioners employ to understand the body's intuitive and phenomenological interaction with space. Since these techniques share intriguing parallels with Christopher Alexander's arguments, I make comparisons between Alexander's pattern language and Feng shui in order to underscore key arguments about the role of the body in design that might help us rethink the inherent paradoxes of the post-traditional condition.

OVERVIEW OF FENG SHUI

At a very basic level, contemporary practitioners of Feng shui focus on the energy systems inside and outside of the human body. Specialists manipulate lines of energy working with knowledge that relates behavioral and emotional states such as being calm, anxious, or aggressive to specific flows of energy in the human body and in space. Most practitioners commonly use the correlative concepts of chi, yin-yang, and the five elements, which together comprise comprehensive knowledge about human beings' relationships with their environments. By allowing practitioners to look at reality through multiple lenses, this framework allows contemporary Feng shui practitioners to hold multiple associations of the metaphysical as well as the physical within one view of reality. Practitioners employ varied techniques that range from interpreting transcendental, astrological, geological, and climatic data to developing basic intuitive sensory awareness of the human body and its environment.

THE CONCEPT OF CHI

The Feng shui tradition sees the entire environment as integrated and alive with chi, the life force energy that animates both the living and non-living. Written

records emphasizing the invisible nature of chi are evident as early as the Han dynasty (179–104 BCE). One of them reads, "Within the universe exist the ethers (chi) of the yin and yang. Men are constantly immersed in them—just as fish are constantly immersed in water. The difference between them and water is that the turbulence of water is visible while the turbulence of the latter is invisible."[8] Understanding chi in Feng shui involves developing an enlarged self-consciousness that remains aware of and attuned to energy systems and dynamic processes inherent in the environment.

THE CONCEPT OF YIN YANG

The vital force of chi is understood through the concepts of yin and yang, according to which all phenomena are the outcome of endless interaction between opposing states of chi: yin and yang. To keep the proper relationship between yin (feminine) and yang (masculine) energy, it is necessary to maintain a balance. Only in the complete harmony of yin and yang is an altered state of consciousness revealed. Feng shui, however, emphasizes that each space has different needs, which depend on the particular use and function of that space; thus, "balance of energy" has a different meaning in different contexts. For instance, a bedroom needs to have more yin than yang energy, with a rough ratio of 2/5 yang versus 3/5 yin. A retail store, on the other hand, needs more yang energy, with a ratio of 3/5 yang and 2/5 yin. In a classroom, where the space must help people stay grounded yet active, the energy balance is a close approximation of equal parts yin and yang (1/2:1/2).[9]

FORM SCHOOL

Furthermore, each of the primary directions holds great power in Feng shui philosophy and ideally is composed of certain geographical features that enhance its particular energy. For instance, the ideal site for a house is surrounded by an elevated terrain such as a mountain to the north, providing protection from the back; flanking ridges to the east and the west that cradle the site; open land with water in the front, facing the south; and possibly a river at a distance. Each direction is metaphorically associated with an animal: black tortoise to the north, green dragon to the east, white tiger to the west, and a phoenix in the front, with each animal symbolizing a particular form of energy (Figure 8.1).

Such metaphorical associations are not arbitrary. At a very basic level, landscapes and architectural structures are considered in Feng shui to be dynamic, responsive living entities that continuously interact with the forces of climate and light topography as well as socio-cultural forces. For instance, green dragon, as the most yang of the animals in Feng shui philosophy, encourages plant growth, falling in the east, the direction where the sun rises. Low-rolling hills manifest this energy; thus, when determining where to locate

Figure 8.1 According to Feng shui, a house is ideally situated within the following landscape: a mountain or other elevated land features to the north, adding protection in the back; ridges bordering the east and the west to cradle the home; an open space with a water element in the south, facing the front; and possibly a river in the south, further in the distance. These directions all have metaphorical associations with particular animals. Black tortoise guards the north; green dragon, the east; white tiger, the west; and phoenix, the front of the site. Furthermore, each animal brings a certain type of energy to the site; for example, green dragon encourages the growth of plants. (Provided by Office of Alex Stark, Feng shui consultant. Redrawn by Andrew Blaisdell.)

a building, a Feng shui practitioner would look for a setting with low, rolling hills to the east. White tiger, to the west, brings protective yin energy, also in the form of low hills. Together, white tiger and green dragon cradle the site from the east and west. Alfred B. Hwangbo provides an explanation for such metaphorical associations:

> In East Asia … cities and buildings were designed in relation to a form of number symbolism tied to the dichotomous yin/yang, five elements, and eight trigrams. The aim was to organize the built environment to be in harmony with nature, often by determining symbolically auspicious directions. The application of Feng shui undoubtedly brought ancient East Asians peace of mind, for in using it they believed themselves to be in tune with Heaven and Earth. This presumably produced in them what would be

termed an aesthetic experience, but it was a cognitive experience dependent on specific beliefs and values.[10]

COMPASS SCHOOL

While these metaphorical associations are more commonly used in the Form school of Feng shui, the Compass school employs orientations in space to understand the energy flows within a site. A house that faces south, for example, is seen as receiving more cosmic energy in the form of light and heat than one facing north. Energy is said to decrease as the sun moves through the southwest, west, and northwest, returning to its calmest position in the north. Because of those associations, north is considered to possess calming, quieting energy due to its relative lack of sunlight. It is therefore suitable for tranquil activities such as sleep, recuperation, and intellectual pursuits. South, on the other hand, is considered to be highly energized, and therefore supportive of strongly active endeavors such as social interaction, business, and sports. The eastern sector of a site or structure, on the other hand, is said to be more suitable for active functions such as living rooms, home offices, and workshops. The western side is best suited for calmer spaces such as dining rooms, bedrooms, and dens. Openings such as windows and doors are seen as allowing for the penetration of energy emanating from one of the compass directions, and thus are believed to have the ability to harness the potential of that type of energy. Walls without openings, conversely, are said to block or diminish such potential. In addition, any objects that block the compass directions outside the structure are also detrimental to the particular energy from those directions, as they impede that energy from reaching the structure. Most contemporary Feng shui practitioners view such ideas as key to understanding human and architectural responses to the movement of the sun, shade, and varying temperatures.

FIVE ELEMENTS

Once Feng shui practitioners discern the flows of chi, they modify spaces using a variety of approaches. They employ color and light while introducing or taking away different types of elements such as wood, metal, water, or earth, and further combine these elements with breathing exercises, physical training, and meditation as recommendations to balance and enhance inhabitants' personal energies. In fact, Feng shui specialists work with remarkable ease through trial and error, allowing for resolutions that are variable and in constant interaction, inciting a range of after-the-fact alterations to existing spaces. Each element is conceived of as a transient state of primal chi, rather than as a stable element in itself, and the theory of five elements further delineates this understanding, as the five elements of water, wood, fire, earth, and metal are understood to be moving through a continual cycle of transformation involving mutual "production" and mutual "overcoming" or "destruction."

Between elemental energies there are also important contradictions, which show how within productive flows lie destructive flows. For instance, water will put out fire, but fire and water are also engaged in a productive cycle, with fire changing liquid water to steam.[11] Neither the productive nor the destructive cycle is necessarily positive or negative in black-and-white terms; rather, as a whole, they represent ways to balance the energy flow within a space by either introducing or taking away elements.

Auspicious moments occur when two elements come together in a productive relationship and in harmony. Feng shui allows one to introduce elements or remove them within an environment to achieve balance. For instance, if the basic element is wood, one can either introduce wood to enhance wood energy, or introduce water, which feeds and nourishes wood. The fact that elements are not perceived as physical things but as elemental energies allows Feng shui experts to use metaphorical associations to justify solutions, thus allowing for a richer and more concrete understanding of abstract concepts. For instance, wood is taken to be symbolic of spring and is associated with creation, nourishment, and growth. Tree and forest environments are generally tall and soaring. Built environments that are not made up of wood, but are tall and soaring, such as pillars, minarets, chimneys, or skyscrapers, can thus be metaphorically likened to wood, and therefore with creation, nourishment, and growth.[12] Such associations are not arbitrary; they derive meaning through metaphorical reasoning and are part of a larger correlative system of thinking. Through such metaphorical references Feng shui, in its contemporary form, is practiced as systematic interpretive art, and functions in a worldview in which synchronicity rather than causality determines human spatial relationships. While providing a normative framework through which users can make design decisions, Feng shui practice allows room to develop and deepen human intuitive responses in the process.

CHRISTOPHER ALEXANDER'S *PATTERN LANGUAGE*

Christopher Alexander's arguments in *A Pattern Language: Towns, Buildings, Construction* (1977), *The Timeless Way of Building* (1979), and *The Oregon Experiment* (1975), which proposed a radical rethinking of the everyday in architecture by providing a language of patterns that empower users to design their own environments, share key epistemic concerns with Feng shui. Alexander's central claim that patterns of everyday life indicate the presence of unconscious relationships with space, and that these relationships can be brought to the conscious realm and improved upon is similar to Feng shui's discernment of energy flows and its emphasis on individuals' agency to enhance their own well-being. Moreover, Alexander's critique of architecture brings to light the idea that deep subjective feelings and unconscious processes reframe conceptions of objectivity.[13] For Alexander, traditional pre-modern built environments remain excellent examples of un-self-conscious methods of construction, through which buildings "cannot be made, but only generated

indirectly, by the ordinary actions of people."[14] Highlighting such attributes of traditional buildings, Alexander criticizes the focus on formal and visual concerns in modern architectural thought, stressing that architects critizes paying conscious attention to buildings, letting processes happen on their own accord in order to enhance "innate human capacities for intuitive learning."[15]

Alexander's *Pattern Language* includes 253 patterns that provide suggestions with which to rethink everyday spaces, ranging from living areas to kitchens, secret alcoves, workplaces, and bathrooms. The ability of patterns to reconfigure and evolve naturally into a language forms the basis of Alexander's epistemology. Arguing that a language of patterns develops from a network of connections among individual patterns, and that the links between patterns are almost as much a part of the language as the patterns themselves, Alexander stresses in *The Timeless Way of Building* that whether a language "lives" or not depends on the degree to which the patterns come together to form a "whole" (Figure 8.2).[16]

The truest test of patterns' validity lies in how they merge together to affect human experience, ultimately dissolving an individual's need to rely on patterns as she learns to rely completely on intuitive processes when designing environments. Furthermore, the fact that patterns are often placed side by side highlights their correlative influence on one another. When different patterns are joined together, qualitative aspects of space, such as encouraging socialization and providing optimal lighting, accrue cumulatively and influence human well-being. Such understanding, according to Alexander, is key to comprehending how good and nurturing environments can be created. He

Figure 8.2 Language for a garden. The links between patterns are a vital part of the language of patterns. (*The Timeless Way*, p. 314.)

refers to the creation of this quality of a space as "the quality without a name" in an essay by the same title. Describing it as alive, whole, comfortable, free, exact, egoless, eternal, and ordinary, Alexander argues that while not a single word does it justice, the quality can be argued to be objective and precise.[17] Much like Alexander's patterns, these metaphors together describe the cumulative qualitative influence that spaces have on the human body.[18]

COMPARISONS OF FENG SHUI AND PATTERN LANGUAGE

Feng shui shares with pattern language an emphasis on deeply felt human intuitions and needs as well as a fundamental critique of modern thought. Feng shui, however, defies any categorization using western epistemological constructs. Alfred B. Hwangbo has described Feng shui as "an unnameable discipline," a mélange of arts and sciences that governs design issues of architecture and planning, embracing a wide range of human interests, including ancient cosmology.[19] The parallels between "unnameable discipline" and Christopher Alexander's "quality without a name" are apparent, and they become even more striking in Joseph Needham's description of Feng shui in *Science in the Early Civilization of China*, wherein he describes it as a "thought-form" in which "conceptions are not subsumed under one another, but placed side by side in a 'pattern,' and things influence one another not by acts of mechanical causation, but by a kind of 'inductance.'" Needham argues that this "intuitive-associative system has its own causality and its own logic."[20]

Similar to Alexander's illustrative patterns, Feng shui abounds in suggestions by which day-to-day living can be enriched, drawing correlations between human tendencies and spatial layouts. For instance, Feng shui holds that one should not have a direct view of the kitchen space from any other given room because that would stir a response to eat when not hungry (Figure 8.3).

Similarly, a bed directly aligned between a door and a window, or even a bed directly aligned with a door, can cause unrestful sleep because in the first case, energy will flow too swiftly, and in the second, it will flow directly in a straight line like a poisoned arrow toward the sleeping person (Figures 8.4 and 8.5). Such thinking pervades Feng shui even on a larger scale; for instance, the corner of a large building angled toward a small building can send a strong line of sha-chi (attacking chi that is considered bad in Feng shui) toward the smaller structure (Figure 8.6), or an interior corner in an office pointed at an occupant's back can cause psychological discomfort due to the aggressive energy behind the person (Figure 8.7). These suggestions echo the yin-yang philosophy, which emphasizes balance between yin (feminine) and yang (masculine) energy. Similar to Feng shui's claims that a bedroom needs to have more yin than yang energy, or that a classroom needs to have an energy balance in a close approximation of equal parts yin and yang (1/2:1/2) so students will stay grounded yet active,[21] Alexander's patterns also emphasize architecture's ability to create a positive or a negative social atmosphere. For instance, in a pattern titled "Alcoves" (Pattern: 179), Alexander argues that a "homogenous,"

Figure 8.3 Direct view of the kitchen. Feng shui offers much advice for improving everyday life by paying attention to intuitive human tendencies and responses to spatial layouts. For instance, rooms should avoid a direct view of the kitchen, according to Feng shui, since that would prompt inhabitants to eat when they're not hungry. (Provided by Office of Alex Stark, Feng shui consultant. Redrawn by Andrew Blaisdell.)

Figures 8.4 and 8.5 Poisoned arrow. Placing a bed directly between a door and window causes energy to flow too quickly, and placing it in front of a door draws energy toward the sleeping person in a direct line like a poisoned arrow. (Provided by Office of Alex Stark, Feng shui consultant. Redrawn by Andrew Blaisdell.)

Figure 8.6 Attacking chi. If the corner of a large building points toward a small one, it sends a direct line of *sha-chi* (harmful attacking chi) toward the smaller building. (Provided by Office of Alex Stark, Feng shui consultant. Redrawn by Andrew Blaisdell.)

Figure 8.7 Office corner. In an office setting, an occupant may experience psychological discomfort if a corner is pointed at her back, since the corner directs aggressive energy toward the occupant. (Provided by Office of Alex Stark, Feng shui consultant. Redrawn by Andrew Blaisdell.)

"unresolved" space can drive a family apart, saying a communal room must give people a chance to be alone or in pairs (Figure 8.8). Alexander suggests that such spaces can be differentiated through alcoves encouraging two people to sit, chat, or play, providing niches for privacy. In another pattern, "The Flow Through Rooms" (Pattern: 131), Alexander argues that dark, narrow passages create an inhospitable environment—"rooms open off to them as dead ends; you spend your time moving between rooms, like a crab scuttling in the dark."[22] Arguing that human relations are inevitably subtle, and that spaces must allow a generous flow for those instincts to play out, Alexander suggests avoiding corridors, instead creating loops of public common rooms with linkages to private rooms (Figure 8.9).

Family room alcoves.

Figure 8.8 Alcoves. In a pattern titled "Alcoves," Alexander asserts that a communal room must accommodate people's needs for privacy or it will drive them apart. He suggests differentiating family spaces by creating alcoves for two people to sit, chat, or play in. (Pattern 179, "Alcoves," *A Pattern Language*, pp. 828–32.)

loops through rooms

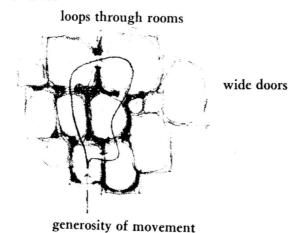

wide doors

generosity of movement

Figure 8.9 The flow through rooms. Arguing that in a complex social fabric, human relations are inevitably subtle, and that spaces must have a generous flow to allow those instincts to play out, Alexander suggests avoiding corridors, instead creating loops of public common rooms with linkages to private rooms. (Pattern 131, "The Flow Through Rooms," *A Pattern Language*, p. 631.)

Much like Feng Shui's emphasis on discerning flows of energy, in which interrupting or severing energy lines or "veins" is considered seriously detrimental to the ability of land to support life and health for its inhabitants, Alexander's patterns stress the importance of recognizing the natural flow of a space and emphasize how purely functional concerns can be detrimental to human well-being. For instance, in the pattern "Staircase as a Stage," Alexander

writes: "A staircase is not just a way of getting from one floor to another. The stair is itself a space, a volume, a part of the building; and unless this space is made to live, it will be a dead spot, and work to disconnect the building and to tear its processes apart."[23] He argues that one should design stairs in such a way that they become fully integrated with the rest of the building, providing a gradual and natural transition to the next level wherein people are naturally inclined to sit and chat.

Yet another parallel emphasizing natural human tendencies is evident in a pattern entitled "Hierarchy of Open Space" (Pattern: 114), in which Alexander describes how, when in open spaces, people tend to intuitively find comfort in spots where they have their backs protected, looking out toward some larger opening.[24] For Alexander, such intuitive responses of users provide insights for designing better environments. The idea of psychological comfort provided by a strong back is central in Feng shui as well, and it is emphasized at various scales. For instance, within a building's site, good support is known to be provided by somewhat higher and more substantial buildings positioned in the back. Likewise, when sleeping, a strong headboard provides essential support, and the bed should have a solid wall at the back, allowing the inhabitant a full view of the room and the door opening (Figure 8.10). Such recommendations extend to the interior of an office space as well, wherein Feng shui emphasizes that a person should not take a position facing his back to the door, but should face the door directly, fully able to observe who is entering and leaving the room. This position gives the person the psychological comfort of remaining aware of who is in the room and what is taking place within it (Figure 8.11). People naturally feel safer and thus more comfortable when they are in full command of their surroundings, and both Feng shui and pattern language honor these intuitive responses.

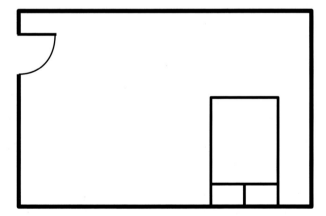

Figure 8.10 Position of a bed. A bed should be situated in a position that lets the occupant fully observe the entryway, and should have a strong back, providing a sense of comfort and protection. (Provided by Office of Alex Stark, Feng shui consultant. Redrawn by Andrew Blaisdell.)

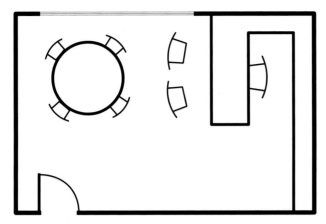

Figure 8.11 Commanding position within an office interior. Within an office
arrangement, one should sit with his back to a solid wall and be located
diagonally opposite the door to the room. The user should face the door
directly, able to see everyone who walks through the doorway, which
allows the user the psychological comfort of knowing what is happening
within the room. To further enhance feelings of security, sharp corners
from columns, beams or overhead soffits should not point at or loom
above work spaces. (Provided by Office of Alex Stark, Feng shui
consultant. Redrawn by Andrew Blaisdell.)

Following such Feng shui guidelines, users can begin to intuitively discern
design solutions through the "felt" experience of energy flow. Feng shui holds
that one's intuition can serve as a guide for what is most beneficial. In fact, an
emphasis on the felt is well-integrated into a normative understanding of the
"balance of energies" and "good" Feng shui. Chi is said to flow in curves in its
most natural state, and Feng shui experts emphasize that movement of chi
should neither be too swift nor too slow. When chi is forced into straight lines,
it starts to behave like an arrow from a bow that threatens to wound anything
at the receiving end. For instance, a site located at the end of a long, straight
road is considered at risk, as chi is said to accelerate along the road, creating
detrimental conditions. Such a normative understanding of the "good" flow of
chi in Feng shui functions to further deepen the discernment of the felt
experience, which does not remain merely subjective but develops an objective
basis in the human body and in architectural space.

The idea that objectivity is not dispassionate and can evolve from deeply
embodied subjective feelings is an argument that pervades much of Alexander's
work as well. To seek this understanding and knowledge, Alexander argues
that architects should let go of all the methods of architecture they know, and
move away from paying conscious attention to buildings. This process "will
enhance innate human capacities for intuitive learning," he asserts.[25] In this
framework of knowledge, objectivity and subjectivity are not mutually exclusive
but are intertwined and in constant flux. Alexander calls for dissolution of the
binary framework of knowledge, describing his work as "a search for the
quality of things that is subjective, cannot be named, and yet has an objectivity

and precision to it."[26] Such precision, he clarifies, cannot be attained mechanically, as it is based on deep human feelings and needs. In *A Pattern Language*, his discussion of a pattern for sleeping (Pattern 138: "Sleeping to the East") serves as a particularly strong illustration of how subjective feelings can be argued to have an objective basis (Figure 8.12). In this pattern, Alexander argues that when deciding which space is most appropriate for sleeping, one must pay attention to the needs of the human body when waking from sleep. He begins by saying that this is one of the patterns that people most often disagree with, for, they argue, "What if one had an intention to sleep late? Why would someone want to be woken up by the sun?" In expressing such concerns, Alexander points out, people often assume that such decisions are only a matter of personal preference. On the contrary, he argues, sensitive biological clocks within the human body work in conjunction with natural rhythms and cycles. The human body is attuned to its own needs for rest, and light will affect it differently depending on how much rest it needs. The description of the pattern reads:

> Since the sun warms you, increases the light, gently nudges you, you are likely to wake up at a moment which serves you the best. Therefore, the right place for sleeping is one which provides morning light—consequently a window in the room that lets in eastern light—and a bed that provides a view of the light without being directly in the light shaft.[27]

Alexander's pattern "Sleeping to the East" corresponds well with the practice of Feng shui, in which eastern exposure in the morning is associated with arousing yang energy that raises vitality. Often Alexander suggests a "right place," or "a more or less correct way," and he argues that this concept of rightness is based on deep human sensations and needs, which aligns well with Feng shui philosophy's emphasis on intuitive processes through which users relate to and find balance in their environments.

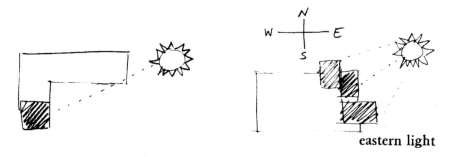

eastern light

Figure 8.12 Sleeping to the east. Alexander writes, "Give those parts of the house where people sleep, an eastern orientation, so that they wake up with the sun and light. This means, typically, that the sleeping area needs to be on the eastern side of the house; but it can also be on the western side provided there is a courtyard or a terrace to the east of it." (*A Pattern Language*, pattern 138, pp. 656–9.)

SELF-KNOWLEDGE AND AGENCY OF THE EVERYDAY USER

Agency and self-knowledge are central to Christopher Alexander's pattern language, which aims to improve the cognitive capabilities of its users through its easy-to-understand patterns, which are amenable to modification. In fact, the success of pattern language has been attributed to the patterns' ability to function as concrete prototypes, in that patterns have the ability to project a reality grounded in concrete experiences that users can immediately relate to and use to reconfigure the most intimate of their spaces.[28]

Similarly, the effectiveness of Feng shui is largely dependent on the intention and intuition that the user brings to it, and Feng shui achieves its communicability through its easy-to-comprehend tools that users can relate to. One such commonly employed tool in Feng shui is called the *ba-gua*, which is an octagonal figure that allocates eight trigrams to the eight compass directions, drawing comprehensive correlations between the human body, the five elements, and qualitative aspects of spaces in a diagrammatic form. Each trigram or sector relates to parts of the human body, which correspond to colors that signify meanings, which, in turn, further correlate to some aspect of a person's life or aspirations.[29] Besides providing direct correlations based on the flow of energy meridians within the human body and surrounding spaces, the *ba-gua* also functions as an easy-to-understand scheme of representation that creates a trustworthy and knowable framework to encourage human creativity and experimentation within a system of constraints.

Furthermore, Alexander's key arguments aim to dissolve the boundaries between professional designers and everyday users. In a similar way, Feng shui connects the specialist with the user; in fact, the personal encounter between specialist and client is considered essential to any remedy in Feng shui. Because intentional development of trust, both in the practice and in the practitioner, is an integral part of Feng shui, its mode of functioning has often been likened to that of a placebo. Such an interpretation acknowledges that human perception is not based entirely on outside "objective" reality, but to a major degree on what the human mind expects to happen. The idea that expectancy can trigger massive cognitive and physiological responses that often provide benefits that parallel or transcend the effects of drugs or other therapies is now well-recognized in the medical profession. Through conscious and intentional development of trust and expectations both in one's ability to develop one's intuitive capabilities and in the practitioner's expertise, Feng shui allows for psychosomatic responses that further the effectiveness of the functional correlations between human bodies and spaces.

Such connections between the feelings of individuals and their normative basis are increasingly being explored by emerging somatic practices, which comprise a variety of approaches such as the Feldenkrais method, the Alexander technique, body-mind centering, eutony, yoga, the martial arts, and dance movement therapy. These practices argue for mind-body cognition and place a great deal of emphasis on the student or client's active participation. Practitioners claim that in modern medicine, the body has been approached as an object and

studied as something external and separate from the self. Somatic practitioners, in contrast, approach the body as a subject, experienced from within rather than from without. In dissolving the object-subject split, somatic practitioners argue for the recognition ("re-cognition") of the fact that the human body is the grounds from which one needs to explore experience.

Moreover, the key issue that somatic practitioners often focus on is patterns—or rather, the re-patterning of thought, movement and behavior—arguing that unconscious patterns that the body engages in can affect functioning at all levels: physiological, psychological, social, and spiritual. Somatics argues against the objectified, static view of the body and holds that the body, like the mind, remains in constant flux, changing from moment to moment in response to the underlying processes of which it is an expression. In doing so, somatics argues for the unlearning of the cultural conditioning that ignores internal sensory experience, and attends to subtle fluctuations within the body-mind, using various techniques such as touch, tissue manipulation, sensory awareness, body imagery, and movement.[30] Through the use of specific techniques, these therapies bring awareness to unconscious patterns, introduce new sensations and choices for response, and support changes leading to greater mind-body integration, health, and well-being. Much like other somatic therapies, Feng shui aims to achieve a re-patterning of thoughts, processes, and behaviors as well as greater well-being through a wide range of spatial reconfigurations which, according to Feng shui, have the ability to refocus energies within spaces to benefit their occupants.

Alexander's pattern language also emphasizes reconfiguration of spaces, making the argument that buildings can come "alive," and asking his readers to pay attention to the *moments* when buildings come "alive," and when buildings could be argued to be "more real" or "less real." For instance, in the pattern called "Zen View" (Pattern: 134), Alexander shows how the design of a Zen monk's house provides a beautiful view of the ocean only once—and just momentarily—through a narrow slit in the wall as the monk passes across the courtyard (Figure 8.13). The decision to restrain the view is suggestive of the design's capacity to counterbalance natural human tendencies toward excess. As Alexander asserts, "the view of the distant sea is so restrained that it stays alive forever."[31] Arguing that design decisions can impact and influence the experience of a more "real world" that is radically different from the physical world as seen, Alexander writes, "When I say something is real, I mean that the fundamental neurological processes and deep-seated cognitive processes going on in the brain are actually taking place in a holistic way. ... and the person who is seeing a thing holistically is actually seeing what is congruent within it instead of just its physical geometry."[32] For Alexander, we perceive more than we consciously see, and are affected by it on a deep level, so that the most extraordinary of experiences can be achieved in the most ordinary of lives.

Alexander's emphasis on paying attention to the moments "when buildings become real" is similar to analytic philosopher Nelson Goodman's arguments for aesthetic cognition in his *Languages of Art* (1968), in which Goodman stresses that the question to ask is *not* "What is Art?" but "When is Art?" or,

distant view

place of
transition

view

House

The monk's house.

Figure 8.13 Zen view. In a pattern called "Zen View," Alexander gives an example of
a Buddhist monk who lived high in the mountains in view of an ocean.
He points out that because of deliberate spatial moves, the beautiful view
of the ocean cannot be seen from the monk's house or the road leading to
the house. The monk can view the ocean just briefly when he walks across
a courtyard to his house and passes by a narrow slit in the wall, which
allows him to view the ocean at that spot. For Alexander, this provides an
interesting insight, because "the view of the distant sea is so restrained
that it stays alive forever." Such design moderates natural human
tendencies toward overindulgence. By restraining the view, the design
allows for a long-lasting appreciation. (*A Pattern Language*, pattern 134:
Zen View, pp. 641–3.)

"When Art happens," arguing that aesthetic experiences are not limited to art,
but can happen anytime in our everyday lives. More importantly, "when art
happens," Goodman asks us to pay attention to moments of non-judgment and
disinterest that allow the subject to experience the deeply transformative
potential of aesthetics.[33] Furthermore, for Goodman, buildings often
communicate metaphorically, and one can make distinctions between different
metaphorical connotations. For instance, a Gothic cathedral that soars and
sings does not equally droop and grumble. Although both descriptions are
literally false, the former, but not the latter, can be argued to be metaphorically
true.[34] Making such metaphorical discriminations allows an understanding of
how feelings and emotions affect our perceptions of buildings, and how such
deep feelings can be distinguished from one another.

The argument that metaphorical distinctions allow principal insight into
understanding knowledge in Feng shui and in Christopher Alexander's writings
also aligns well with the contemporary debates in cognitive sciences wherein
philosophers such as Mark Johnson and George Lakoff have challenged
conventional understanding of metaphors as mere poetical or rhetorical
embellishments, arguing that they are part of everyday speech that affects the
ways in which we perceive, think, and act. Therefore, it needs to be recognized
that metaphors play a critical role in knowledge formation. Blurring
conventional binary distinctions in western epistemology between reason and
emotion, Lakoff and Johnson argue that metaphors are not dispassionate or
disembodied, but grow out of bodily capacities, further reinforcing the point
that our bodies, our brains, and our interactions with our environments need
to be acknowledged as an important unconscious basis for our everyday sense
of what is real.[35]

Furthermore, the claims of contemporary Feng shui and pattern language—to reinsert the body into architectural theory—also align well with Richard Shusterman's recent work on somaesthetics, wherein Shusterman steps outside the traditional domain of art to examine somatic practices, arguing that they not only free us from bodily habits and defects that tend to impair cognitive performance, but also enrich our lives by integrating a rich aesthetic experience into our everyday lives.[36] In doing so, Shusterman further argues, these everyday practices reinvent the postmodern subject. Unlike the Foucauldian subject under a constant panoptic gaze, there emerges an agent who—through a focus on self-knowledge and self-interpretation—is capable of challenging the repressive power relations encoded in our bodies.[37] However, Shusterman points out that this awareness of the body's feelings and movement has long been criticized in western philosophical traditions as a harmful distraction that corrupts our ethics through fostering self-absorption,[38] a point that further highlights the lack of recognition given to the human body in modern western epistemology.

CONCLUSION

Neither pattern language nor contemporary Feng shui is a fully convincing example of a re-conceptualization of traditional knowledge—not that there can ever be a complete and pure translation. Furthermore, there is no denying that they both have their legitimate critics: Feng shui is criticized as a practice in which human gratification is pursued unwaveringly, and Alexander's work has been criticized for being too focused on comfort, legibility, pleasure, ease, and bourgeois satisfaction. However, as self-help practices, they present cognitive frameworks that allow users to experiment with traditional knowledge systems, providing insights about the intuitive and constantly interactive mechanisms by which human bodies relate to space. Although they remain marginal in the academy, they ironically continue to influence architectural thought with the claim that our cumulative experiences of the nature of the spaces we live in affect our mental, physical, and neurological systems. By highlighting how normative frameworks of knowledge that emerge from the body can support and deepen the user's self-knowledge and agency, the two practices, blur the oppositions that exist between essentialist versus skeptical attitudes toward premodern traditional practices. Most importantly, by re-inserting the user's insight and intuition into the design process while emphasizing how design affects the body—both Alexander's pattern language and Feng shui prompt a richer understanding of the concepts "body" and "design" that allows for the generation of designs that more fully enhance human well-being.

NOTES

1 For a critique of skepticism, see Ritu Bhatt, "The Significance of the Aesthetic in Postmodern Architectural Theory," *Journal of Architectural Education* 53, no. 4 (May 2000): 229–38.

2 Advocates of the post-critical position include Robert Somol and Sarah Whiting, "Notes Around the Doppler Effect and Other Moods of Modernism," eds. Michael Osman, Adan Ruedig, Matthew Seidel, and Lisa Tinley, *Mining Autonomy*, special issue of *Perspecta* 33 (2002): 72–7; Michael Speaks, "Design Intelligence, Part 1: Introduction," *A+U: Architecture and Urbanism* (December 2002): 10–18. See also George Baird, "'Criticality' and its Discontents," *Harvard Design Magazine* 21 (Fall/Winter 2004): 16–21; and Reinhold Martin, "Critical of What? Toward a Utopian Realism," *Harvard Design Magazine* 22 (Spring/ Summer 2005): 104–9. For debates about "critical" versus "neo-critical" and the operative role of theory, see a compendium of essays published in *Critical Architecture*, eds. Jane Rendell, Jonathan Hill, Murray Fraser, and Mark Dorrian, London: Routledge, 2007. The essays as a whole provide an important critique of the post-critical turn in architecture.

3 In post-traditional societies, wherein tradition no longer constitutes the basis for our actions, Anthony Giddens postulates that societies evolve a modern reflexivity wherein agents begin to choose and control parts of their everyday lives to a greater extent than before. Anthony Giddens as cited in Kaspersen, "The Analysis of Modernity: Globalization, the Transformation of Intimacy, and the Post-Traditional Society," 106–9. Giddens argues that self-identity in post-traditional societies must be understood as a reflexive project for which the individual is responsible. By using knowledge developed by expert systems, we are able to control a part of our everyday lives, and we, therefore, become re-skilled. However, the expert system also de-skills us (109). Also see Giddens, *Modernity and Self-Identity: Self and Society in Late Modern Age*, Stanford UP, 1991, 70-108.

4 Christopher Alexander, S. Ishikawa, M. Silverstein, M. Jacobson, I. Fiksdahl-King, S. Angel, *A Pattern Language: Towns, Buildings, Construction*, NY: Oxford UP, 1977; and Christopher Alexander, *The Timeless Way of Building*, NY: Oxford UP, 1979.

5 See K. Dovey, "The Pattern Language and Its Enemies," *Design Studies* II, no. 1 (Jan. 1990): 3–9. For a reading that highlights the phenomenological leanings of Alexander's work, see D. Seamon, "Concretizing Heidegger's Notion of Dwelling: The Contributions of Thomas Thiis Evenson and Christopher Alexander," *Building and Dwelling*, ed. E. Fuhr, Munic: Waxmann Verlag GmbH; NY: Waxmann; 2000, 189–202.

6 Bruun, "Feng Shui: A Challenge to Anthropology," *Feng Shui in China: Geomantic Divination Between State Orthodoxy and Popular Religion*, Honolulu: University of Hawaii Press, 2003, 1–33.

7 Some respected texts of Feng shui include: Sarah Rossbach, *Feng Shui: The Chinese Art of Placement*; Jami Lin, *The Feng Shui Anthology: Contemporary Earth Design*; and Derek Walters, *Chinese Geomancy*.

8 Hwangbo cites a prominent philosopher of the Han Dynasty, Tung Chung-shu (179–104 BCE), who conceptualized chi in his book *Chun-chiu Fan lu* ("Luxuriant Dew of the Spring and Autumn Annals"). See Hwangbo, "An Alternative Tradition in Architecture: Conceptions in Feng Shui and Its Continuous Tradition," 112.

9 Alex Stark (Feng shui specialist) in discussion with the author, May 21, 2010.

10 Hwangbo, "A New Millennium and Feng Shui," 196.

11 Ibid.

12 In a similar vein, the element fire is associated with intellect and education, and pointed, sharply angled shapes are seen as symbolic of those qualities. Spaces of learning are generally associated with fire. On the other hand, spaces for cooking, such as kitchens and stoves, are also associated with fire because they use fire. Eyes are also correlated with fire, as well as with human desire, insight, and aspiration.

13 See also Ritu Bhatt, "Christopher Alexander's Pattern Language: An Alternative Exploration of Space-Making Practices," *The Journal of Architecture* 15, no. 6 (Dec. 2010): 711–29

14 See Alexander, *The Timeless Way*, 10–11 for a discussion of pre-modern built environments as un-self-conscious methods of construction. The quotation appears on page xi of the same text.

15 Ibid., ix (also see 546).

16 Alexander, *The Timeless Way*, xii and 314.

17 Alexander, "The Quality without a Name," *The Timeless Way of Building*, NY: Oxford UP, 1979, 19-40.

18 The fact that patterns have the ability to reappear, reconfigure, and evolve into a language naturally, allowing people to share and enhance experience and knowledge, attests to the influence pattern language is known to have had on innovations such as wikis—collaborative websites that allows users to compile their collective knowledge—as well as other grassroots communities. Such reception of pattern language beyond architecture further reinforces the point that patterns in everyday life play a critical role in socially distributed processes of cognition, and that reinforcement of human knowledge and cognition does not occur only within individuals, but through complex combinations of individuals, and their interactions with objects and spaces in our environment. The influence of pattern languages now extends beyond everyday users in architecture, and pattern language is well-acclaimed in computer programming and combinatorial design for its ability to provide powerful theoretical frameworks upon which to anchor complex design decisions.

19 Alfred B. Hwangbo, "An Alternative Tradition in Architecture: Conceptions in Feng Shui and Its Continuous Tradition," *Journal of Architectural and Planning Research* 19, no. 2 (Summer 2002): 111.

20 Joseph Needham, *Science and Civilization in China*, vol. 2, Cambridge UP, 1956, 280–1. For more on correlative thinking and conceptions, see John B. Henderson, *The Development and Decline of Chinese Cosmology*, NY: Columbia UP, 1984, 1–58.

21 Alex Stark (Feng shui specialist) in discussion with the author, May 21, 2010.

22 Alexander, *A Pattern Language*, 628–31.

23 Alexander, *A Pattern Language*, 638.

24 Alexander, *A Pattern Language*, 557–60.

25 Alexander, *The Timeless Way*, ix (also see 546).

26 Ibid., 12 and 25.

27 Alexander cites a study by Dr London at the San Francisco Medical School that claims our whole day depends critically on the conditions in which we wake up. If we wake up immediately after a period of dreaming (REM sleep), we will feel ebullient, energetic, and refreshed for the whole day because certain critical hormones are injected into the bloodstream immediately after REM sleep. If, however, we wake up during delta sleep (another type of sleep, which happens in between periods of dreaming), we feel irritable, drowsy, flat, and lethargic all day long because the necessary hormones are not in the bloodstream at the critical moment of awakening (*A Pattern Language*, 658).

28 Tom Erickson, "Lingua Franca for Design: Sacred Places and Pattern Languages," The Proceedings of DIS 2000, eds. D. Boyarski and W. Kellogg, NY: ACM Press, 2000, 357–68.

29 For instance, the direction south, Li, is associated with the color red; the element fire; the body part, eyes; and the qualities of insight and clarity; as well as the human aspirations of recognition and fame.

30 For more on somatic philosophy, see Hanna, *The Body of Life: Creating New Pathways for Sensory Awareness and Fluid Movement*.

31 Ibid., 642–3.

32 Alexander was highly influenced by Jerome Bruner, one of the pioneers of cognitive psychology at Harvard's Center for Cognitive Studies. The actual quote reads as follows: "There is a certain sense in which the holistic perception actually corresponds more closely to the real structure of the thing being perceived. But just saying that raises a very interesting topic. I know that this is one of the reasons why some people dislike my work. They say he's so dogmatic; or what does he mean by 'real' or 'not real?' After all, we have people seeing this thing in such and such a way and how could he dare say that what they are seeing is not real? And this is the sort of typical kind of criticism that is often leveled at my work. However, we happen to be caught in this weird sort of nominalist period of philosophical history at the moment where someone will say that however you choose to see something is the way you see it; or however you choose to name it is the way you name it. And of course that coincides with pluralism and is a genuine reaction against positivism. So what do I mean when I say that there is a certain perception of this that is more real? I am actually making two different

statements: one of them is psychological and one of them has to do with physics. The psychological statement that I am making is that the fundamental neurological processes and deep-seated cognitive processes going on in the brain are actually taking place in the holistic way and that the sequential way is secondary and constructed out of it. That's the first thing that I mean when I say that one is more real than the other. ... Now the second thing is that when I say it corresponds to physics, I mean that the holistic perception is congruent with the behavior of the reality being perceived. ... the person who is seeing the thing holistically is actually seeing what is congruent with the behavior of the thing and not just its physical geometry." Alexander, *Christopher Alexander: The Search for a New Paradigm in Architecture*, 195–6. Also see R. Bhatt and J. Brand, "Christopher Alexander: A Review Essay," *Design Issues* XXIV, no. 2 (Spring 2008): 93–102.

33 Nelson Goodman, *Languages of Art: An Approach to a Theory of Symbols* (Indianapolis: Hackett Publishing Company, 1976).

34 Goodman, "How Buildings Mean," *Reconceptions in Philosophy* (co-authored with Catherine Elgin), London: Routledge, 1988, 40.

35 See G. Lakoff and M. Johnson, *Metaphors We Live By*, University of Chicago Press, 1981, 3–24. Also see G. Lakoff and M. Johnson, *Philosophy in the Flesh: The Embodied Mind and Its Challenge to Western Thought*, NY: Basic Books, 1999, 17.

36 Shusterman, "Somaesthetics and the Body/Media Issue," *Performing Live*, Ithica: Cornell UP, 2000, 137–53.

37 Shusterman, "Somaesthetics: A Disciplinary Proposal," *The Journal of Aesthetics and Art Criticism*, 57, no. 3. (Summer, 1999), 299–313. In this proposal, Shusterman also argues that Michel Foucault's seminal vision of the body as a docile, malleable site for inscribing social power reveals the crucial role somatics can play for political philosophy (303–4).

38 R. Shusterman, *Body Consciousness: A Philosophy of Mindfulness and Somaesthetics*, NY: Cambridge UP, ix–14.

environmental embodiment, merleau-ponty, and bill hillier's theory of space syntax

toward a phenomenology of people-in-place

david seamon

As discussed in the phenomenological literature, *environmental embodiment* refers to the various ways, both sensuously and movement-wise, that the body in its pre-reflective perceptual awareness engages and coordinates with the world at hand, especially its architectural and environmental aspects.[1] In this chapter, I consider the conceptual and applied relationship between environmental embodiment and architectural thinker Bill Hillier's theory of *space syntax*.[2] Hillier argued that the particular spatial arrangement of pathways—whether streets or interior corridors—plays a major role in whether those pathways are well used and animated or empty and lifeless. I focus on the question of how spatial aspects of a place, particularly its pathway layout, contribute to modes of environmental embodiment that bring users together spatially or keep them apart.

MERLEAU-PONTY, BODY-SUBJECT, AND PLACE BALLET

A key thinker for understanding environmental embodiment is French phenomenologist Maurice Merleau-Ponty,[3] who emphasized what he termed *body-subject*—the pre-reflective but intelligent awareness of the body manifested through action and typically entwined and in sync with the environment in which the action unfolds.[4] He wrote:

> [M]y body appears to me as an attitude directed towards a certain existing or possible task. And indeed its spatiality is not, like that of external objects ... a *spatiality of position*, but a *spatiality of situation*. ...
>
> The word "here" applied to my body does not refer to a determinate position in relation to other positions or to external co-ordinates, but the laying down of the first co-ordinates, the anchoring of the active body in an object, the situation of the body in face of its tasks. Bodily space can be distinguished from external space and envelop its parts instead of spreading them out.[5]

In this sense, body-subject is a synergy of unselfconscious but integrated movements, and one has learned a particular action when the body-subject has incorporated the action into its realm of pre-cognitive taken-for-grantedness.[6] This pre-reflective manner of bodily sensibility, expressed through a flow of in-sync actions, points toward an intentional corporeal unfolding in the world, as that world typically sustains the corporeal unfolding. Through a repertoire of gestures and movements seamlessly interconnected, the body-subject automatically offers up the actions and activities affording and afforded by the person's typical lifeworld. A major architectural and design question is how specific physical and spatial qualities of buildings and places contribute to how this bodily repertoire of movements and actions happens in one way rather than another.

Though Merleau-Ponty only briefly discussed larger-scale actions of the body-subject, one can point to its temporal and environmental versatility as expressed in more complex corporeal movements and ensembles extending over time and space.[7] In my own work,[8] I have highlighted two such corporeal ensembles: first, *body-routines*—sets of coordinated corporeal actions sustaining a specific task or aim, such as driving, cooking, or lawn mowing; and, second, *time-space routines*—sets of more or less habitual corporeal actions that extend through a considerable portion of time, such as a going-to-bed routine, a weekly going-shopping routine, or a weekend family-outing routine. Most relevant to place-making and urban design is the possibility that, in a supportive physical environment, regular bodily routines in time and space (e.g. walking to work, taking out the dog, or stopping at the local café for coffee) can contribute to a larger-scale environmental dynamic that I called, after the earlier observations of urban critic Jane Jacobs,[9] a *place ballet*—an interaction of individual bodily routines rooted in a particular environment, which often becomes an important place of interpersonal and communal exchange, meaning, and attachment. Examples might include a bustling city street, a lively urban plaza, or a thriving city neighborhood.[10]

SPACE SYNTAX THEORY

The next question to ask is how qualities of the world, particularly its physical, potentially designable features, might sustain and strengthen time-space ensembles of body-subject, including place ballets. Particularly important is Hillier's space syntax theory, which provides conceptual and empirical evidence that the physical-spatial environment plays an integral part in sustaining active streets and an urban sense of place.[11] Hillier asked if there is some "deep structure of the city itself" that contributes to urban life.[12] He found this deep structure in the relationship between spatial structure and natural co-presence—in other words, the way the spatial layout of pathways can informally and automatically bring people together in urban space or keep them apart.[13]

Though Hillier's work is not phenomenological but structural and instrumentalist, it is significant phenomenologically because it demonstrates how a world's underlying spatial structure, or *configuration*, as Hillier called it, contributes to particular modes of human movement, corporeal co-presence, and interpersonal encounter. One important concept is *axial space*, which relates to the *one*-dimensional qualities of space and has bearing on human movement through a settlement as a whole. Axial spaces are illustrated most perfectly by long narrow streets. They can be represented geometrically by the longest straight line that can be drawn through a street or other open space before that line strikes a building, wall, or some other material object. Axial lines are significant phenomenologically for at least two reasons. First, because they indicate the farthest point of sight from where one happens to be axial lines speak to the lived relationship between "here" and "there" and thus, have bearing on environmental orientation and finding one's way in a place. Second, because they collectively

delineate the spatial system through which the various parts of a place are connected by pedestrian and vehicular circulation, a settlement's web of axial lines provides a simplified rendition of the potential movement field of a place. Hillier's important discovery was that differently configured pathway webs afford different patterns of pathway movement and interpersonal encounter.

A major quantitative indicator in regard to axial spaces and pathway webs is *integration*, which is a measure of the relative degree of connectedness that a particular axial space has in relation to all other axial spaces in a particular pathway system. The assumption is that a pathway connected to many other pathways will be more used by pedestrians because they will need to traverse that pathway to get to other pathways and destinations in the settlement.[14] Such a pathway is said to be strongly *integrated* in the movement field because many other pathways run into that well-connected pathway and potentially provide a large pool of users. In contrast, a *segregated* pathway has few or no other pathways running into it; all other things being equal, it will be the locus of less pathway movement, since it serves a more limited number of users in its immediate vicinity only.[15]

Through integration and other quantitative measures, Hillier developed a compelling understanding of the *global* pattern of a place—in other words, the way the particular spatial configuration of a place's pathway fabric lays out a potential movement field that draws people together or keeps them apart. *Natural movement* is the term Hillier used to describe the potential power of the pathway fabric to automatically stymie or facilitate movement and such related space-based events as pedestrian co-presence, co-awareness, informal interpersonal encounters, and exuberant local places and street activity.[16] Hillier recognized that other urban elements like density, building types, and number, size, and range of functions and land uses also contribute to urban vitality, but he argued that, ultimately, pathway configuration is most primary and most crucial.[17]

In regard to cities, Hillier demonstrated that most urban pathway systems have traditionally been an integrated, interconnected fabric of variously-scaled *deformed grids*—pathway systems in which the most active, integrated streets form a shape that roughly suggests a wheel composed of rim, hub, and spokes. Typically, each of these deformed grids is associated with some designated neighborhood or district—for example, London's Soho, West End, or City. In turn, the integrated pathway structure of these districts join together to shape a much larger *deformed grid* that founds the movement dynamic of the city as a whole.[18] Hillier also pointed out that twentieth-century urban design and planning regularly replaced integrated pathway configurations with treelike systems of segregated pathways that stymied or destroyed the intimate relationship between local and global integration and thereby eliminated much face-to-face encounter—for example, the "cul-de-sac and loop" pattern of low-density, automobile-dependent suburbs or the hierarchical circulation layouts of many modernist housing estates.[19]

From the perspective of environmental embodiment, Hillier's critique of modernist design and planning suggests that the possibility of individual habitual bodies readily gathering in co-presence is greatly compromised because the

particular pathway configuration does not channel the movements of many people into and along more integrated pathways. In other words, modernist pathway structure regularly holds habitual bodies apart rather than draws them together. Bodies that otherwise might belong together if they could present themselves to each other physically—a situation that the deformed grid readily affords—are separated and cannot meet in the everyday, taken-for-granted co-presence and encounter founded in the tacit ease of bodily regularity. There is much less chance for place ballets and what humanistic geographer Yi-Fu Tuan termed *fields of care*—places that come to be known affectionately through prolonged, recurring, interpersonal exchanges and experience.[20]

PLACE BALLET, SPACE SYNTAX, AND MERLEAU-PONTY

How might place ballet and Hillier's space-syntax discoveries be interpreted from Merleau-Ponty's vantage point? In *Phenomenology of Perception*, he provided several examples of how the body-subject automatically adjusts actions spatially depending on context so there are no disruptions or accidents—for example, a motorist's driving his automobile and a blind man's using his walking stick.[21] His most significant example is his own bodily mastery of his apartment: "My flat is, for me, not a set of closely associated images. It remains a familiar domain round about me only as long as I still have 'in my hands' or 'in my legs' the main distances and directions involved, and as long as from my body intentional threads run out towards it."[22] It is this same unself-conscious awareness "in the hands" and "in the legs" extended over broader environmental scales, which is the lived foundation for wider-ranging time-space routines and place ballets.

In his book *The Sense of Space*,[23] philosopher David Morris sought a language to make Merleau-Ponty's language of body-subject more dynamic and contextual by demonstrating "how the moving body is inherently open to the world."[24] Morris identified what he called "the crossing of body and world," which he described as "a flowing threshold that overlaps body and world."[25] In using this phrasing, he meant that neither the experiencing body nor the world experienced is separate and self-contained but "inherently interdependent": "the body is in the depths of the world, yet in those depths through a flowing threshold that overlaps body and world."[26]

Morris's notion of "crossing" can readily accommodate wider-scaled, flowing thresholds suggested by time-space routines and place ballets; in fact, he emphasized that "the sense of space is rooted in that crossing."[27] He also spoke of *sens*—"meaning as arising within directed movement that crosses body and world."[28] Morris wrote: "There is *sens* within the body's moving directedness toward the world. *Sens* ... is neither a meaning in the head nor is it interior to subjectivity; it is a meaning within a movement that crosses body and world."[29] In regard to the time-space extensions of body-subject identified in this chapter, one might speak of an *environmental and place sens* that underlies the body's unfolding actions in sync with the world's enfolding.

Morris's interpretation, however, is less readily applied to Hillier's discovery that a particular spatial configuration of pathways facilitates a particular mode of natural movement. "Our sense of space," Morris wrote, "is enfolded in an outside, in a world that crosses our body."[30] This claim may be broadly true, but how might we apply the body's enfoldment in an outside as related to the deformed grid? How, in a grounded way, do we describe the lived intimacy between the lived body and pathway configuration?

One relevant theme that Merleau-Ponty developed in his later work is the conception of *flesh*—the intertwining of sense and being sensed, touch and being touched, encounter and being encountered—a sort of "formative medium" between person and world, a kind of already-and-always-present entwining between experience and world experienced.[31] Emphasizing its quality of lived intimacy between person and other, Simms described flesh as "the intentional *chiasm*, or entwining, between dyadic bodies, the invisible form of the other that is inscribed in each."[32] Various commentators on Merleau-Ponty have suggested that an integral part of flesh is the person's lived connectedness with things and other living beings.[33] Jensen[34] highlighted this lived liaison when she wrote that "[as] bodied beings in a shared sensible world, we cohere in and through connection with others. ...'[S]elfhood' is not a demarcation of a simple and autonomous entity. Instead, the self is a site of relation between dual aspects or sides, and this self flourishes through intercorporeal encounters."

Space-syntax findings are significant in relation to Merleau-Ponty's concept of flesh because they demonstrate how particular configurational qualities of the world contribute to the number, manner, and ambience of intercorporeal encounters. In Merleau-Ponty's terms, we might speak of *environmental flesh*— the ways that in touching us, qualities of human-made spaces and things allow us to touch, or not, the worlds to which they contribute. In other words, spatial configuration beckons us and others to move in particular ways so we meet in co-presence and co-awareness or are held apart. In his interpretation of Merleau-Ponty, Morris[35] argued that a sense of ethics arises from a responsibility for things that exceed us, and that a primary source for such responsibility is intercorporeal encounters. In this sense, the spatial and the ethical are integrally intertwined: "Our sense of space develops in a social relation that will have ethical implications; our sense of others and thence of the ethical presupposes our sense of space, for this gives us our initial sense of responsibility to something beyond us."[36]

In regard to effective place-making, space syntax argues for a particular kind of environmental flesh—a deformed grid sustaining integrated pathways along which many habitual bodies meet physically in intercorporeal co-presence and perhaps engage in interpersonal encounter.[37] Space syntax contends that modernist design, through hierarchical pathway layouts, often stymied interpersonal co-presence, which largely defeated Morris's intercorporeal ethics by beckoning bodies toward physical separation rather than toward communal togetherness, place ballets, and fields of care. One is reminded of Jane Jacobs's street ballet that shapes the informal public sphere in which more formal civic life takes place.[38] Through taken-for-granted regularity, neighborhood residents establish bonds of recognition grounding community and provide "eyes on the

street" that keep watch over children and strangers and make a neighborhood sociable and safe. One recognizes a kind of "neighborhood flesh" in which insiders, outsiders, time, and space merge physically and existentially in a tissue of place.

THE THEORY AND PRACTICE OF ENVIRONMENTAL EMBODIMENT

In the last fifteen years, research on the lived body has become a major focus in the human sciences and the design professions.[39] In their review of this work, social geographers Pamela Moss and Isabel Dyck[40] identify two major research thrusts. First, they point to what they call *a social geography of the body*, which involves "the nexus of personal and collective experiences of social, built, and natural environments, including the possibilities of bodily activities in specific spaces." Second, Moss and Dyck speak of *an embodied social geography*, which focuses on conceptual efforts in which "the body itself is both the subject of theory and a site for theorizing [environmental, spatial, and social aspects of human life]."[41] One goal is to facilitate "knowledge that theorizes from bodies, privileging the material ways in which bodies are constituted, experienced and represented."[42]

My aim in this chapter has been to demonstrate a potential conceptual and applied liaison between space syntax and a phenomenology of environmental embodiment, particularly as the latter might be interpreted through Merleau-Ponty. First, this perspective relates to Moss and Dyck's "social geography of the body" in that it focuses on real places and the ways that pathway configuration draws people together or keeps them apart. Second, this perspective relates to Moss and Dyck's "embodied social geography" in that it demonstrates the everyday way in which human beings, through corporeal presence and actions, are intimately and inescapably conjoined with the world in which they find themselves. What is analytically and instrumentally thought of as two—people and world—is existentially understood as one—human-being-in-world, or in Merleau-Ponty's phrasings, body-subject and flesh.

For a phenomenology of environmental embodiment, space syntax is significant theoretically and empirically because it provides a conceptual and analytical language to identify and understand ways in which spatial configuration contributes to particular lived modes of bodily-being-in-the-world. In turn, phenomenological studies grounded in a space-syntax perspective might offer helpful accounts of the experiential structures and situations of these lived modes, particularly as they facilitate place and place-making. This work has important normative and diagnostic value. One of the great questions of our time is whether the unselfconscious place making of the past can today be regenerated self-consciously, through knowledgeable planning, equitable policy, and creative design. Space syntax and environmental embodiment offer much promise for finding theoretical and practical answers to this question.[43]

NOTES

1 An earlier version of this chapter was presented as a paper at the conference "Flesh and Space: Intertwining Merleau-Ponty and Architecture," College of Architecture, Art and Design, Mississippi State University, Starkville, MS, September, 2009. This conference was held in conjunction with the annual meeting of the Merleau-Ponty Circle. Phenomenological literature on this subject includes the following texts: Karen Franck and Bianca Lepori, *Architecture from the Inside Out: From the Body, the Senses, the Site, and the Community*, 2nd edition, NY: Wiley, 2007; Setha M. Low, "Embodied Space(s)," *Space and Culture* 6 (2003): 9–18; Juhani Pallasmaa, *The Eyes of the Skin: Architecture and the Senses*, London: Academy Editions, 1996; Juhani Pallasmaa, *The Thinking Hand*, London: Wiley, 2009; David Seamon, "Merleau-Ponty, Perception, and Environmental Embodiment: Implications for Architectural and Environmental Studies," *Carnal Echoes: Merleau-Ponty and the Flesh of Architecture*, eds. R. McCann and P. M. Locke, 2013, forthcoming; Eva M. Simms, *The Child in the World: Embodiment, Time, and Language in Early Childhood*, Detroit: Wayne State UP, 2008.

2 Bill Hillier, *Space Is the Machine*, Cambridge UP, 1996; Bill Hillier and Julienne Hanson, *The Social Logic of Space*, Cambridge UP, 1984; David Seamon, "A Lived Hermetic of People and Place: Phenomenology and Space Syntax," 6th International Space Syntax Symposium, Istanbul Technological University, Faculty of Architecture, *Proceedings* 1, eds. A. Kubat, O. Ertekin, Y. Guney, and E. Eyuboglu, 2007, iii–16.

3 Maurice Merleau-Ponty, *Phenomenology of Perception*, trans. Colin Smith, NY: Humanities Press, 1962 (originally 1945); Maurice Merleau-Ponty, *The Visible and the Invisible*, Evanston: Northwestern UP, 1968 (originally 1964).

4 In the original French, Merleau-Ponty used the term *schema corporel* (Taylor Carman, *Merleau-Ponty*, NY: Routledge, 2008, 105). Often in English translation, the term "body schema" is used rather than "body-subject" (e.g. David Morris, "Body," *Merleau-Ponty: Key Concepts*, eds. Rosalyn Diprose and Jack Reynolds, Stockfield, Great Britain: Acumen Publishing, 2008, 111–20). I prefer the latter because "subject" better suggests than "schema" the lived body's pre-cognitive but intentional sensibility in regard to bodily movements. Discussions of body-subject include Taylor Carman, chapter 3, *Merleau-Ponty*, NY: Routledge, 2008; David R Cerbone, "Perception," *Merleau-Ponty: Key Concepts*, eds. R. Diprose and J. Reynolds, Stockfield, Great Britain: Acumen Publishing, 2008, 121–31; Fred Evans, "Chiasm and Flesh," *Merleau-Ponty: Key Concepts*, eds. R. Diprose and J. Reynolds, Stockfield, Great Britain: Acumen Publishing, 2008, 184–93; Linda Finlay, "The Body's Disclosure in Phenomenological Research," *Qualitative Research in Psychology* 3 (2006): 19–30; Shaun Gallagher, "Introduction: The Arts and Sciences of the Situated Body," *Janus Head* 8.2 (2005): 293–5; David Morris, *The Sense of Space*, Albany, NY: State University of New York Press, 2004; David Morris, "Body," 111–20; Seamon, "Merleau-Ponty, Perception, and Environmental Embodiment."

5 Merleau-Ponty, *Phenomenology of Perception*, 100.

6 Ibid., 138–9.

7 Chris Allen, "Merleau-Ponty's Phenomenology and the Body-in-Space: Encounters of Visually Impaired Children," *Environment and Planning D: Society and Space* 22 (2004): 719–35; Jonathan Cole, *Still Lives: Narratives of Spinal Cord Injury*, Cambridge, MA: MIT Press, 2004; Miriam Hill, "Bound to the Environment: Towards a Phenomenology of Sightlessness," *Dwelling, Place and Environment: Towards a Phenomenology of Person and World*, ed. D. Seamon, Dordrecht: Nijhoff, 1985, 99–111; David Seamon, *A Geography of the Lifeworld*, NY: St. Martin's, 1979; S. K. Toombs, "The Lived Experience of Disability," *Human Studies* 18 (1995): 9–23.

8 Seamon, *A Geography of the Lifeworld*.

9 Jane Jacobs, *The Death and Life of Great American Cities*, NY: Vintage, 1961, 50.

10 Seamon, *A Geography of the Lifeworld*; Seamon, "Grasping the Dynamism of Urban Place: Contributions from the Work of Christopher Alexander, Bill Hillier, and Daniel Kemmis," *Reanimating Places*, ed. Tom Mels, Burlington, Vermont: Ashgate, 2004, 123–45; David

Seamon and Christine Nordin, "Market Place as Place Ballet: A Swedish Example," *Landscape* 24 (Oct. 1980): 35–41.

11 Hillier, *Space Is the Machine*; Hillier and Hanson, *The Social Logic of Space*.

12 Bill Hillier, "The Architecture of the Urban Object," *Ekistics* 56 (1989): 5–21; 5.

13 Hiller, "The Architecture of the Urban Object."

14 Hillier and Hanson, chapter 3, *The Social Logic of Space*.

15 To test the accuracy of his integration measure, Hillier and colleagues compared integration values with the actual number of pedestrians using pathways. These counts demonstrate a high level of agreement between the integration measure and real-world pedestrian use (see Hillier, *Space Is the Machine*, 161; Seamon, "Grasping the Dynamism of Urban Place," 142, n. 7).

16 Hillier, *Space Is the Machine*, 161.

17 Bill Hillier and Shinichi Lida, "Network Effects and Psychological Effects: A Theory of Urban Movement," *Proceedings of the 5th International Space Syntax Symposium*, ed. A. van Nes, Delft: Delft Techne Press, 2005, 551–64.

18 Hillier, *Space Is the Machine*, chapter 4; Seamon, "Grasping the Dynamism of Urban Place."

19 Hillier, *Space Is the Machine*.

20 Yi-Fu Tuan, "Space and Place: Humanistic Perspective," *Progress in Geography* 6, London: Edward Arnold, 1974, 266–76.

21 Merleau-Ponty, *Phenomenology of Perception*, 143–6.

22 Ibid., 130.

23 2004.

24 Ibid., viii.

25 Ibid., 6.

26 Ibid.

27 Ibid., 5.

28 Ibid., 24.

29 Ibid.

30 Ibid., 6.

31 Merleau-Ponty, *The Visible and the Invisible*, 147.

32 *The Child in the World*, 19. In describing the concept of flesh, Merleau-Ponty (*The Visible and the Invisible*, 14) wrote: "The flesh we are speaking of is not matter. It is the coiling over of the visible upon the seeing body, of the tangible upon the touching body, which is attested in particular when the body sees itself, touches itself seeing and touching the things, such that, simultaneously, *as* tangible it descends among them, *as* touching it dominates them all and draws this relationship and even this double relationship from itself, by dehiscence or fission of its own mass."

33 For example, Suzanne L. Cataldi and William S. Hamrick, *Merleau-Ponty and Environmental Philosophy*, eds. S. L. Cataldi and W. S. Hamrick, Albany, NY: State University of New York Press, 2007.

34 Molly Hadley Jensen, "'Fleshing' Out an Ethic of Diversity," *Merleau-Ponty and Environmental Philosophy*, eds. S. L. Cataldi and W. S. Hamrick, Albany, NY: State University of New York Press, 2007, 191–201; 197.

35 *The Sense of Space*.

36 Ibid., 176.

37 Jacobs, *The Death and Life of Great American Cities*.

38 Jacobs, *The Death and Life of Great American Cities*, chapters 2–4.

39 e.g. Edward S. Casey, *Getting Back into Place*, 2nd edition, Bloomington: Indiana UP, 2009; Linda Finlay, "The Body's Disclosure in Phenomenological Research," *Qualitative Research in Psychology* 3 (2006): 19–30; Franck and Lepori, *Architecture from the Inside Out*; Gallagher, "Introduction: The Arts and Sciences of the Situated Body"; Low, "Embodied Space(s)"; Pallasmaa, *The Eyes of the Skin*; Pallasmaa, *The Thinking Hand*; Arun Saldanha, "The Political Geography of Many Bodies," *The Sage Handbook of Political Geography*, eds. Kevin R. Cox, Murray Low, and Jennifer Robinson, London: Sage, 2008, 323–33; Simms, *The Child in the World*.

40 Pamela Moss and Isabel Dyck, "Embodying Social Geography," *Handbook of Cultural Geography*, eds. Kay Anderson, Mona Domosh, Steve Pile, and Nigel Thrift, London: Sage, 2008, 58–73.
41 Ibid., 60.
42 Ibid.
43 Already, the diagnostic and design-planning achievements of space syntax are considerable; see the *Space Syntax* website at www.spacesyntax.com (accessed June 4, 2011).

mental and existential ecology

juhani pallasmaa

INTRODUCTION: SETTLING THE MIND

The task of buildings is usually seen solely in terms of functional performance, physical comfort, and aesthetic values.[1] Yet the role of architecture extends far beyond the material, physical, and measurable dimensions, and even beyond aesthetics, into the mental and existential sphere of life. Buildings do not merely provide physical shelter and facilitate distinct activities; they are also a mental mediation between the world and our consciousness. Architectural constructions structure and articulate existential space, and they constitute an essential part of our externalized system of order and memory. As Gaston Bachelard appropriately states, "[The house] is an instrument with which to confront the cosmos."[2]

In addition to housing our fragile bodies, architecture settles our restless minds, memories, and dreams. In short, it organizes and structures experiences, beliefs, and fantasies of the world. It projects distinct frames of perception and experience, and provides specific horizons of understanding and meaning. Besides articulating space, man-made structures concretize the passage of time, represent cultural hierarchies, and give a visible presence to human institutions. Grasping the continuum of tradition, and understanding our cultural past, empowers us to have a confidence in the future. These are truly monumental tasks for our buildings, which are, however, increasingly seen merely in terms of utility, investment, or aestheticization.

We have remnants of the tail in our skeletal structure deriving from our arboreal life tens of millions of years ago, we have traces of the horizontally closing eyelid in our eyes to remind us of our reptilian past, and we even have a remains of gills in our body as a reminder of our aquatic life hundreds of millions of years ago. It is clear that we also have a number of existential reactions secured in our nervous system, and they need to be acknowledged in architecture. We are biological and historical beings, and architecture needs to protect the biological and cultural historicity of the human being. Perhaps even more importantly, our constructed world enables us to understand and remember who we are.

THE MEASURABLE AND THE UNMEASURABLE

The analysis of the mental task of architecture takes us outside of physics and physiology, and even beyond psychology, into unconscious motifs and memories, desires and fears. In addition to organizing the outside world, architecture also structures our inner world, the *Weltinnenraum*, to use the beautiful notion of Rainer Maria Rilke. As a consequence, the mental context of architecture cannot be approached through instruments of measurement; its poetic essence is grasped solely through an embodied encounter, intuition, identification, and empathy; poetic signification is always a lived meaning that arises directly from our existential reality. Existential meanings are embodied and lived rather than understood intellectually. This silent and voiceless

knowledge of our bodies is grossly neglected even in the currently prevailing educational ideologies.

Profound architecture focuses on lived experiential essences and mental meanings; this very focus also defines the architect's true approach and method. As Jean-Paul Sartre states: "Essences and facts are incommensurable, and one who begins his inquiry with facts will never arrive at essences. ... [U]nderstanding is not a quality coming to human reality from the outside, it is its characteristic way of existing."[3] All artistic works, including architecture, seek this natural mode of understanding that is chiasmatically entwined with our very existence. Consequently, the true essence of building does not arise from theoretical knowledge, or an aesthetic aspiration; it originates in our existential desire.

Jorge Luis Borges describes memorably the essence of the poetic experience:

> The taste of the apple ... lies in the contact of the fruit with the palate, not in the fruit itself; in a similar way ... poetry lies in the meeting of poem and reader, not in the lines of symbols printed on the pages of a book. What is essential is the aesthetic act, the thrill, the almost physical emotion that comes with each reading.[4]

Constantin Brancusi puts it even more succinctly: "Art must give suddenly, all at once the shock of life, a sensation of breathing."[5] The meaning of architecture emerges similarly in the unique encounter of space and the person, in the very merging of the world and the dweller's sense of self. In the poetic survey of architecture as well as poetry, the perceiving and experiencing self, the first person, has to be placed in the center. Also in responsible education the first person, the unique embodied individual, has to be placed in the very center.

Figure 10.1 Door pull studies, cast bronze, 1991. (Juhani Pallasmaa Architects Archive.)

The mental quality of a building is not a mere surplus value in addition to utility and reason; it is its very essence. Architecture has never in history arisen from purely material, climatic, and economic conditions, or pure rationality; it has always reflected cultural aspirations, beliefs, and ideals. We need to acknowledge that soulless buildings are detrimental to life regardless of their functional, thermal, ergonomic, and economic characteristics, as they fail to root us in our lived reality and to mediate between the world and our consciousness. Such buildings do not help us to understand ourselves. Architecturally inadequate buildings should not be built at any cost. This should be the ground when thinking about sustainable buildings; sustainability is not a technical matter, as only buildings that sustain and vitalize our mental constitutions and identities can be considered sustainable. Only "life-enhancing" (a notion of J. W. von Goethe) buildings can be sustainable.

Herein I attempt to identify the existential, sensory, and embodied ground of architecture that gives rise to a *mental and existential ecology*, or, to put it another way, the sustainability of mental life.

BEYOND VISION

The art of architecture continues to be regarded, theorized, and taught as an art form of the eye. As a consequence, it is dominated by considerations of retinal qualities, such as visual composition and enticing and memorable image. In fact, the dominance of vision has never been stronger than in our current era of the visual image and its industrial mass production, "the unending rainfall of images," as Italo Calvino puts it.[6] As a consequence of this biased emphasis, our buildings are turning into objects of momentary visual seduction, while losing their sense of presence, plasticity, and hapticity; indeed, their sense of the real. They have become mere aestheticized objects that are externally viewed and marveled at rather than lived as an inseparable part of our very awareness and sense of life. Instead of being "instruments to confront the cosmos," as Bachelard suggests, buildings are increasingly objects of social and commercial manipulation. A profound building makes us marvel at the magnificence of the world—gravity and silence, the interplay of light and shadow, and the multiplicity of life itself—not admire the building itself as an aestheticized object.

This unfortunate condition is further strengthened by the development of building processes, techniques, and materials toward generic uniformity, and the detachment from the specificities of place and culture, as well as today's obsessive objectives of economy and instant gratification. Besides, today architecture aspires to rival other artistic media, such as cinema and rock music, but we need to acknowledge that architecture is a slow and silent background phenomenon that frames human experience and gives it specific horizons of meaning. This silent but perpetual presence is the special and monumental power of the art of architecture.

Figure 10.2 Shapes for body movement and touch. Rovaniemi Art Museum, 1986. (Juhani Pallasmaa Architects Archive.)

The sensory and mental impoverishment of contemporary, retinal-biased environments has made it clear that profound architecture is a multi-sensory art form; buildings need to address our senses of hearing, touch, smell, and even taste, as much as pleasing the eye. In fact, architecture needs to address many more sensory and neural entities. The Steinerian philosophy suggests that we have twelve senses instead of the five arising initially from Aristotelian thought.

Our buildings need to provide us with our corner in the world, not mere visual titillation. Maurice Merleau-Ponty argues strongly for the integration of the senses: "My perception is [therefore] not a sum of visual, tactile, and audible givens: I perceive in a total way with my whole being: I grasp a unique structure of the thing, a unique way of being, which speaks to all my senses at once."[7] The true wonder of our perception of the world is its very completeness, continuity, and constancy, regardless of the fragmentary nature of our perceptions. Meaningful architecture facilitates and supports this extraordinary and unexpected experience of fullness and completeness.

The experience of being is fundamentally an embodied and haptic manner of occupying space, place, and time. The current loss of hapticity, the sense of intimacy and nearness, has particularly negative consequences as it evokes feelings of alienation, rejection, and distance. These experiences give rise to the feeling of "existential outsideness," to use a notion of Edward Relph.[8] In order

to root us in our world, buildings need to go beyond sensory comfort and pleasure into the very enigma of human existence. "Writing is literally an existential process," the poet Joseph Brodsky argues, and the same must definitely be said of architecture.[9]

PRIMACY OF TOUCH: HAPTICITY OF SELF-IMAGE

All the senses, including vision, are extensions of the tactile sense; the senses are specializations of skin tissue, and all sensory experiences are modes of touching, and thus related with tactility. "Through vision we touch the sun and the stars," as Martin Jay remarks poetically.[10] Our contact with the world takes place at the boundary line of the self through specialized parts of our enveloping membrane. Yet the sense of self and identity does not stop at the surface of the skin.

The view of the anthropologist Ashley Montagu, based on medical evidence, confirms the primacy of the haptic realm:

> [The skin] is the oldest and the most sensitive of our organs, our first medium of communication, and our most efficient protector. ... Even the transparent cornea of the eye is overlain by a layer of modified skin. ... Touch is the parent of our eyes, ears, nose, and mouth. It is the sense, which became differentiated into the others, a fact that seems to be recognized in the age-old evaluation of touch as "the mother of the senses."[11]

In *Body, Memory and Architecture*, an early study on the embodied essence of architectural experience, Kent C. Bloomer and Charles Moore emphasize the primacy of the haptic realm similarly: "The body image ... is informed fundamentally from haptic and orienting experiences early in life. Our visual images are developed later on, and depend for their meaning on primal experiences that were acquired haptically."[12]

Touch is the sensory mode that integrates our experiences of the world and of ourselves. Even visual perceptions are fused and integrated into the haptic continuum of the self; my body remembers who I am and how I am located in the world. In Marcel Proust's *In Search of Lost Time: Swann's Way*, the protagonist, waking up in his bed, reconstructs his identity and location through his body memory:

> My body, still too heavy with sleep to move, would endeavour to construe from the pattern of its tiredness the position of its various limbs, in order to deduce therefrom the direction of the wall, the location of the furniture, to piece together and give a name to the house in which it lay. Its memory, the composite memory of its ribs, its knees, its shoulder-blades, offered it a whole series of rooms in which it had at one time or another slept, while the unseen walls, shifting and adapting themselves to the shape of each successive room that it remembered, whirled round it in the dark. ... my

body, would recall from each room in succession the style of the bed, the position of the doors, the angle at which the sunlight came in at the windows, whether there was a passage outside, what I had had in mind when I went to sleep and found there when I awoke.[13]

The writer's description provides a powerful example of the intertwining of the body, memory, and space. My body is truly the navel of my world, not in the sense of the viewing point of a central perspective, but as the sole locus of integration, reference, memory, and imagination.

THE UNCONSCIOUS TOUCH

We are not usually aware that an unconscious experience of touch is unavoidably concealed in vision. As we look, the eye touches, and before we even see an object, we have already touched it and judged its weight, temperature, and surface texture. Touch is the unconsciousness of vision, and this hidden tactile experience determines the sensuous qualities of the perceived object. The unconscious sense of touch mediates messages of invitation or rejection, nearness or distance, pleasure or repulsion. It is exactly this unconscious dimension of touch in vision that is disastrously neglected in today's retinal and hard-edged architecture. This architecture may entice and amuse the eye, but it does not provide a domicile for our bodies and minds.

Figure 10.3 Door handle studies, page of a sketch book, 1980s. (Juhani Pallasmaa Architects Archive.)

The haptic fusion with space and place surpasses the need for physical comfort and the mere desire to touch. Bachelard recognizes the desire for a total merging of the self and the house through a bodily intertwining as he writes: "Indeed, in our houses we have nooks and corners in which we like to curl up comfortably. To curl up belongs to the phenomenology of the verb to inhabit, and only those who have learned to do so can inhabit with intensity."[14] The pleasure of curling up also suggests an unconscious association between the images of the room and the womb; a protective and pleasurable room is a constructed womb, in which we can re-experience the undifferentiated world of the child, the forgotten infant concealed in our adult bodies.

Merleau-Ponty writes emphatically,

> We see the depth, speed, softness and hardness of objects—Cézanne says that we see even their odour. If a painter wishes to express the world, his system of colour must generate this indivisible complex of impressions, otherwise his painting only hints at possibilities without producing the unity, presence and unsurpassable diversity that governs the experience and which is the definition of reality for us.[15]

In developing further Goethe's notion of "life-enhancing art" in the 1890s, Bernard Berenson suggested that when experiencing an artistic work, we actually imagine a genuine physical encounter through "ideated sensations." The most important of these ideated sensations Berenson called "tactile values."[16] In his view, a work of authentic art stimulates our ideated sensations of touch, and this stimulation is life-enhancing.

Similarly, in my view, a profound architectural work generates an indivisible complex of impressions, or ideated sensations, such as experiences of movement, weight, tension, texture, light, color, formal counterpoint, and rhythm, and they become the measure of the real for us. Even more importantly, they become unconscious extensions of our own body and consciousness. When entering the marble courtyard of the Salk Institute in La Jolla, California, I felt compelled to walk directly to the nearest concrete surface and sense its temperature; the enticement of a silken skin, suggested by this concrete material, was overpowering. Louis Kahn actually sought the gray softness of "the wings of a moth"[17] and added volcanic ash to the concrete mix in order to achieve this extraordinary matte visual softness.

True architectural quality is manifested in the fullness, freshness, and unquestioned prestige of the experience. A complete resonance and interaction takes place between the space and the experiencing person. This is the "aura" of a work of art observed by Walter Benjamin.[18]

SPACE AND THE SELF

Our normal understanding, the commonplace "naïve realism," regards space as a measureless, infinite, and homogenous emptiness in which objects and

physical events take place. Space itself is seen as a meaningless continuum; signification is assumed to lie solely in the objects and events occupying space. The assumption that environment and space are neutral concepts existing outside man thus continues to be axiomatic in everyday life. Yet it is precisely this separation of man and environment that anthropologist Edward T. Hall views as one of the most destructive unconscious cornerstones of western thinking.[19]

One of the influential thinkers to point out the essential existential connection between space and the human condition, the world and the mind, was Martin Heidegger. He paid attention to the connectedness—or perhaps we should say, the unity—between the acts of building, dwelling, and thinking. He links space indivisibly with the human condition: "When we speak of man and space, it sounds as though man stood on one side, space on the other. Yet space is not something that faces man. It is neither an external object nor an inner experience. It is not that there are men, and over and above them space."[20]

Surely, we do not exist or dwell detached from space, or in an abstract and valueless space; we always occupy distinct settings and places that are intertwined with our very consciousness. Lived space always possesses specific characteristics and meanings. Space is not inactive, either; space either empowers or weakens, charges or discharges. It has the capacity to unite or isolate, embrace or alienate, protect or threaten, liberate or imprison. Space is either benevolent or malicious in relation to human existence.

The world around us is always organized and structured around distinct foci, such as concepts and experiences of homeland, domicile, place, home, and self. Also, our specific intentions organize space and project specific meanings upon

Figure 10.4 Prototypes for door handles, polished brass, leather and ebony, 1991. (Juhani Pallasmaa Architects Archive.)

it. Even concepts from one's mother tongue, such as the unconscious notions of above and below, in front and behind, before and after, affect our understanding and utilization of space in specific and pre-conditioned ways. So, even space and language are intertwined. As we settle in a space, it is grasped as a distinct place. In fact, the act of dwelling is fundamentally an exchange; I settle in the place and the place settles in me. This merging of space and self is one of the founding ideas of Merleau-Ponty's philosophy that offers a fertile conceptual ground for the understanding of artistic, architectural, and existential phenomena.

EXISTENTIAL SPACE

We do not live in an objective world of matter and facts, as commonplace naïve realism assumes. The characteristically human mode of existence takes place in worlds of possibilities, molded by our capacities of memory, fantasy, and

Figure 10.5 Design for the body. Chair, prototype, 1999. Laminated plywood and carbon fibre, spring steel base. (Juhani Pallasmaa Architects Archive.)

imagination. We live in mental worlds, in which the material and the spiritual, as well as the experienced, remembered, and imagined fuse completely into each other. As a consequence, the lived reality does not follow the rules of space and time, as defined and measured by the science of physics. We could say that the lived world is fundamentally "unscientific," when assessed by the criteria of empirical science. In its diffuse character, the lived world is closer to the oscillating realm of dreams than scientific descriptions. In order to distinguish the lived space from physical and geometrical space, it can appropriately be called "existential space." Existential space is structured by meanings, intentions, and values reflected upon it by an individual or a group, either consciously or unconsciously; existential space is a unique quality interpreted through human memory and experience. On the other hand, groups and even entire nations share certain characteristics of existential space that constitute their collective identities and sense of togetherness. The experiential and lived space, not physical or geometric space, is also the ultimate object and context of both the making and experiencing of architecture. The fundamental human task of architecture is "to make visible how the world touches us," as Merleau-Ponty wrote of the paintings of Paul Cézanne.[21] In accordance with this philosopher, we live in the "flesh of the world" and architecture structures and articulates this very existential flesh, giving it specific meanings. I wish to suggest that it is architecture that tames and domesticates the space and time of the flesh of the world for the purposes of human habitation. We know and remember who we are and where we belong fundamentally through our constructions, both material and mental.

THE WORLD AND THE MIND: BOUNDARIES OF SELF AND EMBODIED CONSCIOUSNESS

"How would the painter or the poet express anything other than his encounter with the world,"[22] writes Merleau-Ponty. "How could the architect do otherwise?" we can ask with equal justification.

Art and architecture structure and articulate our being-in-the-world, or the inner space of the world (*Weltinnenraum*),[23] to repeat Rilke's suggestive concept. A work of art does not mediate conceptually structured knowledge of the objective state of the world, but it renders possible an intense experiential and existential self-knowledge. Without presenting any precise propositions concerning the world or its condition, art focuses our view on the boundary surface between our sense of self and the world.

In the text that he wrote in memory of Herbert Read in 1990, Salman Rushdie writes about the weakening of this boundary that takes place in an artistic experience. "Literature is made at the boundary between self and the world," he writes, "and during the creative act this borderline softens, turns penetrable and allows the world to flow into the artist and the artist flow into the world."[24] In fact, as we feel confident, protected, and stimulated enough to settle in a space, we allow similarly the boundary between ourselves and the space to

soften and become sensitized. All art articulates this constantly expanding and contracting boundary surface both in the experience of the artist and the viewer. In this sense, architecture is not only a shelter for the body, but it is also the contour of the consciousness, and an externalization of the mind.

Human consciousness is an embodied consciousness; the world is structured around a sensory and corporeal center. "I am my body,"[25] Gabriel Marcel claims, "I am what is around me,"[26] argues Wallace Stevens, and "I am the space, where I am,"[27] says the poet Noel Arnaud. Finally, "I am my world,"[28] concludes Ludwig Wittgenstein.

THE BIOLOGICAL GROUND OF ART AND ARCHITECTURE

The view of the crucial role of embodiment in consciousness, perception, and thinking that has arisen in philosophical investigations—particularly the idea of a chiasmatic binding of the world and the self, the outer and the inner space, the physical and the mental—is parallel to current neurological findings and assumptions. These recent insights also begin to reveal how art and architecture are embedded in the human bio-cultural and neurological reality; the arts are not seen as a mere cultural endeavor of the few, as art may well be deeply engaged with the most central qualities of our very humanity.

More than half a century ago J. H. Van den Berg, the Dutch phenomenologist, made the surprising claim: "Things speak to us ... the poet ... and the painter know this so very well, that is why poets and painters are born phenomenologists."[29] Today, Elaine Scarry assumes that great novelists and poets from Homer to Flaubert, Rilke and Heaney, have understood how the brain perceives images by means of their words.[30] This claim by a literary aesthetician sounds far-fetched, but in fact, her assumption is supported by today's neurological views.

Semir Zeki, an esteemed neurobiologist, argues that Shakespeare and Wagner are among the greatest of neurologists "for they, at least, did know how to probe the mind of man with the techniques of language and music and understood better than most what it is that moves the mind of man." He expands his argument by saying that most painters are also neurologists, as "they are those who have experimented upon and, without ever realizing it, understood something about the organization of the visual brain, though with techniques that are unique to them."[31] Zeki condenses his view on the relation of artistic understanding and our brain activities: "The aims of art constitute an extension of the functions of the brain."[32] As a scientist, he hopes to contribute to the understanding of the biological basis of aesthetic experience.

No doubt, profound architects have a similar intuitive understanding of how space, scale, materiality and light in architectural faculties affect our behavior and feelings of place and protection, domesticity and home, connectedness and self, and how architectural situations can stimulate and poeticize our relation with the world. Grant Hildebrand's study of Frank Lloyd Wright's houses reveals this master architect's intuitive grasp of the experiential polarity of

refuge and *prospect* introduced by the geographer Jay Appleton on the basis of bio-psychological theories.[33] I have myself analyzed Alvar Aalto's subtle understanding and fusion of architecturally and experientially relevant images, such as images of layered history and time.[34]

It is evident that our deepest experiences of settings and architecture reflect the course of human bio-cultural evolution, and these conditions are concealed in our neural and psychic constitution and reactions. No doubt, our aesthetic preferences reflect our biological past and our aesthetically based choices have had evolutionary values. Joseph Brodsky, the poet, offers yet another surprising perspective to the dialectics between biology and aesthetics: "The purpose of evolution, believe it or not, is beauty."[35]

Modernity was obsessed with the present and the utopian view of giving rise to a New Man. Yet, in the beginning of the third millennium we are in a more urgent need to acknowledge our fundamental biological and historical nature.

Figure 10.6 Joint of an extendable dining table, birch and blued steel base, 1985. (Juhani Pallasmaa Architects Archive.)

Figure 10.7 Architectural objects (stairways), cast and patinated bronze, 1998. (Juhani Pallasmaa Architects Archive.)

THE TASK OF ART

As the consumer and media culture of today consists of increasing manipulation of the human mind in the form of thematized environments, commercial conditioning, and benumbing entertainment, art has the ethical mission to defend the autonomy of individual experience and provide the existential ground for the human condition. One of the tasks of art and architecture is to safeguard the authenticity and reality of the human experience.

The settings of our lives in the industrialized world are irresistibly turning into a mass-produced and universally marketed kitsch. In my view, it would be ungrounded idealism to believe that the course of our obsessively materialist culture could be altered within the visible future. But it is exactly because of this critical view that the ethical task of artists and architects—the defense of the authenticity of life and experience—is so important. In a world where everything is becoming similar and, eventually, insignificant and of no consequence, art has to maintain differences of meaning, and in particular, the true criteria of experiential quality.

"My confidence in the future of literature consists in the knowledge that there are things that only literature can give us, by means specific to it,"[36] writes Italo Calvino in his *Six Memos for the Next Millennium*, and continues (in another chapter):

In an age when other fantastically speedy, widespread media are triumphing, and running the risk of flattening all communication onto a single, homogenous surface, the function of literature is communicating between things that are different simply because they are different, not blunting but even sharpening the differences between them, following the true bent of written language.[37]

In my view, the task of architecture is to maintain the differentiation and qualitative articulation of existential space. Instead of participating in the processes of the homogenization of space and the further speeding up of human experience, architecture needs to slow down experience, halt time, and defend the natural slowness of our embodied perception and identification. It must defend us against excessive stimuli, change, and speed. Yet the most profound task of architecture is to maintain and defend silence. "Nothing has changed the nature of man so much as the loss of silence," warns Max Pickard, the philosopher of silence.[38]

"Only if poets and writers set themselves tasks that no one else dares imagine will literature continue to have a function," Calvino states. "The grand challenge for literature is to be capable of weaving together the various branches of knowledge, the various 'codes' into a manifold and multifaceted vision of the world."[39]

Confidence in the future of architecture can, in my view, be based on the very same knowledge; existential meanings of inhabiting space can be revealed by the art of architecture alone. Architecture continues to have a great human task in mediating between the world and ourselves, providing a horizon of understanding our existential condition and constructing settings for dignified life.

NOTES

1 This essay is based on the themes of lectures given at the "Sustaining Identity" conference in London in May 2008, and in the "Sustainable School Buildings: From Concept to Reality" conference in Ljubljana in October 2009.
2 Gaston Bachelard, *The Poetics of Space*, Boston: Beacon Press, 1969, 46.
3 Jean-Paul Sartre, *The Emotions: An Outline of a Theory*, NY: Carol Publishing Co., 1993, 9.
4 Jorge Luis Borges, *Selected Poems 1923–1967*, London: Penguin Books, 1985. As quoted in Sören Thurell, *The Shadow of A Thought—The Janus Concept in Architecture*, Stockholm: School of Architecture, The Royal Institute of Technology, 1989, 2.
5 As quoted in Eric Shanes, *Constantin Brancusi*, NY: Abbeville Press, 1989, 67.
6 Italo Calvino, *Six Memos for the Next Millennium*, NY: Vintage Books, 1988, 57.
7 Maurice Merleau-Ponty, "The Film and the New Psychology," *Sense and Non-Sense*, Evanston: Northwestern UP, 1964, 48.
8 Edward Relph, *Place and Placelessness*, London: Pion Limited, 1976, 51. Relph defines the notion as follows: "Existential outsideness involves a self-conscious and reflective uninvolvement, an alienation from people and places, homelessness, a sense of the unreality of the world, and of not belonging."
9 Joseph Brodsky, *Less than One*, NY: Farrar, Straus, Giroux, 1986, 124.

10 As quoted in *Modernity and the Hegemony of Vision*, ed. David Michael Levin, Berkeley, Los Angeles; London: California UP, 1993, 14.

11 Ashley Montague, *Touching: The Human Significance of the Skin*, NY: Harper & Row, 1968 (1971), 3.

12 Kent C. Bloomer and Charles Moore, *Body, Memory and Architecture*, New Haven; London: Yale UP, 1977, 44.

13 Marcel Proust, *In Search of Lost Time, Volume 1: Swann's Way*, trans. C.K. Scott Moncrieff and Terence Kilmartin, London: Vintage, 1996, 4–5.

14 Gaston Bachelard, *The Poetics of Space*, Boston: Beacon Press, 1969, XXXIV.

15 Maurice Merleau-Ponty, "Cezannes's Doubt," *Sense and Non-Sense*, Evanston, Northwestern UP, 1991, 15.

16 Bernard Berenson, as quoted in Ashley Montagu, *Touching: The Human Significance of the Skin*, NY: Harper & Row, 1986, 308–9. Somewhat surprisingly, in my view, Merleau-Ponty objects strongly to Berenson's view: *"Berenson spoke of an evocation of tactile values, he could hardly have been more mistaken: painting evokes nothing, least of all the tactile. What it does is much different, almost the inverse; thanks to it we do not need a 'muscular sense' in order to possess the voluminosity of the world. ... The eye lives in this texture as a man lives in his house"* (Maurice Merleau-Ponty, "Eye and Mind," *The Primacy of Perception*, Evanston: Northwestern UP, 1964, 166). I cannot, however, agree with this argument of the philosopher. Experiencing the temperature *and moisture of air and* hearing the noises of carefree daily life in the erotically sensuous paintings of Matisse or Bonnard, one is confirmed of the reality of mediated or "ideated" sensations.

17 As quoted in Scott Poole, "Pumping Up: Digital Steroids and the Design Studio," unpublished manuscript, 2005.

18 See *Walter Benjamin's Philosophy: Destruction and Experience*, ed. Andrew Benjamin and Peter Osborne, London and NY: Routledge, 1994.

19 Mildred Reed Hall and Edward T. Hall, *The Fourth Dimension in Architecture: The Impact of Building Behaviour*, Santa Fe: Sunstone Press, 1995.

20 Martin Heidegger, "Building Dwelling Thinking," in David Farrell Krell, *Martin Heidegger: Basic Writings*, NY, Hagerstown, San Francisco, London: Harper & Row Publishers, 1997, 334.

21 Merleau-Ponty, "Cézanne's Doubt," 19.

22 Maurice Merleau-Ponty, *Signs*, as quoted in Richard Kearney, "Maurice Merleau-Ponty," *Modern Movements in European Philosophy*, Manchester and NY: Manchester UP, 1994, 82.

23 Liisa Enwald, "Lukijalle," *Rainer Maria Rilke, hiljainen taiteen sisin: kirjeitä vuosilta 1900–1926* [The silent innermost core of art: letters 1900–1926]. Helsinki: TAI-teos, 1997, 8.

24 Salman Rushdie, "Eikö mikään ole pyhää?" [Isn't anything sacred?], *Parnasso*: 1996, Helsinki, 8.

25 As quoted in "Translator's Introduction" by Hubert L. Dreyfus and Patricia Allen Dreyfus in Merleau-Ponty, *Sense and Non-Sense*, Evanston: Northwestern UP, 1964, XII.

26 Wallace Stevens, "Theory," *The Collected Poems*, NY: Vintage Books, 1990, 86.

27 In Gaston Bachelard, *The Poetics of Space*, Boston: Beacon Press, 1969, 137.

28 Ludwig Wittgenstein, *Tractatus Logico-Philosophicus eli Loogis-filosofinen tutkielma*, Porvoo: Werner Söderström, 1972, 68 (proposition 5.63).

29 J. Van den Berg, *The Phenomenological Approach to Psychiatry*, Springfield, Illinois: Charles C. Thomas Publishers, 1955, 61.

30 Elaine Scarry, *Dreaming by the Book*, Princeton, NJ: Princeton UP, 2001.

31 Semir Zeki, *Inner Vision: An Exploration of Art and the Brain*, Oxford UP, 1999, 2.

32 Zeki, *Inner Vision*, 1.

33 Grant Hildebrand, *Origins of Architectural Pleasure*, Berkeley, Los Angeles, London: University of California Press, 1999.

34 Juhani Pallasmaa, "Image and Meaning," in *Alvar Aalto: Villa Mairea 1938–39*, ed. Juhani Pallasmaa, Helsinki: Alvar Aalto Foundation; Mairea Foundation, 1998, 70-103.

35 Joseph Brodsky, "An Immodest Proposal," in Joseph Brodsky, *On Grief and Reason*, NY: Farrar, Straus and Giroux, 1997, 207.
36 Italo Calvino, *Six Memos for the Next Millennium*, NY: Vintage Books, 1993, 1.
37 Ibid., 112.
38 Max Picard, *The World of Silence*, Washington, D.C.: Regnery Gateway, 1988, 221.
39 Calvino, *Six Memos for the Next Millennium*, 1993, 45.

index

Illustrations are shown in italics.

yin yang concept 185, 190

Zeki, Semir 3, 225
Zen Buddhism: breathing 31–3;
 meditation 26–30, 32–3; mindful
eating 29–31; "non-doing"
(Alexander Technique) 152–3;
seeing 28–9; transcendence of
ego 163, 165; Zen view (garden
design) 169, *170*, 198, *199*

420052